THE WARES OF THE MING DYNASTY

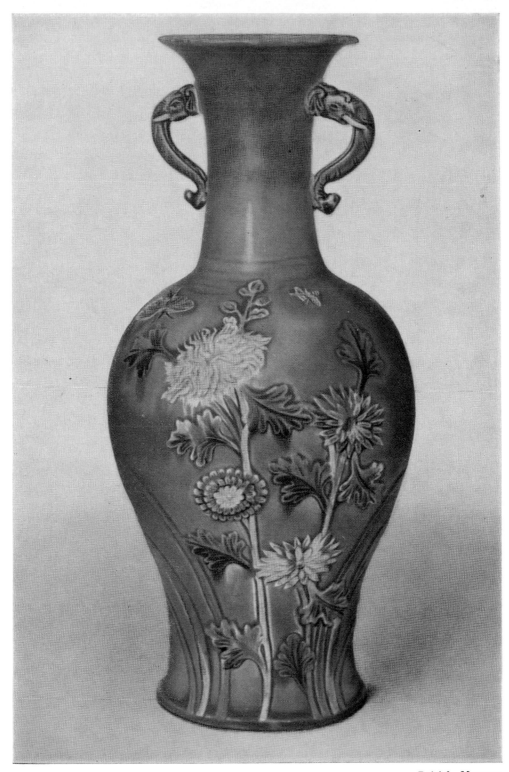

Vase with elephant handles and design
of chrysanthemums in bas-relief. Col-
oured glazes on turquoise ground. Prob-
ably 16th century. H. 18 ins.

THE WARES
OF THE
MING DYNASTY

by R. L. HOBSON

CHARLES E. TUTTLE COMPANY
Rutland, Vermont & Tokyo, Japan

Representatives
Continental Europe : BOXERBOOKS, INC., Zurich
British Isles : PRENTICE-HALL INTERNATIONAL, INC., London
Australasia : PAUL FLESCH & Co., PTY. LTD., Melbourne
Canada : M. G. HURTIG LTD., Edmonton

Published by the Charles E. Tuttle Company
of Rutland, Vermont & Tokyo, Japan
with editorial offices at
Suido 1-chome, 2-6, Bunkyo-ku, Tokyo, Japan

Library of Congress Catalog Card No. 62-18358

International Standard Book No. 0-8048-0623-3

1st edition published 1923 by Benn Brothers, Ltd.
1st Tuttle edition published 1962
(This edition is a complete
photographic reprint of the original,
with the plates slightly rearranged.)
4th printing, 1973

Printed in Japan

PUBLISHER'S NOTE

R. L. Hobson's THE WARES OF THE MING DYNASTY, first published in 1923, continues to maintain its high reputation as one of the primary sources of information on Ming ceramics. The original printing, however, was limited to only slightly more than 2,000 copies, some 280 of which comprised a de luxe edition with an extra color plate and the remainder a regular trade edition. These editions having been printed, the type was distributed, with the result that copies of the book have unfortunately become excessively rare.

The current reprint of the first trade edition makes only two minor changes. First, a slight rearrangement of the plates has been made in order to reduce production costs and at the same time to permit inclusion of the extra color plate formerly used only in the de luxe edition. Second, the captions, instead of appearing on separate facing pages, now appear on the plates themselves. Neither of these alterations, however, will cause the reader any inconvenience.

This reprint is being issued in line with our policy of again making available to scholars, interested laymen, and libraries throughout the world valuable books on Asia containing much original research material not elsewhere available.

Tokyo, July 1962

PREFACE

The early periods of Chinese Ceramic history have received of late some of the attention which they deserve. The initial volume of this series was devoted to them; and the present book, the first monograph on Ming wares, is not only a natural sequel to the *Early Ceramic Wares of China*, but a necessary prelude to the study of the more familiar porcelains of the recent Manchu dynasty.

Europe has been acquainted with Ming porcelain since the fifteenth century. It came to us at first in a slender and uncertain stream, which steadily increased in volume until, in the last years of the dynasty, it almost reached the dimensions of a flood. The wares which arrived in this fashion were mainly strong and somewhat roughly finished articles, suitable for the export trade of the time. It is only of recent years that we have come to know the choicer Ming porcelains, which were made for the Imperial court and the more exacting home markets of China; and though examples of these high-class wares, made in the earlier reigns, are still very scarce, the material as a whole is ample enough to justify a separate book on Ming.

In the sixteenth century the output of the great porcelain centre of Ching-tê Chên was already enormous; and even after the lapse of three hundred and odd years there is no lack of specimens to meet the demands of collectors of all calibres. The Imperial Ming and the splendid three-colour vases are naturally rare and proportionately expensive. This has been called the Ming for millionaires. But there is also Ming " for the million." The blue and white and enamelled ware, which formed the staple of the export trade, and even Imperial wares of the later reigns, are still within reach of modest means, while their bold designs and decorative character will commend them to persons of refined taste.

The purpose of this book is to explain and illustrate as many varieties of Ming as possible. The text is based primarily on information obtained from Chinese sources and the occasional notes made by Europeans who visited China in the Ming period. To this must be added the deductions which can be made from the study of well-authenticated specimens, and, of course, the valuable work enshrined in the books which are mentioned in the bibliography. The first twelve chapters are occupied almost

exclusively by the porcelain of Ching-tê Chên; the next four by the porcelain and pottery made at other centres. For the convenience of printing, all the Chinese characters have been collected together in the final chapter, to which reference is made in each case. The abbreviations used in the text are of the obvious kind and need no special explanation, except perhaps " Cat. B.F.A.," which stands for Catalogue of the Burlington Fine Arts Club. The bulk of the illustrations are drawn from private collections, but reference is made throughout to important examples which can be seen in public museums. Mention is also made of those which have been published in other works; and this will explain (and I hope condone) the unconscionable number of references to my two volumes on Chinese Pottery and Porcelain which were published in 1915. In the colour-plates an attempt is made to illustrate the chief Ming colours.

I take this opportunity to thank collectively the many friends who have allowed me to draw so freely on their cabinets. Their names are given individually in the descriptions of the plates. I tender also my thanks to my colleagues at the Louvre and the Victoria and Albert Museums —Mlle. Ballot and Messrs. Marquet de Vasselot, Rackham and King— for the ready help they have given with the collections under their care; to the following for the loan or gift of photographs—Mrs. Lane, Messrs. Léon Fould, J. Sauphar, M. Calmann, d'Ardenne de Tissac, Bering Liisberg, M. D. Ezekiel, Dr. J. Böttiger and Dr. Bourne; to Mr. R. W. Brandt for some useful notes on the export wares; to Dr. Lionel Giles for checking the Chinese characters; and, finally, to Mr. A. L. Hetherington for invaluable help with the proofs.

R. L. HOBSON.

January, 1923.

CONTENTS

LIST OF ILLUSTRATIONS

LIST OF ILLUSTRATIONS

LIST OF ILLUSTRATIONS

LIST OF ILLUSTRATIONS

LIST OF ILLUSTRATIONS

LIST OF ILLUSTRATIONS

THE WARES OF THE MING DYNASTY

CHAPTER I

INTRODUCTORY

MING : WHAT IT IS AND WHAT IT IS NOT

In the long vista of Chinese history which stretches back in an unbroken line far beyond our era, the Ming dynasty seems relatively near and modern. The supreme periods of the major arts had passed. The great poets and painters of the T'ang and Sung dynasties were already invested with the halo of antiquity; and though there were still names which added lustre to the annals of Chinese art, the Ming dynasty is best known to us for the development of one of the minor crafts.

The porcelain of Ching-tê Chên, with which the name of China is universally associated, reached its full maturity under the Mings; and later generations had little to add to its development except increased production and the inevitable perfection of detail. Chinese writers and collectors of after times speak of the Ming porcelains with deep respect; and some of the Ming reigns have been unanimously voted the classic periods of porcelain manufacture.

This verdict has long been in the possession of European students of ceramics, but it has not always met with the unhesitating acceptance which so authoritative an opinion deserves. The reason was that ocular demonstration was wanting. The finer Ming specimens in our collections were very few, so few that their exceptional nature aroused feelings of scepticism, while the bulk of authenticated Ming pieces, although appreciated for their boldness of colouring and freshness of design, belonged to the large class of export wares which could hardly support the enthusiastic encomiums of the Chinese writers. And so, discounting the statement of the Chinese as the exaggerations of a people who worshipped their ancestors and all their works, we assumed that the Ming was an age of primitives, of things strong but clumsy, virile but crude, and not comparable in finish and refinement with the sophisticated productions of the K'ang Hsi, Yung Chêng and Ch'ien Lung periods.

The Album of Hsiang Yüan-p'ien,[1] with its selected series of the best Ming porcelains described and illustrated, certainly gave food for

[1] See p. 11.

3

reflection ; but unfortunately the illustrations were of questionable accuracy and our scepticism was not seriously shaken. It is only since a slender but increasing stream of the finer Ming specimens has begun to flow westward that our doubts are slowly but surely dissolving.

The ocular demonstration, if not yet complete, is undoubtedly forthcoming ; and some of the conditions, which have helped so materially to a better understanding of the Sung wares, are now operating to supply our deficiencies in regard to the Ming. Whatever the causes—and the old question of demand and supply is largely involved in them—we are now able to see for ourselves that, in addition to the export Ming which we have known for many generations, there were finer qualities of Ming porcelain too delicate and costly to be subjected to the risks of the export trade of former days, things worthy of Imperial use and capable of satisfying the requirements of the most exacting native connoisseurs. It was on these superior wares that the high repute of the Ming porcelain was based, and seeing them we realise that, after all, the encomiums of the Chinese enthusiasts were not excessive.

It would now seem that we have to reckon with two distinct types of porcelain, the one a finely potted, delicately finished article such as the Yung Lo bowl (Plate 15), and the other a thick and heavy, or at any rate roughly finished, ware suitable for transport by sailing ship or caravan to Western markets. The extremes of these two groups are certainly as the poles apart, but they are none the less of one and the same family. Between them is a wide range of porcelains of varying quality which fill the gap and lead us gradually from one extreme to the other. The second and third grades of the porcelain made for native consumption and the better class of export wares merge insensibly into each other ; and the complete series which would be comprised in a really representative Ming collection would show conclusively that the Ming porcelain makers had full command of their craft from the earliest periods, and that their methods, so far from being crude and immature, were the foundation of all subsequent ceramic developments at Ching-tê Chên.

If no mention has been made so far of the wares, whether porcelain or pottery, made in other localities, it is not because they are not taken into account in the subsequent chapters. They will be dealt with in their place. But these general remarks are mainly concerned with the productions of Ching-tê Chên, because it was here that the chief developments took place. The other wares, in so far as they changed their character, developed it on parallel lines.

INTRODUCTORY

The growth of the Ming technique and its essential features are described in detail in subsequent chapters, sufficiently fully, it is hoped, to enable the reader to distinguish and appreciate the points of Ming porcelain. Among these, surface decoration will naturally receive special attention, the most prominent feature of Ming porcelain being the use of the pictorial and polychrome designs as opposed to the monochrome glazes of the Sung period.

The mediums of these painted designs are chiefly underglaze blue, and coloured enamels on the glaze with or without the support of underglaze blue; but there is besides an important group of wares, both porcelain and pottery, decorated with coloured glazes, or broad washes of enamel, applied direct to the body of the ware, the pictorial design being framed by incised or raised lines or more rarely by lines painted in black or brown pigment. The features of this type of polychrome are breadth of design and boldness of colour—resplendent masses of turquoise blue, aubergine, dark violet, deep green and yellow; and there is nothing in the ceramics of any period finer than the best of this gorgeous Ming polychrome.

On the blue and white porcelains, and on those painted with enamel colours on the glaze, there will be found an immense range of pictorial designs. Most of these found their way into the pattern books of the succeeding dynasty; but in their original application there will be observed, besides some peculiarities of technique which will be duly explained, a certain freshness and spontaneity which distinguish the Ming painted wares from those of subsequent periods.

Nor are the Ming shapes without their distinctive features. The wide-mouthed jars, the high-shouldered vases, the tall beakers, the incense burners and the dishes with narrow rim have a character of their own; and even the numerous bowls have many notable peculiarities in their varied forms. The Ming shapes are often distinguished by a certain rugged simplicity, and always by the directness and strength of an art which is still young and virile.

But, after all, these are mere generalities which the critical reader will test in the light of his own experience or by the illustrations provided in this book. It is hardly necessary in these introductory remarks to elaborate further the positive side of the question " what is Ming," seeing that the whole book is concerned with the answer. Something should be said, however, on the negative side of the question.

Misconceptions about Ming are so many, and the word has been so

frequently abused, that it will be well to devote a little destructive criticism to the things which are not Ming, but too often masquerade as such. We do not refer here to the admirable Japanese imitations or to the productions of later Chinese periods copying only too faithfully the Ming style. There is, for instance, a vase in the Love Collection, of a slender but rather clumsy form which is not unlike some of the Wan Li shapes. It is painted with dragon designs, etc., in a dull dark blue which might well be late Ming; and a pair of loop handles on the neck are in Ming taste, though rather weak in execution. It is a piece which would be capable of deluding anyone, were it not for an inscribed panel on the neck in which mention is made of the 38th year of K'ang Hsi.[1] One may be, and often is, quite pardonably deceived by objects of this kind; but here, at any rate, one is arguing on the right lines. We refer rather to the pottery and porcelain which is so often assigned to the Ming period for no better reason than that it is of unfamiliar type, or, worse still, in order to invest it with an interest which would be otherwise lacking.

Ming is not a home for stray pots, in which every mongrel piece, which has no fixed attribution, can find a refuge, nor is it a *locus penetentiae* into which anything wrongfully posing as Sung or Yüan should be degraded when found out. It is true that we know very little about the wares made in hundreds of small potteries scattered up and down the eighteen provinces of China; but because a piece is strange to our limited vision it is not necessarily Ming. Take, for instance, the very numerous wares coarsely made for export to the East Indies and beyond, with grey, buff, green or yellow glazes usually covered with a close crackle. These have been made and traded for many generations, and their manufacture continues to the present day. Among the uninstructed these almost always pass for Ming—the bolder spirits call them Sung; and yet bowls and incense burners with the typical buff crackled glaze of this group are bought by traders in Yunnan to-day fresh from the kiln.

Again, the architectural ornaments in glazed pottery, the coloured roof tiles mounted with spirited figures in full relief, are indiscriminately assigned to the Ming period. And yet Chinese houses and temples are decorated to-day with similar tiles and finials, and some of them have stood for less than two hundred and eighty years. Of course, much of this particular group may well be real Ming, just as quite a number of

[1] Another vase of the same form, with five-colour decoration and without the telltale inscription, may be seen in the Grandidier Collection in the Louvre.

English houses are of Tudor date; but to label all the pottery of tileware type Ming, as is so often done, is surely fantastic.

Similarly the art dealer of past days, when information about things Chinese was a negligible quantity, affixed the Ming label firmly on a large group of porcelains of which ninety per cent belong to the K'ang Hsi or later periods. This is the porcelain decorated on the biscuit with green, yellow and aubergine enamels over designs traced in black outline or with glazes of similar appearance applied in broad washes without outline. It is a much desired and costly type, eagerly sought by collectors and quite capable of holding its own without the support of a spurious antiquity. Like many another style of decoration, both of these have beginnings traceable to the Ming period; but one of the few dated specimens of the class, which we know, was made in the year 1692, and there are plentiful examples in the old collections, such as the Dresden, which were formed round about the year 1700.

It is, of course, very hard to eradicate an error which has so many vested interests tangling its roots. Specimens of this ware have been bought and sold and collected as Ming; and auctioneers in selling them to-day are chary of giving them another name, lest some old-fashioned owner should charge them with " carelessness." Worse still, they have been published as Ming in large and expensive books. This is particularly true of those fine porcelains which have grounds of the precious green-black, green or yellow enamels; and one has seen these confidently described as Ming even when touches of rose-pink and the opaque blue of the *famille rose* appeared among their enamels. It has taken years of wearisome repetition to smother, though not yet finally to annihilate, the "Lowestoft" myth; and it is safe to say that a generation of enlightenment will be needed to get rid of this particular Ming fallacy.

Another error propagated in similar fashion is to call the motley Kwangtung stoneware Ming and even Sung. Here again at least ninety per cent of the pieces so dated are much more modern. There are, for instance, certain figures of Taoist deities, lions, birds on rocks by a hawthorn tree, etc., with an iron-red biscuit freely exposed in places and the rest of the surface coated with the thick Canton glaze of mottled blue-grey, flambé red or celadon green. These are almost invariably labelled Ming, and they are almost invariably of nineteenth-century make.

Not long ago all glazed pottery figures were called Ming as a matter of course. No self-respecting merchant would have thought of stocking anything later in that line of goods; and even the little joss-stick lions,

with slippery blue-green glaze or patches of turquoise and yellow on a rough oatmeal stoneware, which are bought at Kowloon for a few cents, became Ming in London. The same glazes cover the same body on pottery ginger jars. Extract the ginger and place the pots on the shelf. They become Ming in the twinkling of an eye. There is little exaggeration in this. One has seen these jars again and again masquerading as Ming.

And so for the benefit of the beginner a warning note is needed; but it must not be taken as a general tirade against the dealer in antiques. There are dealers and dealers. Those who take the trouble to study the things they handle—and most of them do that—are the best friends to the searcher after truth in this particular field. But there are still people who will pass off anything Chinese as Ming, partly out of ignorance, but mainly because the name Ming is something to conjure with. A convenient philosophy tells them that there are many doubtful specimens, and that they are at liberty to give themselves the benefit of the doubt, and, further, that the less they know of the subject the more doubt there is to benefit from. These sophists are a nuisance and should be exposed on every occasion, if only for the good time that is wasted by the conscientious members of the trade in correcting the errors which they disseminate.

This said, we can return to the constructive side of our theme, ending this introductory note with some old-world phrases of one who lived and wrote in the Far East in the late Ming period[1] :—

" Let us now intreat of that earthen or pliable matter commonly called porcelain, which is pure white, and is to be esteemed the best stuffe of that kind in the whole world : whereof vessels of all kinds are very curiously framed. I say, it is the best earthen matter in all the world, for three qualities ; namely, the cleannesse, the beauty, and the strength thereof. . . . This matter is digged, not throrowout the whole region of China, but only in one of the fifteene provinces called Quiansi, wherein continually very many artificers are employed about the same matter : neither doe they onely frame thereof smaller vessels, as dishes, platters, salt-sellers, ewers, and such like, but also certaine huge tunnes, and vessels of great quantity, being very finely and cunningly wrought, which, by reason of the danger and difficulty of carriage, are not transported out

[1] *Hakluyt's Voyages*, Everyman's Library, vol. iv., p. 215 : " An excellent treatise of the kingdome of China, and the estate and government thereof : Printed in Latine at Macao a citie of the Portugals in China, An. Dom. 1590.''

of the realme, but are used onely within it, and especially in the king's court. The beauty of this matter is much augmented by variety of picture, which is layed in certain colours upon it, while it is yet new, golde also being added thereunto, which maketh the foresayd vessels to appeare most beautifull. It is wonderfull how highly the Portugals do esteeme thereof, seeing they do, with great difficulty, transport the same, not onely to us of Japon and into India, but also into sundry provinces of Europe."

CHAPTER II

MING TECHNIQUE

It will help us towards a correct perspective of the Ming technique if we look back for a moment to the traditions which lay behind the Ming potters ; and this help is needed all the more because our knowledge of Ming wares was so long based almost entirely on the heavier and coarser types made for the export trade. This limited knowledge led us to read with scarcely disguised scepticism the descriptions of his choice Ming porcelains written by Hsiang Yüan-p'ien in the sixteenth century,[1] and also to doubt the repeated assurance of Chinese connoisseurs that such an exquisitely delicate object as the Yung Lo eggshell bowl in the Franks Collection could possibly have been made at the very beginning of the Ming period.

Here, however, our better acquaintance with the earlier phases of Chinese ceramic art will stand us in good stead. We have learnt in recent years that the potters of the Han dynasty (206 B.C.–A.D. 220) were already masters of the ordinary potters' routine, throwing rounded objects on the wheel, forming others in moulds, the use of green and brown glazes, colouring by means of slips or liquid clays, decoration by incising, by sticking on moulded ornaments and by pressing the object itself in a mould ; and we have learnt too that the Han potters were already feeling their way to a kind of porcelain.

In the T'ang dynasty (A.D. 618–906) the art of pottery was mature. Soft faience, stoneware and porcelain were made with equal facility where-ever the requisite materials were forthcoming. The soft pottery glazes included green, yellow, manganese purple and blue, which were used either as monochromes or to fill in designs outlined with a point ; high-fired glazes, too, were beginning to be used, including a celadon green, a brown-black, a chocolate-brown and some flambé effects which were probably accidental ; and painting with a brush in pigments and coloured clays was an accomplished fact. The finds on the ninth-century site of Samarra on the Tigris prove conclusively that fine white porcelain was

[1] *Porcelain of Different Dynasties*, sixteenth-century coloured illustrations with Chinese MS. text by Hsiang Yüan-p'ien, translated and annotated by S. W. Bushell, Oxford, 1908.

11

made and exported at this time as well as the typical green celadons which are usually associated with the Sung and Ming dynasties.

In the Sung dynasty attention was chiefly paid to the development of high-fired glazes—the cream-whites, the grey-blues and grey-greens of the celadon class, and the splashed and flambé glazes of Chün Chou—and painted decoration was held of little account. It was, however, used to a considerable extent at such factories as Tz'ŭ Chou, where the medium was chiefly slips of coloured clay, and we know of actual brushwork in vitrifiable enamels on a rare type of stoneware which may conceivably have emanated from the same factories. A very fine example of this latter kind is a bowl[1] in the O. C. Raphael Collection. It is made of grey stoneware with a coating of white slip and a colourless glaze on which a beautiful design of large flowers and foliage is boldly painted in green and yellow enamels and iron-red. A specimen of this ware dated 1201 was illustrated in the Kokka,[2] showing that we have to reckon with the use of enamel colours fired in a muffle kiln more than a century and a half before the Ming dynasty. The same is probably true of blue and white decoration, though we are not fortunate enough to possess such decisive evidence of it. There is, however, literary sanction for the statement. Thus the *T'ao lu*, in reference to the crackled wares of Yung-ho Chên, states that there were besides " pieces with plain crackled ground to which blue decoration was added." There are, indeed, many specimens of rough porcelain (probably of later provincial make) which would answer this description, and we have seen among them several reputed examples of Sung blue and white ; but it must be admitted that these claimants had an uncommonly close resemblance to comparatively recent Corean wares. We should perhaps make an exception in favour of a bowl in the Kunstgewerbe Museum in Berlin which may be a piece of genuine Sung blue and white. Another Sung factory mentioned in the *T'ao lu* as a producer of blue and white was Nan-fêng Hsien in Kiangsi, which made ware " of refined clay but somewhat thick, and decorated as a rule with blue designs (*ch'ing hua*)." Further, a reference to the cobalt mineral from which the blue was obtained is made in the Sung Annals,[3] and we may now state with confidence that both blue and white and enamelled decoration were in use at certain minor factories and on the less-considered wares of the Sung dynasty. In the Ming dynasty fashion made a *volte face* and decreed that the high-fired monochrome glazes

[1] See Hetherington, *The Early Ceramic Wares of China*, Plate 37.
[2] November, 1921. [3] See p. 47.

of the Sung should surrender the pride of place to the polychrome and blue-painted porcelains.

The natural result, or perhaps the cause, of this was the concentration of the ceramic industry at Ching-tê Chên, where the most suitable medium was manufactured for these two kinds of decoration. Ching-tê Chên (post office spelling Kingtehchen) is an unwalled town (*chên*) situated on the left bank of the Ch'ang River which flows into the Po-yang Lake in the north of Kiangsi, a lake which connects with the great Yangtse waterway. The old name of Ch'ang-nan Chên was abandoned in the first decade of the eleventh century, when the Sung emperor ordered that supplies of porcelain should be regularly sent to the palace and marked with the period name of Ching Tê. The residence of the district magistrate is at Fou-liang Hsien, in the prefecture of Jaochow, which explains the names Jao ware and Fou-liang ware applied by some Chinese writers to the porcelain of Ching-tê Chên.

Pottery was made in this district in the Han dynasty, and it would appear that porcelain was sent as " tribute " to the emperor as early as A.D. 621 in the Wu Tê period of the T'ang dynasty under the name of " porcelain jade " and " false jade vessels." Probably the porcelain exported to Samarra[1] in the ninth century came from this district. In the eleventh century, as we have seen, official orders were received from the palace, and in the T'ai Ting period of the Yüan dynasty (1324–1327) it was one of the duties of the Intendent of the Circuit to inspect the Imperial factory at Ching-tê Chên, to see that the ware was supplied when orders were given and the factory closed when no orders were sent from the Court.

The sources from which materials for the body and glaze were drawn in the early part of the sixteenth century are enumerated in the Annals of the province, the *Chiang hsi ta chih*. The porcelain clay came from Hsin-chêng-tu in the district of Fou-liang, where it was mined in the Ma-ts'ang hills. Four spots in these hills are named as producing the best material, each having a special name, such as the Gully of a Thousand Families, the Dragon Gully, etc. Porcelain stone of good quality was obtained in the Hu-t'ien district. Good earth or stone used for the glaze came from Hsin-chêng-tu, but the best was that brought from Ch'ang-ling and I-kêng. The material for green or blue (*ch'ing*) and yellow glazes was obtained from Ch'ang-ling, and that for the finest white from I-kêng. All these places are within easy reach of Ching-tê Chên.

[1] See p. 11.

Further information is collected in the *T'ao shuo*; and we learn from this authority that the pits at Ma-ts'ang were gradually worked out in the sixteenth century and were practically exhausted in the reign of Wan Li. This disaster was only partially repaired by the discovery of an excellent porcelain clay deposit at Wu-mên-t'o in the same district; but apparently this source was difficult to work owing to increased cost of transport, and it is unlikely that the private kilns got much benefit from it. There is little doubt that the quite obvious deterioration of the material in some of the Wan Li wares is due to these circumstances.

There were, of course, fine and coarse wares at all times, and in the larger and heavier vases and bowls it was only natural that stronger and often coarser material should be used. Thus a special mixture of earth from Yü-kan and Wu-yüan, with powdered stone from the Hu-t'ien district, was used for the making of the large dragon bowls. Yü-kan and Wu-yüan also supplied much of the porcelain stone which was mingled with the porcelain earth in the body of the ware.

The body material of Ming porcelain, especially in the earlier wares, is generally fine-grained and white, and the biscuit, as seen at the foot-rim, is smooth to the touch and often almost unctuous. In some cases the presence of a little iron in the clay has caused the white to take on a rusty red or brown hue in the exposed parts; and the unglazed base of large vases and jars are often burnt almost brown; but even so it will be found that the clay is generally smooth to the touch.

Besides the glaze material from Ch'ang-ling and Yi-kêng, another supply was obtained from T'ao-shu-mu which was suitable for the glaze of the ordinary white and blue and white wares. The glazing material was usually softened with varying quantities of lime mixed with ashes of ferns or other frondage.

It is evident that thickness of glaze was a characteristic (and a prized one) of the earlier wares. In the time of Hung Wu, we are told,[1] that if there were the smallest flaw in the glaze of the Imperial wares the piece was ground smooth on the lathe, then reglazed and refired. Hence the solid appearance of these early glazes, which is likened to "massed lard." This same piled-up glaze was an attraction of the Hsüan Tê wares, according to Hsiang Yüan-p'ien,[2] who felt a special delight if the snow-white mass of glaze was forced up into faint undulations like those of orange-peel or into tubercles like grains of millet. These elevations, of course, implied corresponding depressions and even holes; and these

[1] See p. 36. [2] See p. 48.

14

are apparently what the Chinese writers describe as *tsung yen*, or palm eyes.

It is a matter of general observation that the glaze, even on our finer Ming wares, has occasional flaws and " pin-holes " ; but really striking examples of the " massed lard " effect are not so easily found. There is, however, a white bowl in the British Museum which shows this effect in a most marked manner. It is a rounded bowl of early form with a sugary white body showing at the edge of the foot-rim, which is otherwise rough with sand from the kiln. The glaze outside is thick and solid like curds with a general tendency to unevenness of surface ; but in one place it has begun to shrink up into a series of undulations and depressions like those on the peel of an orange. It is a plain white piece, but the inside has been finely etched with panels and borders of Arabic inscriptions in an excellent style, showing that the bowl had probably been sent to Persia or the Near East and had been treated there with considerable respect. There is no indication of date on the piece, but one is tempted to regard it as one of the early Ming productions, perhaps made near the beginning of the fifteenth century when white wares were in fashion and thick glaze a characteristic feature.

The thick, undulating glaze so lauded by Chinese connoisseurs on the early Ming wares was studiously copied by the Ch'ien Lung potters in the " orange peel " glaze with which collectors of later wares are so familiar. In these later versions the orange-peel effect is exaggerated and regularised, but they will serve to explain the less obvious peculiarity of the early Ming glaze.

Other expressions used by the Chinese to describe the idiosyncrasies of early Ming glazes are not so easy to understand. " Millet-like elevations " would appear to be small lumps of glaze rising above the surrounding level, isolated protuberances as distinct from the more regular orange-peel effect. " A wind-ruffled surface " suggests a slight wrinkling of the glaze, which is seen locally on some of the Chêng Tê blue and white pieces in the British Museum. " Chicken skin " is another term used to describe irregularities of surface, though it is nowhere made clear what its precise nature was ; and we have applied it tentatively in another passage[1] to a glaze peculiarity which was found to be common to a number of specimens of the finer types bearing early Ming date-marks. The glaze of these pieces has a remarkable lustre which is produced by an infinite number of tiny depressions just large enough to be visible to

[1] See p. 16.

the eye if the piece is flashed obliquely to the light. This effect is variously described as an oily sheen, a satin-like shimmer, etc., and as it requires some definite name we have applied the phrase "chicken-skin" to it, in the fond belief that the Chinese intended the term to apply to something of this sort. A glaze texture of a somewhat similar but coarser nature is noticeable on some of the later Ming blue and white (of the Lung Ch'ing and Wan Li period). It has been described as muslin-like, and is the result of innumerable tiny pin-holes in the glaze, caused doubtless by air bubbles. Many of the Japanese porcelains have this characteristic, and it is specially marked in the Arita wares. It should not be forgotten that, apart from inherent peculiarities of the Ming glazes, age and handling have in many cases given them a subdued lustre and pleasantly smooth surface which the modern imitator vainly strives to obtain by artificial means.

It is evident from the exquisite nature of the finer Ming porcelains that the Ming potters had little to learn in the matter of manipulative skill; but there is a common trait in their vases and jars which seems to imply a disregard, if not a contempt, for niceties of finish in the ordinary wares and in those of stouter build. As generally happened, jars, bottles and vases with contracted necks had to be made in two sections and joined together. The K'ang Hsi potter would, as a rule, take pains to smooth over the joint, rendering it invisible on the outside, at any rate. Not so the Ming potter, who left these seams in most cases obvious to the eye and to the touch. Nor is the shape of the Ming export pieces so rigorously exact as in the K'ang Hsi period. In fact, cases of sinkage in the firing and consequent slight distortion of shape are not uncommon.

Other features of Ming potting are discernible in the finish of the base. This is impressed upon us by a Chinese writer,[1] who insists that all porcelain vessels come from the kiln with bottom and foot which can testify to the fashion of their firing. He exhorts us to distinguish the wares by their feet, specifying the Yung Lo bowls, which have a glazed bottom and sandy foot, the Hsüan Tê altar cups, which have a cauldron bottom (i.e. convex beneath) and thin, wire-like foot, and the Chia Ching flat cups, which have a loaf centre (i.e. convex inside) and rounded foot.[2] We shall have occasion to note these peculiarities in dealing with the wares in their respective periods. But it is generally observable on bowls, ewers and other objects, which have foot-rims, that the Ming potters did not take much pains to finish off and trim this part of the vessel. In the

[1] Author of the *Shih ch'ing jih cha*. [2] See p. 88.

K'ang Hsi porcelain the foot-rim is often grooved or finished with a neat beading so as to fit into a wooden stand. This kind of finish is rarely, if ever, found on the Ming foot-rims, which are left with a plain raw edge capable of showing to the enquiring eye and hand the nature of the paste. Inside this foot-rim is generally a wash of glaze more or less evenly spread. One sometimes finds particles of sand and grit adhering to the edge of the foot-rim, the remains of the sand on which the vessel rested in the kiln, and also radiating lines under the glaze of the base which indicate a jerky finish on the lathe. But many of the Ming jars, especially those of heavy construction such as were sent abroad, have flat, unglazed bases ; and these areas of biscuit coming into contact with the fire in the kiln have often assumed a rusty brown colour, indicating the presence of iron in the clay. And even on the finer dishes and bowls, on which the glaze beneath is brought up to the very edge of the foot-rim, a tendency to " browning " is generally noticed at the point of junction of biscuit and glaze.

The porcelain was protected in the kiln by fire-cases called seggars, for the manufacture of which a special department existed at the Imperial factory. The kilns described in the *T'ao Shuo* were not large, and when the biggest of the dragon fish-bowls were to be fired only one case could be put in at a time. In another passage we are told that they were long and narrow, and that in the private factories the ware was arranged in nine rows with the coarser pieces in the front and back rows to break the force of the fire, and the finer wares in the centre. Thus all qualities came out of these private kilns, whereas the Imperial kilns only baked high-class wares, and empty seggars were ranged in the front rows to shield the rest. The fuel used was wood ; and the fire had to be kept up for periods varying from three days for the ordinary blue and white porcelain to nine days for the large dragon fish-bowls.

Among the twenty-three departments of the Imperial factory four were concerned with decoration and a fifth was the " mark or seal depart-ment." There were separate departments for engraving designs, for sketching designs in outline, for colouring and for writing. This implies a division of labour which effectually obliterated the individuality of the decorators. It is true that this division is not so minute as it was in the K'ang Hsi period, when a single piece was reckoned to pass through seventy hands before it was finished ; but it is clear that no one could have fairly put his signature to the finished pieces, if such a liberty as signing the decoration of Imperial wares had been permitted. As a matter

17

of fact, the *T'ao Shuo* gives us a clear picture of the procedure at one part of the Ming period which is not specified, but may be conjectured to have been in the reign of Chia Ching. It evidently had the double intention of securing a good standard of painting and of regulating the quantity of the blue material used.[1] Two men of good character, we are told, were selected, the one to paint a large piece and the other a small one, and the amount of material used by them was exactly calculated. If their work was satisfactory, it was given as a model to the other painters, together with the correct amount of material required to copy it exactly.

The results of such a system would depend largely on the choice of good models, but there would be no lack of these at the command of the Imperial taskmasters. Designs, too, were frequently supplied by the Palace artists, so that we have every reason to expect good workmanship on the Imperial Ming porcelains. Nor are we disappointed. The designs in the main are bold, vigorous and decorative, and the colouring is strong but harmonious.

The private factories, though following the lead of the Imperial factory where possible, would hardly be able to afford such refinements. The decorations here would probably be both outlined and coloured in by the same painter ; and that is why in some of the obvious trade wares we meet with refreshing signs of individuality in the painting.

The patterns and designs used both at the Imperial and private factories were based on well-known pictures and on coloured silk brocades. Many of these designs are described in the list of the Imperial wares mentioned in subsequent chapters, and the *T'ao Shuo* gives a summary, occupying rather more than a page,[2] of the patterns given to the artists in the eighth year of Chia Ching (1529). It is hardly necessary to quote the passage in full, especially as practically all the designs are mentioned in the chapters on Chia Ching and Wan Li porcelains ; but it is a very comprehensive list and introduces us at once to nearly all the types of decoration which we find on the blue and white and enamelled wares. Elsewhere the same volume[3] is careful to tell us that " porcelain enamelled in colours was painted in imitation of the fashion of brocaded silks and we have consequently the names blue ground, yellow ground and brown-

[1] We learn elsewhere that the pilferings of the Mohammedan blue had been a scandal in the previous reign of Chêng Tê, and that it was stopped in the Chia Ching period by a system of weighing out the blue. We may fairly conjecture that this system is the one described.

[2] Bushell's translation, pp. 72 and 73. [3] *Ibid.*, p. 151.

gold (*tzŭ chin*) ground. The designs used to decorate it were also similar and included coiling dragons, clouds and phœnixes, kylin, lions, mandarin-ducks, myriads of gold pieces, dragon medallions, pairs of phœnixes, peacocks, sacred storks, the fungus of longevity, the large lion in its lair, wild geese in clouds with their double nests, large crested waves, phœnixes in the clouds, the son-producing lily, the hundred flowers, phœnixes flying through flowers, the band of eight Taoist Immortals, dragons pursuing pearls, lions playing with embroidered balls, water-weeds and sporting fish. These are the names of ancient brocades, all of which the Imperial

have reproduced more or

eference is made in the
riety of objects made in
ractically everything for
hings for which it is not ;
here ; and, if we merely
will probably be as much
tual forms, of course, are
illustrated works. Many
as the Chinese virtuoso
se of moulds, but the true
clearly displayed in the
there are bowls in great
p'ieh) with narrow foot,
round, cup-shaped bowl
are shallow bowls with
no foot-rim. There are
capable of holding hot
elegant stem-cup, a bowl
d in the Hsüan Tê and
eat fish-bowls with wide

re were also plates with
s, sometimes foliate at

t neck, or shaped like a
and baluster vases with
nouth are perhaps the
cal Ming vase shape and

it is known as *mei p'ing,* or prunus vase, because it was suited to display a bough of blossoming prunus. A late Ming book on vases especially recommends this form :—" The mouth of the vase should be small and the foot thick. Choose these. They stand firm and do not emit vapours." Another characteristic Ming form is the slender beaker-shaped vase with baluster body, tall neck and flaring mouth and frequently a pair of handles of fanciful form on the neck. A foreign influence is discernible in the graceful pear-shaped ewer with long, slender spout and handle, and which was evidently in great demand in the Near-Eastern market. It seems, indeed, probable that this essentially Persian vessel was introduced by the Mongols in the Yüan dynasty, for the *Ko ku yao lun* has a note on the subject :—" The men of old used ' decoction vases ' for pouring wine and did not use ewers (*hu p'ing*) or bowls with contracted lip or tea cups (*ch'a chung*) or dishes with rims. These were all forms used by the Mongols. The men of China only began to use them in the Yüan dynasty."

Another vessel found frequently in India and Persia is a bottle with globular body, narrow, upright neck with small mouth and a mammiform spout. This, at least, is the typical shape ; but there were many variations of it, animal forms (elephant, frog, etc.) being sometimes substituted for the plain globe of the body, the head of the beast forming the spout. Sometimes, again, a plain spout of more ordinary shape is substituted for the mammiform spout, and then it is clear that the intention of the vessel was to serve as a ewer. In its more usual form it could easily be adapted as a bowl for a water-pipe, which explains why these bottles so often pass under the name of narghili. It is improbable, however, that they were originally intended to serve that purpose, because tobacco was not known in China until 1530, and some of these bottles have the appearance of being earlier in date than the reign of Chia Ching. Nor has it yet been shown that an earlier introduction of tobacco into India or Persia could have created a need for these objects as hookah bowls before that date.

Other vase forms common among export wares are ovoid jars, melon-shaped pots with lobed sides[1] and small jars with rounded body and short, narrow neck. Most of the Ming vase shapes are also found in square or polygonal form ; and we are given to understand that the Wan Li potters were specially skilful in the manufacture of square vessels.

[1] It is very unusual to find one of these melon-shaped pots complete with its lobed cover ; but Mr. R. E. Brandt is the fortunate possessor of one. (Plate 44.)

A special class of porcelain on which great skill was lavished at all times was the furniture of the writing table. This included ink pallets and water-droppers for the same, water vessels for dipping the brushes, shallow bowls for washing brushes, cylindrical vases to hold the brushes, screens to protect the paper from splashes while the ink was being rubbed, rests for the brushes often in form of conventional hills, wrist rests for the writer, boxes to hold vermilion for sealing and other similar articles generally small and dainty and often of fanciful shapes.

Uniform sets of five ritual objects—an incense-burner, two flower vases and two pricket candlesticks—were made for the domestic altar, and we learn[1] that dinner sets with uniform decoration were a novelty of the Ming dynasty ; but sets of vases such as those with which Europeans delighted to adorn their mantel-shelves in the eighteenth century were not yet made. They came into being later in response to European demands.

[1] See p. 93.

PLATE I.

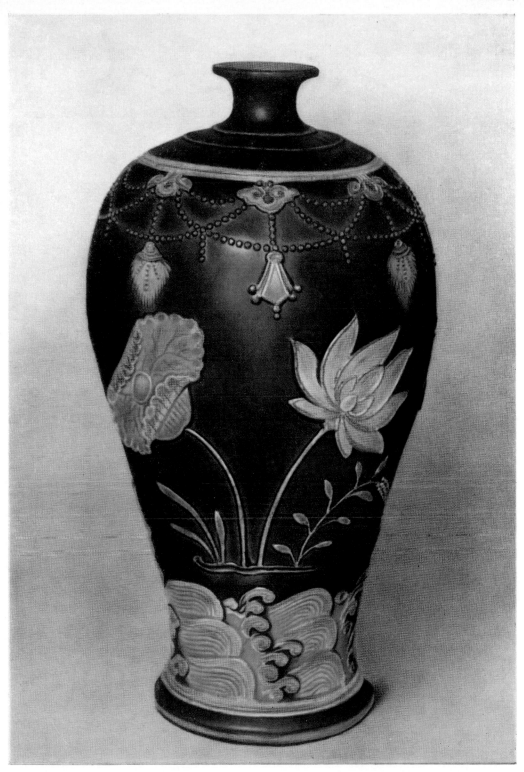

Honble. Evan Charteris Collection.

Vase (mei p'ing) with designs in cloisonné style and coloured glazes. Waves, lotus plants and reeds: band of jewelled pendants. About 1500. H. 14½ ins. (See page 29.)

MING TECHNIQUE—*continued*

With regard to the decoration of the ware, the *T'ung*[1] *ya* states that " in ancient porcelain green (*ch'ing*) was the colour most highly esteemed, till we come to the Ming dynasty, when the art of decorating with the *pi-sê* glaze was lost ; and the porcelain was all made pure white either painted in blue or enamelled in many colours." Without insisting too much upon literal accuracy we can regard this as a fair general description of the change in taste which is reflected in the Ming porcelain. The *pi-sê*, or secret colour, was a name given to a type of glaze used in Sung and pre-Sung times. It was doubtless one of the celadon class of greens, varying from bluish green to greenish grey ; and though the particular shade so much admired in earlier days may no longer have been manufactured, it is not to be supposed that celadon green glazes were not used in the Ming times. Both in the Ch'u Chou district, in Chekiang, and at Ching-tê Chên we know that they were still freely made. But Ching-tê Chên now took the lead in the porcelain world, and here the bulk of the ware was undoubtedly decorated with underglaze blue or with coloured enamels or coloured glazes on a white base.

Pure white porcelain was highly prized in the earliest Ming periods, and it is clear[2] that a specially selected glaze material was used in the manufacture of the finer whites. Indeed, this is apparent from a fine white saucer-dish with Hung Chih mark in the British Museum, which has two kinds of glaze, the one a beautiful, smooth, oily white applied inside and on the sides without, the other the early Ming " chicken skin " glaze, described above,[3] under the base where the mark is written in blue. The only decoration permitted on the white wares was moulded, carved, engraved or painted in white slip[4] under the glaze. The two last kinds of decoration were usually of a very slight and delicate kind, and only seen clearly when the piece was held against the light or obliquely to it. The Chinese called them by the name *an hua*, or secret decoration. Special triumphs in this class of ware distinguish the Yung Lo period ; but fine

[1] See *T'ao Shuo*, Bushell, p. 57. [2] See p. 13.
[3] See p. 16. [4] Slip is liquid clay.

whites continued to be made throughout the Ming dynasty, and we meet examples with the Hung Chih and Wan Li marks which leave nothing to be desired in refinement. The fact that white is the colour used during periods of mourning must have kept up the demand for this choice type of porcelain.

But the decoration most widely used on the Ming ware is that painted in blue under the glaze. It was not the usual custom in China to give the porcelain body a preliminary firing before decorating and glazing; and the blue painting would be applied to the raw body, when dry enough to receive it, and then the piece would be glazed. One single firing sufficed for body, glaze and blue.

Much importance is attached to the quality of the blue colour on these porcelains, and we shall see that certain reigns were noted for the peculiar excellence of their blues. These were apparently made from an imported material variously named *su-ma-ni, su-p'o-ni* and *su-ni-po* blue which came from a Mohammedan source, probably from Persia, as is indicated by yet another name, *hui hui ch'ing* (Mohammedan blue). The same material (cobaltiferous ore of manganese) was found in the neighbourhood of Ching-tê Chên, but in inferior quality. One of these native blues was called *Pi-t'ang* blue and came from the Lê-p'ing district of Jaochow; but we learn that the mines there were closed in the reign of Chia Ching (1522–66), and the blue from Jui-chou, called *Shih tzŭ ch'ing*, or stone-blue, was used in its place.

The native mineral contained impurities which resulted in a dull or greyish colour; but it must be remembered that the wonderful pure sapphire blue of the K'ang Hsi period (1662–1722) was obtained by patiently refining this same impure material, and there is no doubt that the refining processes, though not yet carried so far, were applied in varying degrees by the Ming manufacturers. Hence the great variations in quality observable in the blues of all periods, which will be noted in the succeeding chapters. Hsin-chien, in Lu-ling, also supplied a cobalt mineral which was distinguished by the names of *hei chê shih* (black-red mineral) and *wu ming tzŭ* (nameless material).

The Mohammedan blue could not be used alone on account of its tendency to run. It had to be steadied by the admixture of a proportion of the native mineral, the quantities being one of the native mineral to ten of the Mohammedan for the first quality blue, and four to six for the medium quality. But if the native mineral was added in excess the colour came out heavy and dull.

24

We shall have occasion to note elsewhere at least three distinct styles of blue painting on Ming porcelain. In one, light washes of blue are variegated by touches of a darker tint, giving a rather mottled appearance. This seems to have been a method of the Hsüan Tê period, which was also used in later reigns, such as those of Chêng Tê and Chia Ching. In another, also an early style, the design is expressed in carefully pencilled lines alone, without flat washes of colour. And in the third, which is the commonest Ming style, the design is firmly outlined and filled in with flat washes of blue. This contrasts with the K'ang Hsi method by which the designs were very faintly outlined, and the blue filling, instead of being flat, was washed on in graded depths of colour.

Next to the blue and white, Chinese writers have glorified the underglaze red of the earlier periods. This colour, variously described as clear or fresh red (*hsien hung*), precious stone red (*pao shih hung*), and sacrificial red (*chi hung*), was doubtless derived in every case from copper. This mineral is notoriously difficult to manage in the firing, and it is possible that during the periods which were celebrated for their red, the success was due to the addition of some other material which helped the development of the red. The " red precious stones from the West," rubies or cornelians, added in the form of powder, were traditionally supposed to have served this purpose, though of course the colour of the resultant red had nothing to do with the red of the stones. Another of these auxiliary materials was the *hsien hung t'u* (earth used for the fresh red), probably a ferruginous clay of some kind. The *T'ao shuo* tells us that the source of its supply is unknown and that it gave out before the Chia Ching period, and consequently the potters had to use an over-glaze red derived from iron (*fan hung*) in place of the copper-red.[1] There are, however, specimens of a more or less anæmic underglaze red which point to its survival through the first half of the sixteenth century; and we have reason to believe that the underglaze red was revived with some success in the Wan Li period.

We are introduced to the Ming polychromes under various names such as *san ts'ai* (three colours), *wu ts'ai* (five colours) and *ts'a ts'ai* (mixed colours), the two last occurring in the Imperial lists of the Chia Ching and later periods. Neither of the expressions, three and five colours, are to be taken too literally; for the latter, *wu ts'ai*, is practically a Chinese way of saying polychrome. *San ts'ai* is applied to a variety of porcelains decorated with combinations of three colours such as green, yellow and

[1] See p. 89.

aubergine, or turquoise, yellow and aubergine, the addition of another colour such as a dark violet-blue being perfectly permissible. *Wu ts'ai*, though a general term for polychromes, came to be particularly applied to the porcelains decorated with enamels on the glaze in the later periods. *Ts'a ts'ai* was used of any combination of colours and has no special application.

The most characteristic Ming polychromes are those with coloured glazes, over engraved, carved or relief-edged designs. These glazes include dark violet-blue sometimes verging on black, turquoise blue, yellow, green and brownish purple or aubergine. To these can be added a colourless glaze which over the more or less white biscuit produced a more or less clean white. Washes of such glazes if allowed to touch each other would tend to overlap and mix at the edges, and a technique had to be evolved which would prevent this mishap. This was done in three different ways : by outlining the designs with strongly incised lines which served as dykes, or by applied threads of clay which served as hedges to partition the fields of colour, or by perforation and carved reliefs which effectually sundered the coloured glazes. The raised thread borders, which remind one of the cloisons containing the enamel colours on metal cloisonné work, are the most usual and most characteristically Ming, for the other two are pre-Ming methods ; but all three were used at all periods of the dynasty, and they may sometimes be found in combination on the same piece.

It will be convenient to refer in future to the three types of decoration as cloisonné, graffiato and carved.

The glazes used on these wares are alkali-lead silicates. They are coloured by such metals as oxide of copper for the turquoise and green, iron peroxide for the yellow, manganese for the aubergine purple, and they would be painted on with a brush and fired in the temperate parts of the porcelain kiln. They are what the French have called *couleurs du demi-grand feu ;* and we might call them " medium-fired," as opposed to the high-fired glazes (*du grand feu*) such as felspathic white, celadon green and cobalt blues, which required the full heat of the furnace. It would follow that in these cases the Chinese must have fired the body first at a high temperature to vitrify the mass before submitting it to the medium heat required for the coloured glazes.

The cloisonné group, as we know it, (the " carved " may be taken in conjunction with it) comprises mainly barrel-shaped garden seats, large covered wine jars of potiche form, flower vases of *mei p'ing* shape with

high shoulders and small mouths, flower pots and incense burners and a few beaker-shaped vases. They are all strongly built, sometimes of coarse material which burns a dark rusty brown in unglazed parts such as the base, more rarely of fine-grained white clay; but always thick in the wall and capable of standing hard usage, which accounts for the fact that a fair number of them have survived for the benefit of modern collectors. It is usual to find the interior of these vases, and sometimes the base as well, finished off with a wash of green glaze or, in the case of the smaller objects, with yellow. They are decorated with certain stock designs :—Shou Lao, god of Longevity, and some or all of the Eight Immortals; Immortals crossing the sea; the Eight Immortals of the wine cup; the story of Wang Chih watching the game of chess; dragon designs; lion and peonies; rockery, flowering plants and peacocks; flowering plants of the four seasons; beautiful lotus designs, etc. These are bordered above by bands of floral scroll with large flowers, tasselled ornament or pendant jewels or *ju-i*-shaped lappets enclosing flowers or symbols, and below by false gadroons : on the neck are generally a few cloud scrolls. The designs are picked out with coloured glazes, but the mass of colour is in the background, which is very often a dark violet-blue, sometimes verging on black, or a beautiful turquoise, and more rarely a leaf green or aubergine brown. The Ming turquoise, a favourite and very effective ground colour, varies from a hard, felspathic-looking glaze on the earlier wares to a finely crackled and soft-looking glaze which is usually found on the wares of the later reigns and which continued into the Ch'ing dynasty. In all its varieties it is much sought by the French connoisseurs, and there was a remarkable display of its various qualities at the Cernuschi exhibition in the spring of 1922.

Similar vases were made in stoneware and pottery (see p. 208), and there will always be great difficulty in assigning to specimens of this class anything like an accurate date. The barrel-shaped seats described in the *Po wu yao lan*[1] were undoubtedly of this type, and they belonged to the Hsüan Tê period. There is a tantalising vase[2] now in Major Anthony de Rothschild's Collection with a long inscription on the neck which includes the words " Great Ming dynasty," without specifying any particular reign; and it is only on such remotely related specimens as Fig. 1 of Plate 23 that we get a date mark, viz. " Chia Ching (1522–66)."

We are left, then, to the evidence of style for the dating of this group within the wide range of the Ming period, which means that there will

[1] See p. 58. [2] Cat. B.F.A., E. 41 ; and Hobson, Plate 65, Fig. 1.

always be much difference of opinion and no little argument on the subject. One could pick out a certain number of vases, mostly of the high-shouldered type, on which the cloisons are low and have allowed the glazes to overrun them, giving a rather rough appearance to the decoration. Possibly these are specimens of the earlier periods, while the vases with neat and cleanly outlined designs and well-controlled glazes are of later date. On the other hand, it does not appear that this ware was made to any extent after the Ming period, until we come to the extremely bad modern imitations which sometimes appear in the market with exaggerated " cloisons " so sharp as to be painful to handle.

It is because the examples of this type could not be fitted precisely into any particular reign that they have been considered in this chapter, which is otherwise of a very general and summary nature.

Plate 12 illustrates a typical wide-mouthed Ming jar or potiche with fair round body of comfortable proportions, decorated in the cloisonné style. One sees clearly the threads of clay bordering all the designs except the birds, which are entirely built up in low relief with details engraved with a point. The ornamentation follows the usual scheme. The main belt which covers the body consists of rockery, flowering peonies and peacocks—the *k'ung ch'iao* and *mu-tan* peonies of the Chia Ching list.[1] The subsidiary ornament includes a band of foliate lappets enclosing lotus sprays on the shoulder, with pendent jewels between, a band of " false gadroons " above the base and a widely spaced cloud-scroll on the neck. The ground colour is green, and the designs are filled in with aubergine, yellow and a greyish white.

Jars like this figure in many Ming collections with slight variations in the form. Some have the shoulders rather higher and the body shaped into the semblance of a waist; and many have dome-shaped covers, though these are not often the originals and sometimes merely substitutes made of wood.

A stately jar in the Anthony de Rothschild Collection is illustrated on Plate 10. It is a piece of unusual size with dark violet-blue ground and ornament washed with pale green, yellow and turquoise glazes, with details in biscuit white. The interior is glazed green. Round the body are the favourite figures of Taoist lore—the Eight Immortals, the Twin Genii of Mirth and Harmony, Hsi Wang Mu and her attendant sprites, and the three Star Gods of Longevity, Happiness and Rank seated round a checkers board.

[1] See p. 104.

28

The playing of checkers was one of the Four Liberal Accomplishments of the Chinese (music, painting and literature being the other three), and as such it appears frequently in porcelain decoration. It also figures in two stories which provided themes for the decorator. One tells how Wang Chih[1] wandering in the hills in search of firewood entered a grotto where some old men were seated round a checkers board. He stood and watched the game, and after a time one of the players handed him an object shaped like a date-stone, telling him to put it in his mouth. No sooner had he tasted it than he became " oblivious of hunger and thirst." Presently one of the players said to him, " It is a long time since you came here : you should go home now." Whereupon Wang Chih proceeded to pick up his axe, but found that the handle had mouldered into dust. Returning home, he found that centuries had elapsed since he left and no vestige of his kinsfolk remained. The story ends by this Rip Van Winkle of China retiring to the hills, where he devoted himself to Taoist rites and finally attained to immortality.

The other story tells how the general Hsieh An was so absorbed in his game of checkers that he refused to be interrupted to receive the news of an important victory.

Plate 13 represents a vase of different form, but with the high shoulders and small mouth so characteristic of our period. It has an unusual design of dignitaries on horseback followed by banner bearers, a pictorial subject perhaps representing some historic scene. There are besides clouds, rocks and plants to suggest a landscape setting, and supplementary designs, as on Plate 12. The ground colour in this case is turquoise blue, and the designs, which are sharply outlined, are washed in with yellow, green and aubergine.

The typical *mei p'ing* (or vase for a prunus bough) with baluster body, high-shouldered with small mouth, is seen on Plate 1. Here we can see the colours as well as the design, and are able to appreciate the quality of the deep violet-blue glaze of the *san ts'ai*. The lovely lotus design, always a favourite with the Ming decorators, was to these vases what the prunus tree was to the K'ang Hsi beakers. The water from which the plant is growing is suggested by the conventional waves below ; and on the shoulder is one of the stock border patterns, a band of pendent jewels.

The gourd-shaped vase on Plate 11 is another finely finished specimen of this class with similar dark violet-blue ground and designs washed

[1] See W. F. Mayers, *Chinese Reader's Manual.*

over with full-tinted yellow, turquoise and aubergine : the base is unglazed and discloses a good porcelain body. On the upper bulb are four small figures which appear to represent the Four Liberal Accomplishments—music, painting, literature and checkers. On the lower bulb are four personages in Mandarin dress, two of whom are mounted ; and both designs have a landscape setting in which are rockery, fence, palm trees and a large *ling chih* fungus, one of the emblems of longevity.

The incense burner on the same plate is shaped after a bronze model with oblong, rectangular body and high ears with lion-masks beneath. It is solidly built of a fine-grained porcelain. The ground colour is again dark violet, and the slight designs—drapery on the sides, swastika and " cash " symbols on the neck and cloud scrolls at the ends—are lightly raised in outline and coloured white with touches of dark blue. Turquoise appears on the handles, and yellowish green inside the mouth.

Another *mei p'ing* vase from the Franks Collection is illustrated on the same plate to show the carved and pierced type of ornament. On the sides is a mountain pavilion in a mist, rocks and pine trees, and a sage with attendant ; and on the shoulder is a boldly carved band of peony flowers and foliage. The ground colour is turquoise ; and the supplementary glazes comprise passages of dark violet-blue, large areas of translucent aubergine brown, a little yellow and impure white ; and some of the ornaments remain in biscuit state. There is a wash of yellow inside the lip and a little green glaze under the base which discloses a fine porcelain body in the bare places.

These pierced vases (and there are many of potiche form so treated) are usually fitted with an inner lining capable of holding liquid. One of the finest examples is in the H. J. Yates Collection.[1]

The graffiato type of decoration is not essentially Ming. It is, in fact, as old as the T'ang dynasty,[2] and it is found on post-Ming wares. It appears on Mr. Raphael's vase,[3] which may be of the Hung Wu period, and it is found in company with the cloisonné ornament on barrel-shaped garden seats and other pieces of that rather indefinite group. But there is a fair number of marked examples belonging to the Chêng Tê, Chia Ching and Wan Li periods which have a decided character. These will be discussed in their respective reigns. It is enough to say here that they are mostly " three colour " porcelains in the literal sense, ringing the changes on green, yellow and aubergine, with the addition of the

[1] Figured in Gorer and Blacker, *Chinese Porcelain and Hardstones*, Plate 195.
[2] See p. 11. [3] See p. 38.

30

colourless white. The glazes in this case are again lead silicates, tinted with the oxides mentioned above,[1] and fired in the cooler parts of the porcelain kiln; but they are more transparent, sleeker and softer-looking than the strong glazes usually associated with the carved and cloisonné groups, and we propose to distinguish them as *soft* lead-silicate glazes.

Ming monochromes are not common, but they include examples of most of the above-mentioned glazes used singly. Thus the medium-fired green, yellow, aubergine, dark violet-blue and turquoise are all found in monochrome. A few enamels such as emerald-green were used to cover the outside of bowls[2] or as a wash over a crackled stone-coloured glaze to make the so-called " apple green "[3]; and the iron-red,[4] which replaced the underglaze copper-red, is also seen as a ground colour.

The high-fired monochromes are the pure white felspathic glazes; the celadon green, a survival of the Sung specialities; various shades of blue obtained by mixing cobalt with the white glaze; and the underglaze red from copper, for which the Hsüan Tê period had so high a reputation. Flambé, or splashed glazes, if they occurred, were probably accidental effects due to the chance predominance of phosphate in a red glaze. The controlled and deliberate flambé was a later development at Ching-tê Chên.

The term *wu ts'ai* is most commonly applied to a decoration consisting of designs painted in enamel colours. The pattern or design was outlined in a dull red or black pigment, and the enamels washed into the spaces. It was only a development of the graffiato technique just described, with the difference that the outlines were pencilled instead of being incised, and the washes of colour were low-fired enamels rather than medium-fired glazes. It was, however, a more supple technique and far better suited for rendering pictorial designs. The use of enamels for brush painting on pottery was understood and practised to a limited extent in the Sung period,[5] so that it was no novelty under the Mings, and we need affect no surprise at reading of it in the Hsüan Tê period. The enamels of this time are described as " heaped and piled," thick and rather clumsy as compared with those of the Ch'êng Hua period, which were regarded as perfection. The enamels used on Ming porcelain are greens of various shades, aubergine brown or purple, yellow (usually rather muddy),

[1] See p. 26 and also p. 125. [2] See p. 91.
[3] Ming examples of " apple green " are found, but they are extremely rare (*see* Hobson, Plate 85); the bulk of known specimens are of the succeeding dynasty.
[4] See p. 91. [5] See p. 12.

a turquoise blue which seems to have been a makeshift for the violet-blue enamel of the succeeding dynasty,[1] a composite black formed by a wash of green over a dry black pigment and a tomato red usually showing signs of iridescence. They are manufactured from a soft lead glass tinted with metallic oxides—copper for green and turquoise, manganese for aubergine, antimony for yellow and iron for red—the amount of the glassy flux being very small in the case of the red. The dry black pigment is a derivative of manganese and is used without any glassy flux. Sufficient heat to vitrify these enamels could be obtained in a small muffle or stove.

These enamels are translucent and could be applied over the ordinary porcelain glaze or direct to the biscuit. In the former case they gained an added brilliance from the sheen of the underlying glaze; while in the latter the matt surface of biscuit gave them a softer appearance. In the on-biscuit method it was usual to cover practically the whole surface of the piece with enamels, as the raw biscuit could not be appropriately exposed except in certain parts of figures and wares modelled in the round. With the other method areas of white glaze could be advantageously used to balance the coloured design.

The decoration on the biscuit was used to a great extent in the K'ang Hsi period of the succeeding dynasty, and much of the ware made during this reign has been unwarrantably attributed to the Ming dynasty. In point of fact, specimens which have the true stamp of Ming are exceedingly rare; and it will often be found on closely examining an apparent biscuit-enamelled Ming piece that the decoration, though entirely covering the surface and applied in the on-biscuit style, is really on a glaze.

To take a concrete example. There is a well-known pattern of curling waves on which are floating plum blossoms and symbols, while over them horses or monsters are sometimes depicted in flying gallop. The design is outlined in black and the waves are painted green, the other ornaments in yellow and aubergine; or perhaps the ground is aubergine and the accessories green and yellow. The " wave and ·plum blossom pattern " is expressly mentioned in the lists[2] of porcelain supplied to the late Ming Emperors; but in the known examples where this design

[1] There is an instance of an overglaze blue enamel on a late Ming box in the Eumorfopoulos Collection, but examples are so rare that one may regard the use of this enamel in the Ming period as purely experimental. It developed into a beautiful enamel in the K'ang Hsi period and became a leading characteristic of the polychrome of that time.

[2] See p. 109.

occurs on true Ming forms (see Plate 39), such as wide-mouthed ovoid jars, it is often found to be over the glaze; whereas in the cups and saucers, bowls, etc., of K'ang Hsi style it is more usually applied direct to the biscuit.[1]

The enamelled decoration on the glaze is discussed in its various aspects in the ensuing chapters. The designs used were much the same as those of the blue and white porcelain, and, though in certain types the decoration was expressed in enamels only, much of the Ming polychrome combines the underglaze blue with the overglaze enamels. This colour scheme was popular in the late Ming periods, and it is generally known by the name *Wan Li wu ts'ai*—the Wan Li polychrome.

Gilding was used from the earliest reigns of the Ming. It was the last operation in the manufacture and always required a separate firing at a low temperature. Thus one of the red bowls described on page 91 would be fired first in the full heat to bake the body and glaze and develop the underglaze blue inside the bowl, then it would have the outside covered with red enamel which had to be fixed in the muffle stove; and finally the gilt floral pattern would be painted over this red and fixed by another visit to the muffle. In several cases the gilding on these red bowls is applied in the form of gold leaf,[2] while in others it was evidently painted on with a brush.

[1] See also p. 128.

[2] *T'ieh chin* (see p. 195) is the expression used in the Chia Ching Imperial lists. It means literally " stick-on gold," words peculiarly applicable to the process of leaf-gilding.

PLATE 2.

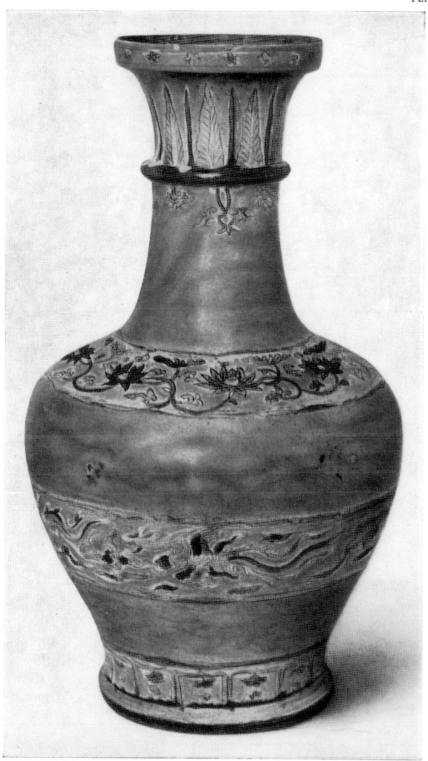

O. C. Raphael Collection.

Vase: porcelain with coloured glazes
and belts of engraved designs—stiff
leaves, lotus scrolls, phœnixes and
clouds, etc. Base inscribed *Hung wu
nien nei yung chih ch'i.* H. 22 ins.
(See page 38.)

HUNG WU AND YUNG LO (1368–1424)

HUNG WU (1368–98)

The misrule of the decadent descendants of Kublai Khan provoked rebellion in many parts of China during the last years of the Yüan dynasty, and it only needed a competent and honest leader to concentrate the forces of discontent on the destruction of the Mongol rulers. The man was found in Chu Yüan-chang, a priest who turned soldier and soon rose to be the chief anti-Mongol leader. In 1355 he captured Nanking, and twelve years later he took the title of Emperor under the name of Hung Wu. This was on the eve of the capture of Peking and the flight of the debauched Yüan Emperor Shun Ti.

A great part of Hung Wu's reign, which is officially dated from 1368, was spent in completing the defeat of the Mongols who retired into Mongolia, in pacifying the outlying provinces and in consolidating his empire; and it was not till 1381 that Yunnan, the last recalcitrant region, was conquered from the Mongol prince Liang.

Under the Yüan dynasty it had been customary to open the Imperial porcelain manufactory at Ching-tê Chên whenever an edict was promulgated from the throne requiring supplies of porcelain. If no edict was issued the factory remained closed, and it would appear that it had been closed for some time before 1368.

According to the *T'ao lu*,[1] an Imperial factory was built in 1369 at the foot of the Jewel Hill to supply the requirements of the Emperor, while at the same time no less than twenty kilns in various parts of the town were occupied with Imperial orders. This would seem to point to an outburst of activity at Ching-tê Chên; and this was only natural, for the old ceramic centres of the Sung dynasty, such as Ting Chou, Ju Chou and Chün Chou, had sunk into secondary importance; and white translucent porcelain being the order of the day, the industry tended more and more to concentrate in Ching-tê Chên, where this kind of ware was best and most conveniently made. Moreover, Nanking was now the

[1] By another method of reckoning the date has been fixed by other authorities as 1398, but the earlier date is probably correct.

capital of China, and Ching-tê Chên is situated conveniently near to Nanking, with which it has direct communication by water.

We have not a great deal of information about the porcelain made at the Imperial factory at this time, but we are told that the outlying factories working under Imperial orders were making large dragon bowls, *ch'ing* ware which may be celadon green or blue, and " colours " which no doubt means coloured wares. Other furnaces made seggars, or fire-clay boxes, in which to bake the finer articles. This implies considerable care in the manufacture, and would point to the production of refined wares. We are also told that the Palace porcelain of this time was made of fine, unctuous clay and potted thin : that the ware was left for a whole year to dry, then turned on the lathe to the requisite thinness and glazed and fired. If there was any fault in the glaze the piece was again put on the lathe and reglazed and refired. As a consequence the glaze of the Hung Wu Palace ware was " lustrous like massed lard." It was impossible for the private factories to attain to such excellence in manufacture.

Some further remarks on the methods of the Imperial and private potters at this time gleaned from the *T'ao shuo* are given in another place ; [1] and the only other light thrown on the nature of the finished wares is a brief but contemporary reference in the *Ko ku yao lun*, written in 1387 :— " Among modern Jao wares (i.e. made at Ching-tê Chên) the good examples, white in colour and lustrous, are highly prized. There are besides, *ch'ing* (blue or green) and black ware with gilding, [2] including wine pots and wine cups which are very lovely."

It cannot be said that these descriptions are very helpful to the seeker of Hung Wu specimens. White, green, blue and black wares existed at many periods, and it would need some good collateral evidence to justify the attribution of any particular specimen to the first reign of the dynasty. Indeed, it is hardly likely that many examples of the Hung Wu wares exist in Europe, though we can point to a few pieces

[1] See p. 14.

[2] *Ch'uang chin chê* (see p. 195). This phrase has a literal sense of "cut or wound with metal," which might be taken to suggest in rather unusual phraseology " engraved with a metal point." On the other hand, Julien (op. cit., p. 89) translates the passage " *noir-bleus et rehaussés d'or*," " dark blue wares with gilt ornament " ; and Bushell (*O.C.A.*, p. 185) renders the passage " porcelain of a greenish black colour pencilled with designs in gold." It may be that variant readings exist, but at any rate the sense of gilding appears to be one generally favoured, though it does not naturally arise from the reading *ch'uang chin*.

which have some claim to belong to this category or at least to represent Hung Wu types.

There is, for instance, a most tantalising object illustrated in the *Gazette des Beaux Arts*[1] in 1897. Tantalising because it can no longer be traced, having passed from the Gaignières Collection in the Bibliothèque Nationale into private hands, and also because the description given of it, while doing full justice to its metal garniture, leaves us in doubt as to whether the ware itself is Chinese or Persian. It is a bottle of decidedly Chinese form mounted as a ewer with handle, spout, cover and foot in silver-gilt, with enamelled ornaments, including a shield with arms of Louis the Great, King of Hungary (1326–82). The ware is described as white porcelain, and the illustration shows that it is decorated with quatrefoil-shaped panels apparently outlined in threads of clay and ornamented with flowering plants in low relief (one would say moulded and stuck on); above the base is a border of false-gadroons enclosing *ju-i* head ornaments incised. The form and ornament are purely Chinese in feeling and technique; and though the Persian potters had already been subjected to Chinese influences, it would be hard to find anything quite like this piece in Persian ware of the fourteenth century. Indeed, if one can judge from an illustration, this must be undoubtedly a piece of white Chinese porcelain, and one imported into Europe not later than 1382—in a word, Hung Wu or earlier.

Mr. Ezekiel in his collection at Hove has an interesting series of Ming blue and white bowls formed in China by a collector of great experience (see Plate 14). It includes two rice-bowls attributed to the Hung Wu period. They are not marked, and we can only assume that the attribution was justified by reference to some authenticated pieces. They have an archaic appearance with uneven glaze and decoration consisting of floral scrolls in dull blue. It may be that we should regard these pieces as examples of Hung Wu porcelain made in the private factories; but the evidence is incomplete, and there is always the lurking suspicion that they may be the product of some provincial factory working at a later period of the Ming dynasty. This suggestion is inspired by an interesting bowl brought by the Rev. Th. Torrance from Szechwan, where it was found in a late Ming tomb. It has a similar floral scroll design and much the same crudity of material. But the argument is one which cuts both ways, for the provincial ware of Szechwan may have been a survival of a much older type, perhaps even as old as Hung Wu.

[1] III Series, vol. 17, p. 55, in an article by F. Mazerolle.

The Hung Wu marks occur on two pieces in the British Museum. One is a blue and white dish of good material, roughly finished, and painted in bright blue, with a landscape in blue and white and border ornament in white reserved in blue. This is a decidedly advanced style of decoration for so early a period; but, judging from the ware, the dish was certainly made in the Ming dynasty, if not actually as early as the mark implies.

The other is a straight-sided, conical bowl, with an underglaze blue ground in which the cobalt has evidently been sponged or sprayed on to the biscuit: in this a design of dragons has been etched with a needle point which removed the particles of blue. The piece is almost certainly a Japanese imitation; and it would not be worthy of mention but for this unusual type of decoration, which may perhaps be an attempt to illustrate the literal meaning of the obscure phrase *ch'uang chin* (cut with metal) discussed above.[1]

The precious note in the *Ko ku yao lun* (first published in 1387) on the subject of Old Jao wares, i.e. the porcelains of Ching-tê Chên in the prefecture of Jaochow, alludes to polychromes[2] in the Yüan period, so that we have every reason to expect that some sort of polychrome would be made in the subsequent period of Hung Wu. The earliest type of polychrome is that in which the designs are incised in outline and filled in with glazes of different colours, a technique used by the T'ang potters on their earthenware and adopted by the Ming potters for their porcelain.

There is a splendid vase decorated by this method in the Oscar Raphael Collection (Plate 2). It is constructed of fine white porcelain, thick in the wall and strongly built with massive foot. The form is archaic and reminiscent of the stately Han wine jars, and it is decorated with zones of engraved ornament filled with brownish yellow and aubergine in a turquoise blue ground. It is, in fact, *san ts'ai*, three-colour ware with medium-fired glazes such as would stand the more temperate parts of the porcelain kiln. The decoration comprises bands of stiff leaves below the lip, of running lotus scrollwork on the shoulder and of formal ornament above the base; while in the middle of the body is a broad belt with four winged dragons and pearls.

The turquoise ground naturally dominates the colour scheme, and it is a singularly beautiful colour which loses nothing in effect by having a slightly mottled and uneven surface. It is not the soft-looking, finely crackled turquoise familiar on wares of the Ch'ing dynasty and on some

[1] p. 36. [2] *Wu sê hua chê*—pieces with ornament in " five colours."

of the Ming pottery; but it has an appearance of hardness almost suggesting a felspathic glaze. It is just such a hard-looking, mottled turquoise which partially covers an interesting bulb bowl found on the site of the old Chün Chou factories[1] and presented to the British Museum by Mr. Chow. It is not suggested that Mr. Raphael's vase is of Chün Chou make, but probably it and the bowl belong to much the same period, which is certainly early in the Ming dynasty and very likely in the reign of Hung Wu. Unfortunately this dating cannot be actually proved, but it evidently represents the opinion of a previous Chinese owner of the vase who incised under the base the characters: *Hung Wu nien nei yung chih ch'i*[2]—" Vessel made for use in the interior (or in the Palace) in the Hung Wu period."

YUNG LO (1403–24)

Hung Wu was succeeded by Chien Wên, who reigned only from 1399 to 1402. He had the misfortune to fall into the hands of bad advisers who brought him into continual conflict with his uncle, the powerful Prince of Yen. Matters eventually came to a head, and the Prince of Yen marched his army against Nanking and overthrew the young emperor. He then ascended the throne under the title of Yung Lo, reigning from 1403 to 1424. The overthrow of Chien Wên was followed by terrible massacres at Nanking, and the place had evil memories for Yung Lo, who moved his capital to Peking in 1421. One of the events of general interest in this reign was the expedition of the celebrated eunuch Chêng Ho in the Indian Ocean. He visited Ceylon and exacted tribute from Sumatra. The same adventurous admiral was sent on a mission to Jiddah in Arabia, and as far as Magadoxo in Africa in the succeeding reign.

The description of the Imperial Yung Lo porcelain in the *T'ao-lu* is not very illuminating. The material is described as refined; and it would seem that there was a preference for thick wares, though by way of antithesis some particularly thin varieties known as *t'o t'ai*,[2] or bodiless porcelains, were made at the same time. The wares were plain white, engraved and embossed (if the phrase *kung yang*[2] is rightly interpreted in this sense), coloured, and decorated with vivid red (*hsien hung*).

The *Po wu yao lan*, a book[3] which is considered one of the best on the subject of Ming wares, gives rather more detail in its brief note on

[1] See Hetherington, *The Early Ceramic Wares of China*, Plate 16.
[2] See p. 195.
[3] Published in the reign of T'ien Ch'i (1621–27).

this period. It describes the *ya shou pei*, or cups made to fit the hand, with broad mouth and contracted waist, " sandy foot and smooth bottom." The best of these had a design of two lions rolling balls drawn inside, and also a six-character mark of the Yung Lo period. In some cases the mark was in four[1] characters as fine as grains of rice. Others had Mandarin ducks inside or flowers ; and besides these there were cups decorated outside in deep blue. The price of all these wares was very high. Late imitations (made at the end of the Ming period) are mentioned, but only with contempt, as being coarse and thick and not worth looking at.

A further reference to Yung Lo ware may be found in the interesting list of ancient porcelains copied at the Imperial factory in the Yung Chêng period (1723–35), viz. " Reproductions of Yung Lo porcelain : eggshell (*t'o t'ai*), pure white with engraved (*chui*) or embossed (*kung*) designs."

Needless to remark, Yung Lo porcelain is very scarce to-day ; but even so there are a few pieces which will serve as a practical commentary on the foregoing paragraphs. The most celebrated is the wonderful white bowl in the Franks Collection in the British Museum (Plate 15). It is a specimen of the eggshell (*t'o t'ai*, or bodiless) type, in which the body material has been pared down to vanishing point on the lathe so that it looks as if the porcelain consisted of glaze alone. The shape, too, is most refined, with wide mouth, sides almost straight but faintly curved, and small foot ; and there are six small nicks in the rim which give a suggestion of a foliate form. It might be described as a *ya shou pei*, though it is rather large for holding in the palm of the hand. The decoration consists of two five-clawed dragons and flame scrolls faintly traced on the body in white slip, so as to be scarcely visible except as a transparency held against the light ; and in the bottom inside is the Yung Lo mark in four archaic characters traced with a fine point. As to the foot-rim, it is unglazed at the edge and so might be described as " sandy," and the bottom is glazed, which may be the sense implied in the word *hua* (smooth, or slippery or polished) used in the *Po wu yao lan*.

The wonderful potting and refinement of form which characterises this bowl would be enough to establish the reputation of the Yung Lo period. The potters who could make such a thing could have challenged their fellows of any reign in manipulative skill.

Other specimens of the same or a similar type are known, but it will

[1] There are two readings in the passage :—*ssu* (four) ; and *pai* (white). The latter would mean that the mark was traced in white slip, as indeed was actually the case in some known specimens.

be remembered that the Yung Lo eggshell was copied in the later Ming periods and, as we have already seen, in the reign of Yung Chêng in the eighteenth century. It may be added, too, that some clever imitations of this kind of ware have been quite recently made in Japan.

There are two other white pieces in the British Museum, both conical bowls of the *ya shou pei* type and small enough to sit comfortably in the hand. But these are of coarser make and may belong to the class of contemptible imitations named in the *Po wu yao lan*. On the other hand, they may be the common ware of the Yung Lo period produced in one of the private factories, and as such they are worth describing. The form is conical with straight sides, a foliate mouth and a small low foot with rather wide foot-rim bare of glaze. There is, however, a patch of glaze under the base. The decoration is inside in radiating compartments, a lotus design slightly embossed in a white slip under the glaze. The general tone of the ware is a rather impure white, and the surface is pitted in several places.

We know, too, of several other small bowls of the same conical form and with wide expanse of biscuit under the foot-rim, which are decorated in blue. They are always of the same kind, having a landscape outside and a close diaper of spirals inside, with the Yung Lo mark in four characters at the bottom. Most of these one regards unhesitatingly as late imitations ; but there is a specimen in the Ezekiel series[1] which differs from the rest (see Plate 14). It is of a softer-looking ware with a sandy paste (resembling the steatitic or " soft paste " ware of a later period), and it has the stock design painted in soft greyish blue. There is, again, a rounded bowl, with similar spiral design inside and the Yung Lo mark, in the British Museum, decorated on the outside with a long poem by Su Shih which covers most of the surface. The ware of this piece is coarse and the blue greyish in tone, but it has the appearance of a Ming piece, though of an inferior and perhaps late make. None of these pieces has any suggestion of Mohammedan blue, though the *Shih wu kan chu* mentions this colour, under the name of *Su-ma-ni* blue, as having been used on Yung Lo porcelain. Sumatra was one of the places from which this material was transhipped in the next reign, and it is quite possible that some of it may have reached China among the spoils brought back by Chêng Ho from his expedition to that island.

The allusion to porcelain decorated with vivid red (*hsien hung*), which was highly prized, brings us to another type of ware on which the Yung Lo

[1] See p. 37.

mark is occasionally seen. It is true that the pieces in question have a covering of overglaze red enamel highly fluxed, and not an underglaze copper-red such as is implied by the phrase *hsien hung*[1] used in the *Po wu yao lan*. But they evidently reflect a Yung Lo style, because the Japanese potter Zengoro Hozen, who made a speciality of imitating this type, assumed the art name of Eiraku (the Japanese form of Yung Lo), evidently in reference to his adoption of the Yung Lo style.

This ware is known to us chiefly in the form of small bowls with blue and white decoration—a figure and a hatched border—inside, and a red ground outside with gilt design of formal lotus flowers.

One of these bowls in the British Museum has the additional indication of early date in its Venetian leather case, which is believed to have been made not later than in the sixteenth century. This particular specimen has the mark *tan kuei* (red cassia, an emblem of literary success), showing that it was made for some aspirant to the honours which came through the State examinations. Doubtless these red bowls were frequently made in later periods, such as the reign of Chia Ching,[2] and it will always be difficult to distinguish the products of the different reigns; but there is one indication which may be helpful, though, of course, even this feature might very well be copied. The base of early bowls was often conical or convex underneath[3] in contrast to those of the Chia Ching period, which were convex inside; and this conical base is sometimes observable on the red bowls, as in the case of one specimen in the British Museum which, in point of fact, bears the Yung Lo mark.

Other interesting examples of this red and gold decoration are, a vase of octagonal, double-gourd shape in the Eumorfopoulos Collection, decorated with the Eight Trigrams, plants and peaches, etc., which was exhibited at the Burlington Fine Arts Exhibition of 1910[4]; a stem-cup in the Henry Oppenheim Collection (Plate 27); and a bowl in the Victoria and Albert Museum, which was mounted as a standing cup in silver-gilt about 1575.[5] It is one of the Swaythling heirlooms, and it has a historic interest, having been given by James II to Mr. H. Green, Groom of the Stairs.

Finally, there are examples of Yung Lo porcelain which, though not so interesting to the collector, are authenticated beyond all cavil. These are the bricks from the lowest story of the famous porcelain pagoda at

[1] A fuller discussion of this term is found on p. 54.
[2] See p. 91. [3] See p. 16.
[4] Cat. B.F.A., F. 27. [5] See *Country Life*, October 30, 1920.

Nanking,[1] examples of which in the British Museum will serve to show the body and glaze of the period. The ware is white and compact with close but rather granular fracture ; and the glazed parts are a pure, solid-looking white, while the unglazed faces disclose a smooth, fine-grained ware which has taken a pinkish tinge where the kiln fire has touched it.

[1] The construction was begun in the reign of Yung Lo and completed in 1430. The pagoda was destroyed during the T'ai-p'ing rebellion in 1853.

PLATE 3.

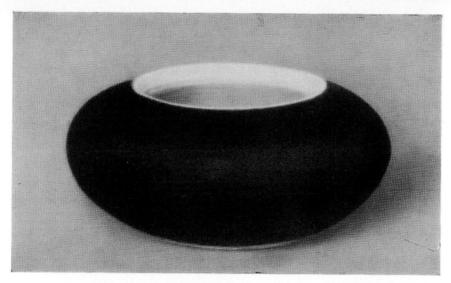

Fig. 1. Water vessel for the writing table: underglaze red outside. Hsüan Tê mark incised under the base. D. 2⅞ ins. (See page 57.)

H. J. Oppenheim Collection.

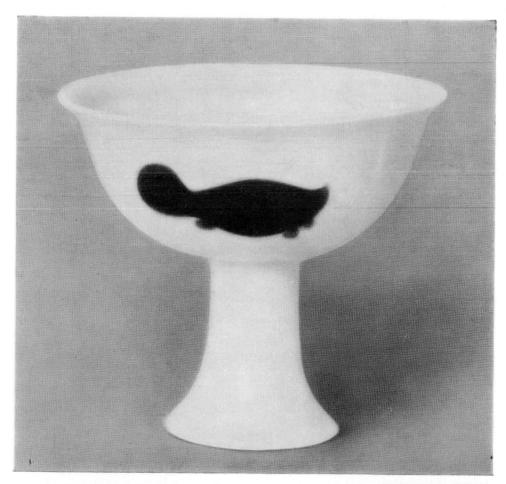

Fig. 2. Stem-cup with three fishes in under-glaze red (*hsien hung*). Hsüan Tê mark in blue inside the bowl. H. 3½ ins. (See page 56.)

G. Eumorfopoulos Collection.

HSÜAN TÊ (1426–35)

Yung Lo was succeeded by Hung Hsi, whose brief reign (1425) is of no account in the history of porcelain. The next Emperor was Hsüan Tsung, who reigned from 1426 to 1435 under the title of Hsüan Tê. Historians have given him a noble character as a statesman and scholar who ruled well and wisely and brought peace and prosperity to his people. These are conditions under which the arts could not but flourish, and it is not surprising that the all-too-short reign of Hsüan Tê is noted for bronzes, lacquer and, above all, for porcelain.

At Ching-tê Chên there was great activity and the number of kilns occupied with the Imperial orders rose to fifty-eight, most of them being outside the walls of the Imperial factory and scattered among the private establishments. The Imperial factory itself was placed under the direction of an officer whose title was *Ying-tsao-so ch'êng.*

An unusually full description of the ware made at this time is given in the *Po wu yao lan.* We shall have occasion to quote most of it piecemeal in discussing the various types, and it will be enough to summarise it here, only giving in full those passages which are not otherwise quoted. The first place is given to the stem cups decorated with fish in underglaze red. Next are the blue decorated wares, such as stem cups with dragon-pine and plum designs or with figure-subjects and lotus designs. There were small cinnabar pots, too, and large bowls red as the sun, pickle pots and small pots with basket covers and handles in the form of bamboo joints, all of which things were unknown in ancient times. " Again, there were beautiful objects of a useful kind, all small and cleverly made with finely and accurately drawn designs. The incense vases, trays and dishes were made in large numbers and belong to a common class. The flat-sided jars with basket covers, and the ornamented round pots with flanged mouth for preserving honey, are very beautiful and mostly decorated in colours (*wu ts'ai*). The white cups which have the character *t'an* (altar) engraved inside the bowl, are what are known as ' altar cups.' The material for these is refined and the ware thick, and the form beautiful

45

enough to be used as elegant vases in the scholar's room. There are besides white cups for tea with rounded body, convex base, thread-like foot, bright and lustrous like jade, and with very finely engraved dragon and phœnix designs, which are scarcely inferior to the altar cups. At the bottom the characters *ta ming hsüan tê nien chih* (' made in the Hsüan Tê period of the Great Ming dynasty ') are engraved in the paste, and the texture of the glaze is uneven like orange peel (*chü p'i*)." The rest of the passage refers to barrel-shaped seats of various kinds described elsewhere.

It is difficult to reconcile the description of the jade-like purity and whiteness of the altar cups with a statement in the *T'ao lu*, that the clay used at this time was red and the ware like cinnabar. It is true that the clay used on many of the early Ming porcelains had a tendency to turn red at the exposed edges of the foot, and it is possible that the phrase used in the *T'ao lu* may allude to nothing more than this. Or again, it may be a quoted phrase which in its original context referred only to some special type of ware of the " soft paste " order with a semi-earthen biscuit. Chinese ceramic books are largely made up of quotations from previous works often unacknowledged and certainly apt to be garbled. In any case the statement cannot be taken to apply to all the porcelain of the time. General experience and even our small acquaintance with early Ming wares are definitely against that. But one cannot altogether ignore a statement in the *T'ao lu*, even if its literal acceptance would make confusion worse confounded. From the other accounts one would gather that the Hsüan Tê porcelain was thickly built but of fine grain and, in the glazed parts, at any rate, white " like driven snow," the glaze itself being thick and fat, with a faintly undulating surface like orange peel, or chicken skin, and with occasional defects, like pinholes, which the Chinese term " palm eye " spots. All these expressions are of course relative, and the unevenness of the surface would in most cases be scarcely perceptible, though we have seen specimens of early Ming ware on which the thick, redundant glaze has been forced up locally into undulations quite as marked as those on the skin of a Jaffa orange.[1]

The *T'ao lu* sums up its description of the Hsüan Tê porcelain in the following terms[2] :—" We find that this was the time when Ming porcelain attained its highest excellence. Of choice material and select form, each piece is perfect in its painted decoration and written inscription. For painting in blue the *Su-ni-p'o* blue was used up to the reign of Ch'êng

[1] See p. 15. [2] Bushell's translation, p. 59.

Hua, when the supply of this colour failed, so that only the common kinds of blue were available. On this account, as regards blue and white porcelain, that of Hsüan Tê ranked first."

It is clear that one of the noted specialities of the Hsüan Tê period was blue and white porcelain. The reputation of this ware was founded on the use of a mineral cobalt imported from some western source, which, though not specifically mentioned, can perhaps be guessed. The various names given for this blue material are *su-ma-ni, su-ni-p'o* and *su-p'o-ni*,[1] names which probably represent a Chinese version of the place from which the mineral was at one time exported. Another expression applied to imported blue in a later reign is *hui hui ch'ing* (Mohammedan blue); and this gives the key to the mystery, for Hsiang Yüan-p'ien, the author of the much quoted sixteenth-century album, uses this term abbreviated to *hui ch'ing* as a synonym for the *su-ma-ni* blue of the Hsüan Tê period.

We may then conclude that this precious blue material was imported from Mohammedan countries, and that it was the same blue as that used by the potters of Persia and the Near East. How long these latter had known the secret of this important material we do not know; but it is certainly found on the ninth-century pottery of Samarra. Nor do we know exactly whence they obtained their supplies; but Burton[2] has pointed out that there were deposits of the purest cobalt ore in Baluchistan which may well have been one source of supply. We may perhaps find confirmation of this in a passage in Chau Ju-kua's interesting annals of Chinese trade in the Sung dynasty,[3] which speak of cobalt blue (under the name of *wu-ming-i*) as one of the products of the country of Chi-tz'ŭ-ni,[1] a place which may perhaps be identified with Ghazni on the N.W. borders of India.

It is not to be supposed that the Mohammedan blue was imported in large quantities or that it would have been used on all the porcelain of the Hsüan Tê period. Probably very little of it got beyond the Imperial factories. But we know that this reign was more favoured in this respect than some of the later periods, for it is recorded in the Ming Annals that the envoys from Sumatra, who brought *hui ch'ing* among other articles of tribute, arrived in the years 1426, 1430, 1433 and 1434. Sumatra was a meeting-place of traders from East and West, and goods from Western Asia arrived here in Arab ships. The famous eunuch Chêng Ho had led

[1] See p. 195. [2] W. Burton, *Porcelain*, p. 68.
[3] Hirth and Rockhill, *Chau Ju-kua*, pp. 138–40.

an expedition to Sumatra in the previous reign, and it is possible that he may have brought some of the blue mineral among his spoils.

We learn from other sources that the Mohammedan blue was unsuitable for use in its pure state, as it had a tendency to run in the firing. It was customary to blend it with the native cobalt, which produces in itself a blue of duller and heavier tone; and the proportion of the mixture varied with the quality of the ware, and doubtless also conditioned the tone of the blue. This will perhaps explain the apparently conflicting accounts of the Hsüan Tê blue, which is described by some writers as pale in contrast with the dark blue of the Chia Ching period, and by others as " deep and thickly heaped and piled and very lovely."

Possibly the fashion of the time may have given preference to a pale shade of blue; but it is evident that collectors in the next century did not despise the darker tones, for Hsiang describes the blue on his picked Hsüan Tê specimens as *hui hu ta ch'ing* (deep Mohammedan blue).

The short reign of Hsüan Tê is regarded as one of the classical periods in the history of porcelain, and specimens made at this time have always been highly prized. Hsiang's album includes seven examples of what must be regarded as the higher quality of Hsüan Tê blue and white. On five of them the blue is confined to the pencilled border patterns, and much is made of the white porcelain ground which is the colour of " driven snow," and of the thick, fat glaze with its uneven, " orange peel " surface. On the other two are designs of dragons in clouds and of " dragon pines." We cannot hope to-day to meet with many examples of the Imperial class, though we do find from time to time pieces, probably made at the private factories, with the Hsüan Tê mark, which may be reasonably regarded as of the period.

A goblet-shaped wine cup of the form described as *pa pei*, or stem cup (*cf.* Plate 3), in the Metropolitan Museum in New York is a favourable example of this type. It is pencilled with a free design, in pale silvery blue, of mythical animals in a ground of spiral wave pattern: inside is a medallion with a shell in similar waves, and under the foot is the Hsüan Tê mark. A similar cup in the British Museum has the Ch'êng Hua mark (1465–87), and yet another piece[1] of the same form, but with design of fish in waterweeds outside, is in the Leverton Harris Collection (Plate 20). This last has the added attraction of a European silver mount which must have been applied about 1530. The decoration in pencilled lines without the usual flat washes of colours, which is a feature of this

[1] Figured in *Country Life*, October 30, 1920.

piece, appears also on a small vase in the Victoria and Albert Museum (Plate 16). A comparison of the glaze under the base of this vase with that of Mr. Oppenheim's red bowl (Plate 3) shows a striking similarity and seems to indicate that both pieces are of the same period. Mr. Oppenheim has also a small vase of similar form and decoration; and Mr. Eumorfopoulos has a tall, almost cylindrical vase also painted with figure-subjects in pencilled lines which is believed to belong to the Hsüan Tê period. This pencilling is a style which appears to have been little used in the late Ming and K'ang Hsi periods, though it revived on the later Ch'ing blue and white porcelains.

Another interesting piece, which was garnished by a silversmith in the sixteenth century, is a bowl[1] exhibited among the Swaythling heirlooms in the Victoria and Albert Museum. It is painted in darkish blue with a design of lotus plants, and bears the Hsüan Tê mark. This bowl has much in common with the celebrated Trenchard bowls (Plate 16) one of which was similarly mounted about the middle of the sixteenth century. These, in addition to a lotus design outside, have a medallion with fish and waterweeds and four fishes round the sides within. Given in 1506 by Phillip of Austria[2] to Sir Thomas Trenchard of Wolverton House in return for hospitality, these bowls have long been regarded as among the first specimens of Chinese porcelain to reach England, and in view of the mark on the cognate Swaythling bowl they may well be export porcelains of the Hsüan Tê period.

There are four bowls attributed to the reign of Hsüan Tê in Mr. Ezekiel's series (see Plate 14). One has a slight and simple design of a trailing branch with a single leaf and blossom alternately rising from it. Another has a free lotus scroll and trellis border. A third has a garden scene with fence and human figures. These all bear the mark of the period. The fourth, with design of lions in peony scrolls, has a complimentary mark only.[3]

It is certain that blue and white export ware found its way to India and Persia in the fifteenth century; and among the specimens which have been collected by Europeans in these parts, there are doubtless examples of the coarser kinds of Hsüan Tê ware made in the private

[1] Figured in *Country Life*, September 25, 1920.

[2] Phillip of Austria, King of Castille, and his wife Joanna, were driven by stress of weather to take refuge at Weymouth, where they were hospitably received by Sir Thomas Trenchard.

[3] *Fu kuei chia ch'i*—Fine vessel for the rich and honourable.

factories. There are, indeed, several pieces in the British Museum, some of them bearing the Hsüan Tê mark, which might reasonably be regarded as of the period. They comprise chiefly ewers or wine pots of a form suited to the Persian market.

There is, for instance, a ewer (*hu p'ing*), the handle, cover and part of the spout of which have been broken and replaced in India or Persia by metal. It has the usual graceful, pear-shaped body with flattened sides on which is a leaf-shaped panel slightly raised. The ware is the usual export type with a good white grain, but coarsely finished and a thick glaze of slightly greenish cast. It is painted summarily but in good style and with a blue of pleasant tone, rendered somewhat hazy by the thick, bubbly glaze. The design in the panels is a lotus pond and cranes, and in the surrounding area are symbols and floral sprays. The mark is under the base in a square frame, *Hsüan Tê nien chih*. There is another ewer in the same case with thick glaze somewhat crackled and discoloured, but painted in a fine free style with a figure of a sage under a tree and landscape setting, borders of pendent jewels, banana leaves, etc. It is clearly an early piece and may well be of the same period. The blue in both these ewers, to a slight degree on the first and to a marked extent on the second, has the light and dark mottling which we have reason to think was a characteristic of the Hsüan Tê blue and white.

A third,[1] a ewer of octagonal form with ribs at the angles, has floral scrolls in rather Persian style in a bright blue rendered hazy by the bubbles of the thick glaze. The biscuit at the edges of the base is deeply browned, and the mark beneath is *Hsüan Tê nien tsao*. It has all the characteristics of an early piece and may well be of the period. At some stage of its existence it has been embellished with oil-gilding, probably in Persia or the Near East, but only traces of this doubtful enhancement now remain.

But the ware which reached Persia at this time was not all of the coarser, export type. There must have been an occasional gift of the finer Imperial porcelains made to rulers or ambassadors. Otherwise how can we explain the charming little saucer dish in the Victoria and Albert Museum? It is made of a ware which, though clearly Persian, is scarcely distinguishable from true porcelain, and marked beneath with a garbled version of the Hsüan Tê mark. This piece is painted in blue with a delicacy which Hsiang himself might have applauded, and it can only have been copied from a first-class model. In the centre is a medallion with

[1] Figured in *Country Life*, September 25, 1920.

a duck standing on a rock among formal lotus plants, and round the sides is a key-fret border.

There is something in the drawing, as well as in the design, of this beautiful saucer with its borrowed mark which invites comparison with a small bowl in the Henry Oppenheim Collection (Plate 20). It is a bowl of rather unusual form, with great thickness in the lower part and an unglazed base which discloses a very white biscuit. The delicately-drawn lotus scrolls on its exterior, strongly outlined and washed in with a clear, bright blue, recall in style the Persian saucer; and the medallion inside with two ducks squatting on lotus leaves, so drawn that one might be the image of the other reflected in the water, has other elements in common with it.

Cairo had long been familiar with the Chinese wares imported by Chinese and Arab ships trading with Red Sea ports, and many fragments of Chinese porcelain have been found in the rubbish mounds of Fostat. One of these in the British Museum is the bottom of a rice bowl bearing the mark *Hsüan Tê nien tsao* (Fig. 1 of Plate 59) in blue underneath, and inside a medallion with a kylin painted in greyish blue. The broken edges give a good view of the body, which is clean white and highly vitrified but of rather a sugary fracture. It has not been mixed with excessive care, for there are occasional particles of grit visible and small holes. Over the places where these holes occur in the body the glaze has sunk, forming depressions like those to which the Chinese gave pet names, such as " palm eyes," etc. The foot-rim is bare of glaze at the edge, and where the biscuit has been exposed to the fire of the kiln it has burnt red. The glaze itself is thick and smooth and resembles in texture that of Fig. 1 of Plate 3, and Fig. 1 of Plate 16.

A deep bowl in the Salting Collection has received attention from previous writers on Ming porcelain. It is a most attractive object, rather larger than the normal, made of fine material and beautifully painted in a pale soft blue. The design outside, partly seen on Plate 16, comprises flowering plants, including a beautiful chrysanthemum, and lizards. Inside is a medallion with the familiar singing-bird on a rock, and a border of lotus plants. The Hsüan Tê mark on the base indicates the period which it aspires and is well worthy to represent, though its unusual size brings to mind the description given of Mr. Ts'ui's imitations which were famous in the Chia Ching period.[1]

Fig. 2 of Plate 19 is a fine blue and white vase in the Grandidier

[1] See p. 107.

Collection which has all the appearance of an early Ming piece and may be of the Hsüan Tê period. In form it is a *mei p'ing*, or prunus vase, with high shoulders and small mouth. The designs, admirably drawn, include a garden scene with personages and the usual Ming borders—on the shoulder *ju-i* shaped lappets with lotus pattern enclosed and pendent jewels between, and false gadroons below.

Finally, there is the little flask-shaped vase in the British Museum which, if we can credit the inscription incised on its box, is a " precious moon vase of Hsüan porcelain " and was formerly in the possession of Hsiang Yüan-p'ien, the hero of the album, himself. It has a thick glaze of greenish tinge and is painted with a fruiting peach bough in a soft, rather hazy blue which has developed a disfiguring blackness in places. This interesting piece has already been illustrated and discussed.[1] In this connection a small ewer in the Victoria and Albert Museum, with lobate body and a spout but no handle, is worth noting. It has a design of a bird on a peach bough which recalls the style of the Hsiang flask.

The expression " heaped and piled " used in the *Ch'ing pi tsang* in reference to blue and white of this period seems specially applicable to a type of blue painting which is noticeable on some Yung Chêng and Ch'ien Lung imitations bearing the Hsüan Tê mark. On these, the designs, usually lotus scrolls, are painted in a mottled blue in which the darker markings seem to have been formed by piling the blue pigment over a wash of light colour. From the late copies alone one would gather that this very distinctive type dated from the Hsüan Tê period ; and there are known specimens of it which take us back certainly to the Ming dynasty, if not actually to the classic reign itself. There is, for instance, the pilgrim flask, exhibited at the Burlington Fine Arts Club in 1910,[2] which was apparently in India in the time of Aurangzeb. There is also the beautiful bottle[3] in the Alexander Collection which is not only an indubitable Ming specimen, but actually bears the Hsüan Tê mark. And an exceptionally fine example of this type is figured in *Antiquités de l'Empire de Russie*,[4] an album which illustrates but unfortunately does not describe an important series of Imperial Russian treasures. The piece in question, rendered in colour and about actual size, is a shapely hexagonal bottle with gold-mounted stopper held by a chain attached to

[1] Hobson, *Chinese Pottery and Porcelain*, Plate 60. [2] Cat., L 23.
[3] See Hobson, *op. cit.*, Plate 67, Fig. 4.
[4] Vol. v., Plate 36.

a band of gold, at the mouth of which is inscribed the name of the Czarevitch Ivan Ivanovitch. This was no doubt the property of Ivan Ivanovitch (1496–1534), Grand Duke of Riazan. On the body are lotus scrolls in mottled blue, and on the slender neck, bands of formal ornament, including stiff plantain leaves. The base is unmarked, but the mottled blue clearly shown in the reproduction is the typical heaped and piled blue under discussion. In assuming this to be one of the Hsüan Tê types we do not lose sight of the fact that the same style was followed by the decorators of later porcelains. Indeed, we find it on what is most probably Chêng Tê porcelain, and certainly on the imitative wares of subsequent periods.

The Hsüan Tê red porcelain vies with the blue and white for pride of place. It also rivals the latter in the variety of names applied to its constituent colour. First there is the general term *chi hung*,[1] commonly rendered sacrificial[2] red and explained as the colour used on the sacrificial cups in the worship of the sun. This we learn was capable of subdivisions into *hsien hung*[1] (fresh or vivid red) and *pao shih hung* (precious stone red). It is not clear what was the difference, if any, between these two colours. They would both appear to have been underglaze reds derived from copper. Possibly the term *hsien hung* was more generally applied to red glazes which covered large areas of the porcelain, and *pao shih hung* to the red as used in painted designs. But the distinction is purely superficial, as in both cases the colour would be an underglaze copper-red.

It is unfortunate that the term *pao shih hung* should have been loosely applied in modern times to an overglaze red derived from iron, because this offers such a temptingly simple explanation of the two types of red— viz. one under the glaze and the other over the glaze. But there can be no mistaking the significance of *pao shih hung* as applied to the Ming porcelains. It is made clear by the passage in the *Po wu yao lan* describing the stem cups decorated with red fish :—" for these they used a powder made of red precious stones (*pao shih*) from the West to paint the fish forms, and from the body (*ku*) there rose up in relief in the firing the precious brilliance of the fresh red ravishing the eye."

It was a tradition that the underglaze red both of Ming and later times was made with powdered rubies, the red precious stones from the

[1] See p. 195.

[2] The character *chi* takes other forms in the hands of different writers. Thus Hsiang used a form which means " massed, or accumulated " ; and elsewhere we find it in the form which means " sky-clearing," suggesting the red of the sky after a storm.

West, a tradition which grew more or less naturally from the fact that certain hard stones (cornelian[1] among them) were pulverised and mixed with the glaze. Though not in any sense a colouring agent, it is not impossible that such powder might in some way have helped the development of the copper-red colour.[2] In any case, the description in the *Po wu yao lan* is only appropriate to a copper-red which would be applied on the body of the ware or incorporated in the glaze. Incidentally it would also appear that the author of this passage, at any rate, made no distinction between the fresh[3] red (*hsien hung*) and the precious-stone red.

The use of underglaze red was not unknown in the Yung Lo period, perhaps even earlier,[4] but it would appear that the Hsüan Tê potters

[1] *Ma nao*. A red stone, doubtless the same, was used in preparing the red glaze of the K'ang Hsi period, according to the contemporary evidence of Père d'Entrecolles.

[2] Similarly the use of a special clay in the body is thought to have contributed to the success of the copper-red. This red is a very difficult colour to manage in the kiln and it may be that the presence of a little iron had a helpful influence on the red. This iron ingredient was probably introduced in a ferruginous earth which was the special clay alluded to. The following note on this intriguing question has been contributed by Mr. Hetherington in consultation with Sir Herbert Jackson :—It is difficult to reconcile this well-established tradition with the actual scientific reactions which take place in the formation of a copper-red glaze. The colour is produced by the aggregation of minute particles of copper under suitable conditions which it is not necessary to elaborate here. Suffice it to say that the best colour will not be produced if the amount of copper present exceeds a certain quantity, viz. about ·5% or less. An excess of copper will produce a red or brown, sealing-wax effect instead of a brilliant clear red. In actual practice the copper is introduced into the glaze in the form of its oxide, and under the reducing atmosphere of the kiln the oxide is robbed of its oxygen and reduced to the metal itself in a very finely divided state. This process of "reduction" would no doubt be assisted by the presence of a reducing agent such as ferrous oxide, and conceivably a ferruginous earth might act in this way. But the tradition of introducing powdered rubies or cornelian could not be explained on these grounds. These stones consist largely of alumina and silica respectively. The presence of these substances in excess in a copper glaze will tend to retard or even to prevent the copper coming out, or "striking" as it is technically called. Alumina, therefore, in some excess, and to some extent this is true of silica also, would counteract a superabundant quantity of copper which otherwise might have produced the undesirable opaque effect. Some such explanation as this is the only one which provides a scientific foundation for this oft-quoted tradition.

[3] The character *hsien* has the meaning of fresh as opposite to dried, and also the sense of pure, clear. It may well be that it was applied to the red glaze and underglaze red to describe its transparence and limpidity as opposed to the opaque, dry surface of the iron-red (*fan hung*) enamel which was applied in a thin skin over the glaze.

[4] See Hetherington, *op. cit.*, p. 142.

were the first to master this capricious material. Chinese potters' methods, especially at this time, must have been mainly empirical, and it was probably the accidental discovery that a certain kind of earth mingled with the body of the ware helped to develop the red colour which gave them an advantage over their fellows of other times.[1] Be that as it may, it is clear that the successful Hsüan Tê red[2] was something of outstanding quality, even if we discount the enthusiasm of collectors like Hsiang, who speaks of it as dazzling the eye. Hsiang, indeed, gives no less than twelve examples of it in his Album. On some of them the red appears as a monochrome glaze covering the whole or part of the surface, and in two cases covering engraved designs. On others it is painted on with a full brush, as in the cups with three fish or three fruits on the outside ; and in others, again, it is pencilled with a fine brush like the blue and white. In one case it appears in combination with blue and white and etched ornament, and in another with brown and green enamels or glazes. It is always described as *chi hung,* which in this case means " massed red," or deep red ; its brilliance is in some cases ascribed to the " red precious stones from the West," and in several instances its tone is compared with that of apes' blood.

The favourite ornament of these red porcelains, if we may judge from the frequent allusions in Chinese writings, was three fishes in brilliant red, apparently swimming in the white glaze. According to Hsiang, the glaze of the Hsüan ware was thick like congealed fat, white as driven snow, and covered with faint elevations like millet grain or chicken skin, or even orange peel[3] ; and the red design stood out against this beautiful white ground in powerful contrast. The red fish cups were copied at the Imperial factories in the reign of Yung Chêng, as were also pieces with designs of three fruits, three *ling-chih* funguses or five bats, which symbolise the five happinesses ; and there are good eighteenth-century copies in modern collections which serve as illustrations of what the Hsüan Tê originals must have been. But we are fortunate to-day in having in three collections in England specimens of the red fish stem cups which may reasonably be supposed to belong to this classic period. One

[1] See p. 89. On two occasions in the sixteenth century the potters appealed to the throne to cancel orders for *hsien hung* ware on account of the difficulty of producing the colour successfully.

[2] It was not always successful. The *Po wu yao lan* speaks of " the brown and blackish colours which resulted from imperfect firing of the red are inferior."

[3] See p. 15.

is illustrated on Plate 3. It resembles so closely the specimen in Hsiang's Album[1] that one may be forgiven for quoting the description of the latter as rendered by Bushell :—"*Hsüan yao* of the Ming dynasty. Tazza-shaped cup decorated in deep red with three fish. The cup (*pei*) was fashioned in the shape of a stemmed cup (*pa pei*) of the Han dynasty carved in jade. . . . The white part of the glaze, looking like congealed fat, is as pure in tint as driven snow ; and the deep red of the three fish, outlined with a vigorous brush, is as crimson as fresh blood." The base, we gather, was flat, and it was bought by Hsiang for twenty-four taels of silver at Shao-hsing Fu.

Except that our present example is in the collection of Mr. Eumorfopoulos and the price paid for it was not twenty-four taels, Hsiang's description applies to it almost exactly. The mark, however, is differently placed, being engraved under the flat base in Hsiang's pieces and painted in blue inside our specimen. The flat base discloses a fine white biscuit ; the glaze, which has great depth and lustre, is of a faintly greenish white with an oily sheen. Naturally one looks for one of the phenomena ascribed so frequently in Chinese works to the early Ming glazes—palm-eye spots, millet-like elevations, chicken-skin or orange-peel surface ; and one finds that the peculiar oily sheen of the glaze is apparently due to a mass of minute depressions with which the surface is seen to be strewn if examined under a glass or even moved in a strong light. This is what we have ventured[2] to regard as " chicken skin." The red fish are slightly raised, and the red is of crimson tone and full of tiny bubble-holes.

Another in the collection of Mr. Vernon Wethered closely resembles that illustrated on Plate 3.

The third example is in the David Collection. It is of similar form, decorated with three brilliant red fish under a glaze of very similar appearance. The mark is also inside and beautifully pencilled in blue, and the chief difference is the base, which is only partly covered in, showing the hollow of the stem.

There is a fourth stem cup with red fish in the Eumorfopoulos Collection. It is larger with wider mouth, completely hollow stem and no mark, and it seems rather to be a Ch'êng Hua type.[3]

As for the Hsüan Tê red monochromes, such as the incense vases with fish handles, half red and half white, the red ewer, the dish with red exterior and the persimmon-shaped rouge pot in Hsiang's Album, and " the small cinnabar pots and large bowls with colour red like the

[1] No. 54. [2] See p. 16. [3] See p. 71.

sun, but white mouth rim " of the *Po wu yao lan*, collectors have sought eagerly for examples both here and in the East, but with very little success. This glaze was copied in the Imperial factories in the Yung Chêng period, and the well-known K'ang Hsi reds of the *sang de bœuf* type were made in practically the same fashion, so that the pursuit of the genuine Hsüan Tê piece will always be complicated by the existence of these later types. There is, however, one piece in an English collection which seems to satisfy the requirements. It is a little water pot in the Henry Oppenheim Collection, one of those dainty pieces of furniture for the writing table in which the scholarly Chinese delighted. Its shape and colour can be seen in Plate 3. The paste, as seen at the foot-rim, is white and of fine grain, with a tendency to turn brown where the fire has touched it. The glaze has a faint bluish green tint with a soft, rather dull lustre, and it has a few of those small holes in the interior which the Chinese call palm-eye spots. They are tiny spaces where the glaze has failed to run and where the exposed body of the ware has generally turned reddish brown. These small irregularities of the early glazes were regarded by connoisseurs as beauty spots rather than as defects. The red of the outside, something between a *sang de bœuf* and a liver colour, is of course an underglaze colour derived from copper. The mark in four characters within a square is faintly incised in the paste and beneath the glaze of the base.

Of the other Hsüan Tê types mentioned in the *Po wu yao lan* we have no difficulty in visualising the beautiful altar cups and the cups for tea (with rounded body and convex base), bright and lustrous like jade. The " secret designs " of dragon and phœnix engraved or traced in white slip under the glaze would be like the ornament of the Yung Lo bowl, and there are some white bowls and dishes in our public collections which, if not actually of the period, are obviously close copies of Hsüan Tê models.

The allusion to flat-sided jars with basket covers and ornamented round pots " as very beautiful and mostly decorated in colours (*wu ts'ai*) " brings us to the polychrome porcelains. We need no longer stop to consider whether painting in enamels on the glaze was known in the Hsüan Tê period, since it has now been proved to have been practised in the Sung dynasty.[1] Our only difficulty is to find genuine specimens of it. Hsiang[2] figures in his Album a model of a pagoda of which the roofs are green, the doors yellow and the railings red. These are all *wu ts'ai fu sê* (" applied colours "). *Wu ts'ai* and *wu sê* (lit. five colours) are current phrases for polychrome decoration in enamels; and *fu*,

[1] See p. 12. [2] *Op. Cit.*, No. 77.

a word used of medicines applied externally, seems to indicate clearly that the enamels were laid on the glaze or, at any rate, on the biscuit in contrast with colours painted beneath or mingled with the glaze. Enamelling appears to have reached perfection in the Ch'êng Hua period (1465–87), and connoisseurs contrasted the thick enamels of the Hsüan ware with the delicate paintings of the Ch'êng. There are specimens with underglaze blue and overglaze enamels bearing the Hsüan Tê mark in our collections ; few, if any, are of unquestioned genuineness. A highly probable example is a cut-down vase in the British Museum which has been furnished with a bronze cover in Japan. It is a square piece which now serves as a box, and it has a well-painted design of crane and lotuses in strong enamel colours and underglaze blue and the Hsüan Tê mark in a fine Mohammedan blue. But the most interesting claimant to Hsüan Tê eminence in the class of enamelled wares is the elegant bowl in the Winkworth Collection (Plate 15). Of shallow form, with thick white glaze showing the pin-holes and slight protuberances which answer to the Chinese expressions " palm eyes " and " millet marking," it is decorated with elegant sprays of prunus painted in red, green, brownish yellow and the typical Ming turquoise blue. The enamels stand out thick from the glaze in the manner recalling the criticism quoted above. Under the base in blue is the Hsüan Tê mark, together with the cyclical date (the *kuei ch'ou* year), which corresponds with 1433 of our era.

The other principal type of polychrome, usually described as *san ts'ai*, or three colour, porcelain, in which the colours are rendered by washes of lead-silicate glazes fired in the temperate parts of the large kiln (*demi-grand feu*), has already been discussed and illustrated in the second chapter, on Ming technique. It was developed widely in the Ming period; and there is little doubt that the barrel-shaped garden seats described in the *Po wu yao lan* as a novelty of the Hsüan Tê period belong to this class of ware. The passage in question runs :—" Again there are the beautiful barrel-shaped seats, some with openwork ground, the designs filled in with colours, gorgeous as cloud brocades : others with solid ground filled in with colours in engraved floral designs so beautiful and brilliant as to dazzle the eye : both sorts have a deep green (*ch'ing*) background. Others have a blue (*lan*) ground, filled in with designs in colours, like ornaments carved in *shih ch'ing*."[1]

[1] *Shih ch'ing* = lit. stone-blue, the usual name for the native cobalt mineral. Bushell renders the phrase here as " carved in lapis lazuli," which certainly makes intelligible sense, though far from literal.

Chinese descriptive passages are not as a rule easy to apply to known types, but here we have a fortunate exception. Not only are we familiar with barrel-shaped seats, but with a whole family of vases, covered jars, flower pots and other large objects decorated in precisely the manner described. There is, for instance, the fine barrel seat in the British Museum.[1] It is of the solid kind and has its ornament—lotus scrolls, horses, cloud designs, etc.—traced in outlines of raised clay and filled in with green, yellow and aubergine, the background being turquoise-blue in the centre and dark blue (lan) above and below. Barrel seats with openwork sides are to be found in several collections, the general appearance of the pierced ornament being either that of a bold lattice-work or a closer fretwork, as Fig. 3 of Plate II. A further description of this kind of porcelain, with illustrations, has been given in the chapter on technique.[2]

Compared with the delicate stem cups of blue and white or fresh red, these large pieces are relatively numerous. Their massive build would enable them to survive much usage, though it will generally be found that they have suffered some loss at the hands of time, as witness here the wooden cover or newly made-porcelain one, and there the neck or handles restored in cloisonné enamel. Their massive build, too, would have recommended them, like the celadons, for the export trade, which would account for the presence of some of them in unexpected places. It is certain, too, that these wares were made with little change of style throughout the whole range of the Ming dynasty; so that there is plenty of latitude for the dating of our specimens, and it is not to be expected that many of the existing pieces actually belong to the brief reign of Hsüan Tê. It was, in fact, because this important group belongs to no particular reign that the more detailed description of it, with illustrations, was included in the general note on Ming technique.[3] Nor should it be forgotten that these wares have a counterpart in earthenware,[4] which was made at the different potteries and tileworks scattered up and down the country.

Another type of Hsüan Tê porcelain is represented by a dish in the British Museum which has all the appearance of a Ming ware and may actually be of the period in question. It has a thick, lustrous glaze of greenish white and a gilt decoration consisting of lotus scrolls similar to those on the red bowls.[5] It bears the Hsüan Tê mark in Mohammedan blue under the base.

[1] Hobson, *op. cit.*, Plate 62. [2] See p. 30.
[3] See p. 26. [4] See p. 178. [5] See p. 91.

Several writers refer to crackled wares of the period. In the *Po wu yao lan* reference is made to " crackled grounds like ice," and other writers speak of " pieces with ice crackle and eels' blood markings rivalling Kuan and Ju wares," two of the most famous of the Sung wares. Though the exact nature of the various glazes of the Ju and Kuan groups is still undetermined, it is extremely probable that some of them at least were of the celadon type and that the Hsüan Tê glazes in question belonged to this category. The " eels' blood marking " refers to the practice of rubbing red pigment into the crackle to emphasise the lines. A shallow bulb bowl in the Eumorfopoulos Collection with a Hsüan Tê mark and a pale celadon green glaze suggests that celadon glazes were used at Ching-tê Chên at this time, if it is not actually a Hsüan Tê specimen ; and there is an interesting bottle in the J. F. Bloxam Collection in the Victoria and Albert Museum with a rather clumsy square-cut body glazed celadon green, and a straight neck painted in pale blue with a phœnix design in a style which one associates with the early Ming periods.

A list of porcelains made at the Imperial factory in the Yung Chêng period was published in the *Chiang hsi t'ung chih*.[1] It consists mainly of imitations of old types, and it is understood that specimens of the originals were sent to the factory to be copied. As may be imagined, it supplies a valuable commentary on many of the ancient types and fills not a few gaps in our information. We learn, for instance, that a blue or lavender-blue monochrome was one of the Hsüan Tê types. It is classed as *chi ch'ing* (or sky-clearing blue), and a note is added to the effect that this " glaze is deep and has a reddish tinge " and that it has the " orange peel markings and palm eyes " which seem to have characterised so much of the Hsüan Tê ware. Another item in the same list describes " porcelain with ornament in Hsüan Tê style in a yellow ground," no doubt blue and white porcelain with the ground filled in with yellow enamel.

The forms and decorations of Hsüan Tê wares described in the *T'ao shuo*[2] are comparatively few, and in view of the importance of the period it may be useful to summarise them. They comprise white altar cups (*t'ai chan*), inscribed inside with the character *t'an* (altar).

White tea cups (*ch'a chan*), usually engraved with designs of dragon and phœnix, etc., under the glaze. The white ware is described as of

[1] Bk. 93, fols. 11–13. See Bushell, *O.C.A.*, p. 368, and Hobson, vol. ii., p. 223.
[2] See Bushell's translation, pp. 134–40.

" fine paste covered with a thick glaze," and again " the surface is marked with faint elevations, rising like the small tubercles on the peel of an orange. Even in the porcelain of Tingchow we find no pieces to rival these."

Red fish goblets (*hung yü pa pei*).

Stem cups painted in blue with dragon-pines and plum blossoms; and with figure scenes and monsters.

Basket bowls on jointed bamboo stems. The last three are described as novelties of the time.

Tea cups decorated with figures armed with light silk fans striking at flying fire-flies : after a picture by Li Ssŭ-hsün.

Wine pots, painted in " five colours," and moulded in the form of peaches ; pomegranates ; two gourds ; a pair of Mandarin ducks ; or geese.

Washing dishes (*hsi*) " in outline like a Buddhist gong," with moulded fish and water weeds ; with hibiscus flowers ; with lizards. These are dishes for washing brushes after writing.

Large bowls (*ta wan*) of cinnabar-red colour ; small pots (*hsiao hu*) of cinnabar-red.

Pickle pots (*lu hu*) and small pots (? for tea). These are both mentioned as novelties, but unfortunately their forms are not made clear.

Flower vases (*hua tsun*). These are beaker-shaped with mouth wider than the body, as opposed to the *hua p'ing*, vases with wide body and small mouth.

Barrel-shaped seats.

Flat jars (*pien kuan*), a sort of basin ; and cylindrical jars (*t'ung kuan*) for honey preserves.

Lamp brackets (*têng ch'ing*).

Rain lamps (*yü t'ai*).

Vessels for holding birds' food.

Cricket pots (*p'ên*).

" We find that the pots of Hsüan Tê porcelain painted in gold were the most highly valued. Some of the pots made for the fighting crickets were painted in gold, as we see described in an ode included in the collected works of Wu Mei-ts'un."

These are apparently pots in which fighting crickets were kept and carried to the contests. Their form has been much debated, various impossible objects being from time to time described as cricket pots. Doubtless they would have some sort of perforation to admit air, but

the openwork would need to be of fine mesh to prevent the cricket escaping. Apart from this requirement, there is nothing to define their character ; and, as openwork was also used on perfume pots of various kinds, the identification of a cricket pot is no easy matter.

It would appear from the same passage that the Ching-tê Chên cricket pots were surpassed by those made at Soochow.[1]

[1] See p. 177.

CH'ÊNG HUA TO CHÊNG TÊ (1465–1505)

Ying Tsung, who succeeded Hsüan Tê under the title of Chêng T'ung, was a mere puppet in the hands of a powerful eunuch named Wang Chên. The Mongols, who had been repressed by the strong hand of Yung Lo, now resumed their aggressions on the north-west borders; and Ying Tsung going with an undisciplined army to help the menaced city of Ta Tung was surprised, defeated and captured by the invaders in 1449. His brother was proclaimed Emperor and ruled under the title of Ching T'ai from 1450 to 1456, when Ying Tsung was restored by a *coup d'état*, much against the wish of the people. On his return to the throne Ying Tsung adopted the fresh title of T'ien Shun, under which he reigned from 1457 to 1464.

This troubled period of thirty years is practically a blank in the history of porcelain. The directorate of the Imperial factory was abolished in 1436; and as money had to be found to equip an army against the Mongols, it was decided to stop the manufacture of porcelain for the palace for a time. It was apparently resumed after a brief interval; but in the year 1454 Ching T'ai reduced the customary palace orders by one-third. Under T'ien Shun the Imperial factory was reconstituted and given into the charge of a eunuch. These meagre records are practically all we have to represent the interval between the reigns of Hsüan Tê and Ch'êng Hua.

The Ching T'ai period was noted for cloisonné enamels, but the reign mark is apparently unknown on porcelain. The T'ien Shun mark has appeared on one or two pieces, but they are of doubtful date and of no artistic merit. Still, though we have no indication that any special type of ware was made at this time, we may be sure that the manufacture went on in the private factories, even when the Imperial works had closed down, and that the types made in the previous reign persisted even if there were no new development. In the absence of information about this period from Chinese sources particular interest attaches to an incidental reference to Chinese porcelain in the contemporary European writings. Mathieu de Coussy quotes a letter addressed to Charles VII

63

of France by the Sultan of Egypt or Babylon—the date of the reference is 1447—in which mention is made of a present of " trois escuelles de pourcelaine de Sinant, un plat de pourcelaine de Sinant, deux grandz platz ouvertz de pourcelaine, deux tongues verdes de pourcelaine, deux bouquetz (bottles with handles) de pourcelaine, ung lavoir-mains et ung gardemanger de pourcelaine ouvré, une jatte de fin gingembre vert, etc." Here we have a variety of familiar objects—saucer-dishes, plates, large dishes, bottles, basins and ginger jars—of Chinese porcelain, with the further indication that some of them were green (probably celadon) and some *ouvré,* which probably means with carved or moulded designs.

Nor was Chinese porcelain unknown in Italy at this time. Otherwise the little bowl which appears in Andrea Mantegna's " Adoration of the Magi "[1] would hardly have taken such an obviously Chinese form. It is of typical rice-bowl shape and apparently painted in blue ; but, curiously enough, it is held by one of the figures in the hollow of his hand as though it were one of the *ya shou pei,* or " press-hand " cups of the Yung Lo period.

Hsien Tsung, who succeeded his father in 1465 and reigned until 1487 with the title of Ch'êng Hua, fell unfortunately under the combined influences of a favourite concubine, Wang Kuei-fei, and an ambitious eunuch, Wang Chih. Such conditions did not make for enlightened rule, but we hear nevertheless of certain works of utility undertaken at this time, such as the repairing of the Great Wall and the deepening of part of the Grand Canal. As for the porcelain industry, we have many indications that it received every encouragement, and it is generally agreed that the reign of Ch'êng Hua was the second great and classical period of Ching-tê Chên porcelain. On this subject Chinese writers are unanimous, and their opinion is endorsed by the potters of after times who used the reign-marks of Hsüan Tê and Ch'êng Hua impartially on their wares. To take the *Po wu yao lan* as representing literary opinion, we find the Ch'êng Hua porcelain described as follows :—" In the highest class of Ch'êng ware it is impossible to surpass the stem cups with spreading mouth and flattened sides decorated in colours (*wu ts'ai*) with grape-vine pattern. They excel the Hsüan Tê cups in workmanship. Next to these come the toasting[2] cups (*ch'üan pei*) decorated with plants and insects,[3] which

[1] Mantegna's dates are 1430–1506. The picture was illustrated in the *Burlington Magazine* of November, 1905.

[2] Bushell renders this phrase " wedding cups."

[3] *Ts'ao chung.* The phrase can also be rendered " grass insects," i.e. grasshoppers.

are delightful ; the tub-shaped cups with hen and chickens ; the wine cups with figure-subjects and lotuses[1] ; shallow cups with the five sacrificial vessels (*wu kung*) ; small cups with plant designs and insects ; blue-painted cups thin as paper ; small flat dishes for chopsticks, painted in colours ; incense boxes and all manner of small jars, all extremely fine and pleasing. In my judgment the Ch'êng yao blue and white does not equal that of the Hsüan yao ; but the coloured ware of the Hsüan court is inferior to that of the Hsien[2] court. The reasons are that the blue of Hsüan ware is *su-ni-p'o* blue and this was exhausted after that reign, so that in the Ch'êng Hua period only the ordinary class of blue was used, and that the colours of the Hsüan ware are deep and thick and piled on and consequently not very beautiful, while those of the Ch'êng ware are rather thin and subdued in colour and produce a pictorial effect.[3] This I consider a well-grounded opinion."

Other writers tell us that, in general, the Hsüan Tê ware was thick and that of Ch'êng Hua was thin ; and that the blue of the former was pale and of the latter dark. But the second of these two statements, at any rate, is open to question ; for we have seen that dark blue is mentioned in connection with the Hsüan Tê porcelain, and " Ch'êng Hua porcelain with designs painted in pale blue " is listed among the wares copied by the Imperial potters in the Yung Chêng period.

We learn from the Ming Annals that the envoys from Sumatra,[4] who had been in the habit of bringing the Mohammedan blue material among their articles of tribute, arrived for the last time in 1486. This would have been too late to have affected much of the Ch'êng Hua porcelain, even if they always brought back a tribute of blue, which is by no means certain. At any rate, we must regard the statement of the *Po wu yao lan* that the supply of Mohammedan blue failed in this period as at present holding the field ; and it certainly explains the scanty allusions to Ch'êng Hua blue and white in Chinese writings.

There is no specimen of blue and white in our collections which can be attributed with certainty to the Imperial Ch'êng Hua factories. On the other hand, there are several pieces which may well have come from the private factories of this period. There is no lack of evidence that Chinese porcelain was a regular article of trade in the

[1] This could also be rendered " wine cups shaped like lotus pods and decorated with figure-subjects."

[2] Hsien Tsung is the posthumous title of Ch'êng Hua.

[3] Lit. have the picture idea. [4] See p. 47.

Near East at this time. The Venetian ambassador at the Court of Persia in 1474 wrote about it to his government, mentioning China as the region in which were made " i cadini e piatine di porcellana." It is evident from the phrasing that his readers were quite familiar with these objects. The ware was also freely imported into Egypt at this time, and we learn that Lorenzo de Medici entered into trading relations with the Sultan of Egypt and that an ambassador from the latter arrived in Florence in 1487, bringing among other presents " vasi grandi porcellana," painted in several colours, the like of which had never before been seen. These were in all probability Chinese porcelain, although it must not be forgotten that the word porcelain was rather vaguely used in early writings. In the same year porcelain is mentioned among the imports from Egypt into Barcelona[1] ; and nothing is more likely than that the Trenchard bowls,[2] given by Phillip of Austria, King of Castille, in 1506 to Sir Thomas Trenchard, reached Europe by the same route.

Reference has been made[3] to a stem cup, painted in underglaze blue and bearing the Hsüan Tê mark, in the Metropolitan Museum in New York, and to another with similar design but slightly different shape in the British Museum. This latter has the Ch'êng Hua mark and is pencilled in pale blue with a winged dragon, a horse, a deer, a kylin and a hare reserved in white in a ground of spirals representing waves. On the stem is the " Rock of Ages " pattern, a design of curling sea waves with conical rocks rising from them, which is probably an allusion to the Shou Shan or Isles of Immortality rising from the sea. Inside the bowl is a medallion of a conch shell in spiral waves.

This piece is interesting in itself and appears to be a Ming specimen and probably of the period indicated ; but it is also important for its bearing on a still more interesting piece in the Leverton Harris Collection (Fig. 3 of Plate 20). This is another stem cup or goblet about the same size. It is pencilled in pale blue in similar free style, and has the same conch-shell medallion inside and " Rock of Ages " pattern on the stem ; but the main ornament consists of fish and water-weeds, a very familiar Ming pattern.[4] This delightful little cup has a silver mount which must have been applied in Europe about 1530, showing that it came into European hands quite early in the sixteenth century. Looking at it in the light of the marked Ch'êng Hua cup in the British Museum and the

[1] See Marryat, *Pottery and Porcelain*, p. 241. There are a number of interesting early references to porcelain quoted in this passage. [2] See p. 49.

[3] p. 48. [4] See p. 19.

Hsüan Tê cup in New York, we can hardly doubt that it belongs to one of these classic reigns.

The medallion with fish and water-weeds painted in a pale blue on Fig. 1 of Plate 32 is a link between an interesting little dish in the R. E. Brandt Collection and the Leverton Harris cup. The dish has, in addition, a finely moulded design on the rim and sides consisting of six medallions of lotus flowers with palmette patterns between. It is a rare type, probably made in one of the fifteenth-century periods.

In Mr. Ezekiel's series there are two small bowls with the Ch'êng Hua mark and believed to be of the period. The ware is rather coarse, obviously the output of one of the private factories ; and the blue is dull in tone. On one is a garden scene with a kylin outside and a bird within. The other has a landscape border, such as appears inside a bowl with Hsüan Tê mark in the Dresden Collection[1] and on some of the Chinese porcelain found in Persia.

A small bowl[2] of similar make but rather cleaner finish was given to the British Museum by Mr. Li Van Ch'ing as a true example of Ch'êng Hua blue and white ; and, as its attribution is supported by one who is reputed the best judge in China, we feel safe in regarding it as an extremely likely specimen. Of fine white unctuous paste, with thick but limpid glaze of faintly greenish tinge, it is decorated in a pure silvery blue, with five figures in flowing robes drawn in summary fashion but with considerable skill, their features having, to the Western eye at least, a suggestion of the grotesque. Inside the bowl is a figure with a large peach which may represent T'ung Fang-so, who stole the peaches of Immortality. Outside are two pairs, one apparently T'ung Fang-so without his peach, and the other a sage with a whisp of beard. This bowl bears the Ch'êng Hua mark. The glaze is wonderfully fresh and clear, but it has many of those small defects, or pinholes, to which the Chinese allude so often on the early Ming porcelains under the name of palm-eye spots (*tsung yen*). Another small bowl in the Eumorfopoulos Collection has strong claims to represent the period (Fig. 4, Plate 14). It has a good white body, a glaze rendered rather misty by microscopic bubbles and with the subdued lustre of much handled marble. It is painted in a blue of indigo tint, with scrolls of lotus flowers and foliage covering the exterior and filling a medallion inside. The base is slightly convex beneath and is marked with the Ch'êng Hua *nien hao* in six characters within a rectangular frame.

[1] See Hobson, *op. cit.*, Plate 67. [2] Figured in *Country Life*, September 25, 1920.

The *Po wu yao lan* mentions "blue-painted wine cups thin as paper"; and the Imperial Yung Chêng List includes imitations of Ch'êng Hua porcelain painted in pale blue; but Hsiang Yüan-p'ien does not condescend to include a specimen of this period's blue and white in his Album, and we gather that he was only interested in the polychrome wares of this reign. For these Hsiang has no words too flattering. They are the cream of porcelain and fit to be rated with the finest Sung wares. The pity is that his illustrations, some almost humorously bad, are such a poor pendant to his enthusiastic descriptions. We gather, however, that the colours used were chiefly green, yellow and aubergine brown, and that they were obviously applied in some cases with a brush over the glaze, while in others one would imagine that they were enamels applied to the biscuit.

There is, for instance, a melon-shaped wine pot[1] with yellow body, aubergine spout and handle in form of twigs, and some foliage in relief in green. Enamelling on the biscuit would be the appropriate treatment for such a piece as this. Similarly the wine cup shaped like a magnolia flower,[2] and that in the form of a chrysanthemum[3] would be more amenable to this treatment. Incidentally these two pieces are absurdities as shown in the Album. Neither of them could be used for drinking, and the magnolia cup could not be made to stand up by any natural method. There are magnolia cups in later Fukien and other porcelains (see Plate 40) in which the magnolia form is elegantly suggested without destroying the usefulness of the vessel, and I suspect that these are the true reflections of the old Ch'êng Hua flower cups.

Of the other pieces five have pictorial designs of a delicate nature and evidently in enamels on the glaze. They include one of the famous stem cups[4] which the *Po wu yao lan* tells us are unsurpassed and superior even to the Hsüan Tê cups. The illustration is feeble, but Hsiang tells us that the original had a glaze white like rice powder with millet-like elevations, and that the enamels of the grape design were like jewels and that the price paid for it was one hundred taels of silver. Another of the types mentioned in the *Po wu yao lan* is illustrated by two small wine cups[5] with growing flowers and a dragon-fly and mantis, "plants and insects": these are described as very thin and light, weighing, in fact, the equivalent of eleven grammes.

Then come two tub-shaped cups,[6] with sides shaped like the big

[1] Hsiang, *op. cit.*, No. 38. [2] *Ibid.*, No. 49. [3] *Ibid.*, No. 65.
[4] *Ibid.*, No. 55. [5] *Ibid.*, No. 59. [6] *Ibid.*, Nos. 63 and 64.

fish bowls made for garden use and with flat bottoms. One is painted with geese in flight over water dotted with sprays of *ling chih* fungus, and the other is one of the famous chicken cups. This latter is " thin and diaphanous as a cicada's wing, so that the finger-nails show clearly through it. The design is of a cock and hen instinct with life and motion, reminding one in every detail of a water-colour picture by one of the Court artists of the Sung dynasty. The flower is in the style of Huang Ch'üan," etc. Doubtless the originals were exquisite things delicately made and daintily painted and full of the picture sense. They were certainly fine enough to attract the attention of the poet Kao Tan-jên, who dedicated an ode to one of them. But it is necessary to make a great effort of imagination to visualise these little porcelain gems from the crude drawings in Hsiang's Album. Another wine cup[1] is shaped like a tree trunk and coloured outside with aubergine brown, the knots on the surface being emphasised with pencilled lines of the same colour. The incense boxes named in the *Po wu yao lan* are represented by a small round box[2] (in this case labelled a rouge box) pencilled with formal floral designs in green in a yellow ground.

Hitherto we have had to content ourselves with conjuring up visions of these dainty Ch'êng Hua polychromes from written descriptions and the good reproductions of the K'ang Hsi and Yung Chêng periods. A *famille verte* stem cup in the Alexander Collection[3] gave us a hint of famous stem cups with vine pattern ; and fine eggshell wine cups with designs of flowers and insects and chicken and peonies, painted in underglaze blue and very delicate enamel colours in the Yung Chêng period, were taken as remotely resembling the famous chicken cups. At last, however, it seems that China has yielded up a specimen of Imperial Ch'êng Hua.

It is the little egg-shaped box in the Oppenheim Collection of which an illustration is seen on Plate 20. It is a piece with all the refinement of form and make and all the delicacy of colour decoration ascribed to the selected Ch'êng Hua enamelled pieces by Hsiang himself. The ware is white, of the finest grain and potted thin. It is painted in green, yellow and red enamels on the glaze and some underglaze blue. On the box is a blue rockery and a vine with grapes in yellow and blue, green leaves and reddish brown stem : the outlines of the coloured parts are in reddish brown ; and under the base is a six-character mark of the period beautifully

[1] *Ibid.*, No. 66. [2] *Ibid.*, No. 76.
[3] Hobson, *op. cit.*, Plate 106.

pencilled in blue. The glaze, which runs thick at the junction of the base and foot-rim, has a bluish cast.

On the cover are designs of green rockery with (1) periwinkle flowers in a wonderfully soft and luminous blue and another flowering plant; and (2) a clump of lotus in blue, pale red and two shades of green.

Apart from this charming little box our only other polychromes which can with likelihood be assigned to this reign are a few of the large, heavy-footed vases whose strength has permitted them to survive, though almost invariably in a truncated condition. A typical example of these is in the British Museum,[1] a baluster vase with greyish crackled glaze painted with a bold lotus scroll in leaf green, yellow, manganese purple and bluish green, in addition to a little underglaze blue of good tone. Unfortunately the neck is incomplete. The walls of the vase are thick, and the massive base is flat and unglazed except for a sunk panel in which is the Ch'êng Hua mark in blue. Certainly a Ming piece and of early date, there seems every reason to regard this vase as the product of one of the private kilns of the period.

A few other specimens of this type are to be found in our collections, such as the vase illustrated on Plate 17, which belongs to Mr. H. B. Harris and which resembles the British Museum piece so closely that no further description is necessary. Another with similar lotus scrolls is in the Eumorfopoulos Collection; while there is yet another in the Benson Collection with fungus scrolls and the Hsüan Tê mark.

Another vase with similarly truncated neck in the Eumorfopoulos Collection is painted with figures of Immortals in a pale aubergine, which gives them a curiously shadowy and ghost-like effect. Another vase of kindred shape, but unmarked, in the same collection has a muddy turquoise ground and designs of formal lotus ornaments, Sanskrit characters and shells outlined in brown and filled with yellow, aubergine and white: there is a little underglaze blue in the borders.

Finally, Plate 18, a vase in the Grandidier Collection at the Louvre of the same form and the same massive build of base and with the usual loss of inches at the neck,[2] is beautifully decorated with a bold lotus design outlined in brown and coloured with green and yellow in a mottled turquoise ground, a superb piece of decoration in the bravest Ming style. It has no mark, but evidently belongs to the same period as the rest of the group.

[1] Hobson, Plate 64, Fig. 1.
[2] Partly made good by an enamelled metal collar.

CH'ÊNG HUA TO CHÊNG TÊ

An interesting note in the works of Kao Tan-jên, besides alluding to the chicken wine cups, refers to " ruby red bowls and cinnabar dishes " among the porcelain of this period, "cleverly made and fine and more costly than Sung ware." From which it would appear that the famous Hsüan Tê red was still manufactured, though we should be much puzzled to distinguish a specimen of Ch'êng Hua make without the guidance of a mark.

It has been suggested that the larger of the two stem cups with red fish in the Eumorfopoulos Collection may be of Ch'êng Hua date. It is a beautiful piece of porcelain with glaze rather bubbly, bluish white in tint and with much the same oily sheen as that of Plate 3, Fig. 2. The underglaze red of the fishes is exceptionally fine in tone. The foot is hollow and unmarked, but the mouth of the bowl is wide and spreading, which we gather[1] to have been a distinguishing feature of the Ch'êng Hua stem cups.

It is a commonplace that the date-marks of the two classical reigns of Hsüan Tê and Ch'êng Hua are used with the utmost freedom on the wares of later periods. If one accepted all the marked pieces at their face value, it would be easy to amass a large and very miscellaneous collection of Ch'êng Hua porcelains; but in reality the marked Ch'êng Hua pieces which could by any stretch of imagination be attributed to the Ming period are very scarce, and from these the collector must sift out the imitations, which were avowedly[2] made in the later Ming reigns, before settling down to consider the claims of a very small residue.

As to the unmarked pieces, there are a few specimens of the blue and white export wares found in the Near East which seem from their style to be of early date. Some of these we may feel justified in ascribing to the fifteenth century, but few would be bold enough to give them a particular reign. Similarly with the large group of " cloisonné " and " graffiato " wares[3] with coloured glazes, doubtless some are of Ch'êng Hua date; but, in the absence of inscriptions, it is virtually impossible to say which they are.

In the official and other descriptions of the Imperial porcelains of

[1] See p. 56, "stem-cups with spreading mouth and flattened sides," and again Hsiang's Album, Fig. 55 : "The shape of the cup " (a stem cup with vine pattern) " resembles the cup figured above " (a Hsüan Tê stem cup), " but the rim of the bowl is slightly more expanded."

[2] See p. 107. [3] See p. 26.

71

Ch'êng Hua very little is said about the forms of the vessels. We may assume that the potters were at this time capable of producing in porcelain any object for which the material was appropriate and that there was no occasion to mention anything but striking novelties. The shapes named are those for everyday use—stem cups, wine cups of various kinds, small cups and shallow cups, plates, little plates for chop-sticks, incense boxes and small jars of different kinds, and the main interest lies in the various kinds of decoration applied to them.

We gather that painting in enamel colours had made great progress and that pictorial designs were much fancied. Decorations were designed by the best artists in the palace and drawings of them sent to the factories to be copied on the porcelain. In addition to the motives named in the *Po wu yao lan,* the *T'ao-shuo* speaks of wine cups decorated with " high-flaming silver candle lighting up red beauty : brocade-design cups : cups decorated with swings, Dragon-boat Procession, Famous Scholars and Playing Children : cups with trellis-frame of grapes, with fragrant plants, fish and water weeds, gourds and aubergine fruit, the Eight Buddhist Emblems, *yü-po-lo* flowers, Indian lotus scrolls."

Most of these descriptions are easily recognisable. Many, indeed, are familiar, such as grape-vine pattern, fish and water-weeds, the Eight Buddhist Emblems and lotus scrolls. But in cases of doubt we have help from the invaluable commentary on Kao Tan-jên's verses, which has already been mentioned on several occasions. The " high-flaming silver candle," etc., is a picture of a fair damsel looking at *hai-t'ang* (cydonia) blossoms by candle light. It is a pretty design, appreciated by decorators in subsequent periods, and examples of it in blue and white on K'ang Hsi bowls suggest that there were Ch'êng Hua originals in blue and white as well as in colours. The brocade-design[1] cups have medallions of flower sprays and fruit painted all round them, designs such as one has seen on old Chinese needlework. The swing design, as one would imagine, depicts the Watteauesque subject of boys and girls playing with swings. On the " Dragon-boat " cups the boat races of the Dragon festival are represented. The Famous Scholars are Chou Mao-shu, with his beloved lotus, and T'ao Yüan-ming, whose favourite flower is the chrysanthemum. The Playing Children (*wa wa*) are five small children playing together. They are sometimes so depicted under a pine tree, and this was doubtless the origin of the design so often used on the Japanese porcelain made for the Prince of Hirado. Other versions of this theme,

[1] Lit. brocade-heap.

a favourite one with both Chinese and Japanese artists, are seen on the large covered jars in blue and white or in polychrome made at the end of the Ming and in later periods. *Yü-po-lo* is a Chinese rendering of the Sanskrit *utpala*, a dark-coloured variety of lotus.

The appointment of Director of the Imperial factories at Ching-tê Chên was abolished in 1486, and the official annals are silent on the subject of porcelain manufacture until the last year of the reign of Hung Chih. This does not, of course, imply a complete cessation of the industry. On the contrary, there were certain types of porcelain then made distinguished enough to find a place in Hsiang's select Album,[1] viz. an incense burner of archaic bronze form, a gourd-shaped wine pot, a flower-shaped cup and spirit jar of bronze form. From the text descriptions we gather that the yellow glazes of the period were especially admired, and also that some of the enamelled ware vied with that of Ch'êng Hua. Yellow certainly is the predominating colour in Hsiang's examples. The incense vase is the yellow of steamed chestnuts (*chêng li*). The wine cup shaped like a *k'uei hua* (sunflower) has a sunflower yellow glaze outside and is white within, and the spirit jar (*yu*) has a yellow glaze of similar tone. The wine pot has a yellow body (*chiao hung*, or pale yellow), and the stalk and leaves of the gourd which form its handle and spout, etc., are brown and green respectively.

Yellow was a long-established ceramic colour at this date. We meet with brownish yellow lead-silicate glazes on the T'ang wares, and harder yellow glazes, too, such as were used on Ming porcelains of the *demi-grand-feu*.

There is a Ming yellow enamel used in the polychrome painting over the glaze and fired in the low heat of the muffle stove which is, as a rule, a thin colour with rather a muddy transparency. Only on exceptional pieces has it the purity of the K'ang Hsi yellow enamel. Such a yellow as this may have been used on the biscuit in pieces like Hsiang's gourd-shaped pot, where it is accompanied by green and aubergine brown.

The other pieces, one would judge, were coated with a yellow glaze rather than an enamel such as one sees on the later yellow monochromes. This, when applied direct on the biscuit, often has a darker and more brownish tone. When applied over a white glaze it is paler. Being translucent, in either case it is affected by the nature of the underlying ground. Specimens of these Ming yellow glazes are not unknown, and

[1] *Op. cit.*, Nos. 7, 42, 46 and 47.

73

an example with the Hung Chih mark in the Victoria and Albert Museum is probably an actual specimen of this reign.[1]

The yellow in this piece is a soft, rich glaze (*chiao hung*) showing signs of wear and, like the typical Ming yellow glazes, full of minute particles of yellow colour apparently held in suspension in an otherwise colourless glaze fluid. These particles are naturally thinner on the higher edges of the piece and more thickly accumulated where the glaze has pooled in the hollow parts, so that we get a graded rather than a uniform coat of colour. Near this piece is another saucer dish with blue flowers in a ground of similar yellow, also marked as of this period. It, too, has every indication of genuineness (Plate 25).

The Hung Chih mark is not a common one, and evidently the reign had not a sufficiently high reputation to tempt the potters of later periods to borrow it. It is, however, found on occasional pieces of pure white, as, for example, a saucer dish in the Franks Collection which is made of fine white ware slightly browned at the edge inside the foot-rim, and clothed in a beautiful greenish white glaze with that satiny sheen which one notices on the finer Ming wares of the early periods. White was the colour used during periods of mourning, and special attention was paid to the preparation of the fine white glazes.[2] Indeed, it would seem that on this piece the special glaze was applied to the important parts, the interior and the sides, while the ordinary glaze of relative inferiority was good enough to cover the pale blue mark on the base.

It is interesting to note that the technique of this and the yellow dish in the Victoria and Albert Museum Collection is the same. Both are of very fine porcelain, thinly potted and beautifully shaped : the foot-rims of both are identical, and the glaze on the base in both cases has the peculiar satiny sheen with a suggestion of the " chicken skin " effect noted on the Hsüan Tê red fish bowls,[3] and again on porcelain with the mark of the Chêng Tê period.[4] It is evident that the potters of this time had lost little of the skill of the classic reigns of Hsüan Tê and Ch'êng Hua.

The Pierpont Morgan Collection contained a fine example of " three colour " ware, a beautiful Kuan-yin figure with yellow, green and aubergine glazes, inscribed with a date corresponding to the year 1502.

[1] See Hobson, vol. ii., p. 28. It is certainly Ming, if we accept the incised inscription in Arabic which mentions the year corresponding to 1611. It was probably at this time in possession of some Persian grandee.

[2] See p. 23. [3] See p. 56. [4] See p. 81.

This will serve to remind us that the reign of Hung Chih had its share of the porcelains of this important class, and we have already learnt from Hsiang's Album that the enamelled porcelain of this period rivalled that of Ch'êng Hua. Neither the red wares nor the blue and white of the Hung Chih period find a mention in Chinese books; but we can assume that in these, as in other types of ware, the traditions of the preceding reigns were followed as far as circumstances permitted.

PLATE 4.

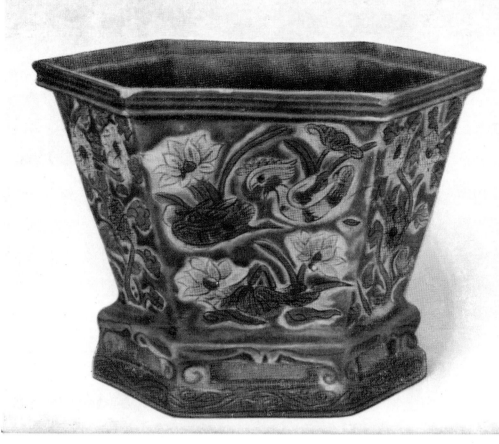

Flower pot with incised designs and
coloured glazes. Chêng Tê period.
H. 6¼ ins. (See page 82.)

J. Love Collection.

Chapter VII

CHÊNG TÊ (1506–21)

Wu Tsung, whose reign name is Chêng Tê, was a child when he succeeded to the throne, and, unfortunately for his subjects, he came under the influence of ambitious eunuchs who encouraged him to abandon himself to self-indulgence and vice while they mismanaged the affairs of State in their own interests. Bad as these conditions were for the country, they do not seem to have affected seriously the industry of Ching-tê Chên, for we learn that the Imperial factory was now reorganised. Indeed, from one account it would seem that it had to be rebuilt. But another authority gives us to understand that the various kilns distributed through Ching-tê Chên, which had been called on from time to time to supply the Imperial needs, were now given the name of *yü ch'i ch'ang*, or Imperial vase houses. Whatever the exact nature of the reconstruction was, the manufacture of Imperial porcelains was now put under the supervision of a palace eunuch.

In spite of the fact that the *Po wu yao lan* omits to mention it and the *T'ao shuo* only gives it a brief notice, this was a period of some interest in the history of Chinese porcelain if only for the reason that fresh supplies of Mohammedan blue became available. It appears that the Governor of Yunnan had received a consignment of this material from a foreign country and that it was used at first for making coloured glass in imitation of jewels. Subsequently it was found to bear the heat of the porcelain kiln, and orders were given that it should be used for porcelain decoration. The results were " antique and splendid," antique no doubt because it seemed to rival the old *su-ni-p'o* blue of the Hsüan Tê period. It was, however, of a deep colour, the choicest variety being known as *Fo t'ou ch'ing*, or blue of Buddha's head, in reference to the traditional rendering of the hair on statues of Buddha in a dark blue colour. Incidentally we are told that the workmen at the Imperial factories were in the habit of selling it to the private factories, and this abuse does not seem to have been stopped till the next reign, when a new system of weighing the material prevented any further pilfering. In these circumstances, the private factories having the use of this precious colour, it will not be

surprising to find the Mohammedan blue even on some of the wares exported to Persia and the Near East at this time.

The *T'ao shuo* informs us that the blue now employed was a mixture of the Mohammedan blue and the native cobalt, the proportion being ten of the former to one of the latter for the best colour, four to six for that of medium quality. A similar account is given of the blending of the *su-ni-p'o* blue in the Hsüan Tê period. Elsewhere we learn that, while the native cobalt (*wu ming i*) had the same appearance as the Mohammedan blue while in course of preparation, it did not, like the latter, retain its brilliancy in the great heat of the porcelain kiln.

The blue and white of the Chêng Tê period was held in high esteem according to a late sixteenth-century writer.[1] It is very rare to-day, and the few known specimens are mainly of a rather special type: This is illustrated by four pieces in the British Museum : a pair of spherical hat stands, the lower portion of a square gourd-shaped vase, a brush rest and a writing box with ink slab. All of them are decorated not only in Mohammedan blue, but with medallions of Arabic writing enclosed by cloud and lotus scrolls. This lotus-scroll design is often described by Chinese writers as *hui hui wên,* or Mohammedan scrolls, and there is little doubt that it was derived from Persian sources. It is, in fact, a type of decoration which is not uncommon on Persian pottery.

More will be said about the interesting interchange of ideas between China and Persia. But for the moment it is not necessary to infer that this little series of Chêng Tê wares was made for the Persian market. The hat stands, the pen rest shaped like a range of hills, and the ink slab are characteristically Chinese forms, and the Arabic inscriptions may merely portend that they were designed for the use of some of the many million Mohammedans in China. The inscriptions are mainly Koranic texts, but that on the cover of the ink slab is secular and one which would appeal to a Chinese literatus : " Strive for excellence in penmanship, for it is one of the keys of livelihood." All these pieces have the Chêng Tê mark, and they are worth studying as types of the Chinese porcelain made at the beginning of the sixteenth century. Though thickly built, their body material is of remarkably fine texture, white and close-grained ; and the glaze, like most of the early Ming glazes, is thick and in this case has a faint greenish tinge. The fact that in three of the pieces it has a peculiar matt and shrivelled appearance is probably explained by all three pieces having been in a conflagration at some period of their existence.

[1] Author of the *Shih wu kan chu,* published in 1591.

This is the explanation given to me by a potter of a similar phenomenon on other porcelain. The blue designs are firmly outlined and washed in with a soft Mohammedan blue. The glaze being full of bubbles has a hazy appearance which it imparts to the outlines of the brush strokes, and in some cases the blue has shown a tendency to run, as if it needed a stronger blend of the native cobalt to steady it.

It is not to be assumed that medallions with Arabic writing are peculiar to the porcelain of the Chêng Tê period. There are many specimens with this kind of decoration in the British Museum belonging to other periods, among them several cylindrical brush pots. On some of these the blue would suggest an early Ming date, on others a later period; and there are a few of Fukien porcelain ranging from the sixteenth century to the nineteenth.

There are examples of marked Chêng Tê blue and white with Arabic inscriptions in the Eumorfopoulos Collection: viz. an incense burner with melon-shaped body and a round box, both very similar in style to the British Museum pieces. Another piece in the same collection (Plate 19), a shapely ewer with handle and spout of dragon form, is assigned to the same period because of its similarity in body, glaze and style of blue painting to the marked group. It has a flat base, as has also the Louvre vase, with two dragon handles, illustrated on the same plate. These two pieces have many points of similarity; but the latter is painted in the motley blue which appears to have been originally a Hsüan Tê type, though it doubtless survived long after that brief reign.

Features of both these specimens appear on Mr. Winkworth's remarkable vase illustrated on Plate 21, the motley blue on the *ju-i* shaped pendants which decorate the shoulders, and the flowing scroll below the openwork panels. These points would seem to indicate that we have here another Chêng Tê specimen, and this is confirmed by the nature of the ware disclosed on the unglazed base. It is a fine-grained biscuit, burned reddish brown, such as one meets on a number of Chêng Tê pieces. But the most striking feature of the vase is the panel decoration of the sides—four mirror-shaped appliques in openwork of floral design (apparently a rendering of the season flowers) coloured in underglaze blue and underglaze red.

Although the openwork design in this instance takes an unusual form, it was fashioned by methods familiar in the previous century[1]; but the underglaze red has a special interest, for we hear nothing of this

[1] See p. 58.

colour in the Chinese references to the Chêng Tê period. The quality of the red, though fair, is not worthy of the encomiums lavished on that of the Hsüan Tê and Ch'êng Hua porcelains, but it shows that the copper red could still be used on a large scale. Mr. Winkworth has several other interesting examples of this underglaze red. One is a narghili-shaped bottle, with biscuit base browned like that of the large vase. It is decorated with a bold lotus design in underglaze red alone. And there are two bowls with floral designs in similar red, the decoration in one case being reserved in white in a red ground. Both of these bowls have an earthy looking biscuit and a slightly crackled glaze, and the red is rather dull in tone. Possibly they belong to the Chia Ching period. It will, however, be remembered that the interesting bowl in the Salting Collection with underglaze red fish and a somewhat crackled glaze bears the Chêng Tê mark.[1]

Another feature of Mr. Winkworth's jar is the cord-like fillets of twisted clay which border the openwork panels. This same miniature cable pattern in applied relief will be noticed on a remarkable stem cup belonging to Mr. Vernon Wethered, which is illustrated on Plate 27. It is of white porcelain with four panels of openwork casing bordered by cords in relief. In the panels are quite elaborate designs carved and built up on a small scale. In one are two fishes in wave-scrolls; in another is a boat with a human figure on board; in another are bamboos; and in the fourth is apparently a boat design which has suffered damage.

The mouth of the cup is foliate at the edge. The stem is pierced and unglazed beneath, and the body where exposed has taken a pronounced reddish tinge. The glaze is thick and white with a slight greenish cast, and the piece has every indication of an early date.

The Chêng Tê mark in Mohammedan blue appears on a square scrap bowl in the British Museum which seems to be a genuine specimen of the period. It is painted on its four sides with a design named in the list of decorations used on the Imperial porcelain of the ensuing reign, viz. full-face dragons holding the character *shou* (longevity) in their claws and surrounded by flames and cloud scrolls. The design is in underglaze blue and the ground is filled in with a clear yellow enamel. As in the preceding reign, yellow glaze or enamel appears to have been a favourite

[1] This bowl is a much debated piece. Its underglaze fish are in a red of good quality and it has all the appearance of a Ming piece, but the enamelled border is clearly no earlier than the K'ang Hsi period and is doubtless a subsequent addition.

decoration. Hsiang illustrates two specimens[1] of Chêng Tê ware, the latest pieces in his Album ; and both are coloured yellow. One is a libation cup (*chüeh*) of helmet shape copied from a bronze. It has a " rich yellow glaze like steamed chestnuts," which has faint inequalities of surface comparable to " chicken skin." The other is a lamp of complex form with saucer-shaped container furnished with a handle and supported by a phœnix standing on the back of a tortoise. This also has a yellow glaze described in the same phraseology.

On another type of Chêng Tê porcelain the yellow glaze is combined with incised decoration coloured green. We should have made acquaintance with this in the Yung Chêng list, which includes " reproductions of Chêng Tê wares with incised green decoration in a yellow ground," even if there were not an actual example in the British Museum bearing the Chêng Tê mark. The latter is a saucer dish similar in make and finish to the Hung Chih yellow dish in the Victoria and Albert Museum[2] and with the same characteristic " chicken skin " glaze of satiny sheen. Inside it is plain white, but on the sides without it is decorated with two Imperial dragons, pursuing pearls among clouds, incised in the paste and washed over with translucent green enamel in a ground of mottled, yolk-of-egg yellow, both colours applied direct to the biscuit (see Fig. 5 of Plate 59).

There are two other saucer dishes in the same collection of kindred type and bearing the same mark. In the centre inside and on the sides without are Imperial dragons incised in the paste ; but the whole surface, except the bodies of the dragons, is covered with the ordinary white glaze and the dragons are washed over with a translucent green enamel. Outlying parts of the incised design, such as the claws of the dragons and the surrounding flame scrolls, have been covered by the white glaze ; but these, too, have received a wash of the green enamel which also furnishes two plain bands to border the centre and the sides of the dish. This green, slightly iridescent with age, is the same emerald colour (*ts'ui lü*) as was used on the green and gold portions of the Chia Ching bowls described elsewhere.[3]

Doubtless this type was closely copied in the early eighteenth century. Indeed, one has met with examples bearing the Ch'ien Lung mark ; but there were obvious differences in the body, glaze and colour of the enamel, and a close study of the British Museum dishes described above and of the Hung Chih plates in the Victoria and Albert Museum will disclose

[1] *Op. cit.*, Nos. 52 and 80. [2] See p. 74. [3] See p. 91.

characteristics in the finish of the base, the shaping of the sides and the peculiar " chicken skin " glaze by which the Ming pieces can be recognised. The fact that a fair number of these dishes still survive need cause no uneasiness in the mind of the collector, who will reflect that the Imperial orders included many thousands annually.[1]

In the same group in the British Museum is a very choice saucer-dish with an intricate design of dragons in lotus scrolls finely drawn in a soft greyish blue. It bears the Chêng Tê mark and has all the technical characteristics of this group at its best. In fact, it is worthy of study as a type of the finely finished Ming such as was supplied to the Imperial Court.

A further development of this decoration with translucent, medium-fired or low-fired colours on the biscuit is illustrated by an octagonal flower-pot in the Victoria and Albert Museum.[2] It is decorated with a broad band of formal floral designs and cloud forms etched in outline and filled in with yellow, aubergine and white in a transparent green ground ; below this is a band of stiff leaves similarly executed, and on the neck is the mark of the Chêng Tê period in four characters in an oblong cartouche. Another of these pots is in the Henry Oppenheim Collection.[3] They are typical three-colour (*san ts'ai*) porcelain decorated with glazes on the biscuit, and their technique is the same in principle as that of Mr. Raphael's vase (Plate 2) and is not new to the Chêng Tê period.

Another notable example of this type is the octagonal flower-pot in the Eumorfopoulos Collection (Plate 22). It stands on cloud-scroll feet after the manner of the old Chün yao flower-pots and bulb bowls, and its incised decoration is filled in with green, yellow and fine aubergine in a beautiful turquoise ground. Inside, the glaze is plain white, and under the base a rich brownish yellow. The border pattern of obliquely overlapping petals is not commonly seen on Chinese porcelain.[4] This piece has the Chêng Tê mark in four characters. A very choice hexagonal flower-pot (Plate 4) in the Love Collection, though unmarked, is doubtless of the same period. The decoration, incised and filled in with aubergine, yellow and white in a turquoise ground, consists of flowering shrubs on two of the facets, and lotus flowers with

[1] See p. 92. [2] See Hobson, *op. cit.*, Plate 66.

[3] See *Country Life*, October 30, 1920.

[4] It appears on a covered jar in the Salting Collection, enamelled in green and red. See Hobson, *op. cit.*, Plate 80.

ducks or egrets in the others. The interior and the base are both glazed yellow.

In this class of ware, which would seem to have been a speciality of the Chêng Tê potters, we see the Ming " three colour " scheme at its best. So good is it that we have no hesitation in showing two more illustrations of it, both of them in the choice collection of M. Léon Fould in Paris. The one (Plate 23) is an elegant bottle with a splendid five-clawed dragon in white biscuit modelled in low relief, and a few cloud and flame scrolls; the background is a deep violet-blue with passages of turquoise, and there is yellow glaze inside the lip. Under the base is the Chêng Tê mark.

The other (Plate 22), a cylindrical brush-washer, is unmarked. Its delightfully drawn decoration of flowering lotus plants and crested waves, is washed in with turquoise, dark violet and white in a yellow ground, and the interior and base are coloured green. There is a drum-shaped vessel of a similar nature in the Oppenheim Collection which further illustrates this group. Unlike the others it has an unglazed base, which allows us to appreciate the quality of the early Ming biscuit. The grain is so fine that the ware is almost greasy to the touch, and its refined nature is none the less evident because it is browned by contact with the fire. Biscuit of this fine unctuous nature is characteristic of the early Ming porcelains; and if it is more rarely seen on the wares of the later reigns, the explanation is probably to be found in the exhaustion of the deposits of choice clay at Ma-ts'ang.[1] Fig. 3 of Plate 23, likewise from the Oppenheim Collection, though belonging in style rather to the " cloisonné " group, has the same quality of body and glaze and is doubtless of the Chêng Tê period.

We have seen that there was plenty of evidence of trade in Chinese porcelain in Persia and Egypt in the fifteenth century, and we may expect the amount of porcelain which found its way to Europe through these channels to have steadily increased in volume as time went on.

Europeans had reached India in the last quarter of the fifteenth century by devious ways, and in 1497–8 Vasco de Gama arrived with his ships at the Calicut. From this time onward direct trade with the East steadily expanded; more European ships arrived in the Indian Ocean and gradually worked their way eastward until Fernando Perez actually reached the coast of China in 1517.

Meanwhile Chinese merchandise had been found at the various entre-pôts on the coasts of India and in the East Indies, where silk and porcelain

[1] See p. 14.

were freely traded. Duarte Barbosa[1] gives us an interesting glimpse of a merchant's house at Reynel, the modern Rander, in India, which he visited in 1515 :—" Those who dwell here have many great and fair vessels which carry on this trade, and whosoever would have at his disposal things from Malaca and China, let him go to this place where he will find them in greater perfection than in any other place soever. The Moors who dwell here are wealthy and distinguished, fair in colour and of gentle birth. They go well attired, their women are beautiful, and they have good houses well-kept and furnished. They use in the front rooms of their houses to have many shelves all round, the whole room being surrounded by them as in a shop, all filled with fair and rich porcelain of new styles."[2] This is no doubt typical of the trade which had been carried on in this and other Indian ports for many years before Barbosa's visit and continued long after. Much of it would, of course, be entrepôt trade, the goods passing to foreign merchants and being shipped to Egypt, Persia or Europe. But naturally a large amount of the Chinese wares were absorbed by India. The ruins of Bijapur have yielded thousands of fragments, and collectors still are able to find considerable quantities of old porcelain in the country. As a rule, these Indian collections consist mainly of later wares, but many fine examples of export Ming celadons and blue and white have come to England from this source. The 1910 exhibition at the Burlington Fine Arts Club, for instance, included an interesting series, lent by Mrs. Halsey, representing various periods, one or two pieces probably going as far back as the fifteenth century ; but we shall refer again to types found in India.[3] Meanwhile we cannot refrain from repeating the oft-quoted excerpt from the Inventory of Margaret of Austria[4] made in the year 1524, which included :—

> " Ung beau grant pot de pourcelaine bleue à deux agneaux d'argent.
> Deux autres petis pots de pourcelàine.
> Six plats et escuelles et salières de pourcelayne de plusiers sortes.
> Deux aultres esguières d'une sorte de porcelayne bleue, garnies les couvercles d'argent doré.
> Ung beau gobelet de porcelayne blanche, à couvercle, painct a l'entour de personnaiges d'hommes et femmes."

[1] Hakluyt Society, Series II, vol. xliv., p. 147.
[2] Apparently this happy place was destroyed by the Portuguese in 1530.
[3] See p. 121.
[4] Laborde's *Glossaire ;* see also Marryat, *History of Porcelain*, p. 241.

There can be little doubt that the " porcelayne " was Chinese, and we can picture to ourselves the large blue vase with two silver handles ; the plates and saucer dishes ; the blue porcelain ewers (probably of Persian form like that on Plate 38) furnished with silver-gilt mounts ; and the goblet of blue and white ringed round with figure-subjects. The " salières " are intriguing ; for the salt-cellar is not a Chinese conception, and it would be surprising if European shapes were being copied by the Chinese potters as early as 1524. But perhaps they were not salt-cellars, after all, but a variety of small pot which was adapted to that purpose by their European owners. It is true that there is a hexagonal brush pot in the Salting Collection standing on four lion feet and moulded with lines strongly recalling a Tudor silver salt. But this curious and interesting piece is decorated in a blue of the Wan Li kind, and was evidently made nearly a century later than the wares in question, at a time when European intercourse with China had greatly expanded.

Another glimpse of porcelain in Europe at this time is given in Dürer's Antwerp Diary,[1] where he tells how on a certain day in 1520 he breakfasted with " the Portugaleser," who gave him a present of three " Porcolona." A year later, after a dinner with the Rentmeister Herr Lorenz Stercken, he received as presents an ivory pipe and another beautiful " Porcolona."

[1] Osborne's edition, pp. 69 and 86.

PLATE 5.

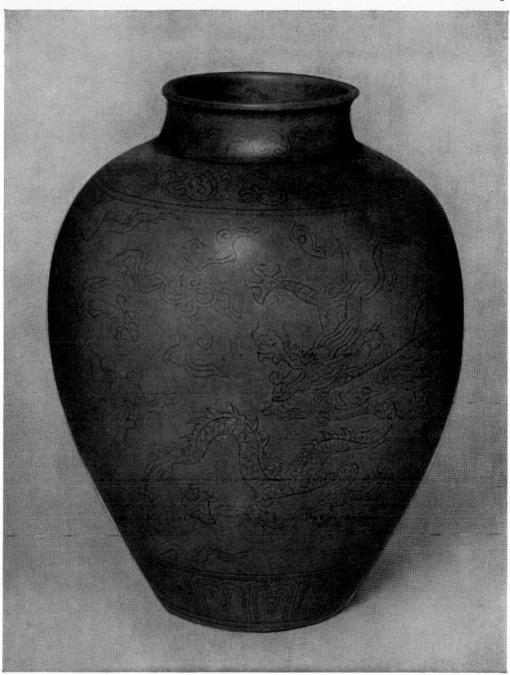

Vase with incised designs (*an hua*)
under a blue glaze: Imperial dragons
and " propitious " clouds. Chia Ching
mark incised. H. 11 ins. (See page **94.**)

CHIA CHING (1522–66)

Shih Tsung, better known among porcelain collectors by his reign name Chia Ching, occupied the dragon throne from 1522 to 1566. Unlike his predecessor, who had proclaimed himself to be the living Buddha, Shih Tsung was a zealous devotee of Taoism. The cult of longevity and the search for an elixir of life had become the chief preoccupations of the followers of this once noble doctrine; and it was in this tempting form of mysticism, with all its demoralising superstitions, that the Emperor became enmeshed. The Chinese have, as a rule, been peculiarly tolerant in religious matters, and we find Buddhism and Taoism living harmoniously together beside the State philosophy of Confucius and even extraneous creeds such as Mohammedanism. But Shih Tsung was an exception, and his Taoists, having got into power, took occasion to humiliate their Buddhist rivals. In 1536 the Buddhist temples in Peking were destroyed and the gold and silver in them were melted down. Not till he knew he was dying did the Emperor see through the deception of the Taoist dealers in immortality; and then he repented of his follies and ordered all the Taoist altars in the palace to be destroyed.

The more important historical events[1] of the reign, such as the frequent incursions of the Mongols in the north and the raids of the Japanese in the south-east, would have comparatively little influence on the ceramic output of Ching-tê Chên; but it is likely that the religious views of the Court, especially when of such a pronounced order, would be reflected in the porcelain decoration of the time.

Taoist legends, the tales of Hsi Wang Mu and the peaches of Immortality, the Eight Immortals and numerous other genii, the emblems of long life, such as the crane, deer, pine tree, *ling chih* fungus, etc., always apt to appear in porcelain decoration, would naturally commend themselves particularly at this time. Conversely, Buddhistic subjects and

[1] A minor event of the period was the introduction of tobacco from Luzon, which is said to have taken place in 1530. So that it appears that the Chinese made acquaintance with the fragrant weed a few years before ourselves; and we gather that their appreciation of it was so great that the last Ming Emperor felt it his duty to forbid its use.

emblems would be out of fashion. But there will be much to say about the decorative motives of the Chia Ching wares further on, and we must first collect what information there is about the general history of the manufacture.

As we approach the end of the Ming dynasty our information about the Imperial porcelain becomes fuller. Chia Ching wares are described in the *T'ao shuo*, which quotes from the *Po wu yao lan*, published 1621-7, and the *Shih wu kan chu*, published in 1591. In addition to these, the annual accounts of the porcelain made for the palace are recorded in the Annals of Fou-liang from the eighth year of the reign. These lists form an invaluable catalogue, and two of them can be studied in Bushell's *Oriental Ceramic Art*[1] and in a summarised form in the *T'ao shuo*.

The eunuch in charge of the Imperial factory was now replaced by one of the sub-prefects of the district, who acted in rotation as director of the works. In the year 1565 the sub-prefect was ordered to take up his residence at the factory. With regard to the output at this time the *Po wu yao lan* tells us that it included blue and white and coloured (*wu ts'ai*) wares of every kind. It goes on to specify certain small white cups (*ou*) inscribed inside with the characters *ch'a* (tea), or *chiu* (wine) or *ts'ao t'ang* (decoction of dates) or *chiang t'ang* (decoction of ginger), which were among the ritual altar vessels used by the Emperor. These, it adds, were called white altar cups, though they were not up to the standard of the same type of vessel made in the Hsüan Tê period. Other objects singled out for special mention were the shallow wine cups[2] decorated in " three colours " with fishes, and the small vermilion boxes the size of a copper cash. These are the gems of the period. And as for the tiny boxes beautifully painted with blue designs, it is doubted if even the Imperial factories in later times would be able to make the like.

A good reason why the altar cups fell short of the perfection of the Hsüan Tê cups is given in the statement that the Jaochow earth was

[1] pp. 191-4.

[2] Three qualifying expressions in the descriptions of these cups are tantalisingly obscure. They have gong-shaped mouth (*ch'ing k'ou*), loaf-shaped bottom (*man hsin*) and foot with rim (*yüan tsu*). The first may indicate a mouth-rim sharply turned over and giving the outline of "a sounding stone "; the second clearly describes a convex interior, a shape with which we are acquainted; but the third, which is variously rendered " foot with base-rim," or " round foot," does not suggest any marked characteristic. At a guess one would say these bowls were of the shape of one in the British Museum, shallow with everted rim, convex centre and base-rim non-existent. See Plate 6. For Chinese characters, see p. 195.

gradually deteriorating, so that neither the blue and white nor the polychrome (nor presumably the pure white) porcelains could compare with those of the earlier reigns. The *T'ao shuo* adds to this that the supply of earth from Ma-ts'ang was becoming exhausted. The Ma-ts'ang earth had been regarded as the best body material; but it must be added that another authority[1] makes the same statement about the conditions prevailing in the eleventh year of Wan Li.

Another point of inferiority as compared with the earlier reigns was in the red decoration. The *Shih wu kan chu* tells us that " earth for the *hsien hung* " was exhausted; so that, instead of the brilliant underglaze red, the *hsien hung* and *pao shih hung* of the classic reigns,[2] the potters had to fall back on the overglaze red derived from iron (*fan hung*), " which was the only red that was now successfully fired." On this point the *I chih* gives us further details :—" In the 26th year of Chia Ching the Emperor demanded that vessels should be made with *hsien hung* (fresh red) decoration. They were difficult to make successfully, and Hsü-chên, of the Imperial censorate, memorialised the Throne requesting that *fan hung* be used instead."

It would be interesting to know exactly the meaning of " the earth for the fresh red " (*hsien hung t'u*), the failure of which was the root of the trouble. It is scarcely credible that it can refer to the oxide of copper which was the mineral used primarily to produce the underglaze red colour; and it seems far more likely that it refers to some ferruginous clay, which was found by experience, when mixed with the ware, to assist the development of the red colour.[3] With their empirical methods the Chinese would feel acutely the sudden loss of a supply of this earth, and it might be long before they lit on another material which acted as well.

And so it was a piece of marvellous good luck, to quote the sense of the *T'ao shuo*, that just at the moment when the *hsien hung* had to be given up, a supply of Mohammedan blue should have become available. The *Shih wu kan chu* tells us that this colour was much used in the reign of Chia Ching; and the *T'ao shuo* adds a note that a dark tone of blue

[1] The *I chih*, quoted in the *T'ao lu*. See p. 112.
[2] See p. 53. On the other hand, there is a remarkable vase in the Victoria and Albert Museum, of tall beaker-shape with dragon handles, decorated with a lily scroll and *pa kua* emblems in a dark Chia Ching blue and a band of stiff leaves in deep underglaze red. It is certainly a Ming vase and appears to belong to this reign. There is a somewhat similar vase in the Louvre. [3] See p. 54.

was preferred, in contrast with the pale tint which was in vogue in the Hsüan Tê period.

Hsiang Yüan-p'ien was apparently alive in the Chia Ching period, but he evidently regarded the contemporary porcelain as too modern for inclusion in his Album. Fortunately, however, there are a good many surviving specimens of the porcelain of this time, and we can collect a sufficiently large study series to feel that we have quite a good idea of its character. The dark-toned Mohammedan blue, for instance, which has been compared with violet ink, is well illustrated on a fine vase[1] in the Victoria and Albert Museum with bold design of Imperial dragons and borders of lotus scrolls. A smaller and more delicate example of the same colour is seen in the British Museum in an octagonal stand,[2] like a cruet, with scenes from the life of Confucius on the sides, and lions on the top. Both have the Chia Ching mark. In the latter piece, at any rate, there is no sign of the deterioration of the body material, which is beautifully white and fine of grain.

The famous white altar cups are, as far as one knows, not yet represented in our collections; though there is a small white bowl in the Victoria and Albert Museum with European mount which probably belongs to this period. It is not, however, a pure monochrome, for it has a small medallion inside painted in blue with a horse on waves. As for the shallow wine cups, one may assume that they were, like the little cups with blue and white design or polychrome of which examples exist in several collections, miniature editions of the shallow bowl illustrated on Plate 6, with rounded sides, slightly convex centre and correspondingly hollow base without foot-rim.

Inside this attractive piece there is a band of emerald green enamel with gilt lotus designs, and in the centre a stork and cloud design in dark Chia Ching blue. Outside are two peach boughs and birds in blue; and the mark is *Ch'ang ming fu kuei* (" Long life, riches and honours "), which occurs on many pieces of this period. The green enamel on the sides is probably the *ts'ui lü* mentioned in the *T'ao shuo's* list[3] of the palace porcelains of the time, and it occurs on two other pieces in the British Museum, rounded bowls, one of which has an Elizabethan mount.[4]

[1] Hobson, vol. ii., Plate 72. A reference to the importation of Mohammedan blue occurs in the accounts given by Galeotto Perera of his experiences in China about 1550 : " Certain Tartars and Mogorites that brought into China certaine Blewes of great value." See *Purchas His Pilgrims*, Hakluyt, vol. xi., p. 591. [2] Hobson, vol. ii., Plate 77.
[3] Bushell's translation, p. 150. [4] Figured in Dillon, Plate 5.

These two and certain other bowls in the same collection form an interesting group when considered together. They have a general similarity of form (Plate 6) with rounded sides, and bottom as a rule[1] slightly convex inside, which, of course, implies concavity underneath. This seems to be the *man t'i*, or loaf centre of Chinese writers. Their decoration presents considerable variety. The most usual type has an iron-red glaze outside with lotus scrolls in leaf-gilding,[2] while inside is blue and white ornament consisting as a rule of a central design, perhaps a figure, with or without a border of cross-hatched diaper.

The red on the exterior varies in colour and texture. Sometimes it is a light and translucent tomato-red with considerable gloss and looking like a red glaze. Sometimes it is a dark brick-red less highly fluxed and more opaque ; but in nearly every case it shows brush lines, as if it had been applied with a brush while the bowl was turning on the wheel or lathe. This red is the *fan hung*, an on-glaze enamel derived from iron, which, we are told, replaced the old underglaze copper red during this period. It is the red used in enamel painting in " five colours " on the glaze, and its variations are largely due to the strength or weakness of the fluxing material.

On Ming porcelain it is always more or less heavily fluxed, more so when used as a glaze as on the bowls in question, less so when used as an enamel in company with green, yellow and aubergine. But even in the latter case there is so much flux that it usually becomes iridescent with age. As used on the K'ang Hsi and later porcelains it is a thin and relatively dry pigment, usually of a coral tint, something quite distinct from the glossy, iridescent red of tomato or dark brick colour which characterises the Ming wares.

To return to our bowls, another and a rarer variety, already mentioned, has a translucent emerald green (*ts'ui lü*) enamel in place of the red outside. The interior decoration is similar. Another kind, of which the Dresden Collection includes a few specimens, has a pale sky blue exterior, doubtless the *t'ien ch'ing wan* (sky blue bowls) of the Imperial lists.

A fourth kind must be included from its similarity of form and mark. It is represented by one specimen in the British Museum—a white

[1] The reverse form with base slightly convex also occurs on bowls of this kind with red glaze (see Hobson, vol. ii., Plate 74) ; but this is probably an earlier type. See p. 42.

[2] The gilding of this period is not always leaf-gilding. Gilt traceries painted on with a brush are also to be seen on Ming porcelain.

bowl with white slip traceries under the glaze inside, one form of the *an hua*, or secret decoration, which is named in the Imperial lists. Outside it has three medallions in turquoise blue enamel edged with red, on which cabochon[1] jewels have been set, probably when the bowl was in Indian or Persian hands, and there are traces of gilding on the turquoise blue band round the foot-rim. Two of these classes at least, the red and the green, must have reached Europe in the sixteenth century, for there are known examples with Elizabethan silver mounts.[2] Needless to say, like so much late Ming porcelain they were closely imitated by the Japanese, and one has only to look among the Imari porcelain in the British Museum to see the main features of these bowls carefully reproduced, just as one sees the red ground and gilt designs on the Kyoto porcelain made by Eiraku and others in the early years of the nineteenth century.

Another variety of this type of red porcelain is seen on Plate 27, a stem cup with hollow shank decorated outside with dark opaque-red with gilt lotus scrolls. The gilding, as is so often the case, has worn away with age and is barely perceptible in the reproduction.

The lists of the palace supply for the years 1546 and 1554, to which reference has already been made, give by far the most vivid account of the Chia Ching porcelain obtainable from Chinese sources.

We learn from them not only the quantity and the various types of vessels supplied, but also the decorations used, both colour and design.

The requirements of the Emperor in the year 1554 included 26,350 bowls with dragons in blue, 30,500 plates, 6900 wine cups, 680 large fish bowls, 9000 tea cups, 10,200 bowls and 19,800 tea cups of another pattern, 600 libation cups and 6000 ewers or wine pots.

The actual articles supplied are listed under general headings, such as fish bowls, covered and uncovered jars, bowls of various sizes, dishes and cups for tea and wine, vases, ewers, etc. Much is left to the imagination as to form, though in one case we are told that some of the jars (*kuan*) were octagonal, and again that the libation cups (usually a helmet-shaped, three-legged vessel of archaic bronze form) had hill-shaped saucers to support their three legs. Among the ritual vessels there were eighty tazza-shaped bowls for offerings of bread, fruit, etc.; six large wine jars (*t'ai tsun*) with swelling body and handles in the form of monster heads;

[1] In the will of Lady Kathleen Constable (†1591) is the item : " my purslane cup sett with stones, which will holde noe poison."

[2] *Country Life*, October 30, 1920.

six jars in the form of a rhinoceros (*hsi*) carrying a vase on its back—all shapes which we have met in later porcelains.

Services for the table, with uniform patterns and colours, were a novelty of the Ming period, but in the time of Chia Ching they were evidently indispensable, for the 1544 list includes no less than 1340 of these sets (*cho ch'i*), which comprised twenty-seven pieces,[1] five fruit dishes, five food dishes, five bowls, five vegetable dishes, three tea cups, one wine cup, one wine saucer, one slop bowl and one vinegar cruet.

The list as quoted in the *T'ao shuo* classifies the different kinds of ware as :—

(1) Blue and white (*ch'ing hua pai ti*).

(2) Blue ware (*ch'ing tz'ŭ*), which comprised sky blue, turquoise blue (*ts'ui ch'ing*),[2] best quality blue (*t'ou ch'ing*), doubtless the *Fo t'ou ch'ing* mentioned on p. 89. The blue grounds are decorated with various designs, probably for the most part etched in the paste (*an hua*), as on Plates 5 and 41 ; but in one case a more elaborate technique is indicated, viz. dishes with pure blue ground and dragons in sea waves inside, and outside three gilt lions or dragons on a ground of close cloud scrolls.

(3) The third category consists of bowls and cups, white inside and blue outside. The Dresden Collection bowls[3] would answer to this description, and I have seen a fragment of a similar article which was found in the waste heaps of old Cairo.

(4) White porcelain comes next. It is either pure white (*t'ien pai*) or with designs engraved with a point or traced in white slip under the glaze. Both these decorations are described as *an hua*, or secret decoration.

(5) Next come the brown[4] glazes in two varieties, the *tzŭ chin* (lustrous dead-leaf brown) and *chin huang* (golden brown), in every case decorated with engraved designs under the glaze.

(6) The sixth is an interesting group under the heading "mixed colours." It includes bowls and dishes with iron-red (*fan hung*) instead of the old *hsien hung* ; bowls and saucer dishes with emerald green (*ts'ui lü*) ; bowls with designs in yellow in a blue ground[5] ; cups with blue dragons in a yellow ground ; boxes with dragon and phœnix engraved

[1] See p. 21. [2] See p. 195.
[3] See p. 91.
[4] *Tzŭ* (see p. 195) is purple or dark red-brown ; and the phrase *tzŭ chin* is rendered "red gold" (Giles). Bushell is doubtless right in identifying this colour with the well-known lustrous brown, though by itself *tzŭ* would be rather "aubergine."
[5] *Ch'ing ti shan huang* (see p. 195), lit. blue ground "shot with yellow."

under a yellow glaze[1] ; dishes with yellow designs in a lustrous brown ground ; and globular bowls with " embossed " ornament in a pure white ground.[2]

We do not experience any difficulty in visualising these types, and indeed it would be possible to illustrate most of them from existing specimens. The blue and white is abundantly represented in our collections. There are glazes in several shades of blue—the sky blue of the Dresden bowls ; the deeper, softer blue glazes which are perhaps the *t'ou ch'ing* of the list, such as those of Mr. Oppenheim's vase (Plate 5), the large dish in the Victoria and Albert Museum and a jar in the Winkworth Collection, all of which have engraved designs *an hua* ; and a dark but brilliant mottled blue, which looks almost like an overglaze enamel, on a small bowl in the Oppenheim Collection. The *ts'ui ch'ing*, or turquoise, is the beautiful monochrome seen on a lovely vase[3] in the Eumorfopoulos Collection, and, in an exquisite pale shade, on M. Sauphar's vase (Plate 41), both of which have, again, engraved designs.

The gilt lions and dragons with cloud-scroll patterns in a blue ground are perhaps not so easy to identify, unless we regard the description as applying to such wares as Fig. 1 of Plate 23, with blue ground and designs of dragons, etc., in white biscuit which was originally gilt. Nor can we lay our hands on a specimen of lustrous brown or golden brown with a Chia Ching mark ; but the type of ware is familiar enough from later examples, and there is a bowl in the British Museum with engraved dragons under a lustrous brown glaze which bears the Ch'êng Hua mark.

Of the mixed colours one can find good representatives of nearly every type mentioned and even go beyond the list into the bargain. The red and green bowls have already been dealt with. Mr. Oppenheim has a beautiful marked specimen of blue designs in a yellow ground—a square bowl with dragons and fungus scrolls outside and the character *shou* (longevity) and yellow sides within (Plate 27) ; while Fig. 1 of Plate 29 is a libation cup (unfortunately without a hill-shaped stand)[4] with a similar combination of colours in the Eumorfopoulos Collection. The latter

[1] *Huang hua an lung fêng hua ho* (see p. 195) might also apply to dragon and phœnix designs engraved and coloured yellow (in a white ground).

[2] *Su jang hua po* (see p. 195). *Su*, which means plain or plain white, is also used of single colours ; and *jang*, lit. luxuriant or abundant, has been rendered " embossed " by Bushell. It is an obscure phrase which might refer to bowls (*po*) with figures in relief (cf. Plate 34), or with ornamental traceries in white slip on a white ground.

[3] Cat. B.F.A., Plate LVI. [4] See p. 92.

collection includes a square dish with sloping sides decorated with pine, bamboo, plum and fungus in blue in a yellow ground. The blue in all three cases is, of course, under the glaze, and the yellow over the glaze; but the base of this dish is washed over with yellow enamel on the biscuit, so that we have here the two applications of the yellow on one piece.

Yellow boxes with engraved dragon and phœnix designs are familiar from later specimens; but the dishes with yellow designs in a lustrous brown ground are a type which has not yet appeared. On the other hand, we can add combinations of (a) iron red over a yellow glaze, as on the little square bowl (Plate 27), on a beautiful jar with dragon designs in the Cologne Museum,[1] on two jars in the Love Collection, etc. (b) Red ground and green designs, e.g. saucers with lions in green reserved in a lustrous iron red ground in the British Museum and elsewhere; a similar saucer with phœnixes in the Love Collection. (c) Conversely, green ground and red designs reserved, as on a double gourd with lotus scrolls in the Grandidier Collection, and on another in the Bloxam Collection in the Victoria and Albert Museum. The same colour scheme is used on the fine piece (Plate 29), which is, however, unmarked. It is a basin with shaped rim of characteristic Ming form; a red and green dragon design inside and out, and red on white border on rim: the base is unglazed. (d) Another vase in the Grandidier Collection has an underglaze blue lotus design with touches of red in a green ground; a double gourd in the same series has blue and red scrolls in a yellow ground. (e) The combination of turquoise blue with aubergine violet is so frequent on later porcelains that it is quite familiar; but there is an unusually fine example of it in a box with engraved designs of Imperial dragons[1] in the Victoria and Albert Museum, which bears the Chia Ching mark.

Though by no means common, good examples of the dark Chia Ching blue are to be found in many collections. Mr. S. Winkworth has a large jar painted with the familiar subject of wa wa (children playing in a garden), which is a superb example of the colour. Plate 24 in the Oppenheim Collection illustrates a favourite Ming form and excellent drawing as well as the blue of the period. It is a double-gourd vase decorated with designs symbolical of Long Life—the deer and stork, the peach and pine, and finally, on the neck, the character shou (longevity) itself. Plate 26 represents a fine fish bowl in the Love Collection with Imperial dragons and lotus scrolls in characteristic blue. It is a striking piece with its monumental size, simplicity of line and big, bold design in strong blue.

[1] See Hobson, op. cit., Plate 70.

95

A glimpse of the colour itself is given in the interior of the shallow bowl on Plate 6.

To build up in porcelain and fire successfully the large fish bowls was one of the most difficult problems which the Imperial potters had to face. Some details of their special requirements are given in another chapter[1]; but it is evident that, owing to the demand for increasingly large sizes, they became a perfect bugbear to the potters towards the end of the Ming period. Protests were lodged against them from time to time[2]; and the *T'ao shuo* tells us how the potters in the Wan Li period were driven to despair after the large dragon fish bowls had failed in the baking year after year, and how one of them named T'ung cast himself into the kiln fire. As a result of this sacrifice the bowls came out perfect, and T'ung was eventually deified as the " Genius of Fire and Blast."

T'ang Ying, director of the factory in the early part of the eighteenth century, tells us further how he found one of the spoilt bowls which had driven T'ung to despair, a fish bowl painted in blue with " a fierce frieze of dragons " and a wave pattern below. Its size is given as three feet in diameter and two feet high. This must have been near the practical limit of size, for when an order was given in the early years of the succeeding dynasty for bowls two and a half feet high, three and a half feet in diameter, three inches thick at the sides and five inches at the bottom, the potters wrestled with it for four years without success, and eventually the Emperor was persuaded to withdraw the command.

The shapes of the fish bowls are not always so simple as that of Plate 26. Often the sides are curved like those of the ordinary bowl, with projecting rim; or, again, the piece is of globular form like a fine bowl in the British Museum, decorated in blue and underglaze red with water-weeds and finely drawn fishes which seem to live and move.

Other examples of Chia Ching blue and white are seen in the two boxes on Plate 25. One, of rounded form, is painted with phœnixes in lotus scrolls, a design appropriate to wares intended for use by the Empress. It bears the mark of the period. The other is square and well painted with a figure-subject on the cover in typical Ming style, and in place of a mark it has the characters *yü mên* (the gate of Yü) under the base. In both these pieces the blue, though good in tone, is not intensely deep, and it is clear that there was as much variety in the shades of blue used in the Chia Ching as in other periods. Indeed, in the case of the

[1] See p. 17. [2] See p. 112.

more ordinary export wares—some of which are shown by contemporary mounts to belong to this time—the blue is not distinguishable from that used in the reign of Wan Li.

Some idea of the extent of the export trade in porcelain in the Chia Ching period can be gathered from a passage[1] written in 1563 on the traffic between China and Malacca which speaks of " an infinite quantitie of Porcellane made in vessels of diverse sortes." The same writer speaks also of overland trade by way of Persia—" because every yeare there goeth a great Carovan from Persia to China, which is in going thither sixe moneth."

[1] Hakluyt, Everyman's Library, vol. iii., p. 233.

PLATE 6.

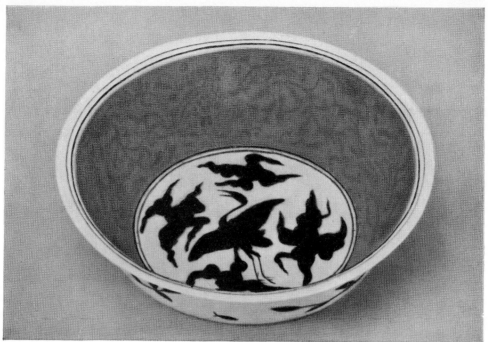

Franks Collection (British Museum).

Fig. 1. Shallow bowl decorated in Moham-
medan blue outside and in the bottom
inside: green enamel borders with
lotus scrolls in leaf gold. Chia Ching
period. D. 4¾ ins. (See page 90.)

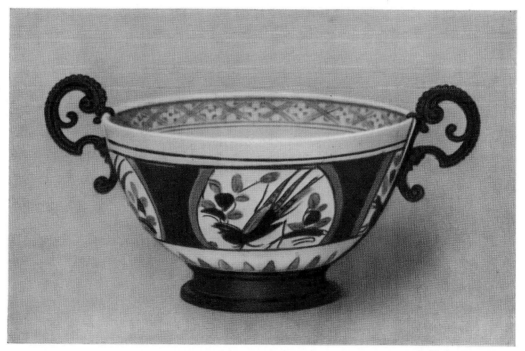

R. W. Brandt Collection.

Fig. 2. Bowl with enamelled ornament outside:
and blue designs, lotus medallion and
egret, etc., inside. Sixteenth-century
Augsburg mount. Chia Ching period.
D. 4 ins. (See page 100.)

CHIA CHING (*continued*) AND LUNG CH'ING (1567-72)

CHIA CHING—*continued*

The heading *Wu ts'ai* does not appear in the two published lists of Imperial Chia Ching porcelains, but perhaps the term "mixed colours" was considered comprehensive enough to include all the polychromes of the period. Certain it is that the various types of ware made in the preceding reigns, such as those with cloisonné and graffiato designs, filled in with medium-fired coloured glazes, continued in use.

There is, for instance, reason to suppose that the exquisite incense burner illustrated on Plate 28 (Fig. 1) confirms this latter statement, if the close analogy of form with that of the dated piece on the same Plate proves anything. In any case, it must belong to the first half of the sixteenth century. It is remarkable for the charming panels of openwork on the sides (the one with a stork and clouds coloured pale yellow, turquoise and white, and the other with a kylin), no less than for the lovely turquoise ground. The glaze inside is yellow, and on the handles turquoise and white.

The Chêng Tê style of decoration, in transparent coloured glazes over designs engraved in the biscuit, equally survived. Witness the beautiful saucer dish in the David Collection with etched design coloured green in a yellow ground (Plate 39). The design here is worthy of note. A peach tree, itself an emblem of longevity, is represented with its branches ingeniously twisted into the shape of the character *shou* (long life). The same idea is expressed in blue and white on a vase in the Bloxam Collection in the Victoria and Albert Museum.

There is, again, another very beautiful series decorated with low-fired, coloured enamels over designs outlined in brown, which usually bears the Chia Ching mark. This series consists chiefly of bowls with yellow, green or aubergine grounds in which are reserved designs filled in with the complementary colours of the group, aided by a greenish white. It is, in fact, the colour-scheme of the K'ang Hsi porcelain with enamels on the biscuit; but in some of the marked Chia Ching bowls it covers an ordinary white glaze which emerges under the base.

A choice example of this group in the David Collection is illustrated on Plate 7. The design on the outside, figures of Buddhist Lohan, is unusual; for the majority of these bowls are decorated, like the inside of Mr. David's, with bunches or clusters of season flowers. Other and rarer motives are a flight of storks[1] (British Museum Collection), phœnixes and peony scrolls[2] (Oppenheim Collection) and lions (Eumorfopoulos Collection). A striking example of this group is the jar with lion-mask handles in the Grandidier Collection in the Louvre.[3] It is painted with lions in peony scrolls, green and white in a yellow ground. In addition there are patterns in underglaze blue, the presence of which shows that in this specimen, at any rate, the coloured decoration is applied over a glaze.

A variation of the ground colouring is seen on two bowls in the Salting Collection which have floral sprays on a mosaic pattern. Like all the choice Ming types, this one was freely reproduced in later reigns, especially in that of Yung Chêng in the succeeding dynasty.

Of the more usual types of painted polychrome with enamelled designs on a white ground, that distinctively Ming group, the " red and green " family, was certainly made in the Chia Ching period. Red and green are the dominating colours in this group, but they are supported by a brownish yellow and a turquoise green which plays the part of the later blue enamel. We find this colour scheme on bowls of typical Chia Ching form and material, such as the double-bottomed hot-water bowl in the British Museum with gilt-red medallions outside and an enamelled figure-subject within and the mark *Ch'ang ming fu kuei*[4] under the base.

A delightful little bowl in the R. F. W. Brandt Collection (Plate 6, Fig. 2) shows some of the characteristic colours, particularly the iron red and the turquoise green. This last enamel, which is so important for the identification of the Ming *wu ts'ai*, was rarely used except in small quantities, and consequently is difficult to illustrate. It appears in little patches on the bird design in the panels of this bowl, in company with red and touches of the turbid Ming yellow, and again on the stiff leaves of the border.

The Brandt bowl has the convex bottom so often noticed on bowls of this period; and inside there is a blue decoration, consisting of a

[1] See Hobson, *op. cit.*, Plate 71. [2] *Ibid.*, Plate 73.

[3] Illustrated by M. J. J. Marquet de Vasselot and Mlle. Ballot, *Ceramique Chinoise*, Plate 30. [4] See p. 194.

trellis border, which is also a feature of the red bowls,[1] and a medallion with a lotus design and an egret. The egret is charmingly drawn with white body which seems to be reserved in the blue background formed by the lotus. An Augsburg mount of the sixteenth century adds historic importance to this piece, showing that it is one of those interesting specimens which came to Europe in the early days of our Far Eastern trade.

A square box in the Eumorfopoulos Collection (Plate 29) provides another excellent example of the red and green colour scheme. On the cover are well-painted figure-subjects, and on the sides striking lotus designs in white reserved in red, and in red and white in a green ground. Inside the box is a kylin and in the lid is an owner's mark in red, while under the base is the inscription in blue, *Chuan hsia pien yung*[2] (" Seal box for use as required ").

A stem cup, of similar form and similar ware to Fig. 2 of Plate 27, in the Oppenheim Collection, is beautifully painted in red, green and yellow with four groups of the Eight Immortals and finely finished border designs ; and a magnificent example, in which red and green (with a very little yellow) form the complete palette, is the large covered potiche in the Salting Collection, with its well-painted figure-subjects and rich border patterns.[3]

The Chia Ching mark on a specimen in the Bloxam Collection is one proof that this colour scheme was used at this time, and more conclusive still is the incense burner illustrated on Plate 28 (Fig. 2). Though somewhat coarsely decorated, this piece deserves attention for the document that it is. The form, obviously taken from a bronze, is one frequently used by the Ming potters. The ware, seen on the unglazed base, is slightly browned in the firing, and the glaze, which has the usual Ming virtues and defects, is thick and pin-holed in places. The design of dragons disputing pearls is painted on the glaze in dark green, red and yellow, and the handles are covered with a thick, dark cucumber green apparently applied direct to the biscuit. Round the neck is an inscription in red which announces that this incense burner was respectfully offered by Ching-wu in the *chia tzŭ* year of Chia Ching (1564) as a gift to the temple of the Supreme Lord of the Dark Heaven, in the hope that He would give protection to his household and peace and tranquillity to his home.

[1] See p. 91. [2] See p. 195.
[3] Figured Hobson, *op. cit.*, Plate 80.

The colour scheme, in which underglaze blue combines with the overglaze enamels, though not yet employed to the same extent as in the Wan Li period, had been in use for fully a century. It is seen on Plate 26 on a handsome jar in the collection of the Comtesse de Beauchamp, with a design of fish and water plants. The plants are in dark Chia Ching blue with green leaves; the fish are in a dark yellow, and details in red give this jar a very distinctive appearance. Others of a similar kind in the Louvre have rounded covers, and there are examples in the Eumorfopoulos, Oppenheim and other collections. A jar in the Bloxam Collection, in the Loan Court of the Victoria and Albert Museum, has the same design with its characteristic drawing in underglaze blue alone.

Ornament in white slip on a blue ground and in white biscuit reliefs is discussed at some length in another chapter,[1] but there is a type of decoration frequently associated with the Chia Ching mark which partakes of the nature of both of these. It has already been incidentally mentioned in reference to gilt design in blue ground,[2] and an illustration from the Oppenheim Collection is now given on Plate 23. It is one of a pair of vases from an altar set with Imperial dragon designs in a dry, white slip slightly relieved from a ground of deep blue glaze. This white ornament has been finished with an engraving tool, and a few remaining traces show that it was once covered with gilt over a red medium. The Chia Ching mark is seen on the lip. A very large incense burner of similar make was exhibited in the Cernuschi Museum in Paris in the spring of 1921, and there is a complete altar set of five pieces—incense burner, two vases and two pricket candlesticks—in the Grandidier Collection in the Louvre. A pair of vases similar to Mr. Oppenheim's were lent by Mrs. Bloxam to the Burlington Fine Arts Club Exhibition in 1910.

Something has already been said about Chia Ching monochromes in discussing the several kinds of blue mentioned in the Imperial lists. It may be fairly assumed that all the glazes and most of the enamels employed in the *wu ts'ai* and " mixed colour " groups were used separately as monochromes at one time or another. There are known examples of most of them in Ming porcelain, but many of them are undated and difficult to assign to any particular period. But it will be worth while to recall certain examples of monochromes with the Chia Ching mark.

There are the beautiful blue glazes on the Oppenheim vase (Plate 5) and on kindred pieces, such as the dish in the Victoria and Albert Museum and the jar in the Winkworth Collection. On a small bowl in the

[1] See pp. 137.　　　　　　　　[2] See p. 94.

Oppenheim Collection we find a deeper variety of this blue approaching lapis lazuli in colour and with a curious mottled texture which suggests the undulating surface of orange-peel. A small square jar in the Bloxam Collection has white glaze which verges on pale celadon in tone, and there is little doubt that celadon glazes were used at this time at Ching-tê Chên. Of the medium-fired three-colour glazes, a bowl in the British Museum represents the transparent aubergine brown, and another the yellow of darker shade, while the lighter yellow appears on a wide-mouthed vase in the Oppenheim Collection.

As for the Chia Ching designs, quite a catalogue of them is given in the palace lists of the period, as summarised in the *T'ao shuo* and elsewhere. Indeed, so many varieties are mentioned that one hesitates to quote them at length for fear of confusing the reader. Many of them are familiar to us from the wares of other periods, for they became firmly established at the factories, where no doubt the patterns were carefully preserved and handed on from generation to generation. Anyone who has attempted to catalogue his own or any other collection will know how important it is and often how difficult to find a correct description of the Chinese ornamental designs, and what a difference it makes when one can discover the meaning which these strange compositions always conceal. In wrestling with these difficulties we shall find the palace lists, terse as they are, an invaluable aid.

In these the blue and white group furnishes the greatest variety of designs, and among them those with dragons are the most numerous. The dragon is the Imperial emblem, and he appears in all manner of forms—in pairs pursuing a jewel (*kan chu*), which may have in the remote past symbolised the sun; grasping jewels (*k'ung chu*); in clouds and flames; in medallions surrounded by bamboo leaves and *ling chih* fungus; among water chestnuts (*ling*) or lotus scrolls; issuing from the waves and holding up the Eight Trigrams; ascending and descending in clouds; holding the characters *shou* (long life) or *fu* (happiness) in its claws; in company with lions or phœnixes. On the porcelain destined for the Emperor's use the dragon is represented with five claws.

Another variety of dragon is the *ch'ih lung*, or archaic, lizard-like dragon with divided tail which sometimes ends in conventional scrolls like foliage. This is the archaic form of dragon which is found on ancient jade and bronzes, ante-dating by many centuries the fierce, scowling five-clawed creature which was first popularised by the paintings of Chang Sêng-yu in the early part of the sixth century.

THE WARES OF THE MING DYNASTY

Next in importance to the dragon is the phœnix (*fêng*), emblem of the Empress, a mythical bird with " head of a pheasant, beak of a swallow, long neck, many-coloured plumage, flowing tail between that of an argus pheasant and a peacock, and long claws turned backward as it flies." It is depicted flying through clouds or through flowers ; with other birds who pay court to it ; in pairs, male and female (*fêng huang*) ; or coiled in medallions.

The lion, too, is often represented. He is shown in the conventional form of the lion dog (*shih tzŭ kou*), and has many of the features of the Pekinese spaniel. He is the guardian of Buddhist temples and rolls a ball of brocade, which once represented the jewel of the Law, under his fore paw[1] or pursues it as it rolls. Sometimes he is speeding at full stretch, a flying lion (*fei shih*) ; or, again, he is described as *ts'ang*, which means hoary and perhaps indicates an archaistic rendering of the beast.

Another animal motive was three rams, which symbolise the return of spring.

Birds include the crane, which is generally depicted flying among clouds, and peacocks (*k'ung ch'iao*) among peonies.

Fish are a frequent motive ; and four of them are particularly specified, viz. the carp (*li*), the perch (*kuei*), the *ch'ing*, which may be a mackerel or a fresh-water fish with marbled appearance, and another kind of carp named *p'o*, which is identified with the Japanese *mi koi*.

Floral motives are very numerous. They include the four season flowers—tree peony for spring, lotus for summer, chrysanthemum for autumn and prunus for winter ; the combination of pine, bamboo and prunus ; the wistaria (*t'êng*), etc. But the commonest floral designs are conventional scrolls of lotus, Indian lotus, water chestnut ; or, again, of " fairy flowers " (*pao hsiang hua*), celestial flowers (*t'ien hua*) and Mohammedan flowers (*hui hui hua*), in which we recognise the floral scroll of Persian pottery. In many cases these floral scrolls support emblems and auspicious phrases, such as *fu shou k'ang ning*[2] (happiness, longevity, peace and tranquility), *shou shan fu hai*[2] (longevity of the hills, happiness as great as ocean), or the character *shou* (longevity) in its various forms.

Nature is represented by mountains, landscapes, etc., the waterfalls in Szechwan (*Pa*[3] *shan chu shui*) being specifically named. A more formal

[1] Mendez Pinto, describing what he saw in Peking in 1542, notices the lions on certain gates and mistakes them for heraldic creations :—" thereon Lions set on balls, which are the Armes of the Kings of China." Purchas, Hakluyt series, vol. xii., p. 97.

[2] See p. 195. [3] *Pa* (see p. 195) is an ancient name for the province of Szechwan.

design represents water by a series of curling waves, sometimes punctuated by conical rocks.[1]

Among the human motives named are children (*wa wa*) at play, children in the *Pao-lao* revels wearing masks; and numerous Taoist subjects (see below). We know, too, of figure-subjects of this period of a secular kind, including men and women. Designs of children masquerading and at play in garden surroundings are favourites with the Chinese. They are most sympathetically rendered and make a very charming decoration. Thus on the ample surface of a large potiche one sees a garden scene with numerous children (" the Hundred Boys ") at play, some affecting the Elegant Accomplishments of chess, painting, etc.; others with paper windmills and hobby horses; another disguised as a lion (a smiling child's face peeping through the terrifying mask); while another, dressed as a warrior chief with armour and nodding plumes, marches ahead of a band of one drum.

Mention is made of the familiar group of symbols—the Eight Trigrams (*pa kua*), the Eight Precious Symbols (*pa pao*), the Eight Buddhist Emblems (*pa chi hsiang*), besides the " six cardinal points of the universe," all of which need explanation. A gold balance or weighing scales is another symbolical motive mentioned more than once.

Fig. A

The *pa kua*, or Eight Trigrams, supported by dragons or on floral scrolls, are eight figures formed by triple lines, whole or variously divided. They are supposed to explain the phenomena of Nature and to have been revealed to the legendary Emperor Fu Hsi by a dragon-horse (*lung ma*) which rose from the Yellow River. They are sometimes used to designate the points of the compass, one group representing North

[1] This design, conveniently named "the rock of ages" pattern, contains an allusion to the sea-girt mountains of the Taoist island paradise.

(also called *k'un*, earth), another South (also called *ch'ien*, heaven), and the remaining six South-west, West, etc. This application of them seems to explain the decoration described as " Heaven and Earth and the six cardinal points " (*ch'ien k'un liu ho*). Fig. A shows the *pa kua* surrounding another emblem, the *yin-yang* which symbolises the dual elements of Nature such as male and female, light and darkness, etc.

The *pa pao*, eight precious things, supported by fungus sprays or fairy flowers, are (1) a jewel or disc ; (2) a " cash," a circular coin with square hole in the middle ; (3) an open lozenge, symbol of victory ; (4) a musical stone (*ch'ing*), shaped like a carpenter's square ; (5) a pair of books ; (6) a pair of rhinoceros horns (cups) ; (7) a lozenge-shaped picture (*hua*) ; (8) a leaf of artemisia, an auspicious plant which drives away disease.

The *pa chi hsiang*, eight sacred emblems of Buddhism, supported on lotus scrolls, consist of (1) the wheel (*chakra*), or hanging bell ; (2) shell trumpet ; (3) State umbrella ; (4) canopy ; (5) lotus flower ; (6) vase ; (7) pair of fish ; (8) angular knot, symbol of longevity (see p. 194).

The *ju-i* sceptre is another symbol. Its form, with " fungus-shaped " head and curved stem, is well known. Its meaning, *ju-i* (as you wish), implied a power to bring about fulfilment of wishes, and it is also an attribute of the god of Longevity. The form of the head is frequently borrowed in ornamental designs, in border patterns and in cloud-scrolls, the latter being called cloud-scroll patterns, *ju-i* cloud patterns and propitious clouds.

As already indicated, the devotion of the Emperor to Taoist doctrines would naturally be reflected in the decoration of the palace porcelain. This we find directly expressed in designs representing " three *hsien* (genii) compounding the elixir of life," " the Eight Immortals crossing the sea," " four *hsien*," " the Immortals paying court to Shou lao " (god of Longevity), and other groups of Taoist sages, or *hsien*. The cult of Longevity, the central feature of the Taoism of the time, is indirectly suggested by various plants, birds, etc., which were regarded as emblems of Longevity—the fungus (*ling chih*), the pine, the crane, deer, the *ju-i* sceptre and the various felicitous phrases in which the word *shou* occurs.

It was evidently against etiquette to record the names of the clever potters who worked on the Imperial wares ; and as such histories as we have deal almost exclusively with the output of the Imperial factories, it is not surprising that the personal element is conspicuously absent from Chinese ceramic history. Of the very few names, however, which have

emerged, two belong to the Chia Ching period, and in both cases they are of men who gained a great reputation by imitating the standard wares of the past. Chou T'an-ch'üan, the copyist of Sung Ting-chou wares, is mentioned elsewhere.[1] The other is a Mr. Ts'ui, whose forte seems to have been close imitation of the Hsüan Tê and Ch'êng Hua porcelains. The fullest account of this artist is given in the *T'ao lu*[2] under the heading of *Ts'ui kung yao*, from which we learn that he lived in the Chia Ching and Lung Ch'ing periods and that in his time he enjoyed the highest reputation for " imitation of the wares in the traditional style and make of the Hsüan Tê and Ch'êng Hua periods. The name given to his work was *ts'ui kung yao tz'ŭ* (Mr. Ts'ui's porcelain), and it was eagerly sought for throughout the empire. His cups (*ch'ien*) differed in size from those of the Hsüan Tê and Ch'êng Hua factories, but displayed the same skill and perfection of design. In the blue and polychrome wares his colours were all like the originals. His porcelain was, in fact, the cream of that made in the private factories."

Another work[3] quoted elsewhere in the *T'ao lu* goes so far as to say that Ts'ui's imitations were even held by some to be superior to the originals, though the price of them was only about one-tenth of the latter.

Another criticism,[4] perhaps from a contemporary writer who had the usual contempt for modern productions, is far less flattering. " One sort," it says, " called Mr. Ts'ui's ware, is very different and may be used for putting fruit stones in."

Be that as it may, it is very interesting to know that avowed imitations of the wares of previous reigns were made and in demand after so short an interval; and though it is not actually stated in so many words, knowing the Chinese practice, we may fairly assume that the reign names were imitated as well as the general style of the wares. This, of course, adds much to the difficulty of making attributions; and even when we find an undoubted Ming specimen with the requisite style of decoration and a Hsüan Tê or Ch'êng Hua mark, Mr. Ts'ui's name will arise in our minds to shake our confidence. Not that we should use one of Mr. Ts'ui's bowls as a jam pot, if we had the good fortune to discover one. On the contrary, if we were only sure that Mr. Ts'ui had made it, we should probably give a full Ch'êng Hua price for it without a murmur.

[1] p. 158. [2] Bk. v., fol. 9 recto.
[3] Bk. viii., fol. 4. The *Ming ch'ên shih pi chou chai yü t'an*.
[4] The *Wên chên hêng ch'ang wu chi*, quoted in the *T'ao lu*, Bk. vii., fol. 3.

LUNG CH'ING (1567–72)

Muh Tsung, whose *nien hao* is Lung Ch'ing, reigned from 1567 to 1572 ; but his brief reign is memorable for successes over the Mongols and for a settlement with these pertinacious foes which gave China many years of peace on the north-west frontier.

From the short note on this reign in the *T'ao shuo* we learn that " the Imperial factory was re-established in the year 1572," when it was again put under the supervision of the assistant prefects of the district acting in rotation. This statement would seem to imply that the factory had been out of commission for some years, an inference supported by evidence from another source. In 1571 a palace eunuch sent forward a colossal order comprising 105,770 items to be furnished in eight months *because supplies had run short*, from which it is clear that the annual contribution from Ching-tê Chên had not been forthcoming for some time. The oppressive nature of this order called forth a protest from Hsü Ch'ih, president of the Censorate, who appealed for a reduction of the amount by about 80 per cent and an extension of the time allowed for manufacture. He also prayed that as the art of making the *hsien hung*[1] had been lost, *fan hung*[1] might be used instead ; and that certain objects very difficult to make should be cancelled, viz. the largest size of fish bowls and square boxes in three tiers which were a novelty of the time. He also complained that the designs of the bowls to be decorated in polychrome (*wu ts'ai*) were too elaborate to be produced successfully ; from which it is clear that the practice of sending designs from the Court, noticed in the account of the Ch'êng Hua porcelain, still continued.

Extracts from the official list of the Court porcelain are given in the *T'ao shuo*, from which we gather that there was little change in the form and ornament of the wares. A few fresh motives of decoration appear and should be noted, though experience shows that mention of a design in the Imperial lists for the first time does not necessarily mean that it was not known before.

The general heading of the *T'ao shuo* summary is blue and white, but it will be seen that coloured ornament is also mentioned incidentally. The fresh motives include :—clusters (*to to*) of chrysanthemum flowers, the *yü tsan hua* (tuberose or iris), the *ch'ang ch'un hua* (jasmine), *k'uei hua* (althæa flowers), flowers of the four seasons supporting the characters *ch'ien k'un ch'ing t'ai*[2] (heaven and earth fair and fruitful), interlacing

[1] See p. 25. [2] See p. 195.

scrolls of mutan peony, the Tartar pheasant (*chai chih*), flying fishes, monsters (*shou*) in sea waves, *tan shui* (faint wave patterns), curled waves and plum blossoms ; figure-subjects are *jên wu* (genre motives), *ku shih* (historic subjects) and *p'an chih wa wa* (children holding branches). The last design is familiar in several forms, e.g. boys among peony scrolls, which certainly dates back to the Sung dynasty, and medallions with a child holding up a branch. Another motive is described as " a joyous meeting," which Bushell explains as symbolised by a pair of magpies ; but there is a design of sages meeting in a mountain, quite frequently seen on later porcelain, which seems to answer literally to the description.

The incidental mentions of colour in this list of blue and white include :—phœnixes in rosy clouds (*fêng hsia*) flying through flowers, nine red dragons in blue sea waves and curling waves and plum blossom in polychrome. Touches of overglaze red added to late Ming blue and white designs are familiar enough and will explain the first two ; while the last is the still more familiar design (though mainly on later wares) of white plum blossoms floating on curled-scroll waves which are washed over with green and aubergine. Other varieties of this wave and blossom pattern have the addition of floating symbols, or horses galloping over the water.

Other types of decoration mentioned are dragon designs engraved beneath the glaze (*an hua*), and wine jars with peacocks and mutan peonies in gold (*chin k'ung ch'iao mu tan hua*). It is further added that these jars have covers with lion pattern. At least, this is the literal rendering of the text[1] of the *T'ao shuo*, though Bushell has given it the far more interesting sense " with covers ornamented with lions moulded upon them," possibly from a variant reading. Of course, we are all familiar with the vase cover which has a knob in the form of a lion in full relief and usually in unglazed biscuit, and it would be interesting to find a reference to this in the Ming lists ; but there is no certainty that the original " covers with lion " pattern bears this interpretation. It may merely mean covers with lions painted on them in underglaze blue. This is a good example of the unsatisfactory vagueness of Chinese texts, and also of the perils of a free translation where the text is not given to serve as a check. Bushell's translation of the *T'ao shuo*, in many ways a most admirable work, suffers seriously from this weakness.

The *T'ao shuo* concludes its notes on the Lung Ch'ing and Wan Li periods with the statement that " the porcelain of the Ming dynasty

[1] *Yu kai shih tzŭ yang.* See p. 195.

daily increased in excellence, till we come to the reigns of Lung Ch'ing and Wan Li, when there was nothing that could not be produced. But the meretricious scenes depicted on porcelain of the reign of Lung Ch'ing were not worthy of artistic culture."

There is no doubt that the variety of forms and decorations increased progressively as the Ming dynasty advanced ; but the implication in the above criticism that the porcelain also increased in excellence is not borne out either by our limited experience or by other Chinese writers, who are almost unanimous in voting the palm of excellence to the Hsüan Tê and Ch'êng Hua wares.

The brief reign of Lung Ch'ing is very sparsely represented in our collections, partly no doubt because the unmarked examples would hardly be differentiated from the wares of the preceding and succeeding reigns ; and consequently only the marked examples, which are very uncommon, are permitted to figure in the space allotted to this period.

Among these are two good examples of blue and white in the British Museum. One is an oblong rectangular box[1] (without cover) of strong build, with thick walls of fine-grained porcelain and a glaze of slightly greenish tone. It is painted in a blue of good quality not unlike that of the Chia Ching period, with good designs of children with their elders in a garden, and other representations of family life. The other is a round, covered box with Imperial dragon and phœnix design. Its glaze has the peculiar " musliny " texture which is observable on some of the Wan Li porcelains and in a marked degree on Japanese Imari.

Mr. Eumorfopoulos has a small square tray with stork and cloud pattern in a Chia Ching type of dark blue, but bearing the Lung Ch'ing mark ; and Mr. Love has two specimens of polychrome similarly dated. One of these, illustrated on Plate 30, is a square jar of characteristic Ming shape. It has a good white body of fine grain and is painted with an underglaze blue approaching the Mohammedan in quality, and red, green and yellow enamels on the glaze. The second piece is a shaped tray, part of a supper set, decorated with similar colours. The hexagonal vase on Plate 30 from the Ezekiel Collection is painted with flying phœnixes and formal designs in the same chord of colours. It also has the Lung Ch'ing mark.

[1] Illustrated in *Country Life*, November 20, 1920.

PLATE 7.

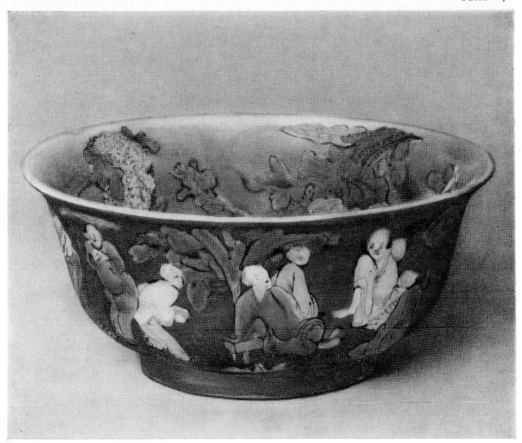

Bowl decorated in enamel colours on
the biscuit. Outside, landscape and
the Eighteen Arhats: inside, sprays
of flowers in an aubergine ground.
Chia Ching mark in blue. D. 7½ ins.
(See page 109.)

WAN LI (1573–1619)

Shên Tsung, whose reign name is Wan Li, succeeded his father at the age of ten. Thanks to the arrangements made with the Mongols in the previous reign, China enjoyed a period of peace and prosperity during the minority of the young Emperor. In fact, the revenue at this time was so plentiful that it was found possible to remit arrears of taxation at the end of the first seven years of the reign. Wan Li as a boy is said to have been of an affectionate and lovable disposition ; but doubtless owing to the influence of ambitious eunuchs who were the curse of the Ming dynasty, his character must have deteriorated as he grew up, for a censor later on had occasion to stigmatise the " bad temper and licentiousness of the Emperor."

Nor was it long before the political horizon became clouded. Wan Li had the misfortune to find himself in conflict with Noorhachu, who was destined to be the founder of the Manchu dynasty ; and the last years of his reign witnessed more than one serious defeat at the hands of this redoubtable Tartar leader. Meanwhile the Japanese invasion of Corea involved the Chinese in a war with the famous Taiko Hideyoshi, which lasted till the death of the latter in 1598 and was marked by more defeats than successes. Internal insurrections were added to the external pressure, and by the end of the long reign of Wan Li the Ming dynasty was tottering to its fall.

Meanwhile there was great activity in the porcelain industry at Ching-tê Chên. The Imperial factory was put under the permanent charge of one of the sub-prefects of the district and oppressively heavy demands were made on the potters on the palace account. Such was the severity of the Superintendent and the burden of the Imperial orders that it is said that the potters made daily intercession in the temple of the God that the Imperial orders might be merciful.

The god worshipped by the potters was named Chao, a potter of the Chin dynasty (A.D. 265–419) whose super-human skill had caused him to be canonised. He was superseded eventually by the potter T'ung, whose story is evidence of the unhappy state of affairs prevailing at the Imperial

factory in the reign of Wan Li. The Imperial orders included some very large fish bowls,[1] such as had been mentioned in the protest made by the censor Hsü Chih in the previous reign. Great difficulty was experienced in the firing of these large pieces, and the failures brought down the wrath of the Superintendent on the hapless potters. " Thereupon the divine T'ung took pity on his fellow-potters, and served them by alone laying down his life. He plunged into the fire, and the bowls came out perfect."

The exhaustion of the beds of fine porcelain clay at Ma-ts'ang was already foreshadowed in the Chia Ching period, and it was now reported that this source of supply was practically worked out. An alternative source of good clay was at Wu-mên-t'o ; but it was more distant, and, as the porcelain makers would not increase their price to make up for the additional transport, it was difficult to keep up the supply. This naturally meant using inferior materials, which were obtainable nearer to hand, and a consequent deterioration in the quality of the ware. Moreover, it is stated in the *T'ao lu* that the supply of Mohammedan blue completely ceased in the reign of Wan Li ; and, although there is reason to think that this is overstating the case,[2] it is clear that recourse had to be had more and more to the ordinary native blue, which is a duller and greyer colour. This is apparent on examples of Imperial Wan Li porcelain which have survived to the present day.

On the other hand, it would seem that there was some revival of the underglaze red (*chi hung*), though the results were not comparable with the fine underglaze reds of the fifteenth century.

On the whole it is clear that the Wan Li potters, in spite of increased experience and a wider range of technique, were working under difficulties when compared with those of the earlier reigns ; and it is easy to understand why the censorate appealed on their behalf and asked for the reductions in the Imperial orders which are described below.

The lists of porcelain supplied to the palace during this reign, as summarised in the *T'ao shuo*, are of great interest. They include a number of forms not named in the previous lists, as well as a variety of fresh decorations. Among the fresh forms are :—trays for wine cups (*pei p'an*) ; flower vases (*hua p'ing*) ; flat-backed wall vases in form of a gourd ; screens (*p'ing*) ; hanging oil lamps (*ching t'ai*) ; pricket candle-sticks (*chu t'ai*) ; jars for candle snuff (*chien chu kuan*) ; chess boards

[1] Their size is given as three feet in diameter by two feet high ; see also p. 96.

[2] There are examples of marked Wan Li porcelain with a blue of Mohammedan type in our collections.

(*ch'i p'an*); furniture for the writing table, such as brush handles (*pi kuan*); brush pots (*pi ch'ung*); brush rests (*pia chia*); pallette water droppers (*yen shui ti*); and a variety of boxes, such as perfume boxes (*hsiang lien*), betel-nut boxes (*pin lang lu*), hat boxes (*kuan lu*), handkerchief boxes (*chin lu*) and fan cases (*shan hsia*).

Many of these objects were not novelties, though they figure in the lists for the first time; but some of them were regarded as superfluous luxuries by the censor Wang Ching-min, who rivalled his fellow of the preceding reign in protesting against the extravagance of the palace orders in 1583. The total, 96,000 items, was too large, and included 20,000 boxes of different kinds, 4000 vases and 5000 covered jars (*kuan*). Wang specially singles out the pricket candlesticks, the large slabs for screens and the brush handles as involving unnecessary expense; and chess apparatus, including boards for the game and jars to hold the pieces, as intended for mere pastime. With regard to decoration, he asked that it might be confined to blue and white, because the polychrome and the pierced decoration were difficult to execute and meretricious in taste. As a result of this protest we learn that the number of the obnoxious articles was reduced by one-half.

To the series of decorative motives which we have collected from the lists of previous reigns the following can be added :—Full-face dragons (*chêng mien lung*); squatting dragons (*tun lung*); ascending and descending dragons; winged " thread-like " dragons; the " Hundred Dragons "; fabulous monsters paying court to the Celestial Dragon; medallions of archaic dragons (*ch'ih*) and tigers.

Of the fabulous creatures, often named generically *shou, hai shou* or *i-shou*, the *ch'i-lin*, or kylin, is now specifically mentioned, as well as the sea-horse (*hai ma*). Other animals are elephants carrying the sacred Buddhist vase, and the hundred deer. Birds include wild geese in reeds, the hundred cranes, six cranes " symbolising the cardinal points of the universe." Bees hovering round plum blossoms and goldfish in water-plants complete the animal category.

The phrases " hundred dragons " and " hundred deer," etc., are not to be taken literally, a hundred being used to signify merely a large and indefinite number. The *ch'i-lin*, though mentioned here for the first time, is a very familiar figure in Chinese decoration. He is one of the chief of the mythical animals, and his appearance portends the coming of a virtuous ruler. In form he is composite, with the body of a deer, slender legs and divided hoofs, the head of a dragon, a curled and bushy tail and

flame-like attributes on his shoulders. By these signs he may be distinguished from the miscellaneous chimæras which rank as *hai shou*, or sea-monsters, and he is really not the least like the Buddhist lion or dog of Fo, though he is often confused with the latter.

Fresh floral motives include :—a single spray of lotus (*i pa lien*); lotus petals (*lien pan*)[1]; lily flowers (*hsüan hua*); hibiscus (*kuei*) flowers in a brocade ground; borders of pine, bamboo and plum; pine-pattern brocade; round medallions of season flowers; marsh plants; coiled peach boughs with the character *shou* inscribed on the fruit; apricot foliage; foreign pomegranates; grapes and slices of water-melon; ginseng and fungus; and a decoration described as " Midsummer holiday emblems and autumn flowers," the former explained by Bushell to be acorns and artemisia, which were hung up on the fifth day of the fifth moon.

Figure-subjects are :—*shih nü* (men and women); *jên wu* (genre subjects); *ku shih* (subjects from history); seated boys holding cassia boughs; *shua wa wa* (sporting children); the Hundred Children picture. The supernatural is represented by *shên hsien* (deities) holding up propitious characters, such as *wan ku ch'ang ch'un, ssŭ hai lai chao*[2] (through myriad ages long spring : tribute coming from the four seas); and two motives which may refer to the deities themselves or to symbolical representations of them, viz. *Fu Lu Shou* (Happiness, Rank and Longevity) and " the four lights worshipping the Star of Longevity."

Miscellaneous motives include :—brocade grounds (*chin ti*); *shan shui* (landscape); *ho t'u* (river pictures); floral designs broken by panels of landscape; and *shih i* (poetry ideas), which may mean illustrations of poetical themes or actual verses of poetry which are familiar enough on porcelain of all periods.

There are, too, a number of formal and symbolical designs, such as :— sacred pearls emitting flames; the *yin yang*[3] and the *pa kua* (Eight Trigrams); the lozenge symbol (*fang shêng*); the eight Buddhist emblems tied with fillets; *ju-i* sceptres tied with fillets; *ju-i* cloud borders; emblems of longevity (such as the gourd, peach, fungus, bamboo, crane, deer, etc.); strings of jewels; ancient coins; jewel mountains in sea waves (the " rock of ages " pattern). Various forms of inscriptions

[1] This may refer to the well-known type of dish, saucer-shaped, with the sides moulded in radiating petals like a lotus flower. The moulded design is lined and sometimes shaded with blue or underglaze red, or decorated with holy Sanskrit characters.

[2] See p. 195. [3] See p. 106.

occur, propitious characters held up by dragons or in borders, and in one curious case the characters *yung pao ch'ang ch'un*[1] (ever insuring long spring) are placed in the " four puffs of hair on a symbolical head." There are also archaic characters, such as have been found in the inscriptions at Loyang ; antique seal characters (*chuan*) ; Sanskrit invocations and *shou i* (longevity ideas) which may refer to repetitions of the character *shou* or to symbols of longevity ; and dragons in clouds holding up the characters *shêng shou*,[1] the Emperor's birthday.

The bulk of the foregoing designs are in blue and white, but even in the blue and white lists we find occasional mention of supplementary decoration by other methods. Thus we read of blue and white bowls with enamelled (*wu ts'ai*) phœnixes flying through season flowers ; dishes with dragons or lotus scrolls engraved, in addition to blue and white designs ; cups with nine dragons painted in red among sea waves ; cups with nine blue monsters in red sea waves ; cups with red sea waves with white crests ; cups with yellow hibiscus flowers or enamelled chrysanthemums inside ; incense burners with clouds and dragons worked in relief (*ting chuang*),[1] in addition to blue designs, and with designs carved in openwork (*ling lung*)[1] ; hanging oil lamps with " golden chrysanthemums and hibiscus flowers " may be an allusion to gilding.

A section of *wu ts'ai* (polychrome decoration enamelled on the glaze or otherwise), includes a large number of forms, showing clearly that polychrome was now used to a greatly increased extent. And finally there is a section of mixed colours (*ts'a sê*) which includes the following combinations :—white inside and designs reserved in a blue ground outside ; blue ground and white designs (*ch'ing t'i pai hua*) ; garden seats (*liang tun*), with brown (aubergine) lotus flowers in a yellow ground ; golden brown (*chin huang*) tea cups with engraved dragons and lotus scrolls ; incense burners with enamelled decoration in a yellow ground ; vases of white porcelain with phœnixes and fairy flowers engraved under the glaze. Finally, there are banquet dishes (*shan p'an*) white inside, and decorated outside with dragons in clouds painted in red, green, yellow or aubergine brown, or perhaps this should be red, green, yellow *and* aubergine brown. This is the only occasion in the lists, as extracted in the *T'ao shuo*, in which the enamel colours of the *wu ts'ai* are individually named.

As clearly indicated in the Imperial orders, there was a great preponderance of blue and white among the Wan Li porcelains. Indeed,

[1] See p. 195.

the same is probably true in all the Ming periods. At any rate, blue and white bulks largely among the numerous specimens of late sixteenth-century porcelain which are with us to-day. There is, moreover, a considerable variety both in the blues and in the paste and glaze of the late Ming blue and white, a variety which reflects the varying supplies of material, the different factories and, of course, the different qualities of ware. Much of the ware, for instance, was frankly made for the export market; and one would not expect either the best blue or the most carefully executed designs on things which had to stand the risks of travel and were in the end destined for a less critical public than the Chinese. On the other hand, it is clear that the palace ware of the time was not all made of superfine material or decorated solely with the purest blue. Take, for instance, the big heavy beakers, of square form with lion-mask handles and often with dentate projections on the sides obviously derived from bronze models. Some of these are decorated with five-clawed dragons and phœnixes, the Imperial pattern, and marked with the *nien hao* of Wan Li in six characters. And yet if we look at a typical example in the British Museum we find that the ware is thick, heavy and rather coarse, that the glaze is obscured by a fog of bubbles and the blue, rendered misty by the bubbly glaze, is of a greyish tint. Minor blemishes, such as fire cracks and flaws in the glaze, are also apparent.

In contrast with these rugged, though handsome vases, we have bowls and dishes of fine grain with a soft-looking, melting glaze which shows obvious signs of wear; and again, a thin, crisp porcelain with clean, glittering glaze. The blue of the decoration is equally changeful. Sometimes it is of the fine Mohammedan quality, a beautiful blue of violet shade; again, it is a dark violet like the Chia Ching blue, or a pale silvery tint; but more often it is inclined to be dull and greyish or indigo. There is, as already stated, some reason to doubt the assertion that the Mohammedan blue was extinct in the Wan Li period. But we must remember that the native cobalt, though impure in its original state, was capable of refinement. Père d'Entrecolles tells us from his own observation how the potters of the K'ang Hsi period, a century later, were able by repeatedly refining this material to extract an essence of pure sapphire blue from it. And we are familiar with the wonderful quality of this refined blue on the best K'ang Hsi blue and white. All these varieties of paste and blue can be seen in our Museum Collections. The Franks Collection in the British Museum has examples of all these types; and the Victoria and Albert Museum has a great variety of Ming

blue and white in its permanent exhibition; while the J. F. Bloxam Collection in the Loan Court is full of interesting specimens.

Fig. 2 of Plate 31 illustrates a typical palace vase of the Wan Li period from the Love Collection. It is one of the tall, slender forms which were evidently in favour at this time, and in this case derived from a metal prototype. The lion handles on the neck are pierced to hold rings, and the six crinkled flanges, which seem to defend the lower part, are often seen on the cloisonné enamel vases of the time. The design of close lotus scrolls with formal borders (including a crested wave pattern above the base) is painted in a soft greyish blue, and the mark, in six characters, appears as usual below the lip.

Another tall Wan Li beaker in the same collection, not dissimilar in form though without the projecting flanges, is painted in dull grey-blue with a basket of flowers for a central design and with borders of stiff leaves. There are other examples of this type, but taller still, in the Grandidier Collection in the Louvre. The slender, graceful vase on the same plate is painted in a pale blue with a design of dragon medallions which is mentioned more than once in the Imperial lists.[1]

But the most interesting and the most important specimens for the student are those which, albeit of the export type, can be proved by circumstantial evidence to belong to the late Ming period. These we are bound to take note of, and from them we can deduce the characteristics of the late Ming ware; and, making them a sound base for operations, we can proceed to identify the less authenticated pieces.

First there are the dishes, bowls, ewers and bottles which still retain the silver or silver-gilt mounts in which they were enshrined in the sixteenth century. A good series of these were exhibited at the Burlington Fine Arts Club in 1910, including several pieces which had been preserved in Burghley House since the reign of Queen Elizabeth; and it is interesting to find contemporary allusion to such pieces, which were evidently still rare enough in England to be treated with great respect. We read, for instance, that Lord Treasurer Burghley " offered one porringer of white purselyn garnished with gold " as a New Year gift to Queen Elizabeth in 1587–8, and Mr. Robert Cecil " a cup of greene pursselyne "; and, further, that the celebrated traveller Cavendish presented his royal mistress with " the first vessels of porcelain ware that came to England." We know now that they were not actually the first, but that is a trifling error on the part of the chronicler. The British

[1] See p. 113.

merchants had not yet established a direct trade with the Far East, and whatever Chinese porcelain reached our shores came either through indirect channels of trade or from captured Spanish ships.

But to return to the Burlington Exhibition. There was a blue and white ewer decorated with symbols and formal sprays of peony and lotus, with a mount of the year 1589 ; a bottle mounted as a ewer, with rockery, flowering shrubs and birds ; a bowl with ten vertical panels with white deer reserved in a blue ground ; and a saucer-shaped dish with typical Ming landscape with mountains, pine trees, pagoda and a pleasure boat. Most of these were painted in a blue of greyish or indigo tint ; and, as they were unmarked, we are at liberty to regard them as somewhat earlier than their mounts, perhaps even dating as far back as Chia Ching. But there was one piece which actually had the mark of the Wan Li period, a bowl with phœnixes and lotus scrolls, and this was conspicuous for its superior drawing and better quality of blue.

Another typical specimen is a mounted bowl[1] in the Franks Collection (date of mount about 1580), painted in blue with four panels in which are egrets on a pot of lotus flowers. In this case the ware is fine and white and thinly potted with slightly bluish glaze, thick and lustrous, but, as usual, " pin-holed " in places ; and the blue has the faint tinge of indigo so characteristic of Wan Li export ware.

The visitor to the Rosenborg Palace at Copenhagen will see in one of the first rooms a blue and white covered bowl (Plate 31) secured to the table on which it has stood for many years. It is a hexagonal bowl, with cover (perhaps it should be described as a box) painted in a rather dull blue under a glaze which is full of minute bubbles, giving it the " muslin-like " texture so common in Japanese Imari porcelain. The design consists of seated figures in landscape with roughly drawn pine trees, a decoration freely copied on European faïence ; and the base is unglazed. This bowl was brought to Denmark in 1622 by Admiral Ove Gedde, who commanded the first Danish expedition to the East Indies, and it was given as a present to Princess Sophie Hedvig in 1723. It is interesting as one of the historic pieces of Chinese export ware and it almost certainly belongs to the Wan Li period.

The famous Hainhofer Cabinet at Upsala[2] contains among its numerous treasures a few pieces of blue and white porcelain, of which

[1] Hobson, Plate 69, Fig. 1.

[2] J. Böttiger, *Philipp Hainhofer und der Kunstschrank Gustav Adolfs in Upsala,* vol. iii., pp. 23–7, and Plates 69 and 70.

two plates with stork and cloud pattern in a dull dark blue have the Wan Li mark. The same musliny texture of glaze, noted on the Rosenborg piece, is observable in these plates. It is curious that this feature should appear on two of our export pieces which can be dated to about the same period, because it is not a common trait of Chinese porcelain, though quite characteristic of the later Japanese ware.

There are, besides, three bell-shaped cups without handles, decorated in blue with a narrow belt of formal design bordered above by stiff leaves, and six plates showing the thin, crisp type of ware mentioned above[1] and its characteristic blue decoration, reference to which is made in a letter dated 1626. The centres only of these interesting pieces consist of porcelain. The rims and sides are a framework of wood lacquered in black with gold designs. They come from Goa, and the style of the lacquered decoration leaves little doubt that they were made up there from broken Chinese dishes.[2]

It would not, indeed, be surprising if these dishes had spent some of their life in India, for much of the same kind of ware is found in that country. It is, in fact, spread widely over the Near East. We have seen how it was a staple of the sea-borne trade of the Far East at this time, and as late as 1615 Sir Thomas Roe remarked on the caravans which went every year from Agra to China overland.

At its best it is one of the most attractive of the export types, and is readily recognised by its thin, white, resonant body, often moulded so that it looks like repoussé metal-work, and its clear, crisp and lustrous glaze. Sand adhering to the foot-rim, pin-holes in the glaze and radiating wheel marks under the base are signs of summary execution common on the ware; but the hands which fashioned it rapidly were very skilful, and the brush which painted it with swift, easy strokes was free and sure, and capable at times of exquisitely finished draughtsmanship. The blue, it should be added, is usually of a pale, silvery kind and of pure tone, though naturally it varies and tends to dullness on the poorer specimens.

It is evident that this kind of porcelain had a great and lasting vogue in the foreign market; for not only have large quantities survived, considering what fragile stuff it is, but we can trace its presence over a long period. There are mounted specimens[3] which take it back with

[1] p. 116.

[2] In point of fact, the letter dated 1626 describes them as "*indianische Schaalen von porcellana und indianischen Lackh gemachet die kommen von Goa.*"

[3] See *Burlington Magazine*, March, 1913, and *Country Life*, November 20, 1920.

certainty to about 1580; and there is the bowl in the National Museum at Munich which belonged to William V, Duke of Bavaria (1579–97). It is imitated on a Persian pottery ewer[1] dated 1616 and on Dutch Delft throughout the seventeenth century; and it appears in still-life pictures of the Dutch school, such as those of Frans Snyders (1579–1657) and many more.

It can still be found fairly often in England, but its undoubted merits are becoming more appreciated, and good specimens have greatly augmented in value. It is probable that the better quality pieces with clearer and purer blue are the earlier and belong to the latter part of the sixteenth century—this can be fairly deduced from dateable specimens—and that the poorer specimens, with coarser ware, duller blue and inferior drawings, belong to the middle of the seventeenth century, when the ware had already become vulgarised and decadent.

Typical designs seen on this ware are a singing bird on a stone, geese in a marsh, an eagle on a rock, beside flowering plants or bamboos, or a cicada on a stone among plants and grasses, drawn at times with great charm and with considerable individuality. On others there is a free rendering of a landscape, or panels of landscape alternating with a garden scene with a seated figure by a table or a screen. But perhaps the most frequent design on dishes and bowls is best described by reference to an actual specimen. Picture a shallow bowl or deep dish, the sides lightly embossed by pressure on a mould and the rim slightly turned outwards and waved at the edge. It is a good white ware with limpid glaze and painted in clear blue. In the bottom inside is a mirror-shaped panel with a river scene and a goose in the foreground standing on a rock. The spaces outside the panel completing the circle are diapered with matting and key-fret patterns. The sides are divided, by four vertical bands of tasselled ornament, into panels with quatrefoil medallions, two of which contain peaches and foliage, and two symbols bound with fillets; on the rim are passages of hexagon and matting diaper interrupted by panels of fruit and flowers. The exterior of the sides has a similar scheme of ornament in skeleton form. The foot-rim shows a fine unctuous paste with traces of sand adhering, and the base, which is slightly pin-holed, has radiating wheel lines beneath the glaze and is unmarked. The forms which this ware usually takes are those of bowls, dishes, small basins, pipe-shaped bottles, bottles and ewers. The last generally have a crinkled,

[1] In the British Museum.

star-shaped lip and a graceful spout, with foliage applied in relief at the attachment (Plate 32).

Plate 32, Fig. 3, shows an extremely interesting specimen of this type. It is a cup-shaped bowl moulded in six-foil form and with six panels on the sides which have been shaped on an interior mould. Inside the bowl these panels are decorated in faint relief in white under the glaze with growing plants and birds, a very dainty and delicate ornamentation; and there is a border of *ju-i* pattern with pendent tassels in blue and a blue-painted medallion on the bottom with a cat on a four-legged stool surrounded by a border of six petals. The blue designs outside are seen in the illustration. The incense burner on a table appears in one panel only, and in the remaining five are hanging symbols. The porcelain is thin and crisp, and the blue of the pale silvery kind. This bowl was mounted in silver-gilt as a standing cup (the cover is missing), apparently about 1584, but the tradition in the family to which it belongs holds that the porcelain was a gift from Mary Queen of Scots.

It should be added that the typical decoration of this ware as described above is also found on a thicker and heavier class of porcelain, usually expressed in a dark and rather heavy blue on dishes which seem to have been made particularly for the Indian and Persian markets.

Another not uncommon form of export porcelain is the small melon-shaped vase decorated with grape vines and squirrels, or with gourd vines, or with lotus scrolls. Though roughly made, these are often extremely attractive and decorative objects, and they have the further merit of being still obtainable at a reasonable price. A few examples are shown on Plate 44.

It would be almost impossible, and certainly tedious, to enumerate all the many types of late Ming export ware, the large jars and vases with a variety of decorations, the large and small dishes and bowls, which have been found all over the East and have gravitated to the Western markets. A wonderful series of these forming the collection of the Sultans of Turkey is preserved in Constantinople; and we have been permitted a glimpse of a great collection of five hundred pieces stored in the *Chini-hane*, or porcelain house, in the precincts of the mosque of Ardebil in Persia. This is the collection of Shah Abbas (1587–1628), a contemporary of Wan Li. It was photographed by Prof. Sarre[1]; and though the camera was only capable of showing clearly the front ranks of this great array of pots, we can recognise many familiar types.

[1] *Denkmäler Persischer Baukunst*, Plate III.

They are mainly blue and white, though there are some coloured pieces and, as might be expected, a good number of Ming celadons. There are big vases with dragons in dark blue of Chia Ching type, there is a large bowl with lotus scrolls in the mottled blue which we have noted as originally a Hsüan Tê style of decoration, and there is one of the curious ewers with a *ch'i-lin* lying beside a very European fountain. Several examples of this strange ewer are known in England. One in the Franks Collection in the British Museum[1] is painted with a dark blue of Chia Ching shade[2] and is marked under the base with a hare, which is also found on other kinds of late Ming porcelain.

It is said that some of the pots in the *Chini-hane* measured as much as a metre in height. Not only the manufacture, but the transport of such things must have been a serious problem in the days of Wan Li. Another kind of vase, dimly seen in the back rows of Shah Abbas' Collection, is the large ovoid jar with loop handles on the shoulders. These, one imagines, were used as water jars on board ship and were traded widely in the East Indies and on the mainland. Sometimes they were protected by wickerwork or rope bands, as in the case of the Tradescant jar in the Ashmolean Museum, Oxford.

The Tradescant Collection is one of the oldest in Europe, formed as it was mostly before 1627, and consequently its few specimens of Chinese wares have a documentary interest. The blue Tradescant jar[3] is painted in a strong but rather heavy blue, with lions in a large peony scroll on the sides; a matting diaper with reserves of flowers on the shoulder, typical of the late Ming blue-painted jars; and a foliage scroll in white reserved in blue on the neck. It may be regarded as a good type of late Ming export ware.

[1] See *Country Life*, January 1, 1921.

[2] Some at least of these ewers were made in the Chia Ching period, as is shown by a marked example exhibited at the Burlington Fine Arts Club in 1895. See Cat. (Blue and white Oriental Porcelain) No. 300.

[3] See *Country Life*, November 20, 1920.

PLATE 8.

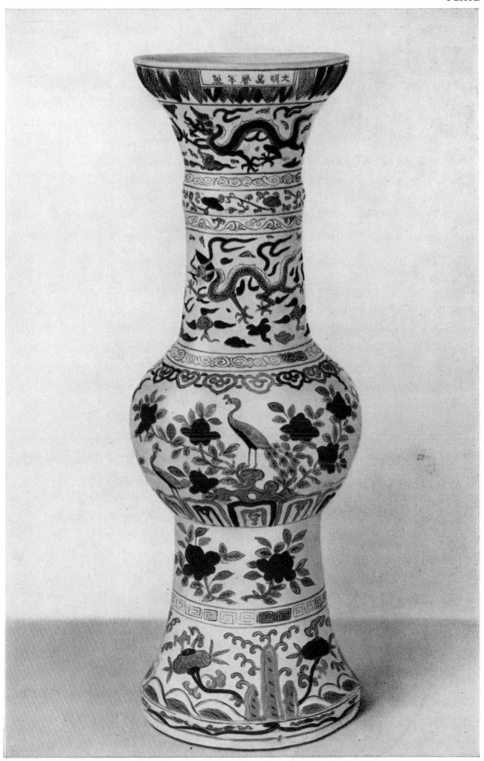

Beaker decorated in underglaze blue
and enamel colours (*wan li wu ts'ai*)
with belts of ornament—Imperial
dragons, peacocks and peonies, " rock
of ages " pattern, etc. Wan Li mark
on lip. H. 22½ ins. (See page 130.)

WAN LI—*continued*

Relief and pierced ornament are both mentioned in the Wan Li lists in connection with blue and white porcelain. Both are met with frequently enough on earlier wares, but there are special types of these porcelains which seem to belong to the late Ming period and to require notice here.

The reliefs (*ting chuang* or *tui hua*) are formed in various ways. The simplest is the comparatively low relief formed in a mould, such as the dragons which coil round a range of hills forming a brush rest (see Plate 37). Then there are figures and other ornaments modelled in relief and applied to the porcelain. These are often left in the biscuit state unglazed, and are sometimes smeared with a red pigment[1] over which gilding is applied. A typical example of this is the covered bowl with blue and white decoration and four medallions on the sides, in each of which is a pair of small biscuit figures of the Immortals in applied relief. The knob on the cover is a lion in biscuit.[2] Specimens of this kind of decoration are also found with the background coloured green or with washes of green, yellow and aubergine (see Plate 34).

The third method is to build up a low relief with white slip (liquid clay), which is left as a rule without glaze in this class of porcelain.

Pierced decoration (*ling lung*) was noted on the early Ming three-colour vases, jars and garden seats. It is effected by carving the porcelain while in the unfired state, dry and " leather tough," but still requiring great care in the handling. The carving of the wide and comparatively coarse openwork on the early pieces must have been child's play to that of the delicate fretwork on the Wan Li porcelains, which fully justified the name of *kuei kung*, or devil's work.

A few examples on Plates 33 and 34 will serve to illustrate the varied uses made of relief and pierced ornament in this period. The bottle (Plate 33, Fig. 3), one of a pair, has a sugary, white paste and a thick,

[1] A seventeenth-century still-life picture in the Rijks Museum, Amsterdam, includes a bowl so decorated with the figures painted in red.

[2] See Hobson, Plate 78, Fig. 3.

rather uneven glaze, and the ornament is applied and left in biscuit state. It consists of two five-clawed dragons with scaly bodies ascending through cloud-scrolls and flames; between them are bosses (doubtless the " pearls " which they are pursuing) with openwork sides and a top pierced with a square within a circle, which suggests the form of a Chinese copper coin or " cash." This detail recalls the incense burners of the Wan Li list, which were decorated " with dragons in relief and with branching fungus in openwork and ancient coins."

A rare bottle in the Collection of M. Léon Fould in Paris (same Plate) is mentioned here, although it appears to be of rather earlier date, because of its *ling lung* medallions. They are foliate medallions, with outer casing pierced with lotus designs and left in unglazed biscuit on which are still to be seen traces of a red pigment used as a medium for gilding. The decoration of the ground of the vase, symbols on a wave pattern, is painted in a soft, rather pale blue.

Two small bosses likewise decorated with openwork are seen on Fig. 1 of Plate 33, a delightful little brush-washer in the Salting Collection. Inside each of the bosses is a Chinese character delicately pierced. But the chief feature of the piece is the daintily constructed designs in biscuit reliefs, and parts of these are still coated with pigments over which gilding has been applied. It is an exquisite object, suited for the furniture of a writing table, where it might have held water for the ink or have been used for washing the brushes. In the same show-case are two small bowls with similar figures in relief, similarly pigmented and gilt, but with *ling lung* work between.

How delicate a touch was needed for the modelling of these tiny reliefs and the carving of these finer *ling lung* works will be quickly understood by anyone who looks at Fig. 3 of Plate 34, a covered bowl with a broad belt of pierced key-fret interrupted by medallions in which are tiny biscuit reliefs of animals and flowering trees. The upper border is a floral scroll with perching birds very daintily modelled in applied relief, and the lower border is a floral scroll traced in relief in white slip. The cover, too, is pierced and has a lion as a knob. The openwork and relief of this piece are both amazingly delicate.

Another example in the British Museum illustrates an interesting variety of the same type (Fig. 2, Plate 34). It is a bowl with outer casing with a broad band of pierced "cash" pattern interrupted by four medallions which contain a figure of an Immortal embowered in flowering shrubs, all modelled in biscuit relief. Behind the pierced work is a wash of blue.

The inside of the bowl is painted in a grey-blue with a full-face dragon in the centre, soaring dragons on the sides and a border of scroll work. Under the base is the Jade-hall mark (*yü t'ang chia ch'i*), which occurs on other porcelains of the late Ming period. Another supremely delicate specimen[1] of pierced work, combined with blue medallions, in the Hippisley Collection, has the Wan Li mark; and another *ling lung* piece in the Marsden Perry Collection has the mark of the next reign. On the other hand, the Ch'êng Hua mark is often found on these *ling lung* bowls; but we can only regard it as apocryphal.

It goes without saying that the potters of the K'ang Hsi period and the eighteenth century also indulged in *ling lung* work and with very beautiful results, but it is doubtful if they ever achieved the amazing success of the late Ming " devil workers."

Another kind of decoration used at this period has a superficial likeness to the pierced work which suggests an attempt to produce something of the same effect with a minimum expenditure of labour and skill. In this type the carving is not much more than skin deep; but the same fret patterns are used as in the *ling lung* bowls, and the partially pierced parts are left in biscuit. A good example of this is a large bowl in the British Museum with a belt of this semi-pierced fretwork interrupted by dragon medallions in Wan Li blue. It also appears on the body of a bottle-shaped vase in the Halsey Collection,[2] and on other pieces in which the blue decoration is clearly of late Ming type. Fig. 1 of Plate 34 depicts a little bowl in the Eumorfopoulos Collection entirely decorated with fret patterns of this kind. It has for a mark, in a blue square beneath, the edifying wish, *Lu wei ch'ing kao* (" High rank and emolument without corruption ").

It is improbable that any of the earlier kinds of polychrome used in the previous reigns of the Ming dynasty was wholly abandoned in the Wan Li period, and we may expect to find three-colour wares of the graffiato and cloisonné types, with decoration incised, carved, pierced or outlined in threads of clay and filled in with coloured glazes (medium-fired) against a background of contrasting colour; the same harder lead-silicate glazes[3] used in broad washes, especially the combination of

[1] Hobson, Plate 78, Fig. 2. [2] Hobson, Plate 68, Fig. 3.
[3] All the Ming *san-ts'ai* glazes are alkali-lead-silicates, containing soda, lime, lead and silica. The higher the proportions of silica and lime, the less fusible will be the glaze. A greater proportion of alkali, while not increasing the fusibility of the glaze, would make it more perishable. The greater the amount of lead in the mixture, the

turquoise and aubergine; the softer and more translucent lead-silicate glazes which come half-way between these early three-colour glazes and the plumbiferous enamels of the muffle kiln; and the enamels pure and simple which were used either to cover designs outlined in dry pigment on the biscuit or over the finished glaze.

About the first, little need be added to what has been said in an earlier chapter. A specimen likely to belong to this period is Major de Rothschild's gourd-shaped wall vase (Fig. 3 of Plate 35). The ground colour is turquoise green with a note of grey, and the reliefs are coloured pale aubergine, blue and white; the flat back is washed with yellow and has a hole for attachment to a wall. Flat-backed wall vases in form of a gourd are mentioned in the Imperial lists of the period.[1] These medium-fired glazes (of the *demi-grand feu*) are common enough to the whole Ming period; but it would seem that in the early sixteenth century more play was made with thinner and clearer washes of green, yellow and aubergine brown glazes. This is the colour scheme on the Chêng Tê flower pots, and we find the same translucent colours on the Chia Ching wares, whether combined or in monochrome. A marked saucer dish in the Winkworth Collection proves the continuance of this type through the Wan Li period. It has a green ground with incised designs, a vase of flowers in the centre coloured a warm amber yellow and eight symbols on the sides in yellow and aubergine.

Another marked example of the same technique is the jar in the Charteris Collection illustrated on Plate 35. It is decorated with four medallions of Imperial dragons with symbols in the spaces, outlined and filled in with yellow glaze in a beautiful pale green ground. This is a peculiarly fine specimen of a type of vase which appears in several other collections.

Moulded wares, figures and ornaments, with washes of these soft, lead-silicate glazes, were very much in vogue a century later than Wan Li. Père d'Entrecolles gives a very minute description of the manufacture of such porcelains and the composition of the glazes in the second decade of the eighteenth century; and there are a large number of examples in

greater its fusibility and lasting power. In distinguishing the earlier types of these glazes (viz. the opaque, dark violet, etc.) as "harder lead-silicate glazes," and the Chêng Tê types as "softer lead-silicate glazes," it is assumed that the former contained more silica and lime than the latter, and conversely that the latter contained more lead than the former. The soft enamels of the muffle-kiln contain a high proportion of lead, and are fusible at a very low temperature. [1] See p. 112.

the Dresden Collection, doubtless accumulated in the last half of the K'ang Hsi period. It will always be difficult to decide whether pieces of this class belong to the late Ming or early K'ang Hsi period, as neither the technique nor the style of the wares can have undergone any great change at that time. But it would be well to make it the rule to class them all as post-Ming unless one has special reasons for doing otherwise. The burden of proof should be on those who would call them Ming.

One of the exceptions is the interesting ewer in the Hainhofer Cabinet[1] at Upsala (Plate 36). This bizarre piece, shaped like a crayfish on a rock, has a biscuit which as seen under the base is barely distinguishable from that of the K'ang Hsi figures. It is coated with washes of coloured glaze, a leaf green and an aubergine which might be K'ang Hsi, and a blue-green,[2] which is a typical Ming colour. The body is glazed yellow and has been gilt; and the white crests of the green waves are coated with that thin, lustrous and almost colourless wash which does duty for white in the on-biscuit colour scheme. A lotus pod forms the filler of the vessel, and the spout and handle are lotus stems which grow beside the rock on which the crayfish is resting. The collection of which this ewer forms a part was completed in the year 1628, so that this particular piece is definitely authenticated as Ming. There are two other ewers, one in the form of a lobster or crayfish, and the other in the form of a phœnix, in the Dresden Collection,[3] which can be traced in Saxon hands as far back as the sixteenth century. They are of very similar ware: one would say made at the same factory. At any rate, they all probably came to Europe together.

The vagueness of Chinese terminology makes it impossible to be sure that any particular group or specimen described in the Chinese books was definitely painted in enamels on the biscuit; but we have seen good reason to suppose that certain fifteenth-century pieces described in Hsiang's Album were decorated by this method, and we may be sure that a method used at that time was also used in the Wan Li period. In fact, the frequent reference to " wave and plum blossom " patterns in the Wan Li list suggests irresistibly the well-known type with wave spirals washed over with green enamel on which are floating plum blossoms, water-plants and sometimes symbols in yellow, aubergine and white; while over this curling water " sea-horses "[4] or other animals are charging at a flying gallop. Though this decoration is applied over the

[1] See p. 118. [2] See p. 100.
[3] E. Zimmermann, *Chinesisches Porzellan*, Plate 30. [4] See p. 32.

glaze on a late Ming jar (Plate 39, Fig. 3) in the British Museum, it is far more commonly found enamelled directly on the biscuit, and we may be sure that some such pieces were made in the Wan Li period. On the other hand, on-biscuit decoration in this style was freely used in the K'ang Hsi period of the succeeding dynasty, and it is probable that by far the larger number of existing examples of it belong to this later time. At any rate, the only dated piece which has been published[1] bears the cyclical date corresponding to the year 1692.

It may be no more than a coincidence that on specimens like the British Museum jar, of which the shape and general style suggest a Ming date, the decoration is applied over a glaze and not direct to the biscuit. The glaze on the late Ming porcelains was often impure, and it is likely that such faulty pieces were selected for a decoration of this kind, which completely masks the glaze and renders it superfluous.

But the most characteristic Wan Li polychrome, doubtless that indicated by the heading *wu ts'ai* in the Imperial list, is a combination of underglaze blue with enamel colours painted on the glaze. This combination was far from new at the time, but it was now used to such an extent that later writers definitely christened the colour scheme *Wan Li wu ts'ai*, or polychrome of the Wan Li period.

The enamels used are greens, light and dark; aubergine; yellow, usually rather muddy and brownish in tone; the Ming iron-red (*fan hung*), which we know as a rather glossy, tomato red, often iridescent and lustrous; a dry manganese brown pigment used for drawing outlines and also, when covered with green enamel, forming a green-black; and occasionally a turquoise green or greenish blue, which was the nearest approach to a blue enamel so far achieved.[2] All these colours are mixed with a lead flux and fired at the low temperature of the muffle kiln. They are all transparent, except the iron-red and the brown pigment; and, in spite of the Chinese term *wu ts'ai*, they number more than five, without counting the underglaze blue which generally went with them. The fact is that *wu ts'ai* (five colours) had come to express an indefinite number of colours in combination, and is best rendered polychrome.

It is easy to distinguish several distinct types among the Wan Li polychromes. First there is the group in which green, muddy yellow

[1] Hobson, Plate 94, Fig. 2.

[2] For a rare example of a true blue enamel on Wan Li porcelain see Cat. B.F.A., 1910, H. 17. This blue enamel later on was characteristic of the polychrome porcelain of the K'ang Hsi period, and its rare appearance on late Ming ware must be regarded as experimental.

and iron-red alone are combined with underglaze blue. This is seen on some of the heavy and rather coarse beakers and vases of bronze form made for Imperial use; and because the component parts of the designs on these pieces are generally small, the effect is rather checkered, the small patches of blue, green and red standing out rather prominently when viewed from a short distance.

Plate 37 illustrates a very attractive specimen in the Love Collection. It is an ink pallet with openwork on the sides and surrounding the " ink stone " and ink well on the top. Imperial dragons pursuing pearls over sea waves form most of the ornament, and the colours are a good dark blue combined with green, yellow and red enamels; but in the well is a passage of " rock of ages " pattern, with white-crested green waves in an aubergine ground. Under the base is a finely painted Wan Li mark in six characters enclosed by two dragons.

Another piece of writing-table furniture appropriately accompanies it—a brush rest with openwork and moulded reliefs in the shape of three Imperial dragons, and a border of rock and wave pattern below. This piece is painted in similar colours and likewise bears the Wan Li mark. These brush rests usually take the form of three mountains; but in this case the heads of the dragons serve as the peaks.

There are several good examples of this class in the British Museum —a large square beaker,[1] a well-modelled box[2] and a charming little ewer (Plate 38). This last piece has a lobed, melon-shaped body with graceful handle and spout. The glaze has a faintly greenish tone, and the quality of the enamel is conspicuously good. The designs comprise sprays of flowers and fruit on the lobes, and full-face Imperial dragons on the neck below the characters *wan shou* (myriad longevities), a legend appropriate for an Imperial birthday gift.

The wine kettle illustrated by Fig. 1 of Plate 38 is a piece of somewhat similar character. It is moulded with six elegantly shaped sides on which are painted fruiting trees and birds. On the shoulders are medallions of floral sprays with cloud-scrolls between. There are formal borders, and the flat cover is decorated to match. The colours used are underglaze blue of a " very luminous ultramarine " tint and red and green enamels. Under the base is the Wan Li mark in six characters. It is a piece not only distinguished for its elegance, but important for its historic associations. Given by Queen Elizabeth to her chaplain, who was afterwards Bishop Parry of Worcester, it descended in the family to

[1] Figured Hobson, *op. cit.*, Plate 81. [2] Figured *Country Life*, January 1, 1921.

John Parry Nash, who married Susanna Bourne. By the will of this lady it passed, with other relics of Bishop Parry, to the father of its present owner, Dr. Bourne, F.R.S., of Twyning Manor. A silver mount, with a flap on the spout, and a mount on the cover which is attached by a chain to the arched handle, are both engraved with Elizabethan designs, and on one of them are the crossed battle-axes which are the crest of Parry.

The general effect of this colour scheme is well illustrated by Plate 8. It shows a tall beaker-shaped vase of typical Wan Li form decorated in underglaze blue and enamels with bands of ornament admirably adapted to the spaces which they cover. On the neck are two belts with five-clawed Imperial dragons separated by narrow bands of scrollwork. On the bulb are peacocks and peony flowers, and above the base are the " rock of ages " pattern and scrolls of *ling chih* fungus. The mark is written in a horizontal line below the lip.

In the second group we get the full pallette of the Wan Li enamelled ware—green, yellow, aubergine, iron-red and green-black combined with underglaze blue, the designs (often figure-subjects) outlined in a dry brown or reddish brown pigment and the colours laid on in broad washes. The effect of this scheme of decoration is broader and better balanced ; and there are many handsome dishes and jars of this kind, whose only drawback is a tendency to coarseness in the paste and glaze. A good example of this class is the wide-mouthed jar in the British Museum (Plate 39) with a historical scene in garden setting, and borders of floral scrollwork and false gadroons. It has the hare mark which we have already[1] met on late Ming porcelain.

In the list of wares imitated by the Imperial factory in the Yung Chêng period " copies of Wan Li and Chêng Tê enamelled (*wu ts'ai*) porcelain " are included ; and we know from experience that the type of ware just described was exceedingly well rendered by the K'ang Hsi and early eighteenth-century potters, who reproduced the flat, unglazed base and the rather dull blue in an uncomfortably exact manner. Many of these good copies are hard to distinguish from the originals, but probably the nature of the iron-red[2] will help to differentiate them as much as any other detail. On the other hand, large quantities of inferior five-colour ware of this class exported to the Near East in the late Ming period have found their way into the European market. Though coarsely finished, these export wares are not wanting in decorative qualities.

[1] See p. 122. [2] See p. 91.

A third type dispenses with the underglaze blue and is decorated in overglaze enamels only, with a predominance of red and green. This is merely a development of the red and green family described in another chapter.[1]

An excellent example of this kind in the Franks Collection formed part of the furniture of the writing table. It is in the form of a screen and served, in fact, the double purpose of an ink screen, behind which the ink was rubbed on a pallet, and of a brush holder; for at the other side is a square compartment for brushes. The decoration is interesting and, as on all good Chinese pieces, perfectly appropriate. In front of the screen in applied relief is a young scholar standing on the head of a dragon and holding in his hand a branch of cassia (emblem of literary success). This symbolises the phrase " alone upon the dragon's head," in allusion to the customary expedition made by the candidates for the official examination to the top of the " Dragon Head " hill. The belief was that the man who first reached the top would come out top in the examination. On the screen itself is depicted the future state of the successful candidate in a high official chair, attended by a fan-bearer. The remaining ornament consists chiefly of red medallions which have been gilt, and washes of an unusually brown yellow.

The enamels of this piece are characteristic—leaf green, brownish yellow, turquoise green in place of blue, green-black on the hat and boots of the relief figure, and a profusion of deep Ming red to which the iridescence of age has imparted almost a ruby lustre. In places, too, we see remains of gilding, as on the dragon's head.

Other examples of this type were described under the heading of Chia Ching ware, and it is, of course, quite possible that this ink screen belongs to the same period. There is no obvious difference between the enamels of the two reigns; but a blue and white specimen in the Bloxam Collection of the same model as our ink screen, with a distinctly Wan Li blue, accounts for this piece appearing in the present context.

In other pieces the red, painted in patterns and diapers, is less massive in its effect, but none the less dominates the colour scheme. This is seen on a circular stand in the British Museum (Plate 39), with an octagonal panel in the centre containing a full-face Imperial dragon and four radiating panels of dragons, the remaining spaces filled with diaper patterns. It has the Wan Li mark in the border. Another saucer-dish in the same collection, with a somewhat similar scheme of decoration but

[1] See p. 100.

with sprays of flowers as well as dragons in the side panels, though unmarked, is clearly of the same period. Both[1] these are examples of the red and green family, pure and simple.

This type of red and green ware, heavily loaded with bands of diaper pattern, was copied with disconcerting fidelity at a late factory, apparently in the early nineteenth century, which used the mark *shên tê t'ang*. In one interesting specimen the mark includes the words *po ku*, proclaiming the dish in question to be " an antique made at the Shên Tê Hall."

A cup in the historic collection at Upsala[2] should be mentioned here. It is decorated outside with two rows of overlapping petals spirally ranged, outlined in reddish brown and washed over with a thin tomato red, to which are added light touches of gilding. Below is a band of pointed leaves coloured green. Like the rest of the Upsala Collection, it is doubtless of the Wan Li period, although it bears a Ch'êng Hua mark.

A few more polychromes are mentioned under the general heading of mixed colours (*tsa ts'ai*) in the Wan Li list. There are, for instance, garden seats with lotus flowers and dragons among clouds in enamels (*wu ts'ai*) and with "brown" (*tzŭ*) lotus flowers in a yellow ground. The brown colour here is doubtless aubergine brown, and it is not difficult to visualise the general appearance of these pieces. Again, we have tea cups with golden brown (*chin huang*) ground engraved with dragons and lotus scrolls. This appears to be rather monochrome than polychrome. Incense burners with enamelled decoration (*wu ts'ai*) in a yellow ground would suggest something like the K'ang Hsi *famille jaune,* with its enamels applied direct to the biscuit and designs in green, aubergine and white in a yellow background. Wares of this kind have been discussed at some length in dealing with the Chia Ching polychromes.[3]

Many of the " mixed colour " types described in the chapter on Chia Ching ware[4] reappear with the Wan Li mark. There is, for instance, an incense burner in the Eumorfopoulos Collection elegantly modelled with bowl-shaped body, high pierced handles and feet in the form of archaic dragons whose tails are continued up the sides. The dragons and other raised parts are in underglaze blue, and the ground is enamelled with yellow. A similar piece in the Oppenheim Collection was illustrated by Mr. Hetherington in the first volume of this series.[5] The latter collection contains a delightful example of the same colours differently

[1] Figured in *Country Life,* January 1, 1921. [2] See p. 118.
[3] See p. 100. [4] See p. 94. [5] *Op. cit.,* Plate 17.

disposed. It is a small saucer-shaped plate with a dragon design reserved and coloured yellow in a blue ground, the blue " shot with yellow " of the Imperial lists. A square high-footed incense burner in the Winkworth Collection has a design of blue dragons with the ground filled in with iron-red ; and with it is a saucer dish with blue dragons in a full-yellow ground inside, and on the exterior incised fungus designs in turquoise, green and aubergine in a yellow ground.

Fig. 4 of Plate 23 illustrates a rare kind of " mixed colour " porcelain. It is a beaker with brownish yellow glaze and reserved designs strongly outlined in brown and washed in with transparent aubergine, all on the biscuit. On the neck are rocks and flowering plants and insects ; on the bulb, landscape with horsemen and fan-bearers, a fisherman with his creel and a rustic with his ox. The base is glazed and bears the Wan Li mark in blue. Mr. H. B. Harris has a small saucer-dish with similar colouring.

A little cup in the Walter Levy Collection combines so many kinds of decoration that it can only be dealt with under the heading of mixed colours. It is also remarkable for its complex form, a libation cup of *ju-i* cloud-scroll shape with foliate mouth. Sprigs of *ling chih* fungus in applied relief serve as feet and handles, and on one side is an archaic dragon in full relief with a *ling chih* spray in its mouth, its tail winding round the handle (Plate 40).

The decoration is partly in lead-silicate glazes on the biscuit, partly in enamels on the glaze and partly in underglaze blue. The dragon is in a powerful Ming blue under a rather bubbly glaze, while the fungus spray in its mouth is enamelled in red. Except for a few touches of blue which is locally glazed, the rest of the exterior and the border inside are decorated with spiral bands of green, amber yellow and aubergine glazes, with an occasional passage of gilding applied also to the biscuit. An ordinary white glaze lines the well of the cup in which is painted an archaic dragon in red and green enamels. From the nature of the blue one would judge this curious cup to be of the Lung Ch'ing or Wan Li period.

WAN LI (*continued*) AND THE FINAL REIGNS

From the mixed colours one passes appropriately to the subject of monochromes, especially as some of the pieces included under that heading appear to belong to the latter class. We should certainly group the white wares with or without engraved decoration, and the golden brown or yellow with engraved dragons among monochromes. We know that the famous white bowls of the Yung Lo period were still attempted, and that many extremely beautiful white wares were made by the Wan Li potters; and we can assume with confidence that the Hung Chih yellow and the Chia Ching aubergine monochromes were still produced. A beautiful green monochrome, the leaf green of the three-colour scheme, was included in the Pierpont Morgan Collection,[1] a slender vase of beaker shape with dragon handles, and ornament engraved under the glaze; and there is a saucer-dish in the Grandidier Collection with engraved designs—a vase of flowers, etc.—under a green glaze. To these must be added turquoise blue, and without doubt underglaze blue of various shades, such as were used in the Chia Ching period. Celadon green, made also in the now moribund Ch'u Chou factories, was produced to some extent at Ching-tê Chên. This is seen on a bowl in the Victoria and Albert Museum (with French metal mount) with blue decoration inside and a pale celadon glaze on the exterior. A low bowl with pale clair-de-lune celadon glaze in the Eumorfopoulos Collection has a mark[2] stating that it was made " to be treasured in the Ju-ch'êng family in the *hsin mao* year of Wan Li " (i.e. 1591). A Ming apple green vase in the British Museum makes it more than probable that apple green should be added to the list; and lustrous brown of the " Nanking yellow " type seems to be indicated by the *chin huang* (golden brown) which we found coupled with *tzŭ chin* (dead-leaf brown) in the Chia Ching lists.

The attempts at making underglaze red from copper probably resulted from time to time in unexpected flambé effects. These, classed as *yao pien* (furnace transmutations), are mentioned with superstitious awe in some of the older Chinese treatises. The appearance of such phenomena

[1] Cat. G. 16. [2] See p. 195.

had been enough to cause the potters on one occasion to break up the furnace and take to flight; but later their meaning was understood and the accident was turned to good account. It does not appear that the potters of the Wan Li period had yet learned to control the capricious *flambé* glazes as their descendants did in the next dynasty; but there is a bottle-shaped vase in the British Museum which may have been one of the accidents of this time. In general style it seems to be a Ming piece, and its glaze is a good *flambé* of crimson red shot with blue and grey opalescence. Another monochrome occasionally found in company with a Wan Li mark is a thick, lustrous black,[1] something between the " hare-fur " or " temmoku " glaze of the Sung pottery and the fine mirror black which is claimed by Père d'Entrecolles as a K'ang Hsi invention.

A tiny bottle-shaped vase with cylindrical body in the British Museum, with a fine black glaze of this kind shading off into lustrous brown, has the Wan Li mark, but it is not a convincing specimen and may well be a later copy of a Wan Li type. Plate 42, on the other hand, figures a beautiful black vase in the Calmann Collection, in Paris, which has all the signs of Ming origin. It has a lovely sleek, black glaze which breaks here and there into passages of lustrous brown. The brown emerges prominently where the glaze has run thin on the raised parts, and conversely the black is more intense where the glaze has run thickly.

Monochromes with the Wan Li mark are exceedingly rare, and, though one may be confident of their existence in all the varieties enumerated above, the identification of individual pieces must perforce rest mainly on the very arguable basis of style.

Two other kinds of decoration, which would probably have been placed under the heading of mixed colours if they had figured in the Imperial lists, are marbling and ornamenting with slip (liquid clay) on a coloured ground. Marbling or " graining," effected either by blending clays of two or more colours in the body, or else by working together two or more coloured " slips " of liquid clay on the surface, is a process as old as the T'ang dynasty. It is not by any means common on Ming wares; but it happens to form part of the decoration of a figure in the Eumorfopoulos Collection,[2] which is otherwise interesting as bearing the inscription " modelled by Ch'ên Wên-ching in Ting yu year of Wan Li " (i.e. 1597).

[1] See p. 138. [2] See Cat. B.F.A., 1910, K. 37.

Another kind of slip-decoration is more common and certainly more attractive. The use of white slip on a white or celadon ground is familiar on K'ang Hsi and later porcelains, on which it was applied with great delicacy and taste. Père d'Entrecolles describes the process at the beginning of the eighteenth century, giving the interesting information that the white slip was formed of *hua shih*, or steatite. The Ming slip ware, however, is different in many ways from this. The steatitic slip is opaque and rather like white paint : the Ming slip is apparently liquid porcelain-clay, white and translucent. It is usually applied thickly to give it body, and more or less modelled with the brush—in the manner of its delightful descendant, the *pâte sur pâte* of Sèvres and Minton manufacture. The background used to set off the white slip design was usually a deep blue glaze, sometimes lustrous brown, and more rarely a celadon, and the designs are usually floral, freely but artistically executed (see Plate 43).

Surviving examples, mainly bottle-shaped vases, flower pots, bottles shaped like narghili bowls, ewers and jars, many of which have come from Persia and India, belong to the rougher type of Ming and were probably made for export. It is probable that they are largely the product of one particular factory, for they have, as a rule, a strikingly similar body, glaze and finish of base. The ware and perhaps the factory survived long after the Ming period ; but a good many of our specimens can be safely assigned to Ming (some even to early Ming) on the score of their form and style. Moreover, there are a few known pieces with the Wan Li mark, and there is a flower pot in the British Museum with the Jade-hall mark (in a blue and white cartouche under the base), which we have good reason to regard as a late Ming mark.[1] This latter piece is a cylindrical flower pot resting on three rudimentary feet : it has a dark lustrous, coffee brown glaze and a white design of kylin in flames and cloud-scrolls, and flowering plants in a border above them.

One of the most interesting examples of the brown-glazed slip ware is the piece exhibited by Lord Swaythling at the Burlington Fine Arts Exhibition in 1910. It is a jar mounted in silver as a tea pot at a period about which opinions appear to differ, though none date it later than the seventeenth century. Like so many interesting mounted pieces, this was formerly in Burghley House.

An interesting bowl in the Grandidier Collection in the Louvre has slip designs in a blue ground outside and underglaze blue painting

[1] See p. 125.

in late Ming style within. In some cases the glaze covers the slip ornament, while in others the slip is left dry. Examples of this class of decoration on a larger scale are seen, in the Louvre on a jar with a design of storks in a curious pinkish yellow biscuit over a white ground, and in the Benson Collection on a magnificent potiche with white slip lotus-scrolls on a deep blue glaze.

Another type of ornament scarcely distinguishable from the slip decoration takes the form of shavings and strips of porcelain clay applied in relief and tooled or worked up with a wet brush. A bottle in the British Museum (though possibly not of the period indicated) illustrates this process. It has on one side a clump of lilies in applied white biscuit, and on the other a stanza of verse with a seal painted in white slip. The ground colour of the vase is a brown-black glaze similar in character to that used on the old Tz'ŭ Chou wares, but there is white glaze inside and a square patch of white under the base in which is the mark in greyish blue, *Wan Li kêng shên*—a cyclical date giving the year 1580.

Black glazes, which are uncommon on Ming porcelain, are discussed elsewhere[1]; but it is worthy of note here that an incense vase in the Eumorfopoulos Collection with a similar brown-black glaze has also an applied design in white biscuit, in this case a dragon in high relief.

Similar technique with marked difference of execution is observed in a large dish in the British Museum, which introduces us to a very interesting and debatable group of export Ming wares. The dish in question is of deep saucer shape, heavily built and covered with a slaty blue ground on which are plant designs with peculiar feathery foliage traced in white slip in a skilful but mannered style. The base of the dish discloses a strong, coarse ware, burnt reddish brown where free of glaze, and rough with adhering sand and grit round the foot-rim.

Other specimens with the same treatment of the slip and the same rough, sanded base have a celadon or coffee brown ground, the latter either in dark or light shades; and by the unmistakable character of the base we are able to recognise other members of this family with different types of decoration, viz. a rather coarse and greyish blue and white, a polychrome roughly painted in Ming turquoise green or leaf green and red, and an impure white ware with incised designs. Much of this ware is found in India and in the East Indies. Mr. Hunt[2] describes a hundred

[1] See p. 136.

[2] *Old Hyderabad China*, by E. H. Hunt, M.A., *Journal of the Hyderabad Archaeological Society*, January, 1916.

dishes of the white variety in the Bibi Maqbara at Aurangabad, a collection of porcelain which belonged to Aurangzeb or, as some say, to Akbar; and he illustrates a dish with red decoration (Koranic verses) and an inscription stating that it was made for Khan Khanan, servant of Akbar Shah. Khan Khanan, Akbar's commander-in-chief and governor of Gujrat, was born in 1556 and died in 1626.

Fragments of the blue and white, enamelled and white types were dug up at Bijapur, a city which was destroyed by Aurangzeb in 1686; and, apart from the style of the ware and the nature of the enamels, there is no lack of evidence pointing to the late Ming period as one of the times of its manufacture. Probably it continued to be made after the Ming dynasty.

It is not easy to discover the origin of this ware, which must have been freely traded by sea. It may have come from some Chinese provincial factory and have been shipped perhaps from the Fukien sea-ports which traded largely with the Eastern Archipelago. On the other hand, it has been customary among many collectors, especially in the United States, to speak of this type as Corean, a suggestion which did not previously commend itself in the absence of any evidence of sea-borne trade between Corea and the East Indies.

It would seem, however, that such evidence is now forthcoming, for among a few fragments of pottery,[1] found in excavating a cave in Borneo, there were types which are usually associated with Corea. One is a rough porcelain with decoration in relief under a pearly white glaze. It is true that this type is *sub judice,* and the question whether it is Northern Chinese or Corean is still debated. But the other was a celadon with brown slip-painting under the glaze, known in Japan as *e-gorai* and almost exclusively associated with Corean kilns. Further, a celadon of thoroughly Corean appearance has been found in excavation in the Philippines[2] by the Honourable Dean C. Worcester, which suggests a trade with Corea at some period in the past; and we know from the observations of travellers in the East as early as the sixteenth century that Corea was in possession of a very large merchant fleet.

Given, then, the possibility of trade between the Hermit Kingdom and the Southern Seas,[3] it is necessary to consider seriously the persistent

[1] In the British Museum. [2] *Pennsylvania Museum Bulletin,* February, 1922, p. 11.

[3] It certainly existed in the Sung dynasty, for porcelain is actually mentioned as one of the articles exported from Corea to Ch'üan-chou Fu in that period. See Hirth and Rockhill, *op. cit.,* p. 168.

attribution of this group of late Ming wares to some Corean factory; and it must be admitted that the curious rusty red ware and sanded edges of the base are most closely paralleled in some of the late Corean blue and white. There is one particular jar in the British Museum, of sixteenth or seventeenth-century date, which has a remarkable similarity in the ware at the base, in the greyish crackled glaze and in the scrawled designs in impure blue. Similarly the white dishes, with their impure greyish glaze, can be readily paralleled among the coarse Corean white wares of this time. The other types have not yet emerged among undoubted Corean pottery; but they are quite *sui generis* and must have been the work of some particular factory, whether in China or Corea. Perhaps there is hardly enough evidence yet to decide the question one way or the other; but there are at least good reasons why Corea should not be left out of consideration.

The ill-assorted union of lacquer and porcelain which is seen on wares of a later period, both Chinese and Japanese, was fortunately uncommon in the Ming period; but a vase in the British Museum shows that it did occur in the reign of Wan Li. The piece in question is a typical Wan Li beaker of square form[1] with lion-masks on the sides to hold ring handles, the kind of vase which we have seen decorated with Imperial dragons, or dragons and phœnixes, and "rock and wave" borders in underglaze blue or in the Wan Li five colours.

Here the same design, Imperial dragons and "rock and wave" borders, is rendered in green and red lacquer in a brown ground, the details incised and touched with gilding. The Wan Li mark (as usual, on the lip) and the lion handles are painted in blue and glazed; but the rest of the surface is unglazed and left rough to receive the lacquer, which covers it completely. As an example of Ming lacquer it is interesting, for the workmanship is good and the lacquer of fair quality; but the tendency to break away from the ground, which is seen in several places, shows that porcelain was not a suitable excipient for the lacquer, and it is unnecessary to add that the lacquer, being opaque, completely obliterates any attractions which the porcelain itself may possess.

The *T'ao shuo* condescends to mention a few of the wares made at private factories when it has concluded the descriptions of the Imperial Wan Li porcelains. Allusion is made elsewhere[2] to one of these favoured wares, the copies of Ting porcelain made with great success by Chou

[1] Figured and described in the *Burlington Magazine*, June, 1922.
[2] See p. 107.

Tan-ch'üan and with rather less by his followers; and another reference to " oblong seal-boxes copied from Ting-chou porcelain" is quoted from the *K'ao p'an yü chih*. Some of these latter were painted in blue on the white ground, while others were plain white. They were apparently a novelty of the time and exceedingly popular, especially those between six and seven inches long. By " seal boxes" is meant boxes for holding the vermilion used in sealing, part of the furniture of the writer's table; and the mention of blue decoration suggests the so-called soft-paste blue and white of which the little vermilion boxes of later date were so often made.

In the K'ang Hsi period, according to Père d'Entrecolles, this class of blue and white differed from the ordinary in having steatite (*hua shih*) blended with the body or washed over the surface. The resultant ware is usually opaque and rather earthy in appearance, and the glaze is almost always crackled. It is mostly found in small objects carefully finished and very finely pencilled with the best blue.

The crackled surface, especially if the ware was creamy in tone, would recall the *t'u* Ting ware (or " earthy Ting ") of the Sung dynasty. On the other hand, it is quite probable that these celebrated seal boxes of the Wan Li period were an early version of " soft paste," or steatitic porcelain.

The story of a distinguished private potter is culled from the *Ch'ih pei ou t'an*, a late seventeenth-century book. Enumerating the most skilful craftsmen of recent times, this work gives the palm to P'u Chung-ch'ien for carving bamboo; to Chiang Ch'ien-li for work in mother-of-pearl; to Chang Ming-ch'i for the copper incense burners of Chia-hsing Hsien; to Shih Ta-pin for the earthenware teapots of Yi-hsing; and to Hao Shih-chiu for the " dawn-red cups of Fou-liang Hsien." Further information is quoted from the *Chü yi lu* to the effect that Hao Shih-chiu[1] lived in the reign of Wan Li, and that his porcelain was of " perfect design and surpassing beauty. The egg-shell wine cups which he made are of translucent whiteness and delicate fabric, each one weighing not more than half[2] a *chu*."

The cups for which Hao was so famous are described as *luan-mu pei*, cups as thin as the curtain inside an egg, the acme of tenuity. Their colour is *liu hsia* (floating red clouds), which has been rendered by Bushell " dawn-red " and " liquid dawn," suggesting a surface clouded with rosy red. The *T'ao lu* adds that his cups (*chien*) were brilliant as vermilion, and that his wine cups (*pei*) were charming in their whiteness and brilliance.

[1] See page 196. [2] Less than a gramme.

We are further told of Hao that he was a man of letters who wrote verses in the style of Chao, a former president of the Han-lin College ; that he was simple and not covetous of gain, living in a " hut with a mat for a door and a broken jar for a window : and yet he was a man of culture and not to be dismissed as celebrated for this one art only."

He was, in fact, sought out by men of learning who admired his wares and exchanged verses with him, such as that quoted in the *T'ao shuo,* which ends with an encomium of the red wine cups :—" I know you, Sir, as the maker of dawn-red wine-cups, fit to be started from the orchid-arbour to float down the nine-bend river."[1]

It would be perhaps too much to expect that examples of this ethereal ware should have reached us to-day, but we can imagine it in the form of tiny wine cups, with underglaze red of clouded crimson shades such as one sometimes sees on choice cups of the early eighteenth century. But apparently Hao had other specialities, " elegantly formed pots (*hu*), in colour pale green, like Kuan and Ko wares,[2] but without the ice-crackle ; and golden brown teapots with reddish tinge, imitating the contemporary wares of the Ch'ên family at Yi-hsing, engraved underneath with the four characters, *Hu yin tao jên* " (the Taoist hidden in a teapot). The inner meaning of this mark is explained in the *T'ao lu,* where Hao's wares are described under the heading of *Hu kung yao,* an allusion to the story of the magician Hu Kung. Hu Kung, who was credited with marvellous powers of healing, had the disconcerting habit of disappearing every night, and it was found at length that he retired into a hollow gourd which hung from the door-post. In like manner Hao concealed his identity in the pots which he made with such skill.

The *T'ao lu* has a further reference to the work of private factories in the *Hsiao nan* street (Little South Street) ; but the account is not very clear and we are left in doubt as to the precise nature of the wares. They were, we are told, of small size only, " like a squatting frog," and for that reason they were called frog wares (*ha ma yao*).

" Though coarse," the account continues, " they were of correct form :

[1] This is an allusion to the doings of a coterie of scholars in the fourth century known as the Worthies of the Orchid Pavilion. The incident of the floating wine cups is depicted on a *famille verte* vase in the Hippisley Collection. See Hobson, Plate 104.

[2] A wine ewer in the Oppenheim Collection of the typical Ming form, with pear-shaped body and long, slender spout and handle, has a thick glaze of pale clair de lune or " egg white " colour, recalling the Kuan or Ko type. Though it has developed a wide crackle, it is a piece worth noting in connection with the description of Hao ware.

the material was yellowish, but the body of the ware was thin; and though small the vessels were strong. One kind of bowl was white in colour with a tinge of blue and decorated in blue with a single spray of orchid or bamboo leaves; and even those which had no painted design had one or two rings of blue at the mouth. These were called ‘ white rice vessels.’ There were, besides, bowls with wide mouths and flattened rims (*p‘ieh t‘an*), but shallow and pure white, imitating the Sung bowls. All these wares had a great vogue both at the time and at the beginning of the present (i.e. Ch‘ing) dynasty.”

The meaning of this last extract is fairly clear, though we are not definitely informed whether these wares were porcelain or otherwise. The yellowish material might well imply an earthy type of ware like the creamy white *t‘u Ting* of the Sung dynasty, or a porcellanous stoneware. But the chief difficulty is to explain the first part of the extract and to reconcile the allusion to a frog with the bowls described afterwards. A simple explanation is that the comparison with a frog only had reference to the size of the wares, implying that they were all no bigger than a squatting frog. It is not quite as vague as “ the size of a lump of chalk,” but it is certainly an elastic standard of measurement; and it could hardly be regarded as such a happy expression that the wares should be called “ frog wares ” to commemorate it. On the other hand, if we take the frog simile literally, it does not seem applicable to the obviously rounded bowls detailed in the second part of the account.

One can only suggest that the story as given in the *T‘ao lu* is a confusion of two accounts, each referring to different types of ware made in Little South Street, and that the name of frog wares was given them because the potters had specialised in small frog-shaped ornaments and vessels, which were evidently rather popular in China. One has seen such in various makes, dating from the Sung dynasty onwards, and generally taking the form of water holders or water droppers for the ink on the writing table. An ornament of frog-shape made in the late Ming period is among the contents of the famous Hainhofer Cabinet at Upsala. It is figured by Dr. Böttiger in his learned work on the cabinet[1] and described as “ grey-brown highly vitrified ware,” a coarse porcelain, in fact. It appears to be merely an ornament in the form of a squatting frog, two and a half inches long, with half-open mouth. The body is covered with dots of white clay, the mouth is lined with similar white and the prominent eyes are white with black-brown pupils. It is certainly *ha ma*

[1] *Op. cit.*, Plate 107, Fig. 1.

yao and of late Ming date, and might have been made in Little South Street itself.

Mr. Vernon Wethered has a pair of ornaments in the form of squatting frogs (Plate 40) which have a general resemblance to the Hainhofer piece. They are, however, white porcelain, and the dots which cover the animal's skin stand out in a ground washed with pale green. The rectangular plinths on which they are mounted are mottled with green, yellow and dark aubergine patches. This mottled decoration, variously known as " tiger skin " and " egg and spinach," though more common on K'ang Hsi wares, is seen on a late Ming saucer-dish in the British Museum[1] ; and it is possible that Mr. Wethered's frogs belong to the same period.

THE END OF THE MING DYNASTY

After the death of Wan Li the days of the Ming dynasty were numbered. T'ai Ch'ang occupied the throne for a few months only in 1620, and T'ien Ch'i, who succeeded him (1621–27), devoted his energies to carpentry while a eunuch and a nurse held the reins of power. The last of the Mings to rule in Peking was Ch'ung Chêng (1628–44), and history depicts him as a good man struggling with adversity. The fortunes of the dynasty had been irrevocably lost by his incompetent predecessors ; and though he did his best to retrieve them, the forces of internal rebellion and the outside pressure of the Manchus were too much for him to resist ; and, when at last the gates of Peking were treacherously opened to the rebels, Ch'ung Chêng mounted the Mei Shan (Coal Hill) which commanded a view of the captured city and hanged himself with his own girdle. Futile attempts were made to establish surviving members of the Imperial family as Emperors at Nanking, then at Hangchow and then further south ; but it was only a matter of time before these successive claimants were overthrown by the advancing Manchu forces. The final stand of the Mings was made in Kwangtung ; and Kuei Wang, the last of the dynasty, eventually took refuge in Burma. But he was pursued there by the relentless San-kuei ; and, when on the verge of being surrendered, committed suicide in 1662.

During these grim dynastic struggles we hear nothing of the Imperial factory at Ching-tê Chên, and we are left to build up the story of the wares from such dated specimens as have come into our hands. The

[1] See p. 145.

material, it must be confessed, is scanty and, on the whole, of indifferent quality, if we except the fine specimen of pierced ware in the Marsden Perry Collection,[1] which shows that the skill in *ling lung* work had not been lost by the potters. Two polychrome saucer dishes in the British Museum give an impression of coarse ware and workmanship and inferior coloured glazes. One, decorated with an engraved dragon filled with purple glaze in a green ground, is authenticated by the T'ien Ch'i mark (Plate 44); and the other is of very similar material, covered with a motley of green, yellow and purple aubergine, in crude patches, a decoration variously known as " egg and spinach " and " tiger skin." In both cases the glazes are applied direct to the biscuit. It may be that some of the so-called " brinjal bowls," with engraved floral sprays in green on an aubergine ground, or in aubergine or yellow on a green ground, belong to this period, though it is certain that the type persisted for long afterwards.

The T'ien Ch'i mark also occurs on a few specimens of blue and white such as a small barrel-shaped incense vase and a bowl in the British Museum, the former painted with floral scrolls in a dull greyish blue, and the latter with four-clawed dragons in a bright but unpleasing shade of the same colour. The ware in both these examples is coarse. Two pieces of better quality are the pair of small jar-shaped vases with floral sprays in blue which have the mark *t'ien* (heaven). But, though these are claimed by some authorities to belong to the T'ien Ch'i period on the strength of the mark, the attribution must be regarded as doubtful. The mark of the Ch'ung Chêng period is rarer still. It occurs on two little wine cups in the same collection, painted in greyish blue under an impure glaze, with geese and rice plants.

It is probable that, if the Imperial factories were at this time in a state of suspended animation, the private factories were kept occupied with an increasing foreign trade added to the current demands for home consumption. The Portuguese at Macao and the Spanish in the Philippines had shared the direct China trade for upwards of a century. The Dutch now appeared in the field. Their settlement in Batavia had served as an entrepôt since 1602, and in 1624 they obtained a foothold in Formosa. The Dutch were very large importers of Chinese porcelain, especially of the blue and white, and we find the Chinese now beginning to modify the forms of their wares to suit European requirements. Such shapes as the cylindrical tankard, with a hole in the handle for the

attachment of a metal cover, began to be made. Mr. R. E. Brandt has an interesting example of this kind of vessel[1] with a Dutch mount, which can be dated between 1632 and 1648. It has characteristics common to a considerable group of blue and white porcelain which we can safely regard as typical of the transition period between Ming and Ch'ing. This is a ware of strong build, suitable for export and of good material, with a clean white body often left unglazed on the flat base. The glaze is thick and rather bubbly, and the blue is of a bright violet tone which, seen under the bubbly glaze, suggested the graphic simile of " violets in milk."[2] The decoration, too, has frequently repeated characteristics which seem to indicate the use of a set of stock patterns. A common type is a figure scene set in a landscape, with a wall of rocks emerging from swirling clouds and grass expressed in a mannered fashion by a series of V-shaped strokes. Borders of stiff leaves, rolling foliage and a formal plant design suggestive of a tulip, are further traits by which this transition ware can be recognised (Plate 44, Fig. 1).

A curious piece in the British Museum, which bears the insignia of this group in the tulip ornament on the neck, is also interesting for the European origin of part of its ornament. In shape a pilgrim bottle with flattened circular body, it has on one side a representation of a Spanish dollar framed in a strapwork border. There is considerable margin for dating the dollar, which would serve equally for several Spanish reigns ; but the style of the ware seems to indicate that it belonged to the period of Philip IV (1621–65).

A comparison of the peculiarities in design and material of this transition blue and white enables us to include in the group a number of polychromes decorated in enamels and underglaze blue in accordance with the Wan Li colour scheme. Wares of this kind are still to be found in considerable quantities and must have been plentifully exported to Europe and the Near East. A variation occasionally seen on wares of this time is a wash of transparent green glaze over a blue and white. There is, for instance, an elegant beaker in the Grandidier Collection in the Louvre with a green wash over a blue design of transition type ; and Mr. Eumorfopoulos has a dish of typical late Ming export ware, with deer in landscape in Persian taste, washed over with green. The latter one would judge, from the character of the ware, to be of the T'ien Ch'i period. A monochrome beaker in the H. J. Yates Collection seems to

[1] See *Country Life*, January 29, 1921, Fig. 10.
[2] See F. Perzynski, *Burlington Magazine*, December, 1910, and March, 1913.

belong to the transition period. It has a dark violet-blue glaze over the design, etched in the paste.

Another feature common to this late Ming group and to some of the Wan Li wares is a faint border of formal scroll-work or some cognate design etched with a point under the glaze. It is well to draw attention to this feature of the ware, because it has been erroneously stated that this engraved border was only used on and after the Yung Chêng period.

FUKIEN WARES

The province of Fukien has been noted for its potteries from early times. The towns of Chien-an and Chien-yang in the Chien-ning district were celebrated in the Sung dynasty for their tea-bowls of dark brown earthenware with thick, lustrous, purplish black glaze streaked or mottled with brown and silver. These bowls commended themselves to tea drinkers in pre-teapot days, both for their colour and for the thickness of their glaze; and the Japanese, with whom the tea ceremony is still a national cult, set a very high value on good examples of the ware which they call *temmoku*. But this early phase of Chien yao, or Fukien ware, is discussed by Mr. Hetherington in the first volume of this series, and we know little of its history after Sung times. There is, however, a small and insignificant pot in the British Museum with buff stoneware body and translucent brown glaze which may be a lineal descendant of the Sung Chien ware. At any rate, it was found in a tomb in the Chien-ning district which was dated by an inscribed slab to 1560.

But it is evident that by this time the glory of the Chien-yang factories had departed. In fact, the term Chien yao was now transferred to a ware of a very different type, made rather more than a hundred miles south at Tê-hua (Tehwa) in the Ch'üan-chou district (Chüanchowfu). This is a very beautiful white porcelain, which the *T'ao lu* informs us was first made in the Ming period, adding that " the cups and bowls usually had a spreading rim, that the ware was known as *pai tz'ŭ* (white porcelain), that it was rich and lustrous, but, as a rule, thick, and that the images of Buddha were very beautiful." A note in the K'ang Hsi Encyclopædia tells us, further, that the clay was mined in the hills behind the Ch'êng monastery and was very carefully prepared; adding that if the porcelain was potted too thin it was apt to lose shape in the firing; if too thick it was liable to crack, and that consequently it was at first very expensive, but by the time of writing (*circa* 1700) it was widely distributed and no longer dear. Beyond these scraps of information we can learn little about the ware from Chinese writings.

There is, however, no lack of actual examples of the Tehwa porcelain

in our collections, and they bear out and supplement the meagre Chinese descriptions. The porcelain is certainly rich and lustrous. It has a white, glassy body and a soft-looking, mellow glaze which blends[1] so closely with the body that it is difficult to see where the one ends and the other begins. The colour varies from milk white to cream white, sometimes suffused with a rosy tinge; and the texture of the glaze has been aptly compared with milk jelly or blancmange. The porcelain is, as a rule, of considerable thickness. Indeed, a brief appreciation of the ware in a late Chinese ceramic book tells us that " when the glaze is white like jade, glossy and lustrous, rich and thick, with a reddish tinge, and the biscuit heavy, the ware is first quality." But in the rare case where a thin piece has safely passed through the dangers of the kiln it is scarcely distinguishable from milk glass. " Cups and bowls " are of frequent occurrence, and the cups often take their form from ritual vessels of horn and bronze. Other favourite objects are incense burners, brush pots, brush washers, water droppers and other small ornamental objects used on the writing table. But whether it was because the nature of the material was peculiarly suited to figure modelling or because the Fukien folk, well known for their religious zeal, were naturally impelled towards religious sculpture, we have plentiful evidence that " the images of Buddha were very beautiful "—a comprehensive phrase which includes images of all kinds of Buddhist and Taoist deities. To this category may be added figures of mortal men (sometimes Europeans), birds and animals in great variety.

The other wares, too, apart from the statuary, are often most artistically modelled; and if ornament is added, it is in the form of applied reliefs (prunus sprays, etc.) or incised designs.

Painted Fukien porcelain is the exception and is generally roughly executed; but there are a few examples with Ming shapes (such as the double-bottomed hot-water bowl in the Eumorfopoulos Collection) and with designs in green, red, yellow and the typical Ming turquoise green. Such pieces as these, though of indifferent quality, may be ascribed with some confidence to the Ming period. But the dating of the pure white pieces (and the really choice Fukien is always pure white) is another matter. It is one of the most difficult problems in the study of Chinese

[1] In spite of this apparent blending of body and glaze one meets with specimens in which the glaze has crazed and become discoloured. A beautiful bottle in the Eumorfopoulos Collection, with prunus design and probably of Ming date, is affected in this way. See Hobson, *op. cit.*, Plate 86.

porcelain, and its solution is not helped by the easy-going method of the auction room and the trade which labels indiscriminately as Ming any Fukien figure of the slightest merit.

The theory that the pinkish white variety is Ming, is equally useless, since there are specimens of the finest quality of this type demonstrably K'ang Hsi. The reputed Marco Polo vase at Venice, and the Crusader plate at Dresden are no longer to be taken into serious account,[1] and we are practically thrown back on our own resources to date individual specimens of a plain white ware which preserved its traditions for at least three centuries.

That some of it is Ming, is obvious. Chinese authorities tell us that the industry began in the Ming dynasty, though it is implied[2] that the porcelain was rare and costly owing to difficulties of manufacture at a period not far removed from the end of the Ming dynasty. We can trace a good deal of the Fukien ware back to the late years of the seventeenth and the beginning of the eighteenth centuries by the close copies made in Europe at our earliest porcelain factories. The French in particular, who call the ware *blanc de Chine*, succeeded in making wonderfully close copies of it at St. Cloud and elsewhere ; but this does not take us back as far as Ming.

There is, it is true, a little white cup with sixteenth-century mount in the Dresden Collection,[3] but it is scarcely distinguishable from others in the same collection acquired about 1700. Occasionally the form of the piece or some point of style will give a hint of Ming origin ; but in the case of figures, especially religious figures of long-established type, it is hardly possible to speak with any certainty. Indeed, it will be wise, as a rule, to concentrate on the quality of the ware and leave the question of Ming or Ch'ing alone.

With these considerations in mind we have confined our illustrations to two good examples of Fukien modelling. The finer Fukien white figures are unrivalled in Chinese statuary, and the exquisite quality of the material, so skilfully modelled, will arouse enthusiasm in the least susceptible. Very many of them, as already hinted, are religious subjects, figures of Buddhist deities and Taoist genii, by far the most frequent being images of Kuan-yin (Plate 45, Fig. 1). This deity appears in various guises, but her most popular form is that of " Kuan-yin the maternal," with a child in her arms. Her statuettes are innumerable,

[1] Hobson, *op. cit.*, vol. ii., p. 113.
[2] See p. 149. [3] Hobson, *op. cit.*, Plate 87.

many of them coarse and common objects, others infinitely gracious. Incidentally the Kuan-yin group has a superficial resemblance to the Madonna and Child, a coincidence noted and exploited by the early Jesuit missionaries ; and we know that some of these Kuan-yin Madonnas are preserved in a Japanese museum among the relics of early Japanese Christianity. There are good examples of Fukien figures in most of our large collections, none better than those in the Salting Collection in the Victoria and Albert Museum. The latter include a cleverly modelled figure of Bodhidarma[1] crossing the Yangtse on a reed and a superb Kuan-yü,[1] the hero of the Three Kingdoms, who was canonised in the twelfth century and elevated to the position of God of War in 1594 under the name of Kuan Ti. On the other hand, Fig. 2 of Plate 45 strikes a more personal note. It represents a Buddhist monk with rosary, carefully modelled in ivory-white ware of the finest quality ; and there is something about its unidealised form and very human features which suggests a portrait taken from the life.

Besides the Tehwa factories there were doubtless many other provincial potteries where porcelain of a more or less inferior kind was made. The *T'ien kung k'ai wu*, a late seventeenth-century manual, quoted in the K'ang Hsi Encyclopædia, mentions a few places where the necessary white earth was found. These include Ting Chou in Chihli (see p. 183) ; Hua-ting Chou in the Ping-liang Fu in Shensi (apparently the modern Hwatinghsien in the Pingliang district, now in Kansu) ; P'ing-ting Chou in the T'ai-yüan Fu in Shansi ; Yü Chou in the K'ai-fêng Fu in Honan ; Tê-hua Hsien (see above) in Fukien ; and Wu-yüan Hsien and Ch'i-mên Hsien in Anhwei. The two last supplied Ching-tê Chên.

The Tehwa porcelain we know. As for the rest, we are told that the ware made in the districts mentioned was generally yellow and dull, and that all put together did not equal the Jao Chou (i.e. the Ching-tê Chên) porcelain.

We are not expressly told, though it is probable enough, that factories existed in the Shensi and Shansi districts in the Ming period ; but in any case we know nothing of their productions, and it is only worth while to remember their existence in view of the miscellaneous wares of obviously provincial make which appear in the market from time to time.

Mention is also made in the Annals of Ch'üan-chou Fu in Fukien of white porcelains made at Tz'ŭ-tsao and in the An-ch'i district, to the

[1] See *Country Life*, February 11, 1922.

south of Tehwa, which are also estimated as inferior to the Jao-Chou ware ; and a white porcelain was mentioned in the Annals of Shao-wu Fu, in the north-west of the same province, as a product of the district, but again far from equalling that of Jao Chou. These may or may not have been Ming wares.

The district of Wên-chou Fu (Wenchow), formerly in Fukien, and now placed in Chekiang, was noted for its pottery in very early times. Incidentally it is not far down stream from Ch'u-chou Fu and Lung-chüan, the homes of celadon. We have no official record of porcelain made in this district, but a blue and white figure—a seated deity—in Ming style, in the British Museum, came from China under the description of Wên-chou ware. This evidence, though not decisive, must be taken into consideration when dealing with other and similar figures which are not unknown to collectors. Another debatable specimen in the British Museum, a bottle with designs painted in Ming style in a soft, pleasing blue,[1] bears the mark " made on the borders of Fukien," which might apply to such districts as Shao-wu Fu or Wên-chou Fu. But beyond these few problematic pieces we have nothing in our collections which can be reasonably connected with the outlying Fukien factories ; and, as we do not even know if these factories were active during the Ming period, it is hardly profitable to pursue the subject further.

[1] *Burlington Magazine*, October, 1910.

CHAPTER XIV

SURVIVORS OF THE SUNG POTTERIES

CELADON

The glory of the Lung-ch'üan celadons belongs to the Sung dynasty, when the most prized of all this class of ware, the grey-blue celadons, were made. These beautiful wares, for which modern collectors have adopted the Japanese name of *kinuta*, have been treated in Mr. Hetherington's volume and need not be reconsidered here at any length, although it may be that we have been too hasty in assuming that the manufacture of them had ended before the Ming period. Many examples, particularly waste pieces from the kiln sites, have reached us in the last few years; and the forms of some of them have set us wondering if the manufacture might not, after all, have survived into the Ming dynasty. We have very little positive information about the industry of the Lung-ch'üan district of Chekiang, though we have reason to believe that its culminating period was reached during the lives of the Ch'ang brothers who lived, at the end of the Sung and beginning of the Yüan dynasties,[1] in the market town of Liu-t'ien. The *T'ao lu* further informs us that the Lung-ch'üan potters moved to their prefectural city of Ch'u-chou at the beginning of the Ming dynasty, and that the ware made on the new site, though similar in style to the old, was not so good. Local tradition states that the industry came to an end at the close of the Ming dynasty.

The typical Ming celadon has a greyish white porcelain body and a sea green glaze of unusual thickness which varies considerably in tone. The presence of iron in the clay of the district, while doubtless helpful[2] in the development of the celadon tint, is apparent in the rusty brown colour which exposed parts, such as the foot-rim, assumed in the firing. This characteristic of the Chekiang wares is very noticeable in the broad ring which so often distinguishes the bottoms of plates and dishes, and

[1] This statement is taken from the *T'u shu*, Bk. ccxlviii., fol. 13.

[2] The recipe for the modern celadon glaze is a mixture of ferruginous clay with the ordinary porcelain glaze, with or without a pinch of cobalt.

which has been considered by some authorities to be peculiar to the Ming period. There is, unfortunately, good reason to regard this easy method of distinguishing Sung and Ming celadons as unreliable. Nor can any simple rule of thumb be extracted from the decoration of the ware, which followed the Sung traditions, the designs being incised or carved, pressed on moulds or applied in relief. The only sound method of distinguishing the two periods of the ware is to study the style of the forms and ornament and take one's impression from them. The greater freedom and vigour of the carved and etched designs on the Sung wares will attract attention ; and conversely a certain staleness and often overcrowding of the designs will be observed in the Ming decoration. The efficacy of these tests, of course, depends on the judgment of the individual, and there is room for endless differences of opinion. There is, however, one type of celadon which can be dated with some certainty in the last half of the Ming period. It is a decadent type with pale watery green glaze rather grey in tone, and the quality of the decoration can be judged by Fig. 2 of Plate 46, one of a pair of vases in the Victoria and Albert Museum, with inscription stating that they were presented to the Han-fêng shrine in 1547 in gratitude for the birth of a son.

Another interesting specimen, though it tells us little of the Ming characteristics, is the bowl[1] which was bequeathed by Archbishop Warham to New College, Oxford, in 1530. It is a dull grey-green celadon with a faintly incised design of lotus petals enclosing a trefoil, and it was no doubt made about the beginning of the sixteenth century.

Celadon, being in general a strong, durable material, was from the earliest times a staple of the export trade, and consequently we find it spread widely over Western Asia along the land routes of Chinese trade and around the seaports of the Indian Ocean[2] and its inlets, and even on the Mediterranean coasts. The bulk of our present collections has been recovered from Persia, India and Egypt in recent years, and there is a large and important collection in Constantinople accumulated by the Turkish Sultans. One feature which endeared the celadons to Eastern potentates was its reputed power of resisting and exposing poison. This

[1] See Cat. B.F.A., 1910, E. 20, and *Country Life*, October 9, 1920. Another historic celadon is that with a fifteenth-century mount in the Museum of Cassel (see Zimmermann, *op. cit.*, Plate 22), but, as in the case of the Warham bowl, the porcelain is completely overshadowed by the mount.

[2] For a note on the export trade in celadon and distribution of the finds, see Hobson, vol. i., pp. 86–88.

reputation of the ware followed it to Europe,[1] where it was widely accepted by the superstitious and even extended to other kinds of Chinese porcelain.[2]

As illustration of the distances to which Chinese merchandise was carried in early times, we read of junks trading with Zang-pa, which is doubtless Zanzibar; and in this very region the late Sir John Kirk formed quite a large collection of celadon dishes and jars. It is improbable that the Chinese traffic continued after the Portuguese had established their hold on the trade of Far Eastern waters in the sixteenth century; but the appearance of most of the Kirk celadons suggests a Ming origin, and we can assume that they belong to the first half of the dynasty. One type is a wide-mouthed jar, the lower part fluted in lotus-petal pattern and the upper part carved with a bold floral scroll.[3] These jars are of very thick and strong construction, and the base is formed in a peculiar fashion by a saucer dropped in and fixed by the flow of the glaze. A good example of this kind of jar, but with rather more elaborate decoration, is shown on Plate 47. It has the fluted band on the lower part and a crinkled pie-crust edge; and the main decoration is in moulded and applied relief in eleven panels, alternately containing plants and animal designs. The glaze is thick and smooth and of a beautiful grey-green colour. A deeper green and a slight crackle characterise the first specimen on Plate 46, a vase of the slender form so much affected by Ming potters, with lion-mask handles, baluster body and high foot. It has an inscription engraved on the base in four characters[4] which read, *Ch'ên Chên shan chih* (" Made by Ch'ên Chên-shan ").

TING WARES

Another celebrated Sung ware was the Ting, which originated at Ting Chou in Chihli. The finest type was a white ware which can be classed as a porcelain, with a beautiful ivory-white glaze which usually runs here and there in creamy " tears." Another kind, called *t'u* Ting, or earthy Ting, has a body softer in appearance and opaque, and a creamy white glaze finely crackled. The decoration, like that of the Lung-ch'üan celadon, is chiefly carved, incised or pressed in a mould.

[1] See Marryat, *op. cit.*, p. 245. Chardin, too, in describing his experiences in Persia about 1665, tells us that :—" Everything at the King's is of massive gold or porcelain. There is a kind of green porcelain so precious that one dish alone is worth four hundred crownes. They say this porcelain detects poison by changing colour, but that is a fable."

[2] See p. 92. [3] *cf. Country Life*, October 9, 1920. [4] See p. 195.

THE WARES OF THE MING DYNASTY

When the Sung emperors were driven south by the Tartars in 1127 we are told that the Ting Chou potters accompanied the Court and that the manufacture was established in the neighbourhood of Ching-tê Chên. Here the *nan* Ting, or Southern Ting, was made, a ware practically indistinguishable from the original Ting.

It is quite clear that the tradition of the Southern Ting was carried on through the Ming dynasty, though we hear little of it until the reign of Chia Ching, when one of the cleverest potters of the time devoted himself to this kind of ware. This was Chou Tan-ch'üan, the hero of the classic story of T'ang's censer. He was particularly skilful in making copies of Wên Wang[1] censers and sacrificial vessels with handles in form of monster heads or with halberd-shaped ears, which so closely resembled the Ting originals that if one just reduced the kiln-gloss by judicious friction they would be taken for the genuine article.

Asking leave to examine a famous tripod incense burner in the collection of one T'ang, President of the Sacrifices, he took the measurements on his hand and an impression of the design on a piece of paper concealed in his sleeve, and going back to his pottery made an exact replica of the piece. Returning six months later, he produced the copy to the astounded T'ang, who found it to correspond in every detail with the original. T'ang bought it for forty ounces of silver and placed it beside his famous censer. Some years later another collector, infatuated with T'ang's famous Ting censers, importuned the owner to part with one of them, and T'ang consented eventually to let him have T'an-ch'üan's copy for a thousand ounces of silver. The new owner, we are assured, went away completely happy.

Chou T'an-ch'üan was not the only potter of his time to specialise in Ting imitations. The *Po wu yao lan* speaks of magnolia-blossom cups, covered censers and barrel-shaped censers with chain-armour pattern, ball-and-gate brocade designs and tortoise pattern mingled together in an ornamental ground. But these things were too elaborate "for the taste of the simple scholar," and they were by no means equal to T'an-ch'üan's handiwork.

The *T'ao lu* gives us another reference to copies of Ting ware, quoting a sixteenth-century work, the *K'ao p'an yü shih*. "Among the things made in recent times there are the oblong seal boxes copied from those of white Ting-chou porcelain, as well as others painted with blue

[1] A well-known type of bronze incense burner of the Shang dynasty.

158

on a white ground." These were eagerly sought after, especially when between six and seven inches in length.

The allusion to blue decoration on this ware at once suggests " steatitic blue and white," which collectors call " soft paste."[1] It was in all probability a crackled ware of *t'u* Ting type painted in blue under the glaze.

There was evidently a considerable manufacture of these Ting types in the late Ming period and, for all we know, in the earlier reigns as well ; and doubtless there are examples in our collections, though it is not easy to identify them with certainty, for two good reasons. In the first place, because the forms of these wares are confessedly archaistic in most cases, and therefore liable to be taken for Sung now that four centuries have effectually removed " the kiln gloss " from their surface ; and, secondly, because an exquisite " soft-paste " ware, which was evidently a lineal descendant of the Ting, was made in large quantities in the K'ang Hsi, Yung Chêng and Ch'ien Lung periods. And so between the claims of the Sung and the Ch'ing reigns little is left of this group to allocate to the Ming.

It is a false position, we confess, but we are well-nigh helpless to put it right. If Chou's tripod could completely deceive a Chinese connoisseur in the sixteenth century, what chance have we of distinguishing such things to-day from the genuine Sung ?

On the other hand, the Ch'ing group of " soft-paste " wares, with their delicious cream white glaze on a dry, buff biscuit, finely finished with carved or etched designs in archaic style, would be worthy productions of any period. These latter consist mainly of small vases for a single spray of flowers, water vessels, brush holders and washers (Fig. 2 of Plate 43), boxes for seal vermilion and other dainty pieces of furniture for the writing table. Some such things are no doubt of Ming date ; but in face of the difficulty of identification we are compelled, as in the case of the white Fukien figures, to suspend our judgment for the present, and, while admiring the perfection of these exquisite cream white wares, to leave their chronology an open question. Two examples of Ting type attributed to the Ming period are illustrated by Mr. Hetherington.[2]

The manufacture of white ware more or less remotely resembling Ting was widespread[3] in the Sung and Yüan periods, and in several

[1] See p. 141. [2] *Op. cit.*, Plate 25.

[3] A number of factories so engaged will be found in Hobson, vol. i., chap. vii., and in Hetherington, *op. cit.*, chap. xiv.

districts we know that it continued under the Ming dynasty, while in others we are not expressly told whether it did or not.

There is, for instance, the large group of Kiangnan factories,[1] of which Hsüan Chou in Anhwei produced a thin white ware with "earthen" body in the Yüan and Ming periods; and under the name of Kiangnan Ting we are familiar with many handsome vases with thick creamy glaze, sometimes minutely crackled and tinged with brownish stains, and sometimes granular and rough like the shell of an ostrich egg. But these types have already been adequately treated among the Sung wares in this series.[1]

Tz'ŭ Chou Wares

Another ware which in certain types is classed by the Chinese writers as one of the Ting family is that made from early times at Tz'ŭ Chou, in the southern corner of Chihli. It is, however, so varied and so important that it is given a section to itself in modern books. The Tz'ŭ Chou factories are practically without a rival in age and continuity. We can trace them back to the sixth century, and they are still active and carrying on the traditions of their most flourishing period, which was in the Sung dynasty. They are celebrated for a hard greyish ware—a porcellanous stoneware—covered sometimes with a creamy glaze, with or without an underlying white slip, sometimes with brown or black slip. The decoration varies much, but it may be summed up in two main categories, the painted and carved.

The latter is usually effected by cutting a design through a slip covering and exposing the body beneath, a method used with splendid effect on the big jars with bold floral scrolls.

The former category includes painted designs in black and maroon slips under a glaze which is generally white, but sometimes blue or green; and painting in red and green enamels on the glaze in addition to the underglaze slips. There are also specimens on which aubergine, green and turquoise blue glazes are combined in the style of the Ming three-colour porcelain. It must, however, be admitted that this last and the blue glazed pieces are not absolutely proved to be of Tz'ŭ Chou make. It is probable from analogies of style that they are; but we must not forget that other factories, such as those at Po-shan in Shantung, were

[1] See Hetherington, *loc. cit.*; and Hobson, vol. i., p. 97. Kiangnan includes the two present provinces of Kiangsu and Anhwei.

working on similar lines and may prove to have been the producers of these wares.

Of the undoubted Tz'ŭ Chou wares there are numerous specimens in public and private collections ; but there will always be great difficulty in dating them on account of the continuity of the old traditions. If the merchant had his way, every Tz'ŭ Chou piece would be Sung, a manifest absurdity. Collectors are more disposed to admit that the Ming dynasty must have furnished a proportion of the existing examples, but even they are slow to allow the very strong probability that a still larger proportion date from the Manchu period.

Fortunately we have a few dated pieces to serve as finger-posts, one with engraved design of Sung date in the British Museum, a small-mouthed globular bottle with carved brown slip and a Yüan date in the Eumorfopoulos Collection, a black-painted jar with oval body and wide mouth, dated 1446, in the same collection,[1] and a few examples with enamels combined with slip painting which bear the Wan Li reign mark. Otherwise we must depend chiefly on the shape of the wares and the general style of the ornament, as compared with the porcelain, for our chronology, though we may safely conclude that those with typical Ming decoration in enamels of the " red and green " family belong to the period to which this book is devoted.

Of the illustrations, Fig. 3 of Plate 48 belongs to this last class. It is painted in green and red in combination with the usual black and maroon slips, and the style of the design is that of the early part of the Ming period. Fig. 2 is one of those debatable pieces, decorated in a style which has the closest analogy with the early Ming Tz'ŭ Chou wares, but having a rather redder body than is usually associated with Tz'ŭ Chou and a pale blue, crackled and transparent glaze. The third illustration represents a pillow modelled in the form of a reclining girl. It is decorated with black and maroon slips on a cream white ground, and on the head rest are the characters, *fêng hua yü yüeh* (wind, flowers, rain and the moon), a phrase which has more meaning than meets the eye.

CHÜN CHOU WARES

It is clearly established that the factories at Chün Chou, near Kaifeng in Honan, so celebrated for their mixed-colour glazes in the Sung dynasty, continued through the Yüan and Ming periods. But how to differentiate

[1] Hobson, *op. cit.*, Plate 30.

the productions of the several centuries is a problem at present practically insoluble. It is customary to relegate the rougher wares of Chün type, those with coarse stoneware bodies of buff, red or brown colour, to the Yüan dynasty, and collectors hitherto have scarcely taken into account the possibility of any of them being Ming.

And yet we are informed in the pottery section of the K'ang Hsi Encyclopædia, quoting from the official Ming records, that " a large supply of vases and wine jars " from Chün Chou and Tz'ŭ Chou were sent to the palace in the Hsüan Tê period, and again in the year 1553 in the Chia Ching period. Further, we are led to suppose that the Chün factory was actually in receipt of a subsidy up to the year 1563, when the tax hitherto levied on the ware was remitted and the subsidy simultaneously lapsed.

The question naturally arises what was the nature of the vases (p'ing and t'an) and wine jars supplied to the palace in the fifteenth and sixteenth centuries? Had they the old high-fired, opalescent glazes of dove-grey and lavender colour, shot with streaks of blue and purple and splashed here and there with patches of crimson?

The typical Ming wine jar we know, a potiche shape with domed cover or a high-shouldered oval vessel with wide mouth; but these are not forms usually associated with this type of Chün glaze, which is found as a rule on vessels of smaller size. Can they have been the " soft Chün " with buff, earthen body and thick, opalescent and often crystalline glaze of turquoise or lavender tints? This ware, which is also known in China as *Ma Chün*,[1] is variously assigned to Sung and Ming periods; and, though there is little doubt that much of it should be regarded as a Ming product, here again we are not accustomed to vessels of the large dimensions indicated. The *Ma Chün* are nearly always small objects.

There is, of course, always the possibility that the Chün Chou potters adopted other styles of manufacture which were popular in the Ming dynasty. Indeed, this seems to be indicated by the very interesting bulb bowl which was found on the site of the Chün Chou factories and given by Mr. K. K. Chow to the British Museum. It was figured by Mr. Hetherington in his book on early wares [2] to show the continuity of the Sung form of bowl with its three cloud-scroll feet and the band of studs below the mouth-rim. It was pointed out, too, that it has a greyish white porcellanous body similar to that of the finer Sung Chün wares

[1] Apparently from the name of a potter who originated it.
[2] *Op. cit.*, Plate 16.

and doubtless made of clay from the same deposit, but that instead of the opalescent, felspathic Sung glaze it is partly coated with a turquoise blue glaze, apparently of the harder lead-silicate type, partly with an aubergine brown, while there are also some patches of yellow. It is, in fact, a waster or spoilt piece, and the glazes have misfired, all being failures except portions of the turquoise, which are singularly beautiful and not unlike that of Mr. Raphael's fine vase (Plate 2). This, then, is evidently an attempt at a piece of " three-colour " porcelain of characteristically Ming type, with the very glazes which appear on the big wine jars and vases of the cloisonné and graffiato class.[1] The provenance of many of these jars is far from clear, their body varying from fine porcelain to greyish stoneware; and, though many of them were doubtless made at Ching-tê Chên, it is practically certain that others were made in other districts, and on the strength of Mr. Chow's bulb bowl we venture to suggest that Chün Chou was one of them. This does not imply that the old types of Chün glaze were now abandoned, even though it may be hard to prove their existence by authenticated examples. Indeed, the traditions associated with the *Ma Chün* seem to imply the contrary. Doubtless there were many potteries in the district, and some kept up the old traditions, while others were less conservative. At any rate, the taste for the old Chün glazes was far from dead, for Hsiang Yüan-p'ien included a number of them in his selected series formed in the sixteenth century, and a celebrated potter, named Ou, at Yi-hsing, in the late Ming period, made a reputation by his clever copies of them.[2]

[1] See p. 26. [2] See p. 169.

KWANGTUNG AND YI-HSING POTTERY

KWANGTUNG AND YI-HSING WARES

There are numerous potteries in the province of Kwangtung, and doubtless some of them are of considerable antiquity ; but our information is limited to the description of modern wares sent to recent exhibitions, on the one hand, and to the history of the important potteries near Canton on the other. The latter are situated at Shekwan,[1] which is close to Fatshan, the great industrial city on the Canton–Samshui railway, and about ten miles west of Canton. Henry,[2] who visited and described the place in 1859, states that " at Shekwan near Fatshan, famous in China for its glazed earthenware, seats, flower-stands, lattice-work, balustrades, flower-pots, tiles, animals, fruits, vases, plates and ornaments in endless variation are produced. This ware is very cheap but ornamental, the glazing being done in many colours, blue, green, white and red predominating."

The most familiar types of this Shekwan ware, which is commonly called Canton stoneware, or Fatshan ware, are made of a hard-fired material, usually dark brown at the base, but varying at times to pale yellowish grey and buff, with a thick, smooth glaze distinguished by a peculiar mottling and dappling. " The colour is often blue, flecked and streaked with grey-green or white over a substratum of olive brown, or, again, green with grey and blue mottling." Specimens in which the blue predominates are much prized, but there are others with *sang de bœuf* red flambé which are also desired by collectors. Another type has a celadon green glaze over the familiar red-brown biscuit.

All these kinds of ware are familiar in the form of vases, trays, ornamental figures, fish bowls, etc., and they should easily be recognised as belonging to the Canton group, though the red flambé and the celadons are often wrongly attributed. It is much more difficult to decide on the age of the Shekwan wares. The manufacture flourishes to-day, and

[1] Shekwan West. There is another Shekwan a few miles east of Canton which was erroneously conjectured to be the famous pottery centre in my *Chinese Pottery and Porcelain*, vol. i., p. 172. [2] *Lingnam*, p. 60.

vases such as are bought in Chinatown in San Francisco as modern trade goods are often auctioned in London as Ming, or even Sung.

In point of fact, it would be difficult to find a single piece which is demonstrably Ming. There are some which from their form or the breadth of style shown in their modelling or the fine rich quality of their glaze seem entitled to special consideration, and among these it is likely enough that a few Ming specimens could be found. But to prove the case would be well-nigh impossible. There is, indeed, a tray in the British Museum, which belongs on its own merits to the élite of Canton wares and which has an incised inscription stating that it was made by Chin-shih in the *i-ch'ên* year of T'ien Ch'i (i.e. 1625). It has a fine-grained drab stoneware body and a liberal glaze of dappled and streaked grey and blue with a few flecks of brown, in material, colour and finish undoubtedly a superior specimen; but it is now apparent that the inscription was cut in " cold " after the piece had left the factory, and, though it may well give a true account of the tray, it cannot be accepted without reserve. Mr. Sauphar's vase (Fig. 2 of Plate 49) has a characteristic Ming form and every indication of belonging to our period. It has an iron-coloured base and a rich purplish brown glaze flecked with tea green.

It is hardly necessary to remind the reader that the words Ming and Yüan which occur in the names of two well-known makers of the Canton stoneware, Ko Ming-hsiang and Ko Yüan-hsiang, have nothing to do with the dynasties suggested. The marks of these potters occur on a variety of wares, some of which have a very modern aspect. Attention, too, is drawn elsewhere[1] to the unwarranted attribution to the Ming period of Canton stoneware figures with flambé red glaze, or with dappled grey and blue, or with celadon green glazes. These figures, representing Taoist sages, deities, animals and birds, often modelled with considerable skill, are recognisable by the typical reddish buff or iron-red stoneware body which is generally left unglazed on the nude parts of human figures; but they are mostly of quite late period of manufacture and more likely to be nineteenth century than Ming.

Another group of Kwangtung wares known to-day as Fatshan Chün, and evidently, like the rest, a product of the Shekwan potteries, has the same body, much the same shapes, and a glaze of similar thick, viscous consistency, but in colour recalling the lavender Chün glazes with purple splashes. These, like the Yi-hsing Chün[2] wares, are among the many

[1] p. 7. [2] p. 169.

attempts to reproduce the old Chün Chou glazes, and there is no reason to credit them with any antiquity.

On Brinkley's authority[1] another kind of ware has been attributed to the Kwangtung potters. " The characteristic type is a large vase or ewer decorated with a scroll of lotus or peony in high relief and having a paint-like, creamy glaze of varying lustre and uneven thickness, its buff colour often showing tinges of blue." It may be added that the glaze of this kind of ware sometimes seems to copy the red-splashed lavender of the Chün types, but it is opaque and lacks the fluidity of the true Chün glazes, and it has a strongly marked crackle.

Specimens of this class[2] are sometimes dated back as far as the Sung dynasty, but not on very convincing grounds; though we should be probably right in ascribing some of them to the Ming period, such as the high-shouldered, small-mouthed baluster vases with lotus scroll in relief, the shape in this case clearly supporting the attribution. On the other hand, there are a few specimens in the British Museum which have no claims to greater age than the eighteenth century.

Some of these imitative wares have a light buff body which it has been thought advisable to wash over with a dark brown clay, a sign of recent manufacture which also appears on another interesting species of the genus Canton Chün. I allude to the dishes and bowls within which the glaze has been allowed to run into a deep crystalline pool and has taken on brilliant tints of violet-blue, green or amber. Many of these peacock glaze effects are very beautiful; but why they should have ever been regarded as Sung or Ming types is a mystery.

YI-HSING WARES

It is such a rare experience to have all the materials to hand for a compact and informative treatise on any Chinese ware that one is tempted to give more space to the potteries of Yi-hsing than their relative importance warrants. A good Japanese description of the ware and its history, translated by F. Brinkley,[3] and excerpts from a seventeenth-

[1] F. Brinkley, *Japan and China*, vol. ix., p. 261.

[2] See Hobson, *Chinese Pottery and Porcelain*, Plate 47, Fig. 2, and *Burlington Magazine*, January, 1910.

[3] *Japan and China*, vol. ix., pp. 355–63. The work is based on a Chinese text, probably the *Yang-hsien ming hu hsi*, " story of the teapots of Yang-hsien " (an old name for Yi-hsing).

century Chinese work given in the *T'ao lu* tell us about the Yi-hsing potteries as much as, if not more than, we know of our own Staffordshire industry.

Yi-hsing Hsien (Ihing) is situated on the west of the Great Lake in Kiangsu. The materials miraculously discovered in the neighbouring hills include a variety of clays which, after firing, produced wares of cinnabar red, dark brown, " pear-skin," green and light red colours, while other shades could be obtained by discreet blending. A priest of the neighbouring Chin-sha temple was the first person to put these clays to their proper purpose, viz. to make " choice utensils for tea-drinking purposes," and his secret was surreptitiously acquired by one Kung Ch'un, whose subsequent fame far surpassed that of the true originator of the ware. Kung Ch'un lived in the Chêng Tê period (1506–21), and his teapots are described as " hand made, with thumb-marks faintly visible on most of them." They were chestnut coloured with the " subdued lustre of oxidised gold," and their simplicity and accuracy of shape were inimitable, worthy, in fact, to be ascribed to divine revelations. Hsiang's Album[1] purports to illustrate two teapots by Kung Ch'un which were bought for five hundred taels. One is hexagonal and of greyish brown colour like felt, and the other ewer-shaped and vermilion red; and both had the miraculous quality of turning to a jade green colour when the tea was made in them. Hsiang adds that if he had not witnessed this phenomenon with his own eyes he would not have believed it.

Quite a number of Yi-hsing potters made a reputation in the Ming dynasty, the most celebrated being Shih Ta-pin, Li Chung-fang, Hsü Yu-ch'üan, Ch'ên Chung-mei and Ch'ên Chün-ch'ing; and we hear of another named Tung Han in the Wan Li period (1573–1619) who " was the first potter to ornament the surface of the ware with elaborate reliefs." Ch'ên Chung-mei had been a porcelain maker at Ching-tê Chên, and in addition to tea wares he made perfume boxes, flower vases, paper weights, etc., " with singularly fine moulding and chiselling," and even statuettes of the goddess Kuan-yin.

It is interesting to read that the true teapot form began in the days of Kung Ch'un; and, according to Brinkley's authority, the ideal teapot should be small and shallow, with cover convex inside and a straight spout. Little Yi-hsing teapots of this kind are still very highly prized by the masters of Japanese tea ceremonies, and they were evidently made by another noted Ming potter, Hui Mêng-ch'ên, for there is a specimen

[1] *Op. cit.*, Figs. 44 and 45.

(though probably not original) with his mark in the British Museum. But to judge from existing, if later, examples of the ware, this severe simplicity of form did not appeal to the Yi-hsing potters for long, and the ware as we know it best is distinguished, on the contrary, by fantastic forms cleverly modelled.

The factories are active at the present day, and as the old traditions are preserved with the usual Chinese conservatism, it will always be difficult to date individual pieces. In any case, we are not concerned with the bulk of the numerous existing specimens which are obviously post-Ming. The difficulty is to find a piece which can with any probability be assigned to one of the Ming potters. We can point with some certainty to types of teapots which are at least as old as 1670, because they were exactly copied by Dutch potters, such as Ary de Milde, and by English potters, such as Dwight and Elers, about that time and shortly afterwards. These have moulded ornament in relief or applied sprigs of prunus or stamped designs in considerable variety; but as tea drinking only took a firm hold in Western Europe in the last half of the seventeenth century, it is improbable that Yi-hsing teapots of Ming date ever reached us in the ordinary ways of trade.

The Yi-hsing ware as we know it, and doubtless it reflects very accurately the earlier types, varies from comparatively soft pottery to a hard stoneware capable of taking a polish on the lathe. As a rule, it is an unglazed stoneware of varying colour, but most often red or drab. This is the type which has long gone by the name *buccaro*, a term which, strictly speaking, belongs only to certain American-Indian potteries; but there are other kinds of Yi-hsing ware which are less familiar. These have glazes added to the buff or red body, and they are apt to be confused with the " soft Chün " wares on the one hand and the Kwangtung wares on the other.

It appears that this glazed Yi-hsing ware, if not originated by a Ming potter named Ou,[1] at any rate owed its fame to his successful copies of " Ko ware crackle and Kuan and Chün ware colours." Ou's " Yi-hsing Chün " was doubtless the subject of the interesting note in the *Po wu yao lan* under the heading of Chün yao—" at the present time (viz. 1621–27), among the recent manufactures, this kind of ware is all made with the sandy clay (*sha t'u*) of Yi-hsing as body : the glaze is rather like the original, and in some cases beautiful, but it does not wear well."

[1] See p. 195.

THE WARES OF THE MING DYNASTY

The glazes of Ou were considered good enough to be copied at the Imperial factory at Ching-tê Chên in the Yung Chêng period, and two kinds are named in the official list of that time, " that with red and that with blue markings."

We have no authenticated example of Ou's ware, and we can only infer the nature of these imitations of Chün glazes. The modern Yi-hsing Chün, which doubtless carried on the old traditions, has in some cases a light buff stoneware body and a glaze of lavender colour breaking into blue. It is a thick and rather opaque glaze which flows freely, leaving the upper levels thinly covered and forming thickly in the lower parts, and its colour is broken by streaks and cloudings. The surface is crazed with an inconspicuous crackle, and it has a subdued lustre " between the brilliancy of the old opalescent Chün types and the viscous, silken sheen of the Canton glazes which also imitate them." Another type of Yi-hsing Chün is very like the *Ma Chün*[1] in many respects. It has a similar yellowish body, though rather harder than the original, with a thick, unctuous glaze of somewhat crystalline texture. The colour is usually a turquoise lavender ; but the patches of dull crimson, which usually break the surface, are thin and feeble and have an artificial appearance. The illusion of the Chün imitation is also kept up sometimes by incised numerals under the base.

It is difficult to assess the age of these wares, and the appearance of most of the existing specimens suggests a comparatively modern date ; but it is possible that a bowl of this class in the British Museum may be as old as the late Ming period. It has a typical Yi-hsing red stoneware body and a thick, undulating glaze of pale lavender blue colour, with a slight and probably accidental crackle. The interior of the bowl shows signs of severe usage, and the comparatively soft glaze is perceptibly worn. It has no red or blue patches, and the colour is rather that of the Sung Kuan ware than the Chün ; it is certainly " a beautiful colour and it does not wear well." But it is very easy to fit the old Chinese descriptions (especially our translations of them) to our pet pieces, and, though sorely tempted, we must refrain from claiming this bowl as Ou's manufacture. It is pretty safe, however, to say that it is an early specimen of glazed Yi-hsing ware.

The one example of Yi-hsing ware illustrated on Plate 49 is reputed to be the work of one of the celebrated Ming potters. It is a teapot of simple shape and unadorned, of a deep red colour verging on chocolate

[1] See p. 162.

brown, with the surface rough like the skin of a pear and with a subdued lustre which is due to a natural gloss. Under the base are six finely incised characters,[1] *ching ch'i hui mêng ch'ên chih*—made by Hui Mêng Ch'ên in Ching-ch'i. Ching-ch'i (King-ki) is an old name for Yi-hsing.

[1] See p. 196.

PLATE 9.

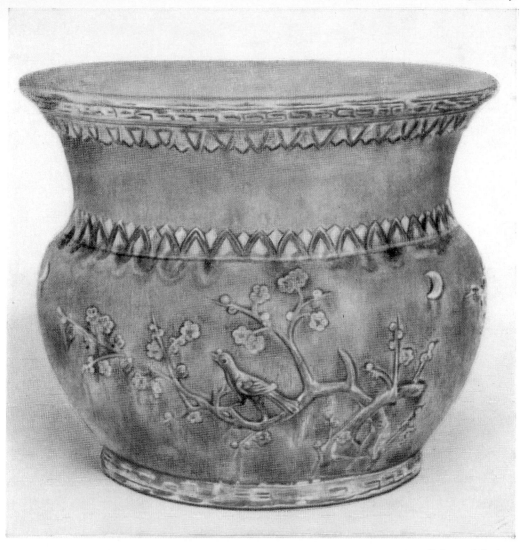

Flower pot with raised designs of
prunus boughs and birds and the moon
crescent: borders of stiff leaves and key
fret: buff stoneware with coloured
glazes. Sixteenth century. H. 15½ ins.
(See page 178.)

CHAPTER XVI

MISCELLANEOUS POTTERIES

Though the manufacture of porcelain in the Ming dynasty was in the main centred in one or two districts, that of pottery seems to have been very widely distributed up and down the length of the Empire. Pottery, in general, is a low-priced commodity, and the cost of transport was against the concentration of the industry in any one favoured centre. In a word, local needs were as a rule supplied by local potteries, and as our information about these local potteries is practically confined to a few names, it will be seen that the heading " Miscellaneous Potteries " will have to cover a great deal of ground.

But before approaching the question of individual potteries or particular types of ware, mention must be made of a kind of manufacture which in the nature of things was not confined to any one district. This is the mortuary pottery. The immensely interesting finds of mortuary wares of the Han and T'ang and intermediate periods have been discussed in other works[1]; and it is only necessary to recall here that it was the Chinese custom to furnish the honoured dead with representations of all the persons, animals and things which could help him to carry on his earthly pursuits and enjoyments.

In the earlier dynasties pottery seems to have been the favourite medium for these representations; later we gather that other materials, such as wood, were more extensively used, and we know that at the present time the same purpose is served in an economical fashion by burning paper pictures of the burial outfit in front of the tomb.

The extent to which the old burial customs were still honoured in the Ming dynasty may be gathered from the following extract from the list of contents of the tomb of a Ming grandee[2] :—" a furnace-kettle and a furnace, both of wood, saucer with stand, pot or vase, an earthen wine-pot, a spittoon, a water basin, an incense burner, two candlesticks, an incense box, a tea-cup, a tea-saucer, two chop-sticks, two spoons, etc.,

[1] Laufer, *Chinese Pottery of the Han Dynasty;* Hobson, *op. cit.*, vol. i. ; Hetherington, *op. cit.*; and Dr. O. Rücker-Embden, *Chinesische Frühkeramik.*
[2] De Groot, *The Religious System of China*, vol. ii., p. 809.

173

two wooden bowls, twelve wooden platters, various articles of furniture, including bed, screen, chest and couch, all of wood; sixteen musicians, twenty-four armed lifeguards, six bearers, ten female attendants; the spirits known as the Azure Dragon, the White Tiger, the Red Bird, and the Black Warrior; the two Spirits of the Doorway and ten warriors— all made of wood and one foot high." It will be seen in this case that the grave furniture was mostly made of wood; but other graves have been found which show that in some parts of China, at any rate, pottery was still extensively used for this purpose. There is, for instance, in the Victoria and Albert Museum a model of a house taken from a Ming tomb and two figures of attendants, of which one is illustrated in Plate 50. This latter will be seen to bear a distinct resemblance to the mortuary figures found in T'ang graves, and we may conclude that in funeral furniture, as in other matters, the Chinese practice was thoroughly conservative.

Even in the humblest tombs one might expect to find bowls and jars to contain the offerings of food with which the dead were always supplied. A number of such vessels from Ming tombs in Szechwan were given to the British Museum by the Rev. Th. Torrance. They are reddish earthenware with opaque chocolate brown glaze which in some cases is variegated with milky grey splashes; and a common form of ornament is a roughly modelled dragon applied in relief. Jars of a very similar appearance with dragons in relief in white clay on a brown ground have been found elsewhere and are probably mortuary wares. But these pots, however interesting archæologically, are too rough to inspire much interest in the collector of Ming.

Rather more attractive, though still scarcely cabinet pieces, are the jars with masks and rings on the shoulders and dragon designs in relief, which have been treasured for many centuries by the natives of the Philippines and the East Indian archipelago. A small but characteristic specimen of these is shown on Plate 50. It is a jar with six loop handles on which are rude masks. On the sides are two dragons in applied relief " disputing a pearl," and the ground is incised with an imbricated pattern. The glaze, pale olive brown, ends in a wavy line short of the base, after the manner of T'ang pottery. This jar was found in Borneo, where it had been treasured in a Dyak family.

It is probable that this class of pottery was made in the neighbourhood of the southern seaports which traded with the islands in question. The potteries in Fukien would have supplied the traders at Amoy and Ch'üan-

chou Fu; those at Fungkai, a few miles inland, the traders at Swatow, and the Shekwan potteries the trade of the Canton estuary.

Alongside this jar is illustrated (Plate 50) a small vase with design of peony scroll and two rosette-like flowers, summarily but artistically executed in applied relief. It is of a reddish buff pottery with a leaf green glaze, now frosted with iridescence, the raised designs coloured dull yellow and manganese brown. The inside is glazed dark brown. Like the export type just described, it has a series of loop handles to take a cord on the shoulders, and it doubtless was traded from one of the southern Chinese ports. This vase, found in the ruins of a pagoda at Ayuthia, a former capital of Siam, belongs to a group of which there are several specimens in English collections, the best known being the famous jar in the Tradescant Collection in the Ashmolean Museum, Oxford.

The latter piece[1] is not only remarkable for the brilliant quality of its green glaze, but for its historical associations which give a guarantee for the rest of the group. The Tradescant Collection was formed by a man who died in 1627, so that we can confidently ascribe this type of pottery to the late Ming period, at any rate.

Where it was made is not so clear, but there is, as stated above, good reason to assign it to a Southern Chinese pottery. Nearer than that we cannot go at present. A variation of the ornament is given by a specimen in the Goff Collection in which the design is incised instead of being raised in relief.

There are other types of ware which inevitably group themselves together on the strength of certain common traits without giving us any clear indication of their origin or history. One of these is characterised by a hard buff body almost invariably unglazed under the base. It is generally made in moulds and thinly potted; its ornament is in relief, moulded or applied, and it is coloured with washes of turquoise, brownish yellow and dark aubergine glazes.

This is a type of pottery which unquestionably has its origin in the Ming period, a humble scion of the Ming three-colour family; but it is equally beyond doubt that its manufacture has continued to modern times.[2] The collector, then, will need to exercise much discrimination

[1] See *Country Life*, January 1, 1921.
[2] There is, for instance, a vase of this ware, moulded with a lion design on the sides and covered with a greyish turquoise glaze, in the Field Museum, Chicago, where it is kept as a specimen of modern Taiyuan manufacture.

in acquiring specimens, especially as many dealers with the optimism of their kind have labelled it all Ming without distinction.

It is, moreover, probable that this class of ware was made in various parts of China. There are specimens which have been obtained in the south; and, on the other hand, we know that the modern kilns at Ma-chuang, near Taiyuan, in Shensi, produce it to this day. In some specimens, and these of more modern appearance, the body is rougher and more the colour of fine oatmeal. Fig. 3 of Plate 51 shows a remarkable specimen of this group; and, judging from the shape and style of ornament, it may be confidently assigned to the Ming period. Its handles are rampant lions, and on the neck are reliefs representing the goddess Kuan-yin. There is a dragon in foliage on the body, and the feet are of leonine form. The glazes used are green, turquoise, yellow and aubergine. Other examples of this class are the incense burner illustrated on Plate 51, with prunus reliefs in white and turquoise against a dark violet ground and blue and yellow dragon handles; and the hexagonal bottle on Plate 49, with dragon in relief in turquoise, etc., on a similar violet ground. But this type is seen at its best in the slender beaker on Plate 52, which has a buff pottery body and a turquoise ground with flowering plants in raised outlines, filled in with white and violet-blue.

The better specimens of this group have an evident affinity with another kind of Ming " three-colour " ware which has much higher artistic claims. It is a kind which, at its best, stands well in the forefront of all Ming wares for beauty of design and colour. Plates 9 and 52 illustrate some admirable examples of it, and the reader will recall many others, such as those in the Eumorfopoulos Collection and the Louvre[1] and the lovely specimen which enjoys a case to itself in the Salting Collection. One of its favourite forms is the slender beaker-shaped vase with tall neck and flaring mouth; and the handles of these pieces, placed on either side of the neck, are often of an intricately ornamental nature. On a British Museum vase (which figures as frontispiece to the édition de luxe of this volume) they are simple, with merely a suggestion of an elephant's head at the top; but in other cases they blossom out into large sprays of chrysanthemums, lotus or *ling chih* fungus. The sides of these vases are usually decorated with bold floral designs of the season flowers springing from ornamental rocks or water, the outlines faintly raised in threads of clay, as in the cloisonné type of porcelain,[2] and the flowers modelled in low relief. There are, of course, many other shapes:

[1] Hobson, *op. cit.*, Plates 53 and 54.　　　　[2] See p. 26.

flower pots, like Plate 9, huge fish bowls, incense burners, bottles, covered jars and baluster vases. The ware is, as a rule, a porcellanous stoneware of buff tone, close-grained and very hard, and the glazes in contrast have a soft appearance and are almost invariably covered with a minute crackle. They are medium-fired glazes, usually cucumber green, a pale creamy colour,[1] apparently the result of an almost colourless glaze over a yellowish body, a soft pinkish aubergine, a brilliant turquoise or peacock blue, and a dark violet-blue. The last three are used with fine effect for ground colours.

In some of the specimens, especially the flower pots and the large fish bowls, the ware is of coarser nature, softer and redder, and on this body the glazes have rather less refinement and are apt to peel away.

Examples of this beautiful ware, though by no means common, are sufficiently numerous to form a group of great importance; and it is surprising that no information about their history has ever been vouchsafed from Chinese sources. The Chinese seem satisfied with calling them Ming and letting them go at that. And yet some pottery centre must have earned well-merited fame in the past for the creation of these beautiful wares. It is, however, useless to rail, as one is tempted to do, at the Chinese for their apparent indifference to such details as the history of their minor arts; and it can be hardly more useful to make a mere conjecture as to the provenance of this group. But if one may be permitted to draw a bow at a venture, one might hazard Soochow.

Beautiful Soo, one of China's fairest cities, situated on the Grand Canal in Kiangsu, must have been an important centre of the potting industry for many centuries. It has still a reputation for its wares. We know, for instance, the big, decorative fish bowls and large flower pots which are called in the trade " Soochow tubs." The Ming Annals, quoted in the great K'ang Hsi Encyclopædia, speak of tiles made there for the temples of Nanking, and vases and wine vessels for the Imperial Court. Another passage even goes into details of the iron oxide used for the yellow on the yellow wares, and cobalt blue on the vessels with dragon and phœnix designs destined for Imperial use. Even the *T'ao shuo*[2] has a reference to the famous Soochow pots for holding fighting crickets in the Hsüan Tê period :—" those made at Su Chou by the two makers named Lu and Tsou were beautifully moulded and artistically carved and engraved, and the pots made by the elder and younger Hsiu, two

[1] A pale yellow glaze is also used, but its place seems to be more often taken by the creamy white.　　　[2] Bushell's translation, *op. cit.*, p. 140.

daughters of Tsou, were the finest of all. At this time fighting crickets was a favourite pastime, and hundreds and thousands of cash were staked upon the event, so that men did not grudge spending large sums upon the pots, which were decorated in this elaborate way and consequently far surpassed the ordinary porcelain of the period."

The nature of these cricket cages can be easily imagined, though it is doubtful if any of the perforated vessels to which the description is often hopefully attached really satisfy the conditions required. Doubtless they would have finely perforated openwork on the sides and top which would admit light and air without allowing the cricket to escape ; and the manufacture of such objects would give scope for the most skilful *ling lung*[1] work.

But to return to the ware which gave rise to our conjectures about Soochow, a splendid example in the Benson Collection is illustrated in colour on Plate 9 and will serve to show the nature of the beautiful soft aubergine glaze. The turquoise can be seen in the coloured frontispiece of the édition de luxe. Of the other illustrations, the vase with lizard handles (Plate 52) has an aubergine ground with chrysanthemum design in relief and glazes of the complementary colours ; and the handsome bottle on Plate 53 (Fig. 2) has aubergine on its bamboo-shaped neck and turquoise on the body, with white and aubergine on the prunus reliefs. A pair of somewhat similar bottles in the Benson Collection and another in the Anthony de Rothschild Collection have small stamped ornaments in applied relief.

The bottle with bulbous neck on Plate 53 (Fig. 3) has a body which is practically stoneware and a green ground with designs strongly outlined in threads of clay and washed in with yellow, turquoise, aubergine and white. It appears to be a late type which doubtless survived the Ming period ; and with it will be grouped a well-known family of flower pots and bulb bowls, etc., of which an example is given on the same plate.

Another large and important Ming family is very nearly related to the porcelain described on page 26. It has the same range of shapes, including wide-mouthed potiche jars with covers, flower pots, incense burners, figures and grotto pieces decorated with the same chord of coloured glazes over ornament which is sometimes outlined in threads of clay (the cloisonné type), sometimes incised or carved, modelled in relief or framed in openwork. It is, in fact, the counterpart of the porcelain with coloured glazes, but made of pottery which is usually of

[1] See pp. 61 and 123.

a red or buff colour and varies from earthenware to stoneware in hardness. A good example of this type is shown on Plate 54, and it will be observed that in photographic reproduction it is not distinguishable from its fellows in porcelain.　It is a wide-mouthed jar in the Eumorfopoulos Collection, of fine pottery with flat, unglazed base and raised ornament of the cloisonné type.　It is decorated with figures of Shou Lao and the Eight Immortals, coloured with crackled turquoise, dull yellow, blue and pale aubergine in a green ground, and the glaze on the neck is a slaty turquoise blue.　The faces of the figures are left unglazed ; and there are the usual borders of cloud scrolls and false gadroons, while on the shoulder are *ju-i* shaped pendants enclosing the emblems of the Immortals.　Here, again, we are left in the dark as to the provenance of these noble pots.[1]　We have no knowledge of any particular factory which was famous for them ; and we may perhaps assume that, like most of the Chinese earthenware, this was made locally for local consumption, and that our specimens may come from factories widely scattered over the Chinese provinces.

The material of these wares, after all, does not greatly differ from that of the glazed tiles and architectural ornaments which are universally used in China and made in innumerable districts.　Their glazes—green, yellow, aubergine, dark blue and turquoise—appear on the tile-work, and the body of some of them is much like that of the finer architectural pottery.

The dating of these wares, as also that of the architectural pottery, should always leave a wide margin for error.　Both types go back to the beginning of the Ming and persist to the present day.　The shapes, however, in the case of the vases and a comparison of the style of their decoration with that of cognate porcelains will tell us something ; but the persistence of certain types in China is a baffling element and inspires caution.　It would, for instance, be difficult to draw a palpable distinction between a large tripod incense vase in the Messel Collection[2] and another in the Louvre.[3]　Both have relief designs of dragons and peonies on the sides, a panel with mounted figures on the neck and two large upstanding handles with incised inscriptions.　But the Messel vase is dated 1529, and the Louvre pendant has the name of Wan Li (1573–1619) in its legend.　Again, there is a glazed pottery figure in the Lindley Scott Collection[4]

[1] Doubtless some of them were made at Yi-chên, Ning-kuo Fu and Ch'ü-yang Hsien, places which supplied wine jars to the Court in the sixteenth century. See p. 183.

[2] Hobson, *op. cit.*, Plate 55, Fig. 2.　　[3] Marquet de Vasselot, *op. cit.*, Plate 22b.

[4] It was exhibited at the Burlington Fine Arts Club in 1915.

which would almost certainly have been assigned a Ming date, were it not for the incised inscription, which gives the year of its manufacture as 1659. Further, this inscription describes the figure as " a glazed tile of the district," significant words[1] which bear out our theory that many of these glazed pottery ornaments were the products of local tileworks.

The cylindrical vase on Plate 51 will serve to illustrate this class of pottery ; and its ornament, a dragon in foliage in high relief, has much in common with the dated incense burners in the Messel Collection and the Louvre. The colours used are green and blue with touches of yellow, while portions of the relief are left in a light buff biscuit.

The tiles and architectural ornaments are still more apt to be ante-dated. The types of these are most conservative ; and, though many new temples and public buildings, elaborately roofed, sprang up in the seventeenth and eighteenth centuries, the tiles and finials follow closely the Ming designs. Typical early Ming architectural pottery can be studied in the tiles and fragments from the Nanking pagoda and the Ming tombs near Nanking, both of which were built in the early reigns of the dynasty and suffered destruction in the T'ai-ping rebellion in the middle of last century. Specimens can be seen in the British Museum. The Nanking roof tiles end in the usual ornamental disc with a coiled dragon in sunk relief, and the glazes are chiefly green and yellow over a hard buff pottery. Ornamented roof tiles have, of course, other designs and glazes ; but the collector is not likely to load his cabinets with such objects, though he may be tempted to acquire the circular end of one which has been mounted in Chinese fashion or converted into an ink slab. But the roof finials and ante-fixal ornaments of temple buildings, with their cleverly modelled figures of mythical personages, birds and animals, are much desired by the collector. They are often most spirited and attractive objects, with a pleasant display of coloured glazes. Many of these are doubtless Ming, but one knows of many others which have been brought from eighteenth-century buildings in Peking ; and the distinction between the two is based chiefly on that elusive quality called style.

A list of the best-known tileworks in China would not be particularly instructive and would certainly be dull reading, especially when we cannot point to any distinguishing characteristics of their work. We may be sure, however, that there were tileworks near almost every large centre of population, and that in many of them pottery vessels and ornaments were made as well as the architectural wares.

[1] See p. 195.

The potteries at Liu-li-chü,[1] which date from the Yüan dynasty, doubtless supplied the Peking builders; and we are told that Soochow sent tiles for the palaces at Nanking in the Ming dynasty, and that others were made at Nanking itself in the Hung Wu period. One would conjecture that the ante-fixal ornaments, yellow-glazed dragon heads, in the British Museum, which came from the Temple on Golden Island in the Yangtse, were manufactured at the neighbouring Kwachow on the left bank of the river.

From the architectural pottery one passes by easy transition to the Ming statuary, which is of considerable importance. It was necessary to give a word of warning in another chapter against the promiscuous attribution of glazed pottery figures to the Ming period. But there are plenty of genuine specimens in our collections, both pottery and porcelain, which can be identified by the quality of their modelling and the nature of the coloured glazes with which they are bedecked. They include single figures and groups, elaborate ornaments in the form of shrines and grottoes and other objects less monumental, such as shells and piles of fruit, boats, joss-stick lions, pillows and plaques with small reliefs. The modelling of these pieces, whether large or small, is usually strong and spirited, and the glazes on those which inspire most confidence are the glazes used on the various types of three-colour porcelain. There are many excellent examples of Ming statuary in the Benson Collection which played an important part in the exhibition of early Chinese wares at the Burlington Fine Arts Club in 1910,[2] and among them, to give only one instance, a particularly fine set of the Eight Immortals.

A well-designed group in the Grandidier Collection is illustrated on Plate 55, a noble horse with its groom and its rider standing by ready to mount. Made of buff pottery, with a dark violet-blue glaze and details in green, turquoise and yellow, it is evidently an ornament pure and simple, complete with its own pottery plinth; but it is a pleasing and well-balanced composition in which the calm dignity of the aristocratic master contrasts delightfully with the pompous air of the " first-class groom."

The specimen on Plate 56 combines ornament and use. It is an incense burner in the form of the lame Immortal Li T'ieh-kuai, Li with the iron crutch. The removable base is intended to hold the burning incense, and the smoke escapes through the mouth of the gourd held in

[1] Wu-ch'ing Hsien is also mentioned as having tile factories in the neighbourhood of Peking. This may be the district city Liu-li-chü.

[2] See Catalogue, *passim.*

the left hand. Li was the patron saint of astrologers and magicians, himself a dealer in magic and spells from whose gourd issued wonderful emanations.[1] Doubtless some picture of Li in this character suggested to the ingenious potter the idea of making the gourd exhale a cloud of incense smoke. The figure is made of reddish buff pottery, the robe is glazed with turquoise and dark violet-blue, and the flesh parts are left in biscuit, unglazed. The base is of wave pattern, suggesting that the Immortal is on his way to the sea-girt Taoist paradise.

Plate 57 illustrates a more monumental figure acquired by the British Museum in 1917. It is a temple statue of one of the seven judges of Hell, carrying his fateful portfolio and wearing the stern expression appropriate to his office. It is made of hard, greyish buff pottery, glazed chiefly with a fine aubergine brown, green and yellow; and one would assign it on grounds of style to the latter part of the Ming dynasty. The head and shoulders of a Kuan-yin in the Sauphar Collection (Plate 58) supply another example of the finer temple statuary. The flesh is a warm white, the under and over robes respectively yellow and green, and the hair is black. Complete, it must have been an imposing figure, not unlike the Kuan-yin in the Eumorfopoulos Collection.[2]

In the lists of potteries given in the *T'u Shu*[3] several are mentioned as of some note in the Ming period. For the most part they are merely names to us, but even the very meagre descriptions given of their products may help us to identify a stray specimen.

In Honan there was a pottery at work in the fifteenth century at the village of Ts'ai,[4] in Ju-ning Fu. "In the valleys of Ching and the mountains of Shu," names which cover a vast tract of land, including the provinces of Szechwan, Hunan and Hupeh, we are told that the potters made jars, drug pots, cauldrons, dishes, bowls, and sacrificial vessels, using a yellow clay for the body and overlaying it with black. Another kind of ware made in these regions resembled the Chün ware. But these descriptions are disappointingly vague, and we are left in doubt how far back the manufacture of the black-coated ware dates.

Potteries at Ch'ü-yang Hsien, in the Chên-ting Fu in Chihli, are mentioned in the records of the Hsüan Tê period, and also under the dates 1553 and 1563, as supplying wine jars and vases for the Court.

[1] See W. Perceval Yetts, *The Eight Immortals.*
[2] *Catalogue of an Exhibition of Chinese Applied Art*, Manchester, 1913, frontispiece.
[3] Section, *T'ao kung pu hui k'ao*, fols. 9 and 10 ; and *T'ao kung pu chi shih*, fol. 2.
[4] See p. 196.

This place is quite close to the site of the celebrated Sung factories of Ting Chou and is in a district noted for its fine white wares. In another passage Yen-shên Chên, in the Ch'ing-chou Fu in Shantung, is mentioned as a large pottery centre where the people made no less profit from their industry than the inhabitants of Ching-tê Chên. Cisterns, jars and cauldrons and the like are named among their chief productions.

Yi-chên, in the prefecture of Yangchow in Kiangsu, was celebrated for its tile factories. It also supplied wine jars, etc., to the palace at Nanking in the early Ming days. Similar vessels were supplied in 1528 from the potteries at Ning-kuo Fu, in Anhwei, a place which under its early name of Hsüan Chou is mentioned as making a thin white ware in the Yüan and Ming periods. The " snow white porcelain of Hsüan Chou " is celebrated by the sixteenth-century poet Wang Shih-chêng. The *T'ao lu* gives the names of several potteries which began operations in the Ming period in Honan, Shantung, Shensi and Kiangsi ; but we know nothing of their wares except that they were an inferior type of porcelain or stoneware ; and the names alone have little interest, except perhaps that of Hêng-fêng in Kiangsi. A pottery was established here by a man named Ch'ü Chih-kao, from Ch'u-chou Fu, in the early Ming period, and transferred in the sixteenth to Ma-k'êng, near Ching-tê Chên. The wares made at both places were coarse ; but the fact that the founder came from the home of celadon manufacture might be taken to suggest that they were a celadon type.

CHAPTER XVII

MARKS, INSCRIPTIONS AND CHINESE CHARACTERS

MARKS, INSCRIPTIONS, ETC.

Inscriptions of various kinds are frequently seen on Chinese pottery and porcelain. Those which occur in the field of decoration are usually of a poetical nature, having reference to the ornament on the vessel, but not to the date or place of its manufacture. The marks, on the other hand, which often throw light on the history of the ware, are found, as a rule, under the base. They are stamped, incised or painted; and on the Ming porcelains they are in most cases painted in underglaze blue, rarely in overglaze colours such as red. The ordinary script (*k‘ai shu*) is the usual medium employed, and the seal characters (*chuan shu*) are rarely seen in Ming marks, though the mark itself is often surrounded by a square or rectangular frame, as though it were the impression of a seal. Chinese inscriptions, if horizontally written, are read from right to left; if in vertical columns, from top to bottom, the sequence of the columns being from right to left.

Marks may be grouped conveniently under the following headings :—
(1) Date marks, (2) Hall marks, (3) Potters' names and factory marks, (4) Marks of commendation, dedication, etc.

(1) *Date Marks.*—The usual method of indicating the period of manufacture is to give the name of the reigning Emperor. The reign mark complete consists of six characters, e.g. *ta ming hsüan tê nien chih*= made (*chih*) in the Hsüan Tê period (*nien*) of the Great Ming (dynasty). Abbreviated forms of mark are *hsüan tê nien chih*, omitting the " Great Ming," and the vague *ta ming nien chih*,[1] in which the reign name is omitted. A further slight variation substitutes the character *tsao* for *chih;* but, as both mean " made," the sense is not affected. The reign mark was often framed in a double ring; and as the rings were made by one workman and the writing done by another, it sometimes happened

[1] It has been plausibly argued that this mark was used in the first reign of the dynasty, viz. that of Hung Wu ; but this inference can only be accepted with the greatest reserve. Incidentally the mark occurs on Japanese porcelain.

that porcelain went from the factory with the ring space left vacant by an oversight. It is a mistake to suppose that an empty double ring is a peculiarity of the post-Ming period.

The reign name (*nien hao*) of the Emperor is always used in these date marks, and a complete list of the Imperial *nien hao* will be found in Mayers' *Chinese Reader's Manual*, Giles' Dictionary,[1] etc. Those of the Ming dynasty are tabulated below; and a few photographic illustrations are given on Plate 59 which will show how the marks are applied and incidentally the nature of the bases of several specimens, in itself a feature of great interest to collectors. Occasionally the reign mark is placed elsewhere than on the base (see Plates 8 and 23).

It will hardly be necessary to remind the reader that Chinese reign marks cannot always be accepted at their face value. Indeed, those of the classic reigns, such as Hsüan Tê and Ch'êng Hua, have been vulgarised by promiscuous repetition on later Chinese wares, to say nothing of the carefully studied imitations of Ming porcelain made at various times in Japan.

Those who understand the niceties of Chinese calligraphy may get some guidance from the style in which the marks are written; and we may assume that those on the Imperial wares were written by skilled calligraphers in the " Mark Department,"[2] and that the true *nien hao* was given on the palace porcelains. In the private factories less attention would be paid to the writing of the mark or to its accuracy, and the connoisseur will take little heed of the ordinary date marks unless they are supported by good collateral evidence.

A more precise indication of date is given on the rare specimens, which have a cyclical date in addition to the *nien hao*; e.g. Fig. 2 of Plate 15, which is marked *ta ming hsüan tê kuei ch'ou nien tsao* = made in the *kuei ch'ou* year of the Hsüan Tê period, viz. 1433. The Chinese cycle consists of sixty years, and each year has an individual name in two characters formed by combining one of the Ten Stems with one of Twelve Branches. For a full explanation of the system with tables, the reader is referred to Mayers' *Chinese Reader's Manual*. All that he will require here is a ready method of interpreting such cyclical dates as he may come across, and this is supplied by the ingenious table worked out by Mr. Hetherington in another volume of this series.[3]

[1] See also Burton and Hobson, *Handbook of Marks on Pottery and Porcelain*, the *New Chaffers*, etc.

[2] See p. 17. [3] *Op. cit.*, p. 145.

甲 chia	乙 i	丙 ping	丁 ting	戊 mou	己 chi	庚 kéng	辛 hsin	壬 jên	癸 kuei
子 1 tzu	丑 2 ch'ou	寅 3 yin	卯 4 mao	辰 5 ch'ên	巳 6 ssŭ	午 7 wu	未 8 wei	申 9 shên	酉 10 yu
戌 11 hsü	亥 12 hai	子 13	丑 14	寅 15	卯 16	辰 17	巳 18	午 19	未 20
申 21	酉 22	戌 23	亥 24	子 25	丑 26	寅 27	卯 28	辰 29	巳 30
午 31	未 32	申 33	酉 34	戌 35	亥 36	子 37	丑 38	寅 39	卯 40
辰 41	巳 42	午 43	未 44	申 45	酉 46	戌 47	亥 48	子 49	丑 50
寅 51	卯 52	辰 53	巳 54	午 55	未 56	申 57	酉 58	戌 59	亥 60

" The first horizontal line of characters represents the ten stems. One of these stems will be found in combination with one of the branches in every cyclical date mark. If the eye is carried vertically downwards from the stem which has been detected in the inscription until it recognises the branch character, the year can be read off at once." Take the inscription on Fig. 2 of Plate 15. The character 癸 (*kuei*) is detected and is found to be the tenth stem, reading the table from left to right. With it is the character 丑 (*ch'ou*), the second branch. By carrying the eye vertically down the column headed with 癸 the combination is found in the sixth horizontal line of the diagrams indicating the fiftieth year. In some inscriptions the cyclical date is all that is mentioned, and we are left to determine the particular cycle concerned as best we may from indications of style or other internal evidence. But here we have only to do with the cycle in which the Hsüan Tê period fell, and we have no difficulty in arriving at the date 1433.

The cyclical system is supposed to have been instituted in the year 2637 B.C.; but in the Ming period we are only concerned with the cycles which began in 1324, 1384, 1444, 1504, 1564 and 1624 A.D.

Simpler still, but very uncommon, are those convenient date marks

in which the number of the year in the reign is specified. To read those one must know the Chinese numerals :—

1 = 一 i.	5 = 五 wu.	9 = 九 chiu.
2 = 二 êrh.	6 = 六 liu.	10 = 十 shih.
3 = 三 san.	7 = 七 ch'i.	
4 = 四 ssǔ.	8 = 八 pa.	

DYNASTIC PERIODS MENTIONED IN THIS BOOK

Han dynasty	206 B.C.– 220 A.D.	
T'ang „	618 A.D.– 906 A.D.	
Sung „	960 A.D.–1279 A.D.	
Yüan „	1280 A.D.–1367 A.D.	
Ming „	1368 A.D.–1644 A.D.	
Ch'ing „	1644 A.D.–1912 A.D.	

REIGNS OF THE MING DYNASTY

Hung Wu	洪武	1368–1398.
Chien Wên	建文	1399–1402.
Yung Lo	永樂	1403–1424.
Hung Hsi	洪熙	1425.
Hsüan Tê	宣德	1426–1435.
Chêng T'ung	正統	1436–1449.
Ching T'ai	景泰	1450–1456.
T'ien Shun	天順	1457–1464.
Ch'êng Hua	成化	1465–1487.
Hung Chih	弘治	1488–1505.
Chêng Tê	正德	1506–1521.
Chia Ching	嘉靖	1522–1566.
Lung Ch'ing	隆慶	1567–1572.
Wan Li	萬曆	1573–1619.
T'ai Ch'ang	泰昌	1620.
T'ien Ch'i	天啓	1621–1627.
Ch'ung Chêng	崇禎	1628–1644.

CH'ING REIGNS MENTIONED IN THIS BOOK

K'ang Hsi	1662–1722.
Yung Chêng	1723–1735.
Ch'ien Lung	1736–1795.

年製 洪武　Hung Wu
(1368–1398)

成厫款製　Ch'êng Hua
(seal characters)

年製 永樂　Yung Lo
(1403–1424)

治年製 大明弘　Hung Chih
(1488–1505)

Yung Lo
(in archaic
characters)

德年製 大明正　Chêng Tê
(1506–1521)

德年製 大明宣　Hsüan Tê
(1426–1435)

靖年製 大明嘉　Chia Ching
(1522–1566)

Hsüan Tê
(in seal
characters)

年製 嘉慶　Chia Ching

化年製 大明成　Ch'êng Hua
(1465–1487)

慶年製 大明隆　Lung Ch'ing
(1567–1572)

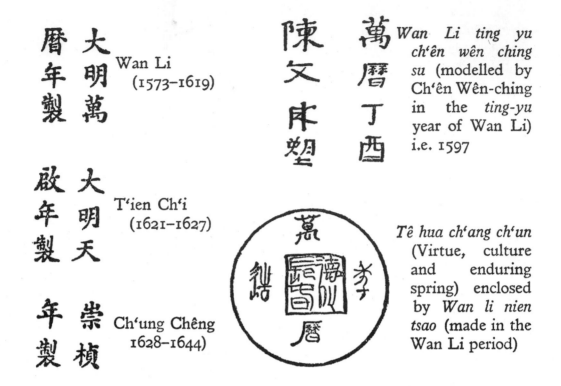

曆年製 大明萬 Wan Li (1573–1619)

陳文卿塑 萬曆丁酉 *Wan Li ting yu ch'ên wên ching su* (modelled by Ch'ên Wên-ching in the *ting-yu* year of Wan Li) i.e. 1597

啟年製 大明天 T'ien Ch'i (1621–1627)

年製 崇禎 Ch'ung Chêng 1628–1644

Tê hua ch'ang ch'un (Virtue, culture and enduring spring) enclosed by *Wan li nien tsao* (made in the Wan Li period)

(2) *Hall Marks* are so-called because they include the word *t'ang* 堂 (hall), or an equivalent such as *chai* 齋 (study) or *t'ing* 亭 (pavilion). The dictionary meaning of *t'ang* is a " hall : hall of justice or court ; the ancestral hall ; and an official title." The *t'ang ming* is the " family hall name," making reference to some outstanding event in family history, e.g. *wu tê t'ang chin* = Chin of the military valour (*wu tê*) hall. It is inscribed in one of the chief rooms of the house, on graves, in deeds, etc.

It is clear, then, that the hall mark is open to a variety of interpretations, as conveying the studio name of the potter, the family hall name of the person for which the vessel was made, the building for which the vessel was intended, as in the case of the various halls and pavilions in the Imperial palace, the name of the shop for which the ware was ordered or that of the workshop in which it was made. There is rarely any indication of the correct choice of these various meanings in the hall marks themselves, but fortunately we are not often called upon to decide in the case with Ming porcelains.

Ming hall marks are rare, though there is one which is found on a considerable variety of pieces. This is *yü t'ang chia ch'i*, " beautiful vessel of (or for) the Jade Hall." Possible interpretations of this mark are that it was a factory name, or that it was put on vessels destined for the *yü t'ang*, a name given to the Han Lin College at Peking ; but there are good reasons[1] for rejecting both of these explanations, particularly the latter. The specimens on which the mark occurs show considerable variety, but they are all patently in late Ming style. They include blue and white and five-colour ware[2] : the *ling lung* bowl (Fig. 2 of Plate 34), a jar with white slip designs on a coffee-brown glaze,[3] two bowls with underglaze red and blue decoration (the mark in this case is in the interior of the bowls), all in the British Museum ; and a bottle, with carved ornament washed over with tomato red, in the Eumorfopoulos Collection. It may be that the Jade Hall mark is less of a hall mark than a mark of commendation[4] in vogue in the late Ming period, just as *fu kuei chia ch'i* was common at a slightly earlier date.

Though not by any means a Ming mark, the mark of the Shên Tê Hall (*Shên tê t'ang*) is included because it appears on porcelain which avowedly imitates the Ming. Some of the pieces so marked have admirable decorations in the style of the Wan Li enamelled ware, and others in the style of Wan Li blue and white, even the summary finish of the base with radiating lines and defects in the glaze being included in the make-up of the latter.

(3) *Potters' names* are of very rare occurrence on porcelain, and they could hardly be expected to appear on the productions of the Imperial factories ; but they are frequently found on pottery and the wares issued at private works. It is not, however, easy to find examples which can be referred with certainty to the Ming period. Hao Shih-chiu[5] we know[6] signed his pots *Hu yin tao jên*,[5] but we have not yet seen a specimen ; and of the celebrated Ming Yi-hsing potters, who doubtless signed their work, we have only come across the marks of two, viz. a seal of Ming-yüan and script marks of Hui Mêng-ch'ên. The latter name appears in the incised inscriptions under Fig. 1 of Plate 49, which reads *ching ch'i hui mêng ch'ên chih*,[5] made by Hui Mêng-ch'ên of King-ki (another name of Yi-hsing).

[1] See Hobson, *op. cit.*, vol. i., p. 218.
[2] See two dishes in *Country Life*, January 29, 1921. [3] *Ibid.*
[4] Jade Hall would have some such general meaning as " Hall of pure worth."
[5] For characters, see p. 196. [6] See p. 142.

佳 玉 *Yü t'ang chia ch'i*
器 堂 (fine vessel for the
堂 慎 jade hall)
製 德
博 慎 *Shên tê t'ang chih*
古 德 (made in, or for,
製 堂 the Shên-tê hall).
On imitations of
Ming

*Shên tê t'ang po ku
chih* (antique made
in, or for, the
Shên-tê hall)

Ming - yüan. A
Yi-hsing potter

Hui Mêng-chên.
A Yi - hsing
potter

Fu fan chih tsao
(made on the
borders of
Fukien)

(4) *Marks of commendation*, etc.—It is not unusual to find in the place of a date mark, or potters' mark, a few characters indicating the destination of the piece, a good wish for the owner of it or even a moral aphorism for his edification.

The inscriptions recorded in the *Po wu yao lan* as appearing in or under the altar cups would come under the heading of marks of dedication, indicating as they do the purpose of the vessel. Thus the altar cups of the Hsüan Tê period were inscribed 壇 *t'an* (altar) ; those of the Chia Ching period 茶 *ch'a* (tea), 酒 *chiu* (wine), 棗 湯 *tsao t'ang* (decoction of jujubes), 薑 湯 *chiang t'ang* (decoction of ginger). These characters apparently were written inside the cups ; while 金 籙 *chin lu* (golden seal), 大 醮 *ta chiao* (great sacrifice) and 壇 用 *t'an yung* (altar use) were written under the base. *Han hsing* (to contain fragrance), engraved under the base of a wine cup in the British Museum, belongs to this category.

Dedicatory inscriptions at greater length are sometimes written or incised in the field of decoration, as on Fig. 2 of Plate 28 and Fig. 2 of Plate 46.

Good wishes are expressed by such phrases as *ch'ang ming fu kuei* (long life, riches and honours !), *wan fu yu t'ung* (may infinite happiness embrace all your affairs !), or by symbolical phrases such as *tan kuei* (red cassia), which implies a wish for success in the State examinations,[1]

[1] "To pluck the cassia in the moon " means to obtain a high place in the examinations.

etc. Several of these marks are found recurring on the Chia Ching porcelain, and one of them occurs in combination with the Wan Li mark on a dish in the British Museum. Probably the most familiar of them all is *fu kuei chia ch'i* (fine vessel for the rich and honourable), which is found on quite a number of specimens with late Ming characteristics. A more spacious benison worthy of an Imperial ware is *t'ien hsia t'ai p'ing*[1] (great peace throughout the Empire) on a tripod incense vase in the Victoria and Albert Museum; and a moral precept will be read in *lu wei ch'ing kao*[1] (rank and emolument without corruption) on Fig. 1 of Plate 34.

Again, a good wish may be expressed by a symbol such as the stork, peach, etc., for longevity, the bat for happiness, etc. Such symbol marks occur frequently on post-Ming porcelains; but a stork on the base of some late Ming dishes[2] shows that they are to be looked for in our period as well. Doubtless a similar idea underlies the *hare mark* which is found on a variety of porcelains assignable to the Chia Ching or Wan Li period. It appears, for instance, on the ewer with fountain design,[3] another example of which has the Chia Ching mark; on Fig. 1 of Plate 35, a dish painted in blue with the design of three rams; on a pipe-shaped bottle in the Victoria and Albert Museum decorated with boys and branches in white reserved in a blue ground[4]; on a jar with " mixed colour " designs; and on a jar with " five-colour " decoration (Fig. 4 of Plate 39). In Taoist lore the hare is one of the denizens of the moon, where he assists the moon toad to pound the elixir of life; and in a rather late variety of the hare mark the crescent of the moon is included.

The Buddhist emblems, symbols of the Taoist Immortals, etc., which are so often seen on later porcelains, do not seem to have been used as marks in Ming times.

長 富 春 貴	*Fu kuei ch'ang ch'un* (Riches, honours and enduring spring)	丹 桂	*Tan kuei* (Red cassia)
收萬 同福	*Wan fu yu t'ung* (A myriad happinesses embrace all your affairs)	含 馨 香	*Han hsing* (To contain fragrance)

[1] For characters, see pp. 195 and 196.
[2] Cat. B.F.A., 1910, E. 28.
[3] See p. 122.
[4] Figured in Dillon, *op. cit.*, Plate 15.

Fu kuei chia ch'i (Fine vessel for the rich and honourable)

 Stork

Ch'ang ming fu kuei (Long life, riches and honours). Arranged as on a "cash" or coin

 Hare marks

Shuai fu kung yung (For public use in the general's hall)

THE EIGHT BUDDHIST EMBLEMS (*pa chi hsiang*)

See page 106

194

LIST OF CHINESE CHARACTERS USED IN CRITICAL PASSAGES
AND PHRASES THROUGHOUT THE BOOK

p. 33.　t'ieh chin 貼金

p. 36.　ch'uang chin chê 戧金者

p. 39.　hung wu nien nei yung chih ch'i 洪武年內用製噐

p. 39.　t'o t'ai 脫胎
　　　　kung yang 拱樣

p. 47.　su ma ni 蘇麻泥
　　　　su ni p'o 蘇泥浡
　　　　chi tz'ǔ ni 吉慈尼

p. 53.　chi hung 祭紅 (sacrificial red), variants 積 (massed) and
　　　　霽 (sky-clearing)
　　　　hsien hung 鮮紅

p. 88.　ch'ing k'ou 磬口
　　　　man hsin 鏝心
　　　　yüan tsu 圓足

p. 93.　ts'ui ch'ing 翠青
　　　　tzǔ 紫
　　　　ch'ing ti shan huang 青地閃黃

p. 94.　huang hua an lung fêng hua ho 黃花暗龍鳳花盒
　　　　su jang hua po 素穰花鉢

p. 96.　yü mên 禹門

p. 101.　chuan hsia pien yung 篆匣便用

p. 104.　fu shou k'ang ning 福壽康寧
　　　　shou shan fu hai 壽山福海
　　　　pa 巴

p. 108.　ch'ien k'un ch'ing t'ai 乾坤清泰

p. 109.　yu kai shih tzǔ yang 有蓋獅子樣

p. 114.　wan ku ch'ang ch'un ssǔ hai lai chao 萬古長春四海來朝

p. 115.　yung pao ch'ang ch'un 永保長春
　　　　shêng shou 聖壽
　　　　ting chuang 頂粧
　　　　ling lung 玲瓏

p. 125.　lu wei ch'ing kao 祿位清高

p. 135.　wan li hsin mao ju ch'êng chia tsang 萬曆辛卯如成家藏

p. 157.　ch'ên chên shan chih 陳珍山製

p. 169.　ou 歐

p. 180.　pên hsien liu li wa (glazed tile of the district) 本縣琉璃瓦

p. 182. Ts'ai 蔡
p. 185. ta ming nien tsao 大 明 年 造
p. 171. ching ch'i hui mêng ch'ên chih 荆溪惠孟臣製
p. 191. hu yin tao jên 壺 隱 道 人
p. 141. hao shih chiu 昊 十 九
p. 193. t'ien hsia t'ai p'ing 天 下 太 平

NAMES OF CHINESE WORKS MENTIONED IN THE BIBLIOGRAPHY

Ch'in ting ku chin t'u shu chi ch'êng 欽 定 古 今 圖 書 集 成
Ch'ing pi tsang 清 秘 藏
Ching tê chên t'ao lu 景 德 鎮 陶 錄
Ko ku yao lun 格 古 要 論
Po wu yao lan 博 物 要 覽
T'ao shuo 陶 說

PLACE NAMES

The following list contains the names of the principal pottery and porcelain centres, mentioned in the book, of which the Chinese characters have been ascertained.

The double romanisation represents (1) the *Mandarin* pronunciation, which is the official style common to China in general; and (2) the *Post Office* version, which is a convenient compound of the Mandarin and the local pronunciations.

The Post Office form of place names will tend more and more to be the accepted version; and it is probable that in a few years it will be generally adopted in books dealing with Chinese subjects. Meanwhile during the transition period it will be necessary to give both versions where they are available.

Mandarin.				*Post Office.*
Ching-tê Chên	景	德	鎮	Kingtehchen.
Ch'u-chou[1]	處	州		Chuchow.
Ch'ü-yang[1]	曲	陽		Küyang.
Chün Chou	均	州		
Fo-shan	佛	山		Fatshan.
Fêng-ch'i	楓	溪		Fungkai.

[1] Hsien 縣.

Mandarin.		Post Office.
Fou-liang[1]	浮梁	Fowliang.
Hêng-fêng	橫峰	
Hsüan Chou	宣州	
Jao Chou[1]	饒州	Jaochow.
Ju Chou[1]	汝州	Juchow.
Kua Chou	瓜洲	Kwachow.
Liu-t'ien	琉田	
Lung-ch'üan	龍泉	Lungchüan.
Nan-fêng[1]	南豐	Nanfeng.
Po-shan[1]	博山	Poshan.
Shao wu[1]	邵武	Shaowu.
Shih-wan	石灣	Shekwan (West).
Su Chou	蘇州	Soochow.
Tê-hua[1]	德化	Tehwa.
Ting Chou[1]	定州	Tingchow.
Tz'ŭ Chou	磁州	Tzechow (Chihli).
Wên Chou[1]	溫州	Wenchow.
Yang-hsien	陽羨	
Yen-shên Chên	顏神鎭	
Yi-chên	儀眞	
Yi-hsing[1]	宜興	Ihing.
Yü Chou	禹州	Yüchow (Honan).
Yung-ho Chên	永和鎭	Yungho (Kiangsi).

[1] Hsien 縣.

197

SELECTED BIBLIOGRAPHY

Bosch-Reitz, S. C. Bulletin of the Metropolitan Museum of Art. December, 1919, etc.

Brinkley, Captain F. China : its History, Arts and Literature. Vol. IX. London, 1904.

Burton, W. Porcelain : A Sketch of its Nature, Art and Manufacture. London, 1906.

Burton, W., and Hobson, R. L. Marks on Pottery and Porcelain. London, 1912.

Bushell, S. W. Chinese Porcelain, Sixteenth-century coloured illustrations, with Chinese MS. text by Hsiang Yüan-p'ien. Translated by S. W. Bushell. Oxford, 1908. Sub-title : Porcelain of Different Dynasties.

Bushell, S. W. Description of Chinese Pottery and Porcelain, being a translation of the *T'ao shuo*. Oxford, 1910.

Bushell, S. W. Oriental Ceramic Art. Collection of W. T. Walters. New York, 1899.

Bushell, S. W. Chinese Art. 2 Vols. Victoria and Albert Museum Handbook, 1906.

Bushell, S. W., and Laffan, W. M. Catalogue of the Morgan Collection of Chinese Porcelains. Metropolitan Museum of Art, New York, 1907.

Ch'in ting ku chin t'u shu chi ch'êng.[1] The Encyclopaedia of the K'ang Hsi Period. Section XXXII, Handicrafts (*k'ao kung*).

Ch'ing pi ts'ang.[1] A Storehouse of Artistic Rareties. By Chang Ying-wên. Published by his son in 1595.

Ching tê chên ta'o lu.[1] The Ceramic Records of Ching-tê Chên. By Lan P'u. Published in 1815.

De Groot, J. J. M. The Religious System of China. Leyden, 1894.

Dillon, E. Porcelain. London, 1904.

Franks, A. W. Catalogue of a Collection of Oriental Porcelain and Pottery. London, 1879.

Grandidier, E. La Céramique Chinoise. Paris, 1894.

Hetherington, A. L. The Early Ceramic Wares of China. London, 1922.

Hetherington, A. L. The Pottery and Porcelain Factories of China. London, 1921.

Hippisley, A. E. Catalogue of the Hippisley Collection of Chinese Porcelain. Washington, 1906.

Hirth, F., and Rockhill, W. W. Chau Ju-kua : his Work on the Chinese and Arab Trade in the Twelfth and Thirteenth Centuries, entitled *Chu fan chi*. St. Petersburg, 1912.

Hobson, R. L. Chinese Pottery and Porcelain. 2 Vols. London, 1915.

Hobson, R. L., and Burton, W. See Burton.

Hobson, R. L. Catalogue of a Collection of Early Chinese Pottery and Porcelain. Burlington Fine Arts Club, 1910.

Hsiang Yüan-p'ien. See Bushell.

Julien, Stanislas. Histoire et Fabrication de la Porcelaine Chinoise. Paris, 1856. Being a translation of the greater part of the *Ching tê chên t'ao lu*, with Notes.

Ko ku yao lun.[1] Essential Discussion of the Criteria of Antiquities. By Tsao Ch'ao. Published in 1387 ; revised and enlarged edition in 1459.

[1] For Chinese characters, see p. 196.

SELECTED BIBLIOGRAPHY

Laffan, W., and Bushell, S. W. See Bushell.

Marquet de Vasselot and Mlle. Ballot. Céramique Chinoise. Documents d'Art, Musée du Louvre. Paris, 1922.

Mayers, W. F. The Chinese Reader's Manual. Shanghai, 1874.

Perzynski, F. Towards a Grouping of Chinese Porcelain. *Burlington Magazine*, October and December, 1910, etc.

Playfair, G. M. H. Cities and Towns of China. Hongkong, 1910.

Po wu yao lan.[1] A General Survey of Art Objects. By Ku Ying-t'ai. Published in the T'ien Ch'i period (1621-7).

T'ao lu. See *Ching tê chên t'ao lu.*

T'ao shuo.[1] A Discussion of Pottery. By Chu Yen. Published 1774. See Bushell.

T'u shu. See *Ch'in ting ku chin t'u shu chi ch'êng.*

Zimmermann, E. Chinesisches Porzellan. Leipzig, 1913.

[1] For Chinese characters, see p. 196.

INDEX

INDEX

INDEX

INDEX

INDEX

INDEX

INDEX

Upsala, 118, 127, 132, 143

Vasco de Gama, 83
Victoria and Albert Museum, 42, 49, 50, 52, 60, 74, 82, 89, 90, 94, 95, 116, 135, 174, 193
Violet-blue enamel, 32, 128
Violet-blue glaze, 29

Wa wa, children, 72, 114
Wall-vase, 126
Wan Fi wu ts'ai, 33, 128
Wan shou, 122
Wang, Kuei-fei, 64
Wang Chên, 63
Wang Chih, 29
Wang Ching-min, 113
Wang Shih-chêng, 183
Warham, Archbishop, 156
"Wave and plum blossom" pattern, 32, 109, 127
Wên-chou Fu, 153, 197
Wethered, V., 56, 80, 144
White wares, 23, 31, 39, 41, 93, 135, 149
William V, of Bavaria, 120
Wine cups, shallow, 88, 90
Wine jars, 162
Wine kettle, 129
Winkworth, S., 58, 79, 94, 95, 102, 126, 133
Worcester, Honble, Dean C., 139
Wu Mei-ts'un, 61
Wu ming tzu, 24
Wu ts'ai, 25, 26, 31, 57, 64, 99, 115, 128
Wu ts'ai fu sê, 57
Wu Tsung, 74
Wu-ch'ing Hsien, 181
Wu-mên-t'o, clay form, 14, 112
Wu-ming-i, 47, 78
Wu-yüan Hsien, 152

Ya shou pei, "press-hand" cups, 40, 41, 64
Yang hsien ming hu hsi, quoted, 167, 197
Yates, H. J., 30, 146
Yellow glazes, 73, 74, 80, 95
Yen, prince of, 39
Yen-shên-Chên, 183, 197
Yetts, W. P., 182
Yi-chên, 179, 183, 197
Yi-hsing, 141, 163, 166–171, 197
Yin yang, 105, 106, 114
Ying Tsung, 63
Yü Chou, 152, 197
Yü mên, mark, 96, 195
Yü t'ang chia ch'i, 125
Yüan dynasty, 35, 38, 155, 181, 183
Yung Chêng lists, 40, 60, 65, 67, 130, 170
Yung Lo bowls, 16
Yung Lo period, 39–43, 135
Yung-ho Chên potteries, 12, 197
Yunnan ware, 6
Yü-po-lo, 73

Zanzibar, 157
Zengoro Hozen, 42
Zimmermann, E., 127, 156, 200

208

PLATES

PLATE 10.

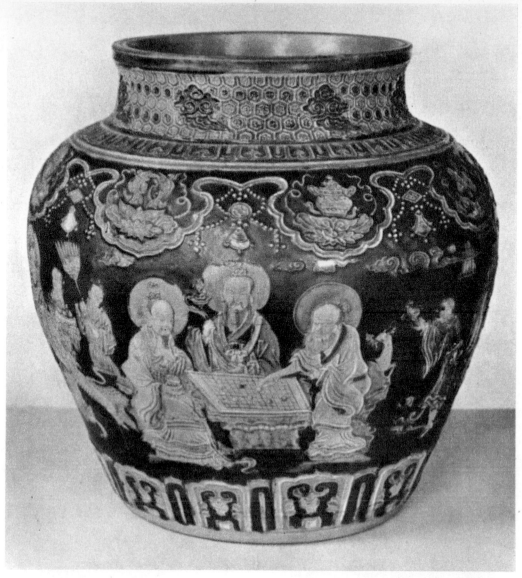

Potiche with decoration in cloisonné style, with coloured glazes. Dark blue ground. Taoist subjects—the three Star Gods playing checkers, the Eight Immortals, the twin Genii of Mirth and Harmony, and Hsi Wang Mu with attendants. H. 15 ins. (See page 28.)

PLATE 11.

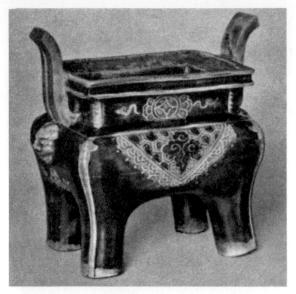

Fig. 1. Incense burner of bronze form, with coloured glazes: lion masks beneath the handles. Dark violet blue ground. Drapery design on the sides: swastika and "cash" symbols on the neck, and cloud-scrolls at the ends. L. 8¾ ins. (See page 30.)

Honble. Evan Charteris Collection.

Anthony de Rothschild Collection.

Fig. 2. Vase of double-gourd shape, decorated in cloisonné style, with coloured glazes. Dark violet-blue ground. Four figures on the neck representing the Four Liberal Accomplishments. On the body, figures, landscapes and plants. H. 15½ ins. (See page 29.)

Franks Collection (British Museum).

Fig. 3. Vase (*mei p'ing*) with carved and pierced designs. Mountain pavilion, sage and attendant; band of peony flowers and foliage on the shoulder. Blue, aubergine, yellow and white glazes, in a turquoise ground. Fifteenth century. H. 13½ ins. (See page 30.)

PLATE 12.

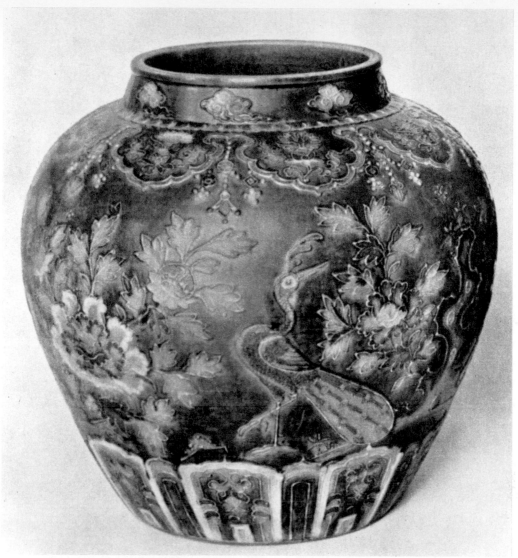

Potiche decorated in cloisonné style, with coloured glazes. Green ground. Garden landscape with peacock and peonies. H. $11\frac{1}{2}$ ins. (See page 28.)

PLATE 13.

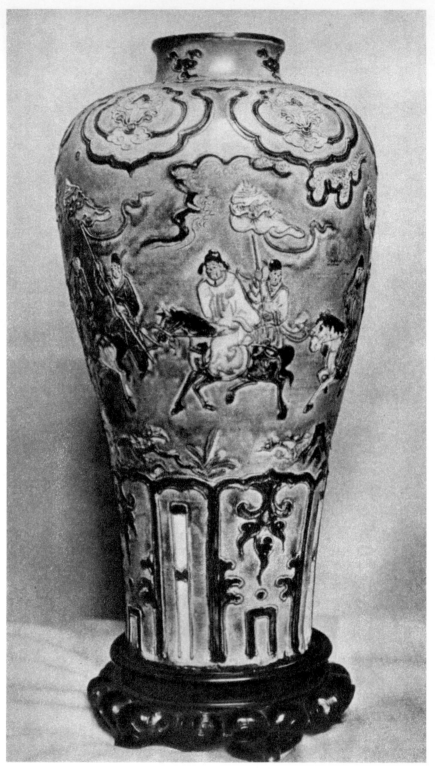

Grandidier Collection (The Louvre).

Vase of baluster form, decorated in cloisonné style with coloured glazes. Turquoise ground. Landscape and horsemen with banner bearers. H. 17½ ins. (See page 29.)

PLATE 14. Four blue and white bowls.

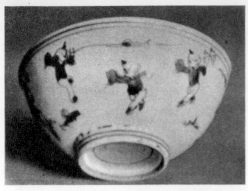

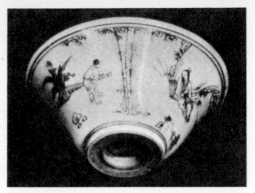

M. D. Ezekiel Collection.

M. D. Ezekiel Collection.

Fig. 1. Children at play. Said to be Hung Wu period. D. 4½ ins. (See page 37.)

Fig. 2. Landscape outside. Scrolls and Yung Lo mark inside. D. 4 ins. (See page 41.)

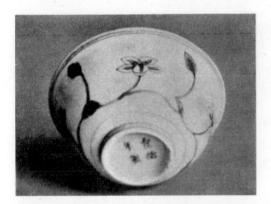

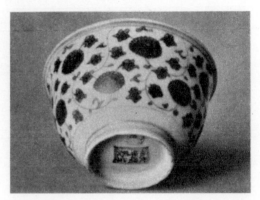

M. D. Ezekiel Collection.

G. Eumorfopoulos Collection.

Fig. 3. Floral scroll. Hsüan Tê mark. D. 4½ ins. (See page 49.)

Fig. 4. Floral scrolls. Ch'êng Hua mark. D. 3¾ ins. (See page 67.)

PLATE 15.

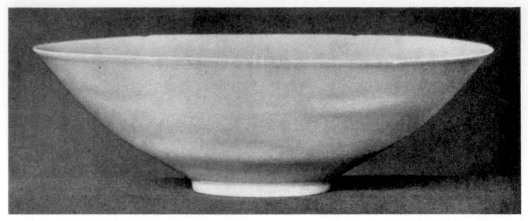

Franks Collection (British Museum).

Fig. 1. Bowl of white eggshell porcelain, with
two Imperial dragons traced in white
slip inside. Yung Lo mark engraved
in the bottom. D. 8¼ ins. (See page 40.)

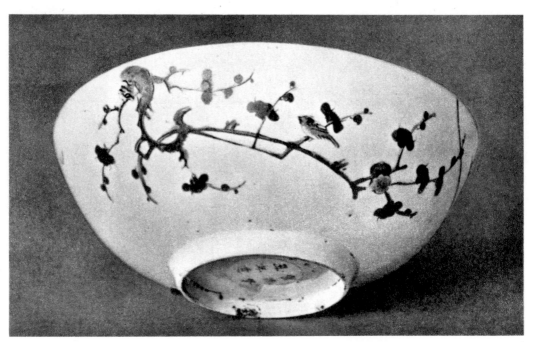

S. D. Winkworth Collection.

Fig. 2. Bowl with enamelled prunus design.
Cyclical mark of the year 1433. D. 8½
ins. (See page 58.)

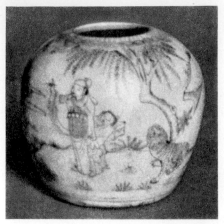

Victoria and Albert Museum.

Fig. 1. Jar pencilled in blue with tiger and figures in landscape. H. 3⅞ ins. (See page 49.)

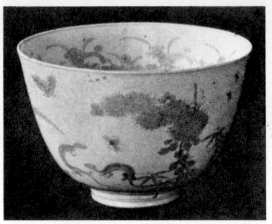

Salting Collection (Victoria and Albert Museum).

Fig. 2. Bowl with blue decoration: flowering chrysanthemums and lizards; lotus border inside. Hsüan Tê mark. H. 3⅞ ins. (See page 51.)

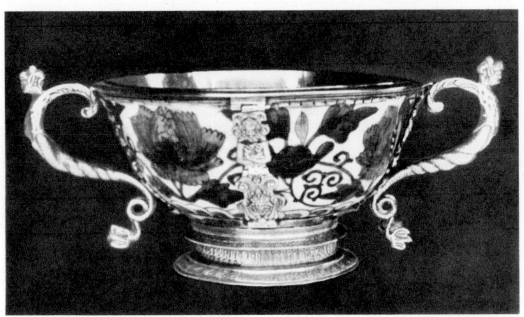

Mrs. Lane's Collection.

Fig. 3. " Trenchard " Bowl, decorated in blue with peony design outside and fish inside. Mount about 1550. D. 8 ins. (See page 49.)

PLATE 17

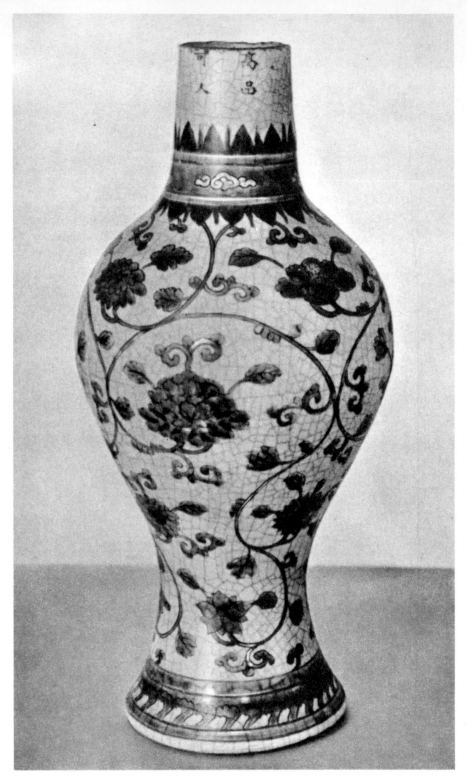

Vase: greyish white crackled glaze and floral scroll painted in enamels and underglaze blue. Ch'êng Hua mark. H. 18½ ins. (See page 70.)

PLATE 18.

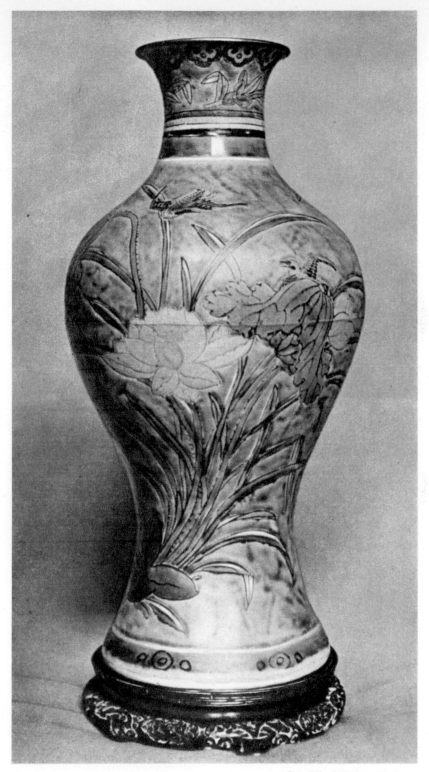

Grandidier Collection (The Louvre).

Vase with lotus design and birds, in
green and yellow enamels in a turquoise
ground: brown outlines. Ch'êng Hua
period. H. 17½ ins. (See page 70.)

PLATE 19.

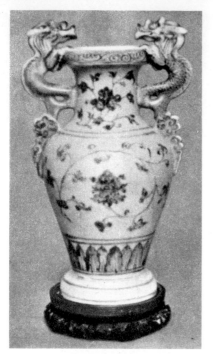

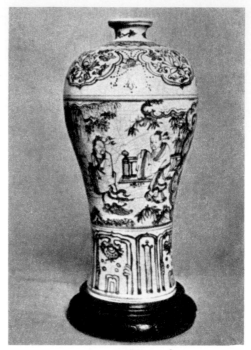

Grandidier Collection (The Louvre).

Grandidier Collection (The Louvre).

Fig. 1. Vase with dragon handles: blue and white. Chêng Tê period. H. 8¾ ins. (See page 79.)

Fig. 2. Vase of baluster form: blue and white. Fifteenth century. H. 12 ins. (See page 51.)

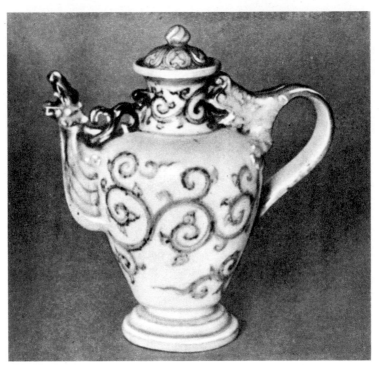

G. Eumorfopoulos Collection.

Fig. 3. Ewer with dragon handle and spout: blue and white. Chêng Tê period. H. 7¼ ins. (See page 79.)

PLATE 20.

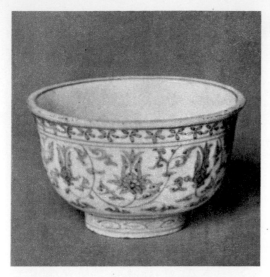

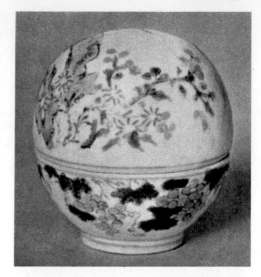

H. J. Oppenheim Collection.

H. J. Oppenheim Collection.

Fig. 1. Bowl delicately painted in blue with lotus scrolls outside and a medallion inside with ducks in a lotus pond. Perhaps Hsüan Tê period. D. 3¾ ins. (See page 51.)

Fig. 2. Egg-shaped box of fine porcelain painted in underglaze blue and enamels —light green, pale red and brownish yellow—with rocks and flowering plants on the cover and a grape vine on the sides. Ch'êng Hua mark. H. 2½ ins. (See page 69.)

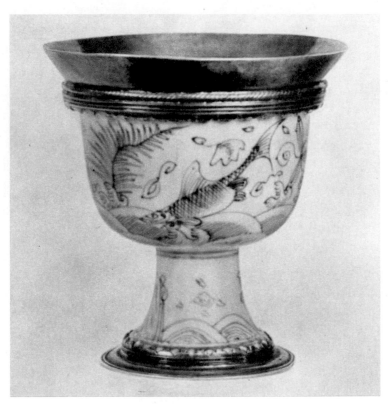

Leverton Harris Collection.

Fig. 3. Stem cup, pencilled in light greyish-blue with fish and water plants: medallion with conch shell inside: '' rock of ages '' pattern on foot. European silver mount about 1530. H. 3⅝ ins. (See page 66.)

PLATE 21.

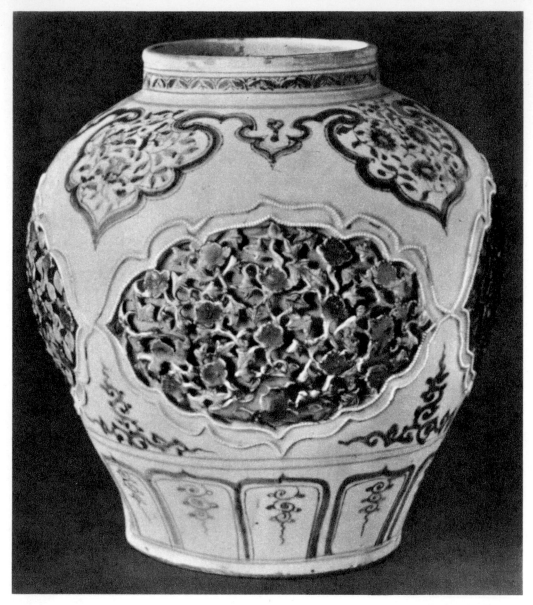

S. D. Winkworth Collection.

Potiche with four panels of floral design in openwork coloured blue and red under the glaze: other ornament in blue. Chêng Tê period. H. 13½ ins. (See page 79.)

PLATE 22

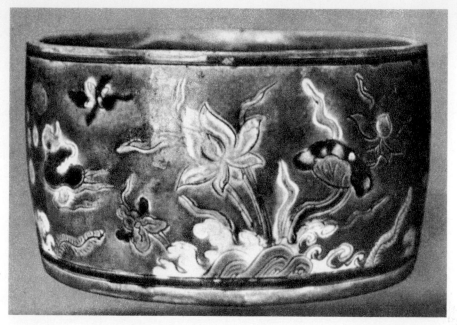

L. Fould Collection.

Fig. 1. Brush washer with engraved lotus
designs and coloured glazes—turquoise,
violet-blue and white in a yellow
ground. Chêng Tê period. H. 3½ ins.
(See page 83.)

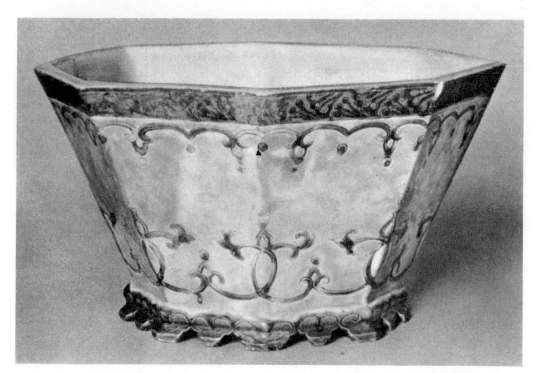

G Eumorfopoulos Collection.

Fig. 2. Flower pot with engraved designs and
coloured glazes—green, yellow and
aubergine in a turquoise ground. Chêng
Tê mark. D. 9½ ins. (See page 82.)

PLATE 23.

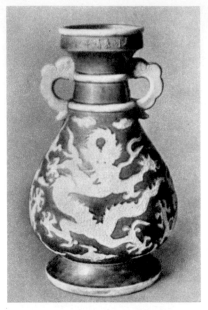

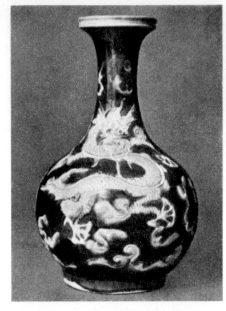

Fig. 1. Altar vase with Imperial dragons in white biscuit (traces of red colour and gilding) in a dark blue glaze. Chia Ching mark. H. 10½ ins. (See page 102.)

Fig. 2. Bottle with raised design in white biscuit and turquoise in a dark blue ground. Chêng Tê mark. H. 9 ins. (See page 83.)

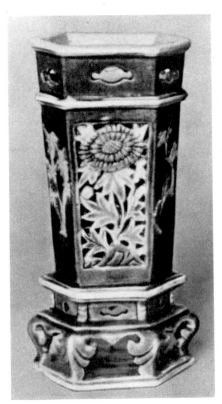

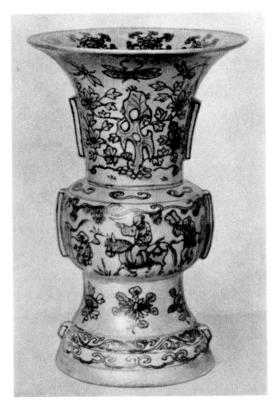

Fig. 3. Brush holder with carved and pierced designs and coloured glazes. Dark blue ground. Chêng Tê period. H. 8¼ ins. (See page 83.)

Fig. 4. Square beaker with figure subjects, etc., in aubergine in a yellow ground. Wan Li mark. H. 9¾ ins. (See page 133.)

PLATE 24.

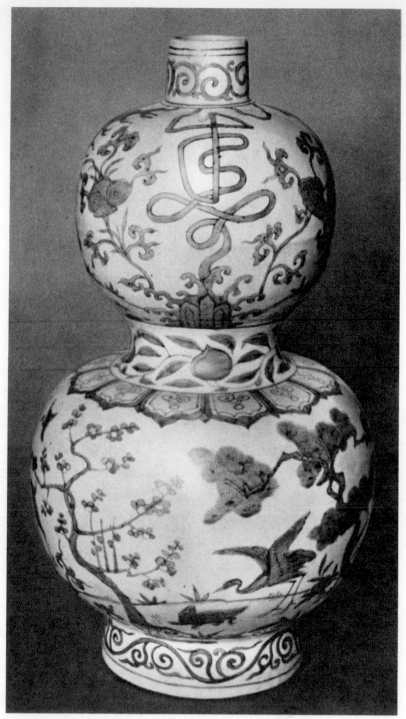

Vase of double-gourd shape, painted in dark blue with the various emblems of Longevity. Chia Ching mark. H. 17½ ins. (See page 95.)

PLATE 25.

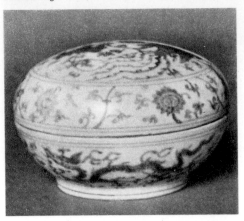

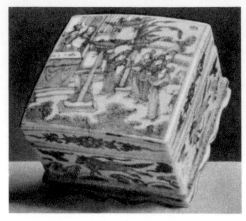

H. J. Oppenheim Collection.

S. D. Winkworth Collection.

Fig. 1. Box: blue and white, with phœnixes
and lotus scrolls. Chia Ching mark.
D. 5½ ins. (See page 96.)

Fig. 2. Square box: blue and white, with figure
subject on the cover. Mark, Yü mên.
Chia Ching period. L. 4⅛ ins.(See page 96.)

Victoria and Albert Museum.

Fig. 3. Saucer-dish painted in underglaze blue
with sprays of flowers and fruit in a
yellow ground. Hung Chih mark.
D 10¼ ins. (See page 74.)

PLATE 26.

Comtesse de Beauchamp Collection.

Fig. 1. Potiche painted in enamel colours and underglaze blue, with fish and water plants. Chia Ching mark. H. 13 ins. (See page 102.)

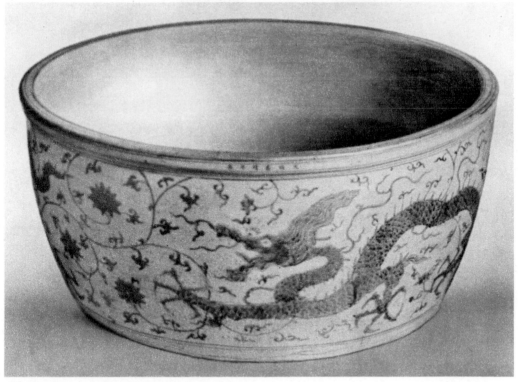

J. Love Collection.

Fig. 2. Fish bowl with Imperial dragons and lotus scrolls in dark blue. Chia Ching mark. D. 30½ ins. (See page 95.)

PLATE 27.

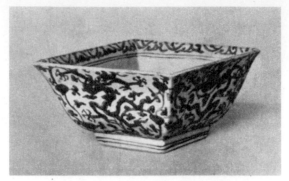

G. Eumorfopoulos Collection.

Fig. 1. Square bowl with fish and water plants
in yellow and green in a red ground.
Inside, fish and green scroll border.
Chia Ching mark. L. 5 ins. (See
page 95.)

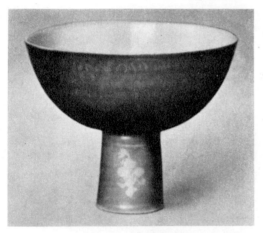

H. J. Oppenheim Collection.

Fig. 2. Stem-cup with overglaze red ground and
gilt lotus scrolls. Chia Ching period.
H. $4\frac{1}{4}$ ins. (See page 92.)

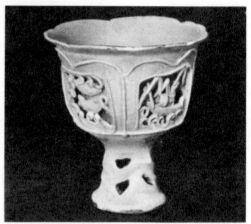

V. Wethered Collection.

Fig. 3. Stem-cup with four openwork panels
and cable borders. Chêng Tê period.
H. 4 ins. (See page 80.)

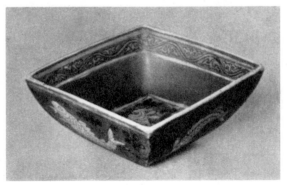

H. J. Oppenheim Collection.

Fig. 4. Square bowl with " thread-like "
dragons in underglaze blue and a
yellow ground: seal character *shou*
inside. Chia Ching mark. L. $5\frac{1}{4}$ ins.
(See page 94.)

PLATE 28.

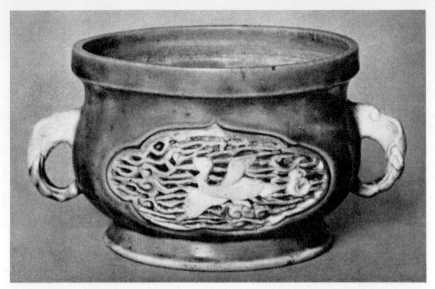

Honble. Evan Charteris Collection.

Fig. 1. Incense burner with elephant handles,
decorated with pierced designs and
coloured glazes: panels with *ch'i-lin*
and crane: turquoise ground. Chêng
Tê or Chia Ching period. D. 8 ins.
(with handles). (See page 99.)

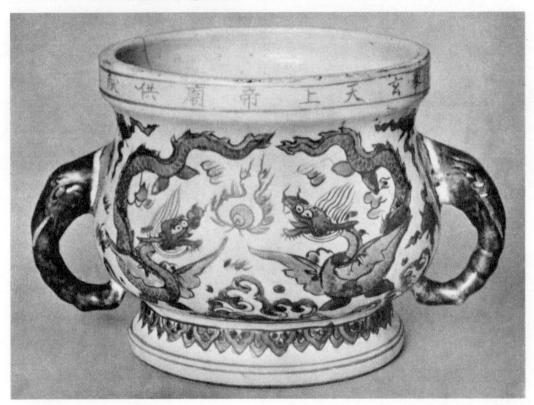

H. J. Oppenheim Collection.

Fig. 2. Incense burner with elephant handles:
enamelled with red, green and yellow.
Dragon designs; inscription in red with
date 1564. D. 6¼ ins. (See page 101.)

PLATE 29.

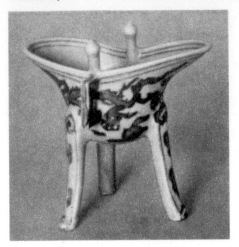

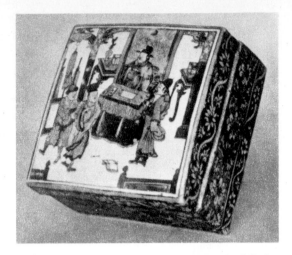

G. Eumorfopoulos Collection.

G. Eumorfopoulos Collection.

Fig. 1. Libation cup, helmet-shaped. Painted in underglaze blue with Imperial dragons and cloud scrolls: yellow ground. Chia Ching mark. H. 4⅛ ins. (See page 94.)

Fig. 2. Square box painted in green, red, yellow and turquoise green enamels. On the cover a high official at a table with writing implements: a screen behind him with symbolical design of leaping salmon: two persons disputing in the foreground. Borders of peony scrolls, etc., reserved in green and red grounds. *Ch'i-lin* inside. Mark, *Ch'uan hsia pien yung* (seal box for use as required). Chia Ching period. L. 5½ ins. (See page 101.)

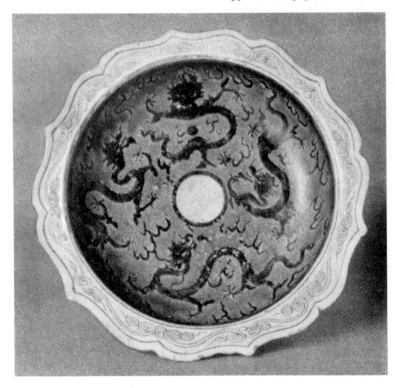

G. Eumorfopoulos Collection.

Fig. 3. Deep dish, with narrow rim shaped at the edge. Enamelled with Imperial dragons " pursuing pearls " in red in an emerald green ground: red borders. Chêng Tê or Chia Ching period. D. 9 ins. (See page 95.)

PLATE 30.

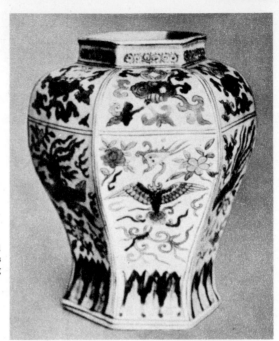

Fig. 1. Vase painted in underglaze blue and
enamel colours with flying phœnixes
and formal designs. Lung Ch'ing
mark. H. 10 ins. (See page 110.)

M. D. Ezekiel Collection.

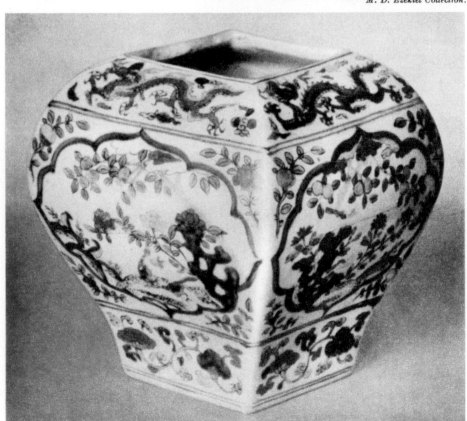

J. Love Collection.

Fig. 2. Square jar painted in underglaze blue
and enamel colours with mirror-shaped
panels of flowers and fruit: dragons
and floral scrolls in the borders. Lung
Ch'ing mark. H. 7½ ins. (See page
110.)

PLATE 31.

Rosenborg Palace Collection.

Fig. 1. Hexagonal bowl and cover: blue and white. Figures and landscape. Brought to Denmark in 1622. D. about 6 ins. (See page 118.)

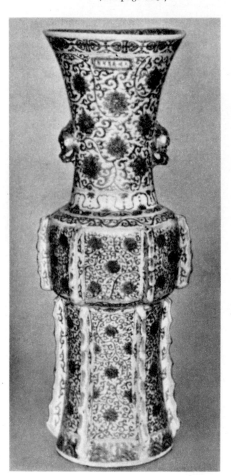

J. Love Collection.

Fig. 2. Beaker-shaped vase with lion handles and six projecting ribs: painted in blue with close lotus scrolls: borders of crested waves, etc. Wan Li mark. H. 30½ ins. (See page 117.)

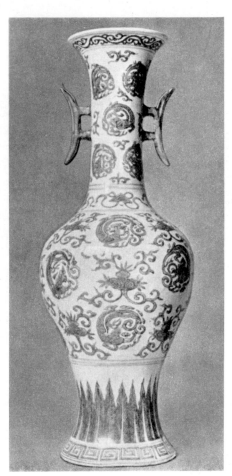

Marquet de Vasselot Collection.

Fig. 3. Baluster vase with two handles shaped like head-rests: painted in blue with coiled dragon medallions and borders of stiff leaves, symbols, etc. Wan Li period. H. 20 ins. (See page 117.)

PLATE 32.

R. E. Brandt Collection.

Fig. 1. Shallow bowl: with moulded reliefs on
the sides and medallion of fish and
waterweeds painted in pale blue.
Fifteenth century. D. 5¾ ins. (See
page 67.)

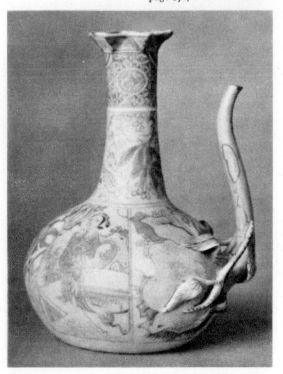

Franks Collection (British Museum).

Fig. 2. Ewer with star-shaped mouth and
moulded sides with branches in relief:
painted in pale blue with figure subjects,
rat and vine pattern, etc. Wan Li
period. H. 6¾ ins. (See page 121.)

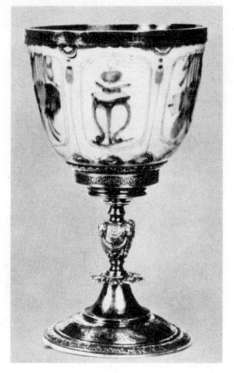

Anonymous.

Fig. 3. Blue and white bowl mounted as a cup
about 1584: moulded ornament in low
relief inside. H. 7½ ins. (See page 121.)

PLATE 33.

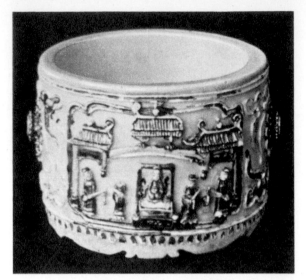

Fig. 1. Cylindrical brush washer, white with relief ornaments in biscuit on which are pigments and gilding. Designs of pavilion and figures and two bosses enclosing characters. Wan Li period. H. 2½ ins. (See page 123.)

Salting Collection (Victoria and Albert Museum).

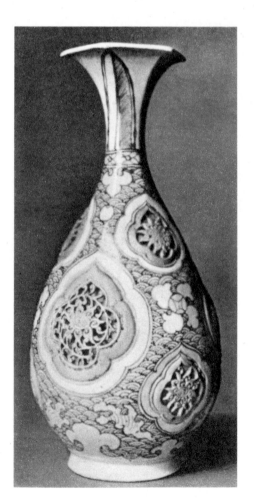

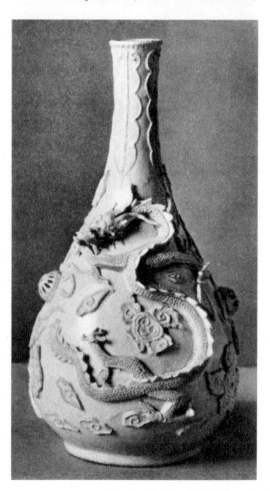

L. Fould Collection.

Franks Collection (British Museum).

Fig. 2. Bottle with hexagonal neck: painted in blue with "cash" symbols, etc., in a wave pattern ground: interrupted by medallions with rosettes and foliage in openwork unglazed and showing traces of gilding. Early sixteenth century. H. 12 ins. (See page 123.)

Fig. 3. Bottle, white with biscuit designs in high relief: dragons pursuing "pearls", and cloud scrolls. The "pearls" are in openwork. Late Ming. H. 11½ ins. (See page 123.)

PLATE 34.

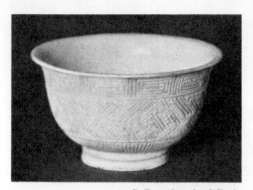

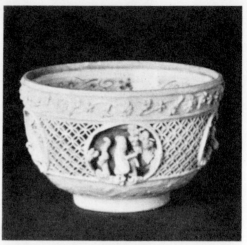

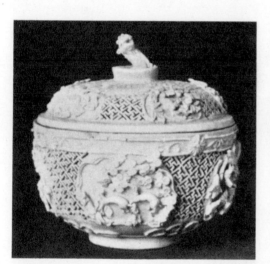

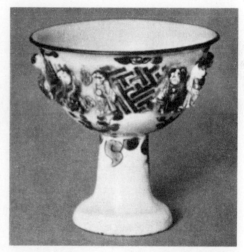

G. Eumorfopoulos Collection.

Fig. 1. Bowl with incised fret designs outside: mark in blue, *lu wei ch'ing kao.* Late Ming. D. 3½ ins. (See page 125.)

Franks Collection (British Museum).

Fig. 2. Bowl, with outer casing, of pierced work interrupted by medallions with Immortals in relief, backed by a wash of blue: the ornament in biscuit. Inside, dragon designs and border in greyish-blue. Mark, *yü t'ang chia ch'i.* Wan Li period. D. 4½ ins. (See page 124.)

Franks Collection (British Museum).

Fig. 3. Perfume bowl and cover with lion knob: white with pierced (*ling lung*) and raised ornament in biscuit. On sides and cover, four medallions with animals and flowering trees in relief and swastika fretwork between. Wan Li period. D. 4½ ins. (See page 124.)

G. Eumorfopoulos Collection.

Fig. 4. Stem-cup with figures of the Immortals in relief in biscuit and incised swastika fret between, coloured with red, green and aubergine: brown edges. Ch'êng Hua mark. H. 3⅝ ins. (See page 123.)

PLATE 35.

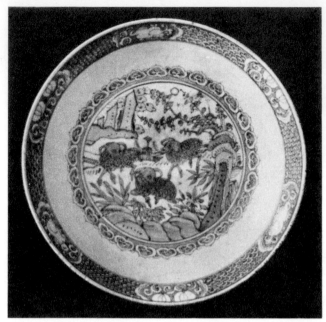

Victoria and Albert Museum.

Fig. 1. Saucer-dish: blue and white. Land-
scape and three rams which symbolise
Spring. Mark, a hare. Chia Ching or
Wan Li period. D. 12½ ins. (See
page 104.)

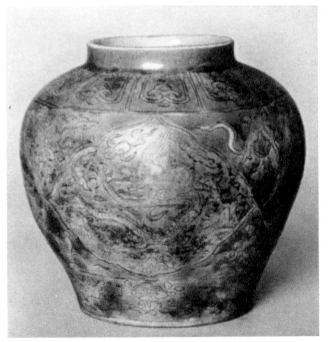

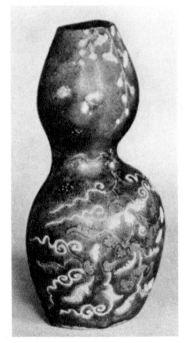

Honble. Evan Charteris Collection.

Anthony de Rothschild Collection.

Fig. 2. Jar with coloured glazes on the biscuit.
Incised designs; dragon panels and the
Eight Buddhist Emblems, yellow in a
green ground. White glaze inside and
under the base. Wan Li mark. H. 7
ins. (See page 126.)

Fig. 3. Wall vase of double-gourd shape with
flat back, decorated with coloured
glazes. Raised designs in pale auber-
gine, blue and white in a greenish
turquoise ground, yellow on the back.
Wan Li period. H. 11¼ ins. (See
page 126.)

PLATE 36.

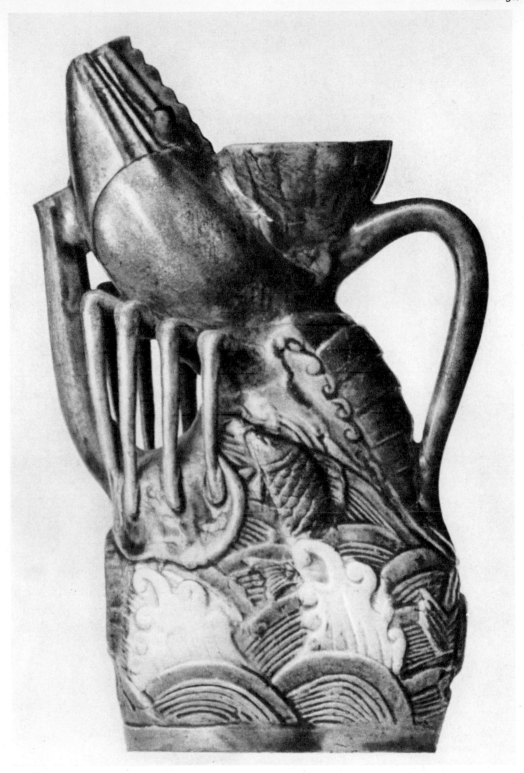

Hainhofer Cabinet, Upsala.

Ewer in form of a crayfish on rock with
lotus plants, fish and water. Coloured
glazes on the biscuit and gilding. The
crayfish is yellow with traces of gilding:
the fish is aubergine: the waves are
green with white crests: other details
are in turquoise blue. Wan Li period.
H. 8 ins. (See page 127.)

PLATE 37.

J. Love Collection.

Fig. 1. Brush-rest with three peaks formed by
dragon heads, the dragon bodies
moulded below in openwork. Painted
in underglaze blue and enamel colours:
red round the base. Wan Li mark.
L. 5½ ins. (See page 129.)

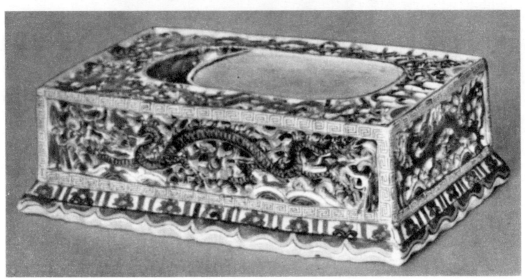

J. Love Collection.

Fig. 2. Ink pallet with design of dragons pur-
suing pearls in openwork. Painted in
underglaze blue and enamel colours.
Wan Li mark enclosed by Imperial
dragons. L. 8½ ins. (See page 129.)

PLATE 38.

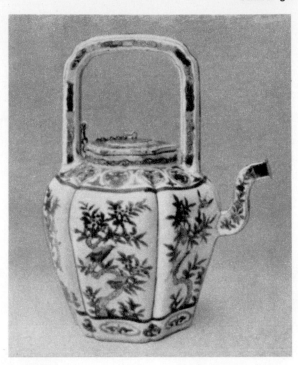

Fig. 1. Wine kettle, six-sided. Painted in underglaze blue and enamel colours with fruiting trees and birds, medallions of flowers and cloud-scrolls. Silver mounts with crest of Parry. Wan Li mark. H. 9½ ins. (with handles). (See page 129.)

Dr. Gilbert Bourne's Collection.

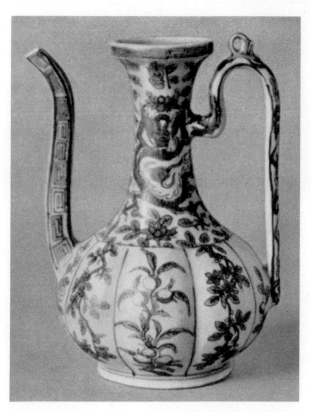

Fig. 2. Ewer of Persian form with lobed body. Painted in underglaze blue and enamels. A full-face dragon on neck and characters *wan shou:* branches with flowers and fruit on the body. Wan Li mark. H. 6¾ ins. (See page 129.)

Franks Collection (British Museum).

PLATE 39.

Franks Collection (British Museum).

P. David Collection.

Fig. 1. Stand painted in red, green and yellow enamels with dragon panels, etc. Wan Li mark. D. 7½ ins. (See page 131.)

Fig. 2. Saucer-dish with engraved designs and coloured glazes on the biscuit. Panel with peach tree twisted into the form of the character *shou* (longevity), in green in a yellow ground. Chia Ching mark. D. 5¾ ins. (See page 99.)

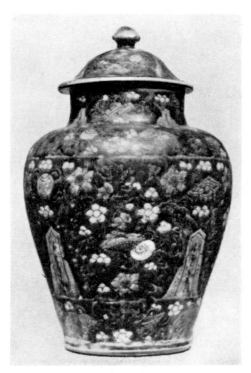

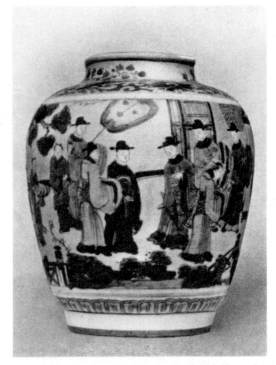

Franks Collection (British Museum).

Franks Collection (British Museum).

Fig. 3. Covered jar with "wave and plum blossom" pattern enamelled in colours in an aubergine ground. Wan Li period. H. 15½ ins. (See page 128.)

Fig. 4. Vase decorated in underglaze blue and enamels with figure subjects. Mark, a hare. Chia Ching or Wan Li period. H. 9 ins. (See page 130.)

PLATE 40.

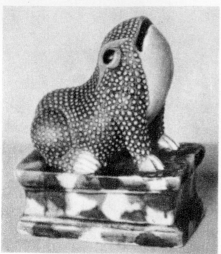

Fig. 1. Figure of a frog with green back dotted with white, white breast and black eyes. The stand mottled with green, yellow and aubergine patches. H. 4¾ ins. (See page 144.)

V. Wethered Collection.

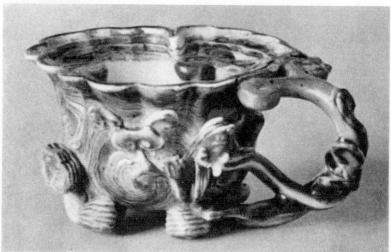

W. Levy Collection.

Fig. 2. Libation cup of "cloud-scroll" form with lizard-dragon handle and sprays of fungus. Decorated with bands of coloured glazes on the biscuit, gilding, passages of underglaze blue and enamel colours. Wan Li period. L. 5 ins. (See page 133.)

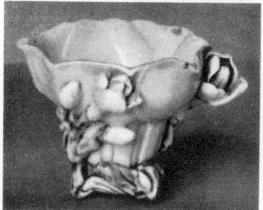

Fig. 3. Cup in the form of a magnolia blossom with buds, the stalks forming the base. White porcelain with blue mottling on the stalks. H. 3⅛ ins. (See page 68.)

V. Wethered Collection.

PLATE 41.

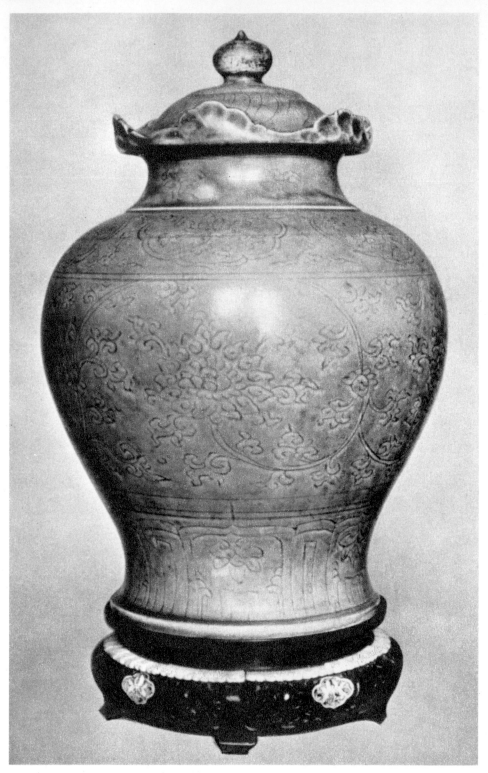

J. Sauphar Collection.

Potiche, with cover turned up at the
sides like a lotus leaf: engraved orna-
ment under a beautiful pale turquoise
glaze: green inside: yellow on the
knob of the cover. Chia Ching period.
H. 15 ins. (See page 94.)

PLATE 42

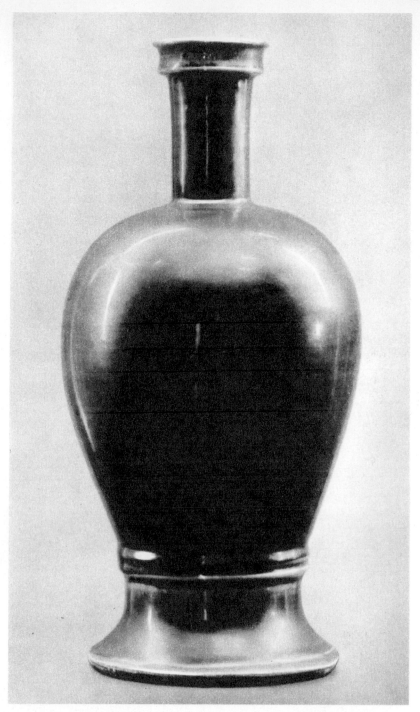

M. Calmann Collection.

Vase with baluster body and slender
neck: brilliant black glaze breaking
into brown at the edges. Wan Li
period. H. 15 ins. (See page 136.)

PLATE 43.

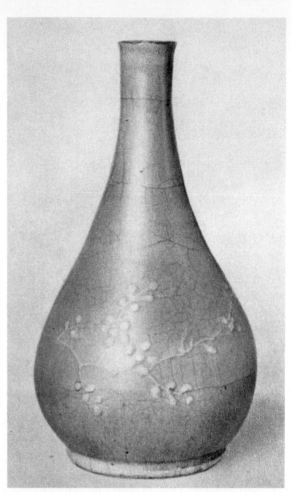

Fig. 1. Vase, bottle-shaped, with pale pea-green celadon glaze and budding prunus sprays in white slip. An early example of slip ware, probably about 1500. H. 10½ ins. (See page 137.)

Franks Collection (British Museum).

British Museum.

Fig. 2. Brush washer of soft-looking cream-white porcelain with faintly incised borders: in Ting style. D. 3¾ ins. (See page 159.)

PLATE 44.

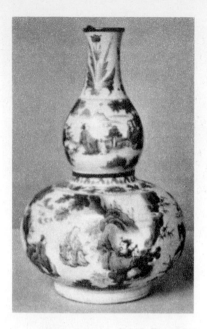

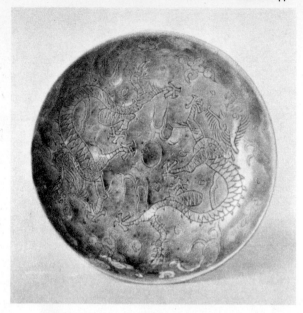

Franks Collection (British Museum).

Franks Collection (British Museum).

Fig. 1. Bottle, gourd-shaped: blue and white. Landscape and figures: tulip design on the neck. About 1640. H. 12 ins. (See page 146.)

Fig. 2. Saucer dish with engraved designs and coloured glazes: aubergine dragons in a green ground: yellow outside. White glaze under the base and T'ien ch'i mark. D. 7¾ ins. (See page 145.)

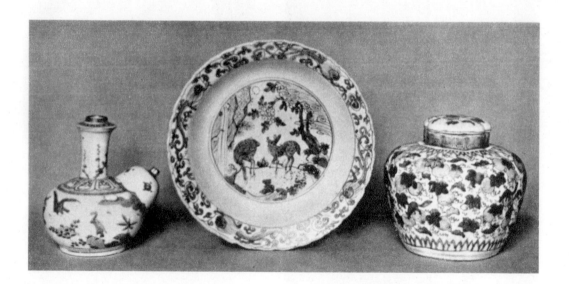

Fig. 3. Group of export blue and white: a pipe-shaped bottle, a dish and a melon-shaped jar and cover with gourd-vine and rats (see page 121). The jar is from the R. E. Brandt Collection. H. 7½ ins.

PLATE 45.

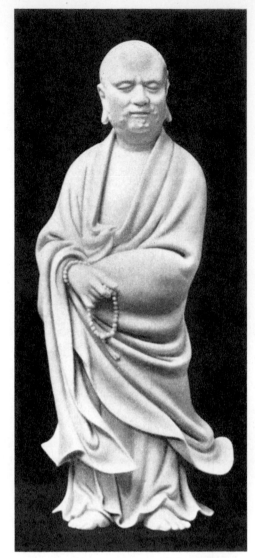

J. Love Collection.

Fig. 2. Figure of a Buddhist monk with rosary. Ivory white Fukien porcelain with pinkish tinge. H. 10⅝ ins. (See page 152.)

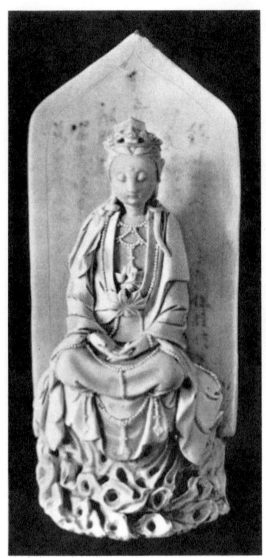

S. D. Winkworth Collection.

Fig. 1. Figure of Kuan-yin seated on a rock-base with inscribed tablet behind. Ivory white Fukien porcelain. H. 11 ins. (See page 151.)

PLATE 46.

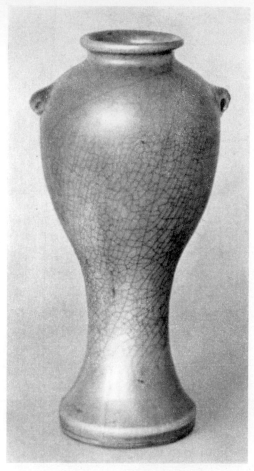

Fig. 1. Vase with lion-mask handles and crackled celadon green glaze. Mark of Ch'ên Chên-shan. H. 10½ ins. (See page 157.)

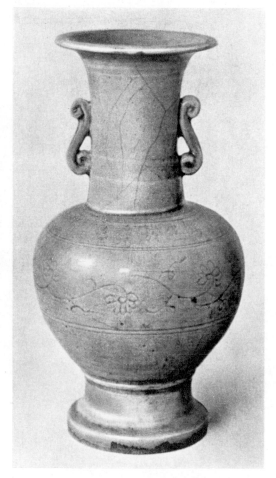

Fig. 2. Vase with pale celadon green glaze: engraved floral scrolls and inscription with date 1547. H. 12 ins. (See page 156.)

PLATE 47.

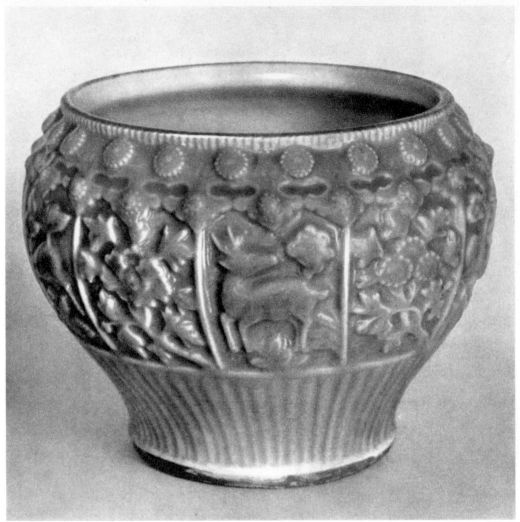

G. Benson Collection.

Wide-mouthed jar with grey-green
celadon glaze. Eleven panels with
animal and plant designs in moulded
relief. Fifteenth century. H. 9¼ ins.
(See page 157.)

PLATE 48.

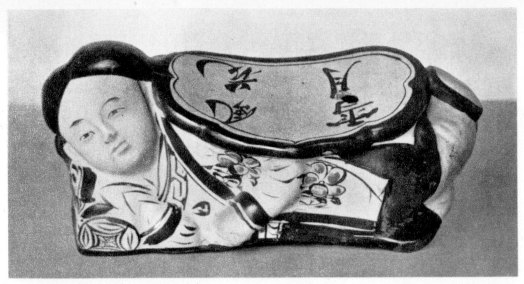

British Museum.

Fig. 1. Pillow in form of a reclining girl:
painted in black and maroon slips.
L. 11 ins. (See page 161.)

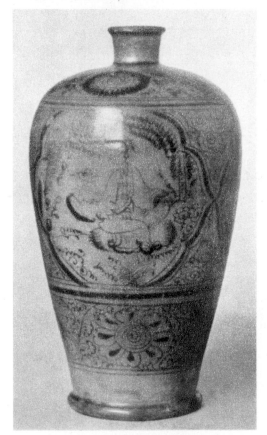

Franks Collection (British Museum).

Fig. 2. Vase (*mei p'ing*) painted in black under
a turquoise blue glaze. Three panels
with figures in two of them and a stork
in the third. Fifteenth century. H. 10½
ins. (See page 161.)

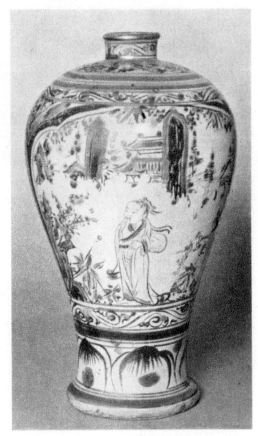

G. Eumorfopoulos Collection.

Fig. 3. Baluster vase with small mouth (*mei
p'ing*) painted in black slip, and red and
green enamels on a cream-white glaze.
Tz'ŭ Chou ware. H. 13½ ins. (See
page 161.)

PLATE 49.

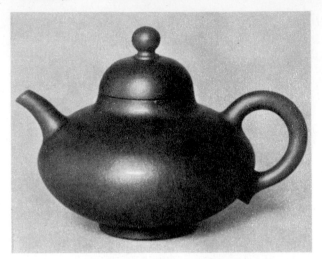

Fig. 1. Teapot of deep brownish-red stone-
ware, with rough pear-skin surface.
Mark of Hui Mêng-ch'ên. Yi-hsing
ware. D. 4¾ ins. (with handle and
spout). (See page 170.)

G. Eumorfopoulos Collection.

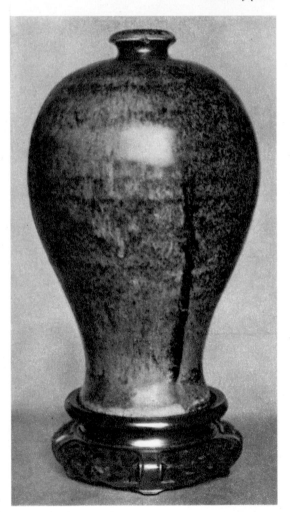

J. Sauphar Collection.

Fig. 2. Vase (*mei p'ing*): reddish-brown stone-
ware with thick flocculent glaze of
purplish-brown flecked with tea green.
H. 10¾ ins. (See page 166.)

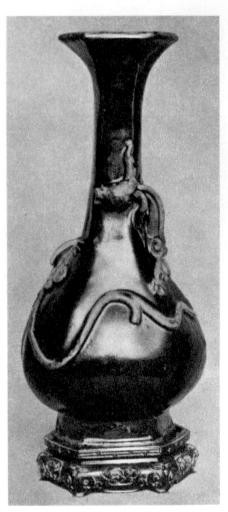

Grandidier Collection (The Louvre).

Fig. 3. Hexagonal bottle with archaic dragon
in relief on the neck. Buff pottery with
dark violet-blue glaze: turquoise glaze
on the reliefs. H. 8¼ ins. (See page
176.)

PLATE 50.

Fig. 1. Sepulchral figure of reddish buff pottery: man with long-slieved coat which is glazed green: the rest un-glazed, but washed with white slip. From a Ming tomb. H. 7⅞ ins. (See page 174.)

Victoria and Albert Museum.

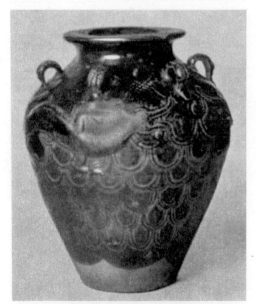

Franks Collection (British Museum).

Fig. 2. Jar of buff stoneware with pale olive-brown glaze: two dragons in relief disputing a pearl: imbricated pattern incised on ground. About 1600. H. 9 ins. (See page 174.)

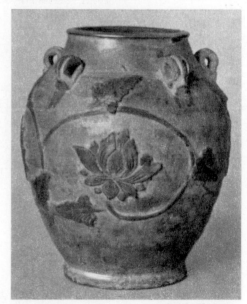

British Museum.

Fig. 3. Jar of reddish pottery with green glaze: peony scroll in applied relief, coloured yellow and brown. Found in the ruins of Ayuthia. Late Ming. H. 8¾ ins. (See page 175.)

PLATE 51.

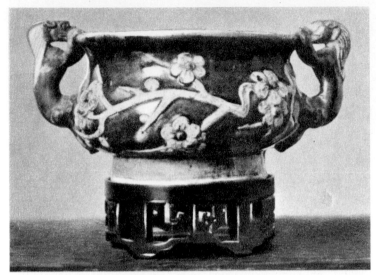

Comtesse Cahen d'Anvers Collection.

Fig. 1. Incense burner with two handles in the
form of archaic dragons: prunus sprays
in relief on the body. Buff pottery with
coloured glazes: dark violet-blue
ground: white and turquoise on the
reliefs, and yellow and blue on the
handles. Sixteenth century. H. 4 ins.
(See page 176.)

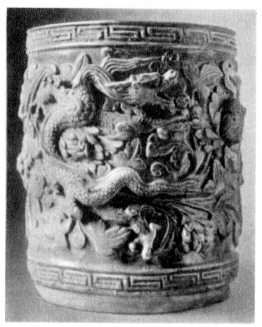

Jean Hennessy Collection.

Fig. 2. Cylindrical vase of light buff pottery
with dragon and peony flowers in high
relief: key-fret borders: blue and
green glazes with touches of yellow:
some details in unglazed biscuit. Six-
teenth century. H. 10 ins. (See
page 180.)

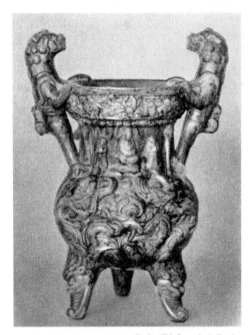

S. D. Winkworth Collection.

Fig. 3. Incense burner with lion handles and
three feet with lion masks. Buff pottery
with moulded and applied reliefs and
coloured glazes — green, turquoise,
yellow and aubergine. On the neck,
Kuan-yin and other figures in relief:
on the body, dragon and foliage. Late
Ming. H. 18 ins. (See page 176.)

PLATE 52.

Fig. 1. Vase with pear-shaped body and wide mouth: buff stoneware with coloured glazes: chrysanthemum designs in low relief in a pale aubergine ground. Late Ming. H. 16½ ins. (See page 178.)

Fig. 2. Square beaker with two handles. Buff pottery with prunus designs in raised outline coloured white and violet-blue in a turquoise ground. Sixteenth century. H. 13¾ ins. (See page 176.)

PLATE 53.

Franks Collection (British Museum).

Fig. 1. Flower pot. Hard buff pottery with coloured glazes: deep aubergine brown ground and lotus designs in green, yellow and peacock blue: blue inside. Late Ming. D. 7½ ins. (See page 178.)

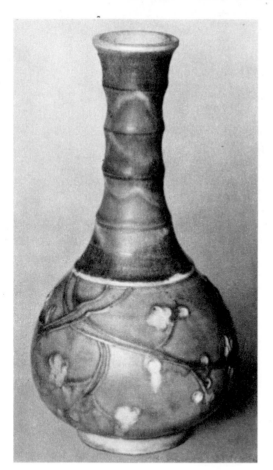

G. Eumorfopoulos Collection.

Fig. 2. Bottle-shaped vase of light buff stoneware with prunus design in low relief: bamboo-shaped neck. Coloured glazes —aubergine on the neck, turquoise on the body and white and aubergine in the reliefs. Sixteenth century. H. 10½ ins. (See page 178.)

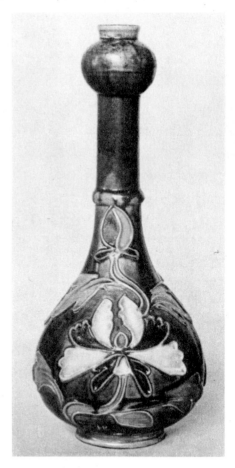

H. J. Oppenheim Collection.

Fig. 3. Bottle-shaped vase: buff stoneware with coloured glazes—green ground and raised lotus designs in turquoise, aubergine, amber-yellow and white. Late Ming. H. 14¼ ins. (See page 178.)

PLATE 54.

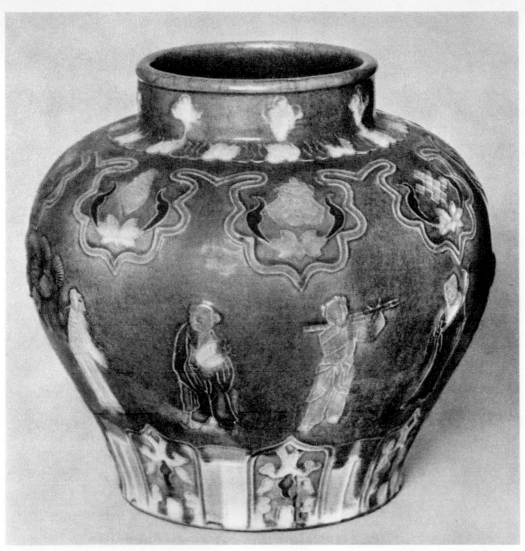

G. Eumorfopoulos Collection.

Potiche of fine pottery, with flat base, decorated in cloisonné style with coloured glazes. The God of Longevity and the Eight Immortals: eight pendants on the shoulder with the Buddhist Emblems: border of false gadroons below, and cloud scrolls on the neck. The figures have biscuit faces; but otherwise the designs are coloured with dull yellow, blue, pale aubergine and white in a turquoise green ground. Probably fifteenth century. H. 10½ ins. (See page 179.)

PLATE 55.

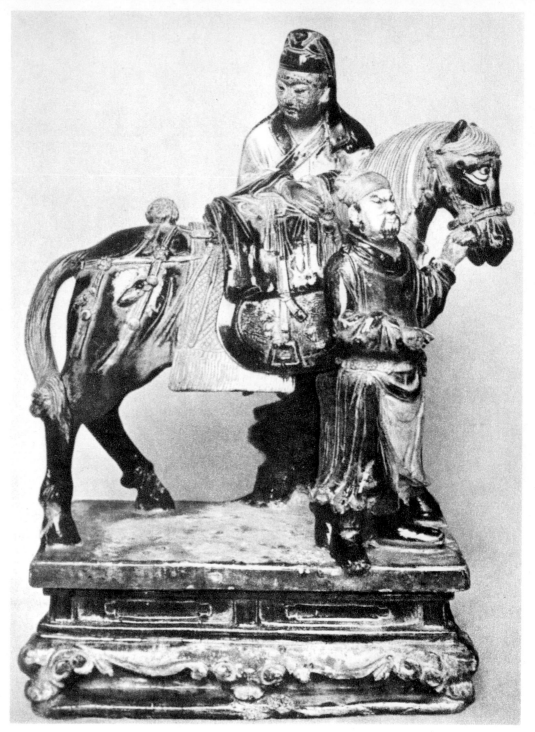

Grandidier Collection (The Louvre).

Group of horse with groom and rider,
on rectangular base. Buff pottery with
coloured glazes: dark violet-blue
ground and details in green, turquoise
and yellow. About 1500. H. 18 ins.
(See page 181.)

PLATE 56.

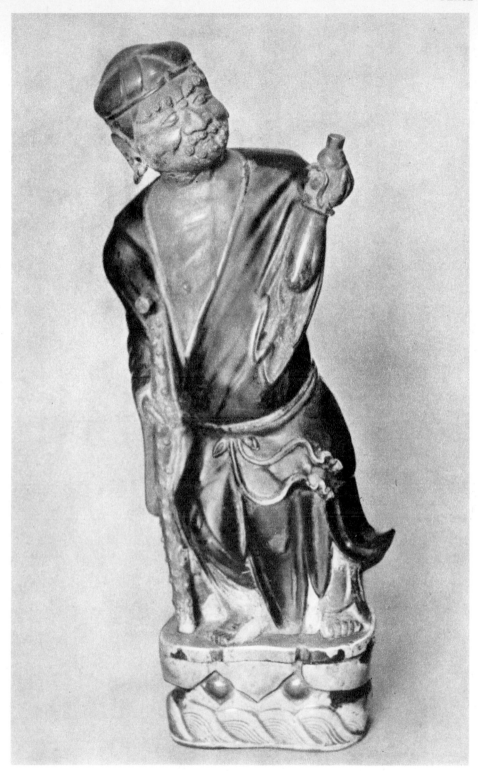

Incense burner in form of Li T'ieh-kuai, the beggar Immortal. Reddish buff pottery: the flesh unglazed and the drapery turquoise and dark violet-blue: wave-pattern on the base. Sixteenth century. H. 16½ ins. (See page 181.)

PLATE 57.

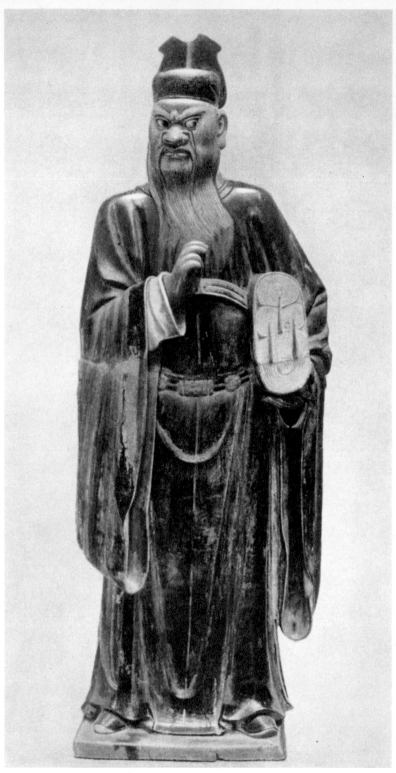

One of the Judges of Hell. Hard greyish pottery with green, yellow, aubergine and colourless white glazes. Late Ming. H. 54 ins. (See page 182.)

PLATE 58

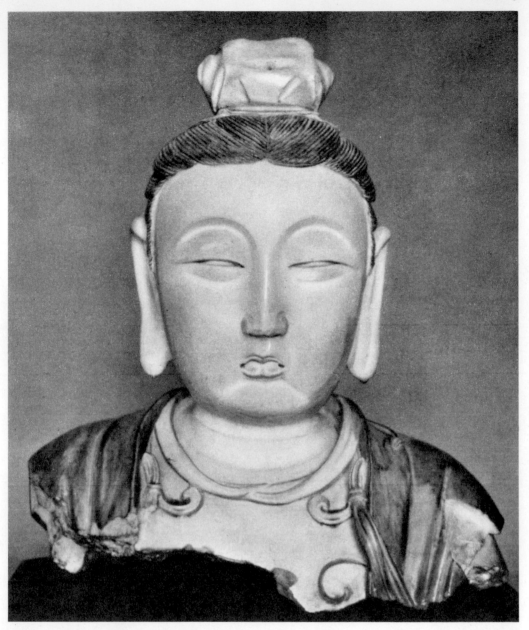

J. Sauphar Collection.

Head and shoulders of pottery figure of
Kuan-yin with coloured glazes: green
over-robe, yellow under-robe, black hair
and white flesh. Sixteenth century.
H. 17 ins. (See page 182.)

PLATE 59.

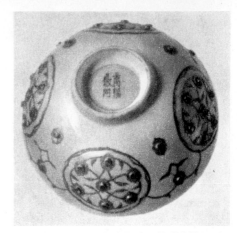

Franks Collection (British Museum).

Fig. 1. Base of broken bowl from Fostat. Mark, *Hsüan tê nien tsao.* (See page 51.)

Franks Collection (British Museum).

Fig. 2. Base of jewelled bowl. Mark, *wan fu yu t'ung.* D. 4½ ins. (See page 92.)

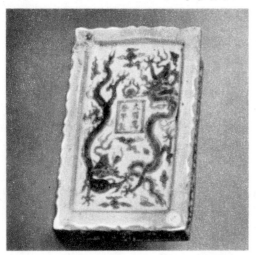

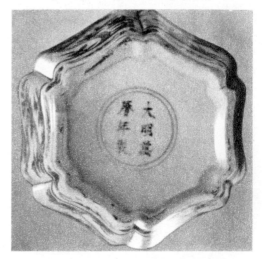

J. Love Collection.

Fig. 3. Base of ink-pallet on Plate 37. Mark, *Ta ming wan li nien chih.* (See page 129.)

Gilbert Bourne Collection.

Fig. 4. Base of wine kettle on Plate 38. Mark, *Ta ming wan li nien chih.* (See page 129.)

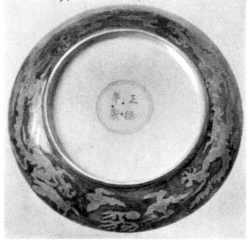

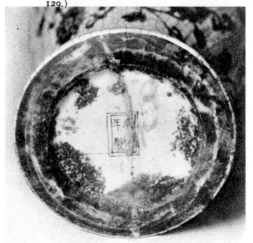

Franks Collection (British Museum).

Fig. 5. Base of saucer dish with green dragons in yellow ground. Mark, *Chêng tê nien chih.* D. 7⅞ ins. (See page 81.)

H. B. Harris Collection.

Fig. 6. Base of vase on Plate 17. Mark, *Ch'êng hua nien chih.* (See page 70.)